To a wonderful friend. Happy 25th

(Oct. '98) - Your friend,

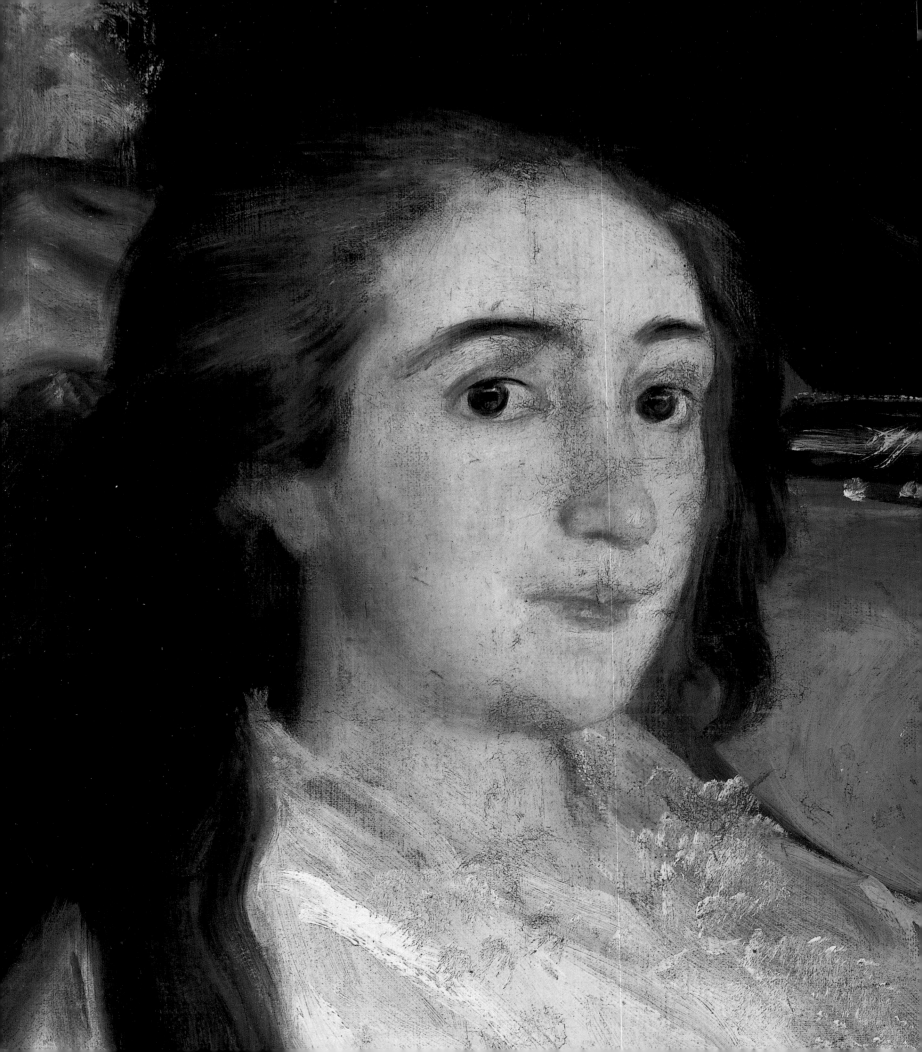

MODERN PAINTING

The Impressionists—and the Avant-Garde of the Twentieth Century

Texts and picture research
by Stefano Zuffi and Francesca Castria

Translation
Christopher Huw Evans

On the cover
Edgar Degas
The Rehearsal of the Ballet Onstage
(detail), 1874
The Metropolitan Museum of Art, New York
H.O. Havemeyer Collection, Bequest
of Mrs. H.O. Havemeyer, 1929
Photograph © 1980 The Metropolitan
Museum of Art

On the first pages
Francisco de Goya
The Family of Don Luis de Borbón
(detail), 1783
Fondazione Magnani Rocca,
Mamiano di Traversetolo

Camille Corot
The Studio (detail),
c. 1865
Louvre, Paris

Pablo Picasso
Harlequin and His Girlfriend (detail),
1902
Pushkin Museum, Moscow

All inquiries should be addressed to:
Barron's Educational Series, Inc.
250 Wireless Boulevard
Hauppauge, New York 11788
http://www.barronseduc.com

Library of Congress Catalog Number 98-72513
International Standard
Book Number 0-7641-5119-3
Economic edition

© 1998 by S.I.A.E.

© 1998 by Electa, Milan
Elemond Editori Associati

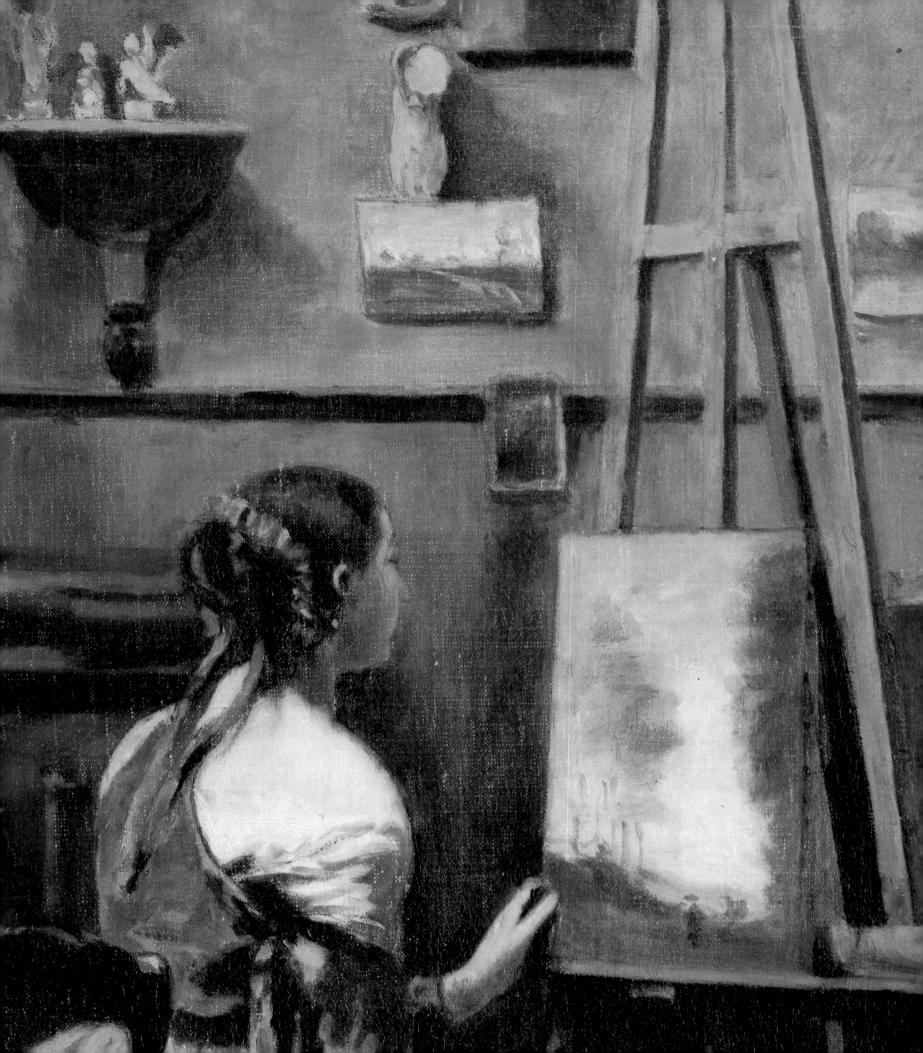

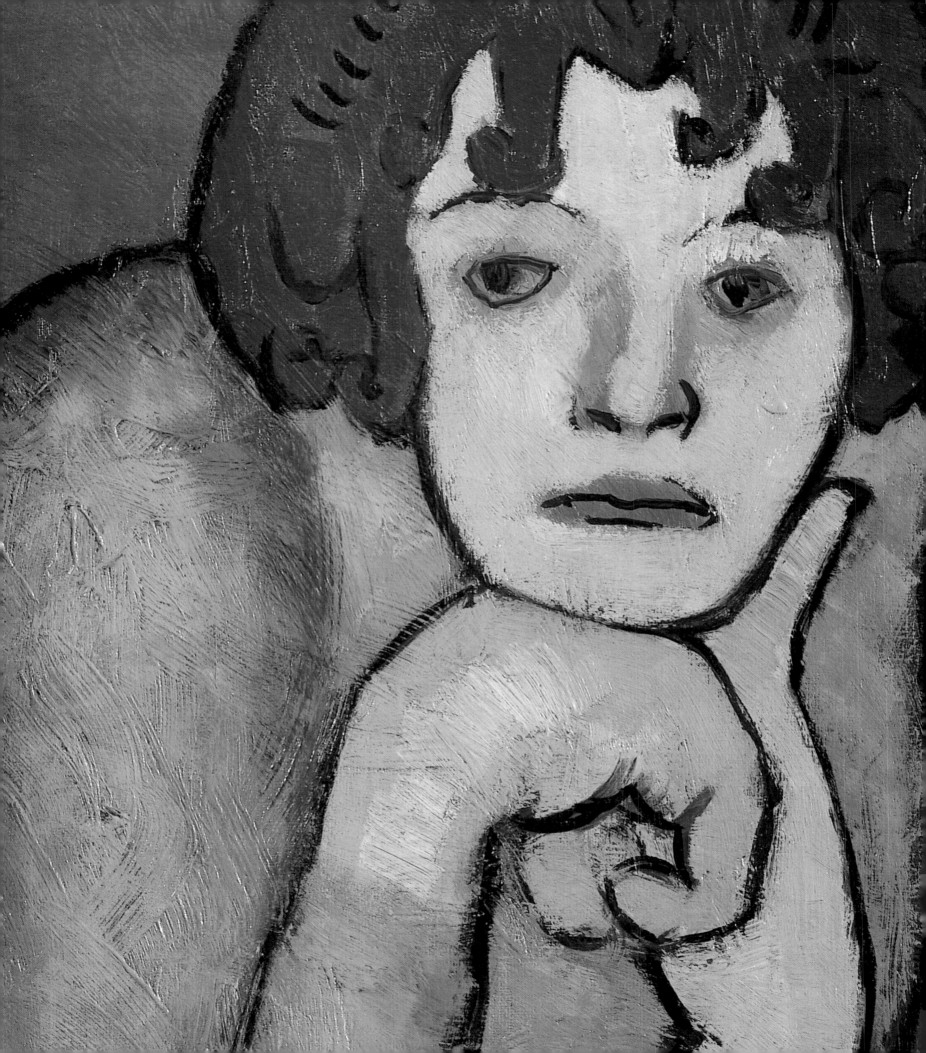

Two centuries ago, the political and cultural system on which Europe had stood for so long came tumbling down along with the Bastille. From Great Britain, factory chimneys and locomotives were beginning to give off the smoke signals of a new era. It is here that the path leading into the heart of our own age starts: with its great upheavals and tragedies, it is the road of a "modern" attitude toward the great themes of the world and humanity.

Among the many "documents" that can help us to understand the origins and development of today's civilization, this book chooses to look at the route followed by painting: year after year, an uninterrupted chain of great artists and memorable masterpieces present us with emotions and passions, fears and joys, confirmations and surprises. The field of view broadens: from the traditional capitals of art, rooted in the heart of Europe and extending out into the Mediterranean, the geographical borders spread to take in the Scandinavian countries, the endless expanse of Russia and even, on the far side of the Atlantic, the contradictory Americas. Despite the variations in latitude, historical situations and "languages" of expression, the painting of the nineteenth and twentieth centuries represents a concurrent search for the essence, for the most profound, direct and daring image of the world that art has ever ventured to propose. This volume is not divided into national schools, but into a succession of different moments in art and in thought, presented through the work of leading figures in a variety of countries.

Thus the story begins with the passage from the eighteenth to the nineteenth century, interpreted in emblematic fashion by Goya. It then moves on to Romanticism, which brought a Europe-wide emphasis on the feelings of the individual in the face of the spectacle of nature, the giddy pace of history, the poetry of the everyday. And it is to the analysis of daily life, presented with an at times brutal realism by such "uncomfortable" figures as Courbet and Daumier, that the third stage of the journey through modern painting is devoted. Next comes the luminous chapter of the Impressionists. Undoubtedly the most familiar and best-loved of all these pictorial currents it takes us along the banks of the Seine, amidst the pleasures of Paris and the cool shade of the city's parks, in discovery of the public entertainments and private thrills of a fascinating society. After this we come to the developments in painting that took place in the late nineteenth century, with the emergence of Expressionism, the birth of Symbolism and the innovative researches into technique carried out by van Gogh and Gauguin, Toulouse-Lautrec and Cézanne. In the meantime, the Vienna of Freud and a declining empire saw the emergence of a sense of disquiet in the psyche of the individual, which was destined to blaze up into Expressionism on the threshold of the new century and in the shadow of the looming tragedy of the First World War.

The twentieth century opens with the debate over the avant-garde, as the great historical movements were born: Picasso's Cubists, Matisse's Fauves, Boccioni's Futurists, Kandinsky's Expressionists. The first few decades of the twentieth century were a period of extraordinary richness in painting, with few parallels in the whole history of art. A succession of events and masterpieces that were continually interacting, coming into collision, strengthening one another. To these years and to the protagonists who moved across a lively stage are dedicated three chapters, examining the developments in art between the wars, and the contest between the new movement of abstractionism and figurative painting, in its turn split between the crude image of reality and the creation of mysterious and enchanting worlds.

Our journey is interrupted by the outbreak of the Second World War, a fundamental watershed in this century and one that was prefigured in such a terrifying way by Guernica, *Picasso's best-loved masterpiece. Six years of horror were brought to a close by the atomic bomb: the new situation in society and the world required a profound change in art, which discarded traditional rules and rendered the customary distinction between techniques of expression almost meaningless. From this point on it is no longer possible to speak of "painting": a different horizon opens, one that the masterpieces in this book have anticipated but which new artists are now tackling, in unpredictable ways.*

Between Two Worlds

Francisco de Goya
The Third of May, 1808 (detail)
1814
Oil on canvas,
104¾ × 135¾ in. (266 × 345 cm.)
Prado, Madrid

Several times in the history of civilization, the end of a century has been a time of radical change, bringing profound political, economic, social, cultural or even psychological upheavals. It suffices to think of what happened at the end of the fifteenth century, with the voyages of discovery and the emergence of religious divisions. Yet perhaps no other moment in history and culture has had the decisive and irrevocable character of the late-eighteenth century. The French Revolution marks a divide not just between one age and another, but also between two different conceptions of our world and the role that we play in it.

The Revolution, followed by the exploits of Napoleon and accompanied by equally significant events like the development of industry in Great Britain and the consolidation of the United States of America, presented European intellectuals with a completely new scenario. A generation of artists, musicians, philosophers and poets found itself in the difficult but exhilarating position of having to interpret, by its own lights, the waning of a world and the painful dawn of a new horizon. Along with painters like Goya, David, Füssli and Blake, this was the generation of Kant and Beethoven, Goethe and Canova, Schiller and Thorvaldsen, Foscolo and the English poets, in an alternation of tension toward the future, moral commitment to the present and agonizing nostalgia for beauty, evoked in the face of chaos as the supreme good and last hope for humanity. The wide variety of proposals and expressions contrasts with our usual view of the period. In fact the whole of Europe, at the turn of the century, embraced the Neoclassical style: from architecture to fashion, people looked back to the models of ancient Greece and Rome and, a little later on, to the Egypt of the pharaohs. For many decades, Neoclassicism has had a negative image, being seen as a flight into the well-established norms and rules of a "cold" academicism. Now, however, a critical reexamination of the Neoclassical era has led to a rediscovery of the underlying values of an age of dramatic transition, in which formalism became a means of expression charged with extreme tension: a subtle and crystalline tension beneath which the agitation of the emotions, the stirring of the senses, is not hard to discern. It is certainly no coincidence that Neoclassicism is very much back "in fashion" today, two hundred years later, but at a time when we are faced with a historical situation of epoch-making change that is perhaps reminiscent of the late-eighteenth century: the rubble left by the collapse of the Berlin Wall is not so different from that of the Bastille. Goya and David may look like antithetical figures: one moody and passionate, the other calculating and precise. In Goya's *Caprices*, *Disasters of War* and *Black Paintings*, we recognize a solitary, corrosive and gloomy spirit, in David's reflection of Napoleon's rising star the splendor of the apologia, of the public world and officialdom. And yet David and Goya represent two faces of the same human and artistic situation, in the middle of the passage between "two centuries, one armed against the other." And both were to meet a similar fate, in exile. In the field of painting, on the eve of the nineteenth century, we can detect a feeling of rejection of the art of the recent past, and in particular the Rococo of eighteenth-century Central European courts. In reality, the dissatisfaction with or even repugnance for the excesses, gallantries and "frivolities" of the Late Baroque had already begun to emerge around the mid-eighteenth century, with the rise of the Age of Enlightenment and the culture of Diderot's *Encyclopédie*. Neoclassicism, spurred on by the remarkable archeological discoveries of the second half of the century (such as the excavations at Pompeii, the study of Athens, the first campaigns in Egypt and

Jacques-Louis David
The Sabine Women Dividing the Ranks of the Romans and Sabines, 1799
Oil on canvas,
151½ × 205¾ in.
(385 × 522 cm.)
Louvre, Paris

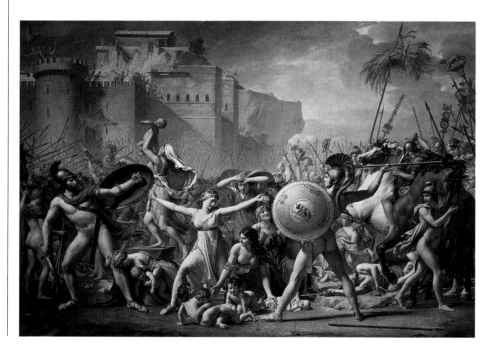

Mesopotamia), found a theoretical basis in the writings of German thinkers. Although standing on shaky foundations, such as the belief that the Roman copies of statues were Greek originals and that the sculptures were white, when they were actually painted in bright colors, Winckelmann, Lessing and Mengs laid down the rules of an art that became a lifestyle, an expression of moral and civic virtues. When Neoclassicism succeeded in becoming the art of the courts, the fate of Rococo art was sealed: Giambattista Tiepolo, the last of the great decorators, died in Madrid in 1770, almost a pauper and superseded by the new fashion. On the other hand, the spread of the Neoclassical style made it essential for artists to go to Rome to study. The Eternal City was once again a magnet for European intellectuals and painters, though not, as it had been at the beginning of the seventeenth century, the crucible of a new art. People came to Rome to study the past: above all the archeological remains, but also the painting of Raphael and Michelangelo, the mythological frescoes of Annibale Carracci and the idealized landscapes of Claude Lorrain and the other masters of the seventeenth century. Thus it is interesting to note how decisive a role familiarity with the "classics" of antiquity, the Renaissance and the Seicento played in the formation of many European painters, and not just the exponents of Neoclassicism but even the members of subsequent generations. The choice of models is the prime indication of the style of the greatest painters of the late-eighteenth and early-nineteenth century, at least up until the time of the Impressionists. From this perspective, we can see the importance of Caravaggio and Velázquez to Goya (and through Velázquez, the decisive influence of Titian), or just how deeply David imbibed the lessons of Nicolas Poussin. Not to forget the developments that took place in Germany with the group of the Nazarenes, and in the Scandinavian countries, dominated by the technique of Bertel Thorvaldsen, the most consistent and rigorous of the Neoclassical sculptors. By contrast, a nation substantially devoid of any local tradition of painting proved to be the liveliest of all at the beginning of the nineteenth century: Great Britain. It was not until the middle of the eighteenth century that Sir Joshua Reynolds, a brilliant portraitist and exceptional cultural promoter, succeeded in founding the Royal Academy of Arts in London: naturally the training of young artists

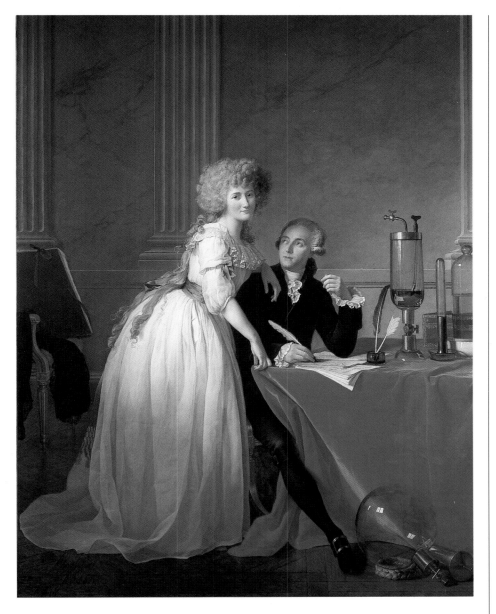

had to include study of the great "classics," but British artists displayed a greater degree of freedom than their counterparts on the Continent. Above all, England saw the establishment of a very close dialogue between painting and literature, so direct and lively that it anticipated what was to take place, over the course of the nineteenth century, in other European nations. English painters took on Ossian and Shakespeare, Milton and Dante, venturing into the realms of nightmare, the unconscious and fantasy. Finally, it has to be remembered that Napoleon's "plundering," the archeological campaigns in the Mediterranean and the sale of works of art by desperate Italians resulted in the dispatch of sublime masterpieces to the Louvre and the British Museum: from Raphael to Phidias, the great museums of the new "capitals of Europe" provided artists with a priceless heritage of models to study and copy. Until the advent of photographic reproductions, the museum became the privileged location for art, partly obviating the need for journeys to distant lands.

Jacques-Louis David
Portrait of Antoine Lavoisier and His Wife
1788
Oil on canvas,
102¼ × 76¾ in.
(260 × 195 cm.)
The Metropolitan Museum of Art, New York. Purchase, Mr. and Mrs. Charles Wrightsman Gift, in honor of Everett Fahy, 1977

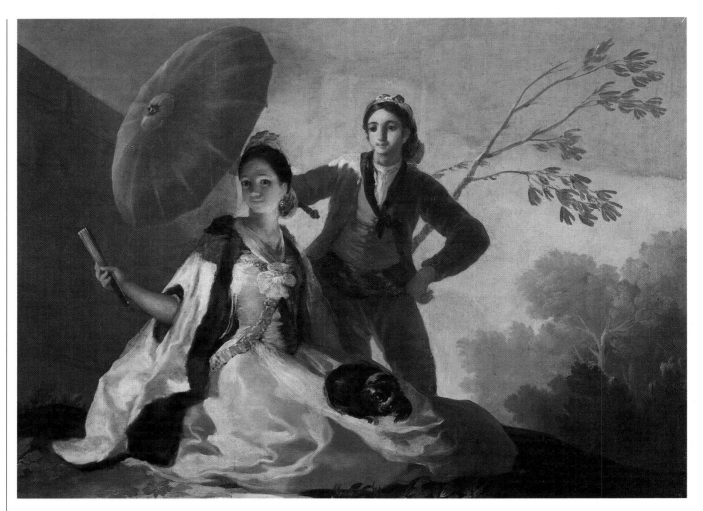

Francisco de Goya
The Parasol

1777
Oil on canvas,
41 × 59¾ in.
(104 × 152 cm.)
Prado, Madrid

This is one of the finest and most celebrated of the cartoons prepared by Goya for the royal tapestry factory: an extremely demanding cycle, which saw Goya assume the role of the heir to Giambattista Tiepolo as decorator of the residences of the Spanish court. Immersed in the elegant and refined climate of Rococo, Goya interpreted popular themes with a sense of gay participation. The compositions, in view of their subsequent transformation into tapestries, are relatively simple, while the combinations of colors achieve a marvelous harmony, unquestionably in line with the tradition of luminous Venetian painting.

Francisco de Goya y Lucientes

Fuendetodos, 1746–Bordeaux, 1828

It is no accident that this volume opens with the name of Goya. The Spanish painter was the first to grasp the radical turning point in history and art that was marked by the end of the eighteenth century, and he interpreted it in a more intense manner than any other artist. The course of Goya's human and stylistic development is remarkable: from the freshest and most indulgent of Rococo to the brink of nineteenth-century realism, passing through an extraordinary series of experiments, almost all of them anticipating cultural tendencies that were later to spread throughout Europe. His laborious artistic training, begun in the provinces and culminating in a journey to Italy in 1771, led the young Goya to acquire a vast figurative culture. This was clearly evident in his first large-scale works of decoration, such as the frescoes in the church of Pilar at Saragossa. In 1774 Goya was given an important post at the court in Madrid, making cartoons for the tapestry factory. Adopting the style of Tiepolo, Goya depicted the elegant world of eighteenth-century Madrid with the lightest of touches. The success of these cartoons (now in the Prado) made Goya the most celebrated artist in Spain and, from 1789, official painter to the king. For the court and nobility of Madrid, Goya painted numerous portraits that reveal a careful study of Velázquez. Gradually, however, Goya's figures lost the richness of color and confident look of the early years and were presented in empty spaces, with a fixed hallucinatory gaze. His sense of solitude increased after 1792, when the painter was struck by an illness that left him almost deaf. On the other hand, while his individual figures withdrew into a troubled incommunicability, Goya observed the movements of the crowd and the habits of the people with great sensitivity, interpreting proverbs with ironic and fanciful subtlety. His frescoes in San Antonio de la Florida in Madrid (1798) are spectacular, and were immediately followed by the engravings of *Los Caprichos* and the extraordinary *Family of Charles IV*, a group portrait that has the flavor of the end of an era, filled with twilight characters and moods. In the early years of the nineteenth century, Goya frequently painted female figures, culminating in the two *Maja*, using brushstrokes laden with paint that would have been worthy of Titian. In 1808 Spain was invaded by Napoleon's troops: it was a moment of terrible tragedy, to which Goya gave grim expression in the *Disasters of War* and, later on, in the two paintings dedicated to the insurrection in Madrid and the executions which brought it to a close. After 1810, Goya's brushwork grew loose and blurred, his colors dark and gloomy, in a crescendo of bitterness that ended in the dramatic *Black Paintings* executed by the artist on the walls of his house in the country. In 1824 Goya left Spain for Bordeaux, where he spent the last years of his life in relative tranquillity. This stay made Goya's influence on subsequent nineteenth-century French painting even more direct.

Francisco de Goya
The Flower Girls

1786
Oil on canvas,
109 × 75½ in.
(277 × 192 cm.)
Prado, Madrid

From the sixth cycle of cartoons for tapestries painted by Goya over a period of many years. The scene is closely reminiscent of the pastoral pictures of Giandomenico Tiepolo, from the viewpoint of both the composition (with the contrast between the dark brown hillside and the slender green tree) and the disenchanted and enjoyable realism with which the figures are portrayed.

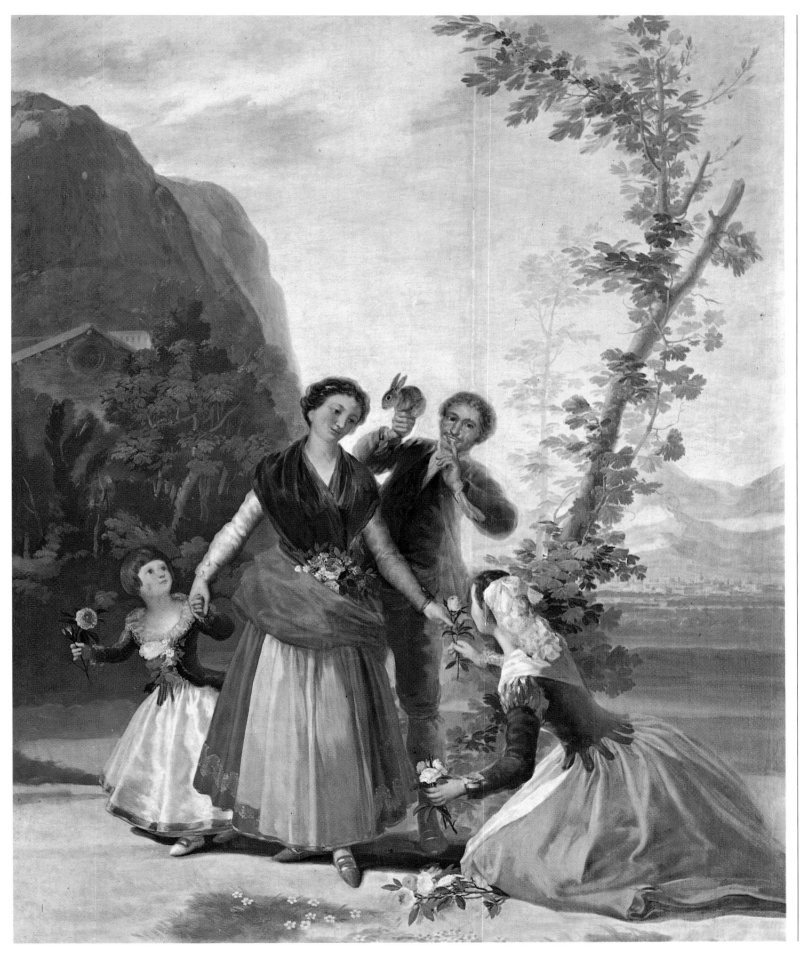

Francisco de Goya
The Family of Don Luis de Borbón

1783
Oil on canvas, 97¾ × 130 in.
(248 × 330 cm.)
Fondazione Magnani
Rocca, Mamiano
di Traversetolo

An extraordinary demonstration of Goya's skill in the composition of group portraits, worthy of the tradition of Velázquez and Rembrandt. The figures are gathered around a dimly lit gaming table, while the artist, on the left, begins to paint. We are presented with a parade of faces belonging to men, women and children, some very young and others lined with age, some noble and others distracted, some pensive and others bizarre: a gallery of characters that throbs with a powerful sense of vitality. The shades of color, in the faint candle light, are lit up with unexpected glows. The group conveys a veiled impression of melancholy, very different from the pompous stolidity of Charles IV's court (see p. 18).

Francisco de Goya
The Family of Don Luis de Borbón (detail)

1783
Oil on canvas,
97¾ × 130 in.
(248 × 330 cm.)
Fondazione Magnani
Rocca, Mamiano
di Traversetolo

The little girl is María Teresa de Borbón, the Countess of Chinchón, at the age of two.

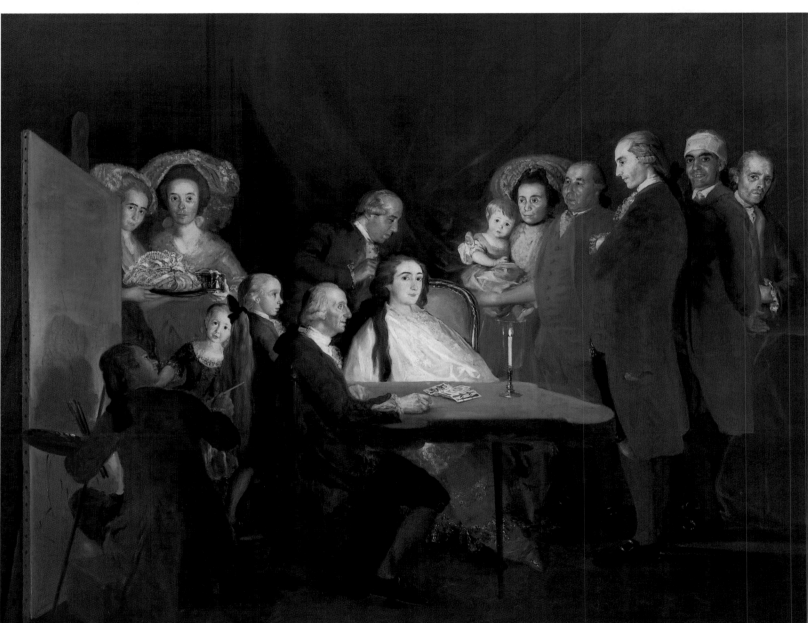

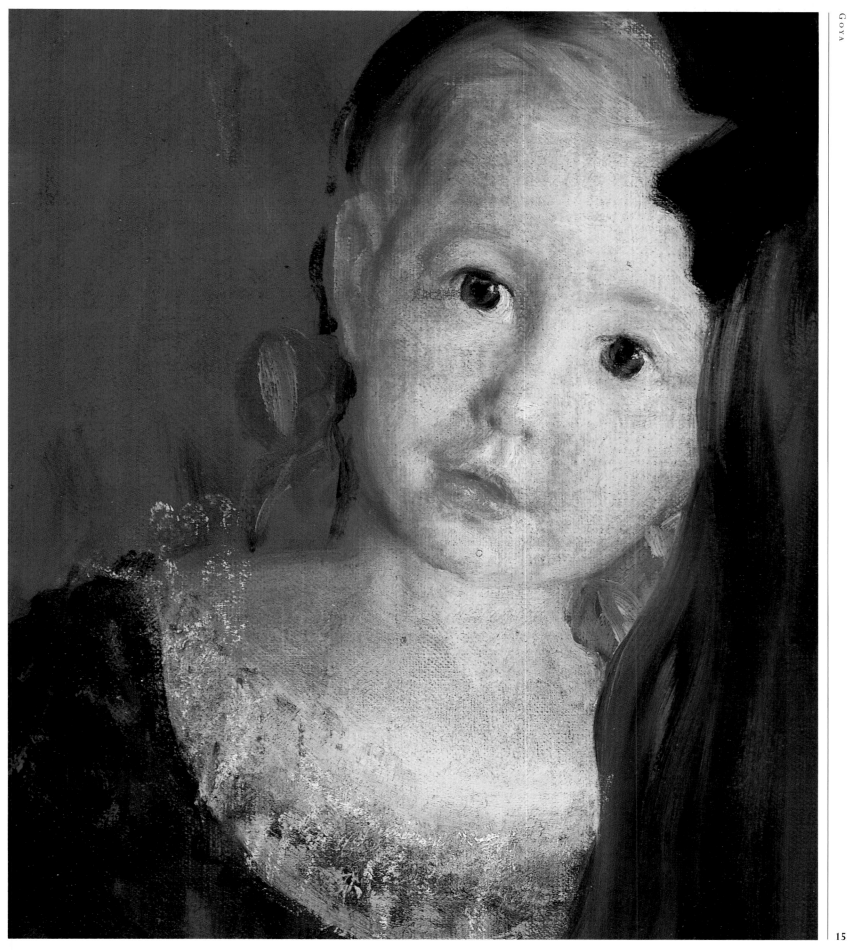

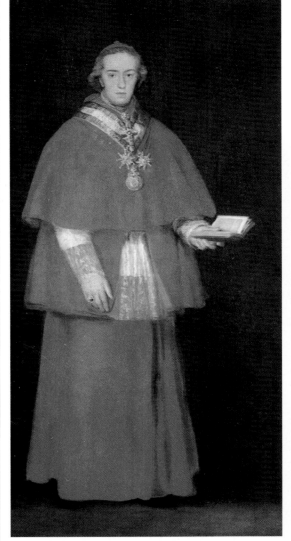

Francisco de Goya
Cardinal Luis María
de Borbón y Villabriga

1798
Oil on canvas,
78¾ × 66½ in.
(200 × 196 cm.)
Museu de Arte, São Paulo,
Brazil

Taken as a whole, Goya's portraiture represents one of the most interesting chapters in the entire history of painting. In his full-length portraits of standing figures, set against a neutral background, the artist certainly harked back to the tradition of Velázquez, and through him to Titian. This heritage is also apparent in the density and richness of the color, laid on in generous and thick brushstrokes. In comparison with his two illustrious predecessors, however, Goya increasingly placed the accent on his subjects' feelings of unease, presenting them as bewildered, isolated and anxious figures. Into them, even before the eighteenth century had drawn to a close, crept a sense of trepidation (conveyed in part by the disintegration of the outlines) that renders the figures tangible and concrete and yet psychologically elusive.

Francisco de Goya
The Marchioness of Solana

1794–95
Oil on canvas,
71¼ × 48 in.
(181 × 122 cm.)
Louvre, Paris

The slim and elegant figure, with a complexion of transparent pallor, almost seems to presage the untimely death of the noblewoman, whose life came to an end in 1795 at the age of only twenty-eight. It is another of the fascinating and disquieting portraits that Goya painted as the century was drawing to a close.

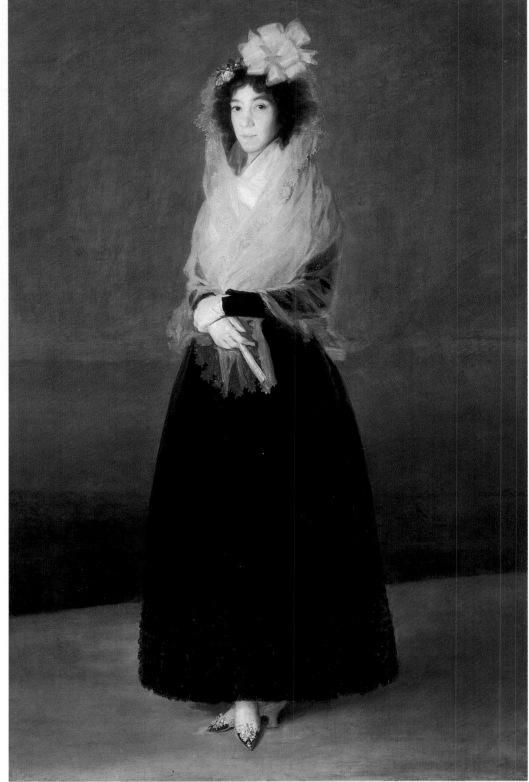

Francisco de Goya
The Countess of Chinchón Seated

1800
Oil on canvas,
85 × 56¾ in.
(216 × 144 cm.)
Prado, Madrid

Goya painted several pictures of the countess, who first appeared as a carefree two-year-old child in the group portrait of the family of Don Luis de Borbón.
Here, seventeen years later, we see her as the young wife of the powerful minister Godoy, one of the most influential figures in Spanish politics and Goya's patron. The painter must have been particularly drawn to the natural, aristocratic composure of the blonde countess, whose innate elegance is apparent even in this relaxed and informal pose. The range of colors, reduced to the essential, accentuates the silky reflections of the light.

Francisco de Goya
The Family of King Charles IV

1800
Oil on canvas,
110¼ × 132¼ in.
(280 × 336 cm.)
Prado, Madrid

The eloquent and dramatic image of a monarchy on the wane: a parade of ghostly masks where in the background on the left, the painter seated at his easel, in a totally incongruous position. The splendor of the painting provides a glaring contrast to the weak, gross and vacuous features of his subjects.

Francisco de Goya
La maja vestida
(*The Maja Clothed*)
La maja desnuda
(*The Naked Maja*)

c. 1803
Oil on canvas,
37½ × 74¾ in.
(95 × 190 cm.)
Prado, Madrid

These two extremely famous paintings were in all likelihood conceived as a pair: the canvas showing the girl with her clothes on would have covered the picture of her naked, forming a lid that could be raised by the owner. The identity of the model is still open to debate, as is that of the person who commissioned the canvases, perhaps the minister Godoy. There remains the keen fascination of two paintings that echo Titian's historic figure of the reclining Venus, but with an unforgettable quiver of coquetry.

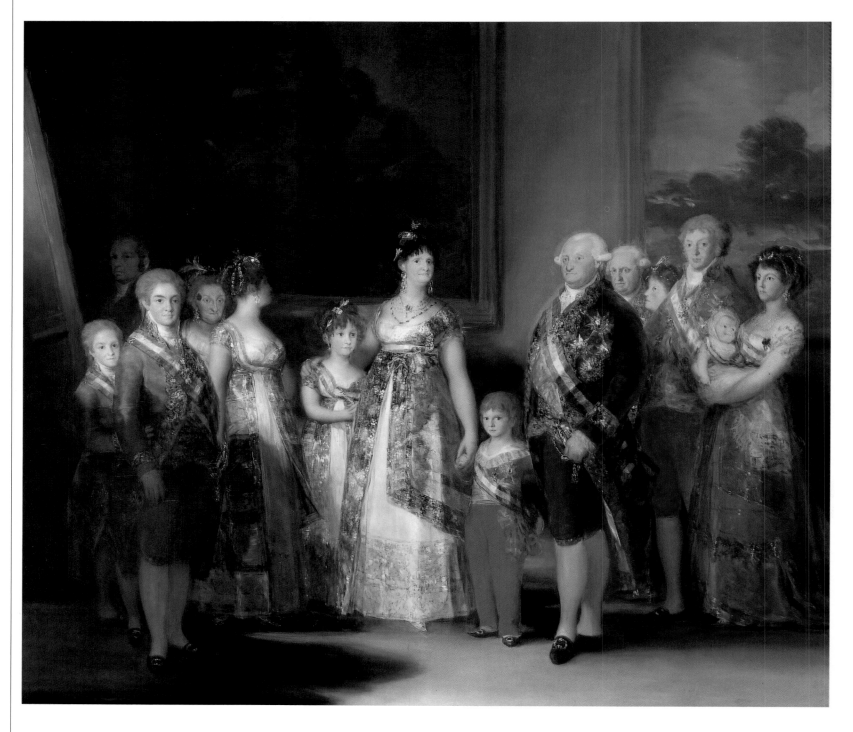

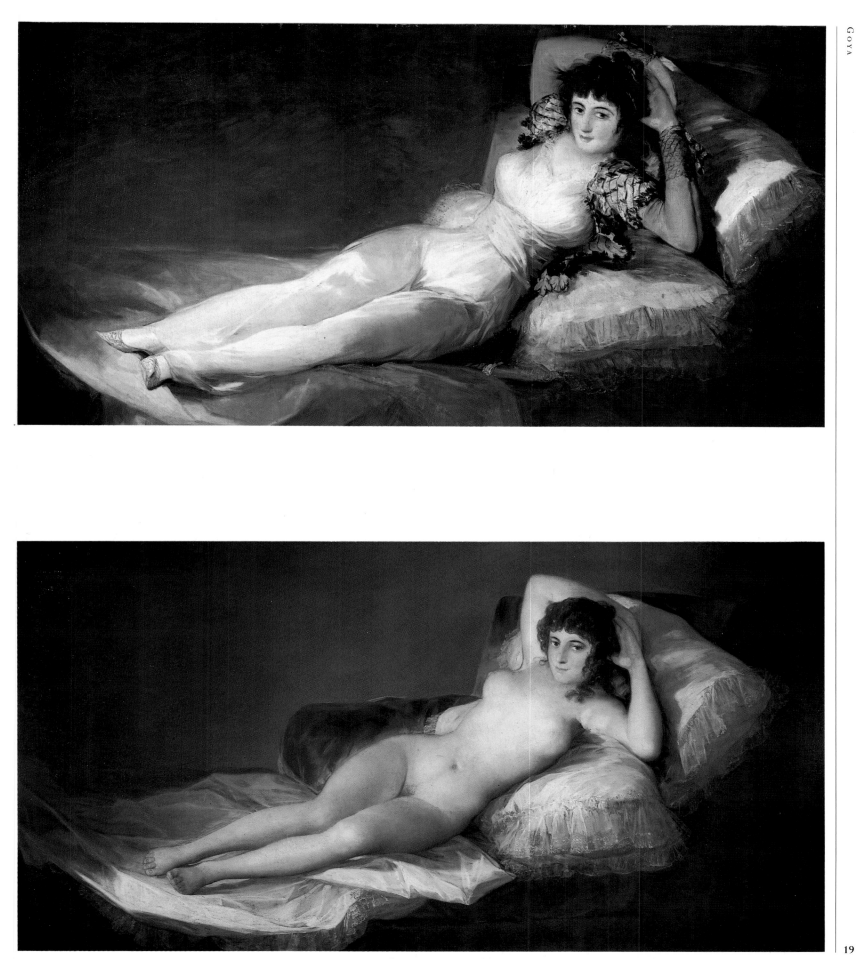

Francisco de Goya
The Second of May, 1808
The Third of May, 1808

1814
Oil on canvas,
104¾ × 135¾ in.
(266 × 345 cm.)
Prado, Madrid

In May 1808 the population of Madrid rebelled against the troops of the French invaders, but the revolt was ruthlessly put down. In 1814, with the return of the Bourbons, Goya was asked to illustrate "the heroic actions of our glorious insurrection against the tyrant of Europe." The painter's response carefully avoided rhetoric. In the scene of the execution two groups face one another: on the right the soldiers of the firing squad carry out their orders in mechanical fashion; opposite them the rebels are seized by terror. These are no heroes ready to die for their country, but ordinary people crushed by history. Ragged and terrified, the condemned men seem to be crying out for mercy and make us understand that the history of peoples is written in men's blood: a workman's shirt is turned into the standard of a universal denunciation of war.

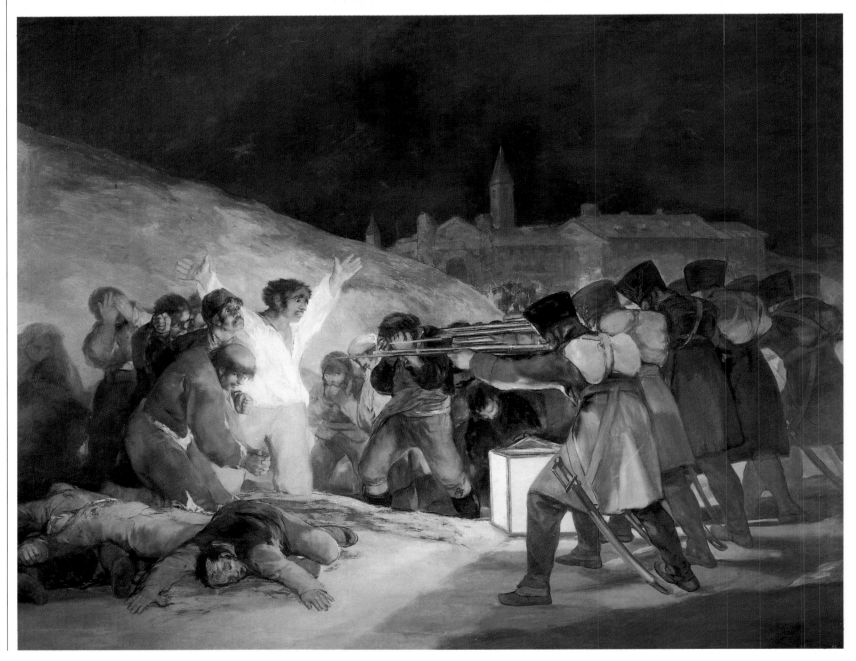

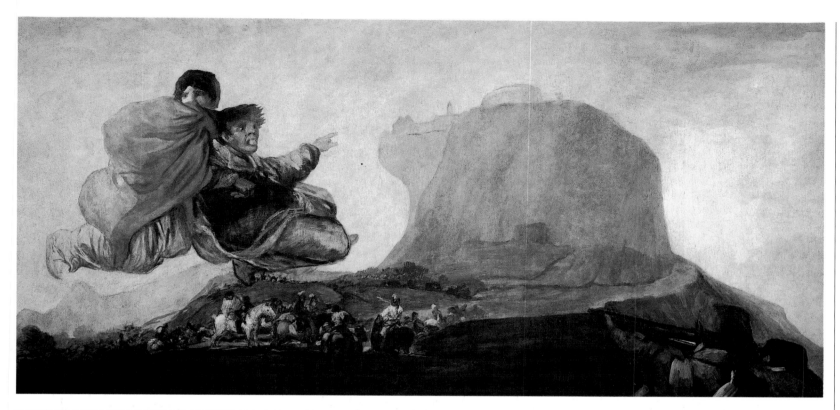

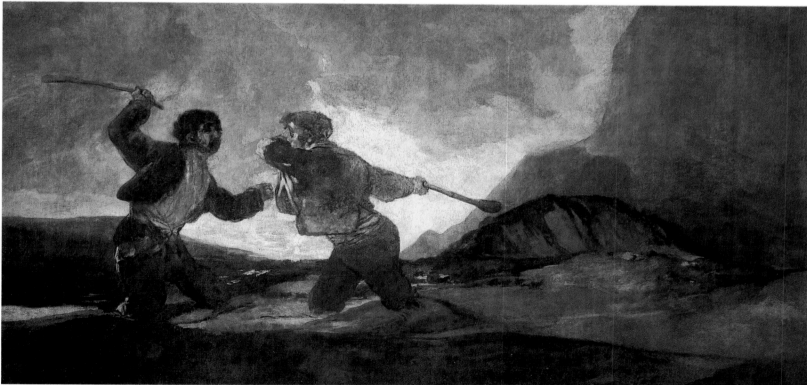

Francisco de Goya
Fantastic Vision
("Asmodea");
Rustic Duel

1820–21
Oil on plaster transferred onto canvas,
64¼ × 104¼ in.
(163 × 265 cm.)
Prado, Madrid

Goya painted these two scenes for the hall on the second floor of his house in the country, just outside Madrid, where the painter had gone to convalesce after a serious illness. The house subsequently came to be known as the "Quinta del Sordo," or "Deaf Man's Villa," after the nature of his infirmity. Here Goya executed one of the most disturbing cycles of all times, the *Black Paintings*. Detached in 1873, the pictures are now in the Prado. There is no narrative thread to the sequence: each scene has the appearance of a nightmare, a succession of diabolic apparitions that terrify a coarse and disheveled humanity, looking almost more frightening and devilish than the creatures of the other world. In some cases it is not even possible to identify a precise subject, and conventional titles are used. What is constant is the atmosphere of inevitable tragedy, as expressed by the man carried off by the witch draped in red in the upper painting. The other episode represents human violence at its most futile: two peasants, trapped in quicksand, are beating each other with sticks, without any means of escape.

21

Jacques-Louis David
The Oath of the Horatii

1784–85
Oil on canvas,
130 × 167¼ in.
(330 × 425 cm.)
Louvre, Paris

This painting is regarded
as a symbol of European
Neoclassicism. The perfect
combination of an
uncompromising
intellectual conception,
a formally impeccable
execution and a content
of intense moral
significance make it the
manifesto of an era. The
restrained strength and
statuesque gestures (not
just of the men but of the
women too) are derived
directly from models
of Hellenistic sculpture.
Through a spectacular
display of artistic
virtuosity, David sets out
to make us admire the civil
virtues of the protagonists.
The large canvas
summarizes the lessons
absorbed by the artist
during his long stay
in Rome.

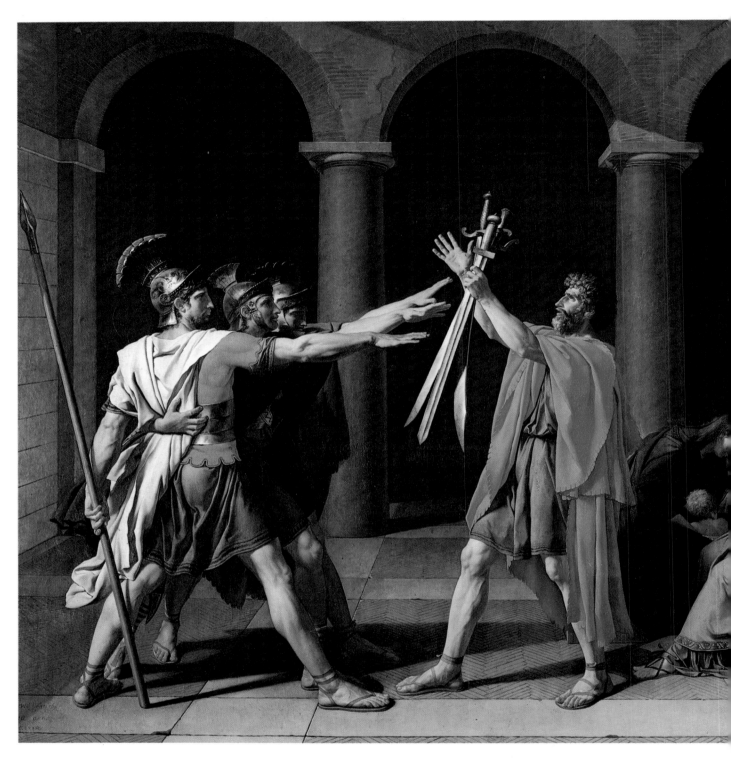

Jacques-Louis David

Paris, 1748–Brussels, 1825

The painter, who became famous for his celebration of the exploits of Napoleon, epitomizes the origin, development and decline of Neoclassicism. Ever since his earliest works, painted in his youth in Paris, David showed a clear preference for historical and mythological subjects, and it was through these that he embarked on a brilliant academic career. In 1775 he won the greatly-coveted Prix de Rome, which allowed him to spend five years in Italy.

There he made a thorough study of the great exponents of seventeenth-century classicism, from the Carracci to Poussin, though his calculated academicism was toned down by the influence of Raphael. With links to the cultural circles of Winckelmann and Mengs, David also took a passionate interest in the study of classical statuary, admiring its purity and perfect composure. To David, classical art was not just a stylistic model but also the reflection of a higher morality. Consequently, on his return to Paris, David painted a series of large classical scenes as monumental examples of private and public virtue.

The most celebrated of these is *The Oath of the Horatii* (1784), a work that played a fundamental part in laying the foundations of Neoclassicism: a closed form, perfectly defined by rigorous drawing, dignified and almost sacred poses, carefully-studied colors and a sense of drama expressed in a restrained way and yet conveying the impression of an imminent explosion. With the outbreak of the French Revolution, David became the great illustrator of the events and figures of the political upheaval: the most unforgettable canvas from that period is *The Death of Marat*. With the fall of Robespierre David was imprisoned and reacted symbolically

by painting the great picture representing the historical episode of the Sabine women, a plea for moderation and reconciliation. When Napoleon appeared on the scene, David became his official glorifier, cloaking his conquests and achievements in the aura of a timeless epic. David became the stylistic model for an entire generation of artists, including Ingres. With the defeat of Napoleon, he fell into disgrace and was exiled to Brussels, where he went back to painting mythological scenes.

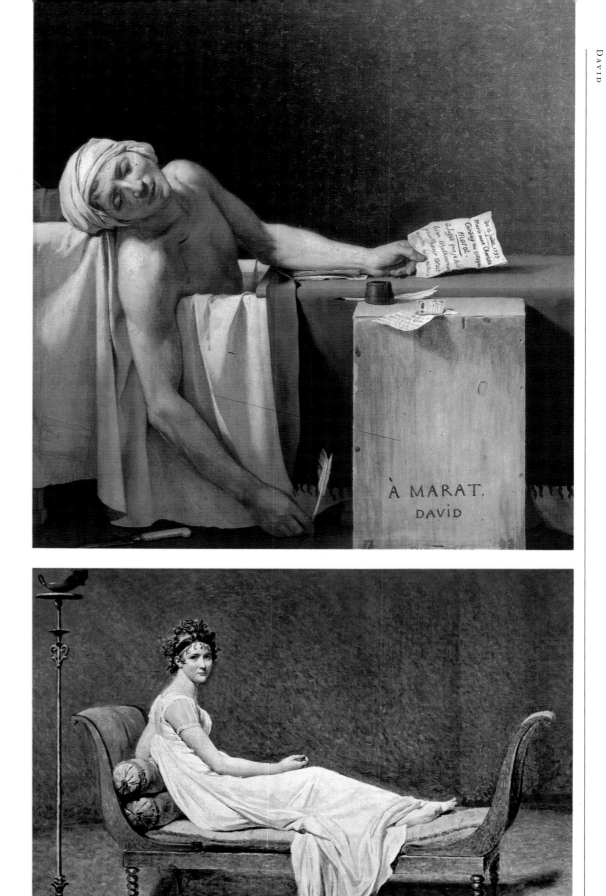

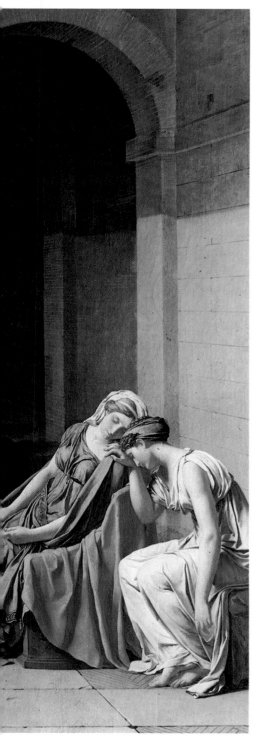

Jacques-Louis David
The Death of Marat

1793
Oil on canvas,
63¾ × 49¼ in.
(162 × 125 cm.)
Musées Royaux des Beaux-
Arts, Brussels

The image of Marat
stabbed to death in his bath
has become almost an
artistic summary of the
French Revolution.

Jacques-Louis David
*Portrait of Madame
Récamier*

1825
Oil on canvas,
67 × 94½ in.
(170 × 240 cm.)
Louvre, Paris

David never abandoned his
formal composure, even
when, as in his portraits,
he shows penetrating
insight into the psychology
of his sitters.

Jacques-Louis David
Napoleon Crossing the Alps

1800
Oil on canvas,
107 × 91¼ in.
(272 × 232 cm.)
Malmaison Castle, Paris

Actively involved in the Revolution and imprisoned for the part he played in it, David saw in Napoleon both a continuation and the concrete expression of revolutionary ideals. Appointed Napoleon's official painter, David celebrated his deeds in a series of grandiose canvases.
In his portraits he presented the general in epic and decisive poses, certainly not free of rhetoric but creating an extraordinarily spectacular effect, enhanced by the way the paint is laid on with great density and richness.

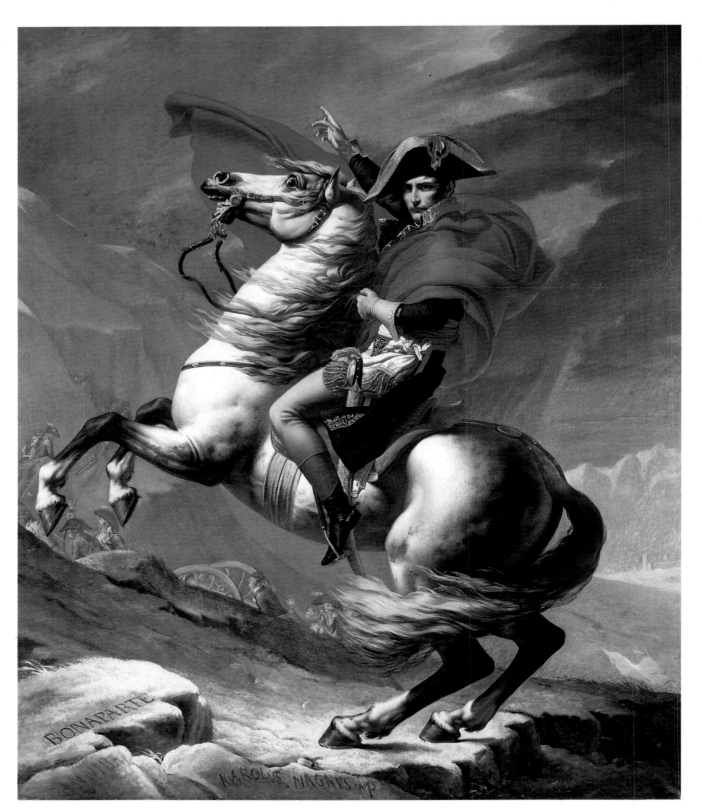

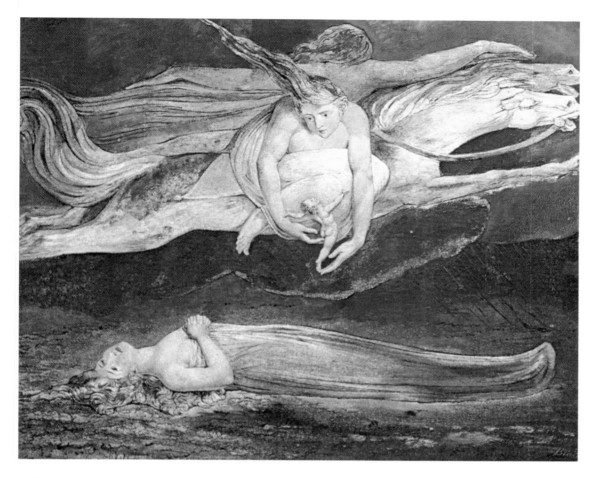

William Blake
London, 1757–1827

Unquestionably the outstanding figure in a contradictory and stimulating period, the artist and poet Blake is not easy to understand. In his pictures and writings a taste for the fantastic and the medieval is blended with mysticism and the ferments of a precious Romanticism. Alternating literary and theoretical work with his activities as a painter and engraver, Blake was trained at the Royal Academy of Arts and went on to give expression, along with Füssli and Flaxman, to the controversial impulses of an era of transition. Particularly interesting are his illustrations of stories and poems, with their extremely close relationship between text and image, as in the ambitious and incomplete series of watercolors for Dante's *Divine Comedy*. While Blake's themes are rooted in imagination, mystery, biblical visions and even hallucinations and the Gothic novel, the technique used for their expression is an innovative one: Blake has to be considered a pioneer of experimentation in the fields of color engraving and the printed miniature.

William Blake
Pity

1827
Watercolor,
16½ × 21¼ in.
(42 × 54 cm.)
Tate Gallery, London

William Blake
*The Good
and Evil Angels*

1795–1805
Watercolor,
17½ × 23½ in.
(44.5 × 59.4 cm.)
Tate Gallery, London

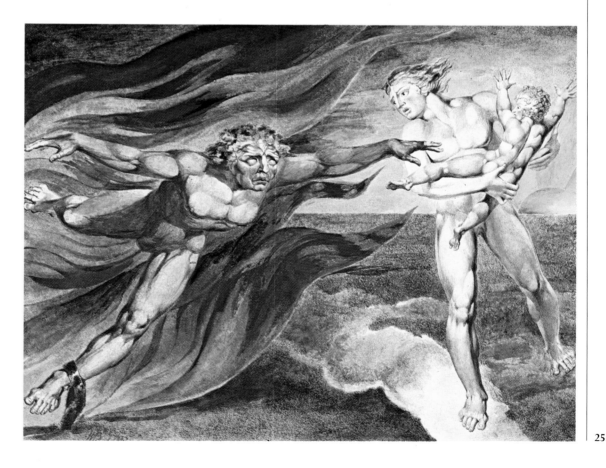

Johann Heinrich Füssli, called Henry Fuseli

Zurich, 1741–London, 1825

After profound literary studies and training to be a priest in Switzerland, Füssli decided to devote himself to art and poetry, which he thought would allow him to express his feelings with full freedom.

In 1736, spurred on by his desire for independence, he moved to London. Sir Joshua Reynolds encouraged him to concentrate on painting, but for the time being he preferred to carry on in his role as a critic and man of letters of international repute: among other things, he translated the writings of Winckelmann into English, making a fundamental contribution to the development of Neoclassicism in Great Britain. In 1770 Füssli went to Rome: he was to stay in Italy for three years, almost overwhelmed by his admiration for classical antiquities and the works of Michelangelo. During his time in Italy, Füssli perfectly embodied the new aesthetics of the "sublime," the feeling of awe and profound unease inspired by the spectacles of art and nature that seem to tower over us. Returning to London, Füssli chose to settle in England permanently and anglicized his name to the more easily pronounceable Henry Fuseli. From this time on he alternated a prolific output of paintings with his activity as an acute art critic and scholar. Along with Blake, Füssli anticipated many of the themes of English Romanticism, such as the exploration of the world of nightmares and visions, the intertwining of the heroes of Greek myths with the settings of medieval sagas and a subtle but penetrating eroticism. One distinctive aspect of his work was the pictorial interpretation of the great poems of Dante, Homer, Milton and Shakespeare. In his illustrations of the culminating moments of tragedies and of classical and medieval epics, Füssli achieved results characterized by their energetic composition and graphic force.

Johann Heinrich Füssli
Paolo Malatesta and Francesca da Polenta Surprised by Gianciotto Malatesta

1786
Oil on canvas,
47¾ × 52 in.
(121 × 132 cm.)
Cantonal Museum of Art, Aarau

Füssli's pictorial work, rendered unmistakable by the efficacy and force of its execution, covers a remarkably eclectic range of subjects, situations and sentiments. In this early canvas, still inspired by the grace and lightness of Rococo painting, the artist anticipates the vogue for themes drawn from Dante or the medieval world that was to characterize at least two generations of painters and writers on the threshold of the nineteenth century. In fact it should be remembered that Delacroix (p. 54) also took an episode from Dante's *Inferno* as the subject of one of his first pictures.

Johann Heinrich Füssli
Solitude at Dawn

1794–96
Oil on canvas,
47¼ × 34¼ in.
(120 × 87 cm.)
N. von Schulthess
Collection, Zurich

Johann Heinrich Füssli
The Nightmare

1790–91
Oil on canvas,
30 × 25¼ in.
(76 × 64 cm.)
Goethemuseum, Frankfurt

His reading of great English poets like Shakespeare and Milton suggested to Füssli the theme of the nocturnal vision, the dream, the nightmare. For the first time, a painter set out to make a systematic exploration of the regions of the subconscious: nighttime apparitions, spirits and phantoms were turned into concrete and frightening presences, in parallel with the emergence of the "Gothic" mystery novel in contemporary English literature. *The Nightmare* is the artist's most famous painting. In extraordinary fashion, he shows us at once the girl dreaming and the terrifying images that crowd around her bed. The most disquieting presence, in the semidarkness of her bedroom, is the head of a large horse, made particularly striking by its large and staring white eyes. A little monster, halfway between a devil and a monkey, crouches on the bed, its flashing eyes trained on the observer. In spite of these ghastly images, it cannot be said that the picture's purpose is to frighten. Füssli always maintains conscious intellectual control, the detachment typical of the Age of Enlightenment, and does not fail to include refined classical citations, such as the studied pose of the woman on the bed, inspired by the Roman sculptures that so impressed the painter during his long stay in Italy.

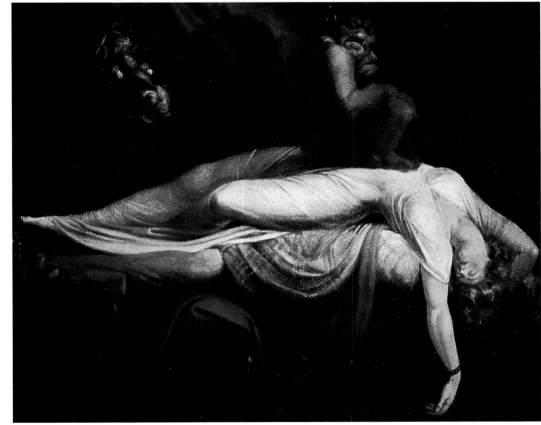

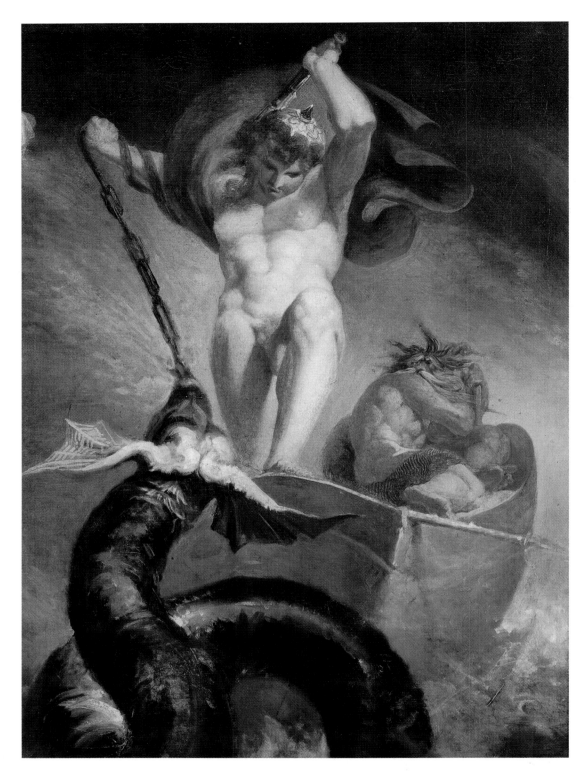

Johann Heinrich Füssli

Thor in Hymir's Boat Fighting with the Serpent of Midgard

1788
Oil on canvas,
51½ × 35¼ in.
(131 × 91 cm.)
Royal Academy of Arts,
London

A passionate student of religions, Füssli showed an unprecedented fascination with themes drawn from Nordic mythology. The Viking god Thor presented the artist with the opportunity for a visionary evocation of the struggle between otherworldly powers, one of his favorite subjects, especially after he had read Milton's *Paradise Lost*. However, the painter never lost his taste for a refined, calculated and almost academic display of the male nude.

Johann Heinrich Füssli

Ulysses between Scylla and Charybdis

1794—96
Oil on canvas,
49½ × 39¾ in.
(126 × 101 cm.)
Cantonal Museum of Art,
Aarau

Another hard-to-define painting, which renders any stylistic "label" virtually meaningless. The theme is drawn from classical literature and the Homeric hero *par excellence* is presented in a pose frankly derived from ancient statuary. Yet this "Neoclassical" point of departure is swallowed up in a seething, threatening and mysterious evocation of nature that is an exemplary anticipation of the Romantic outlook.

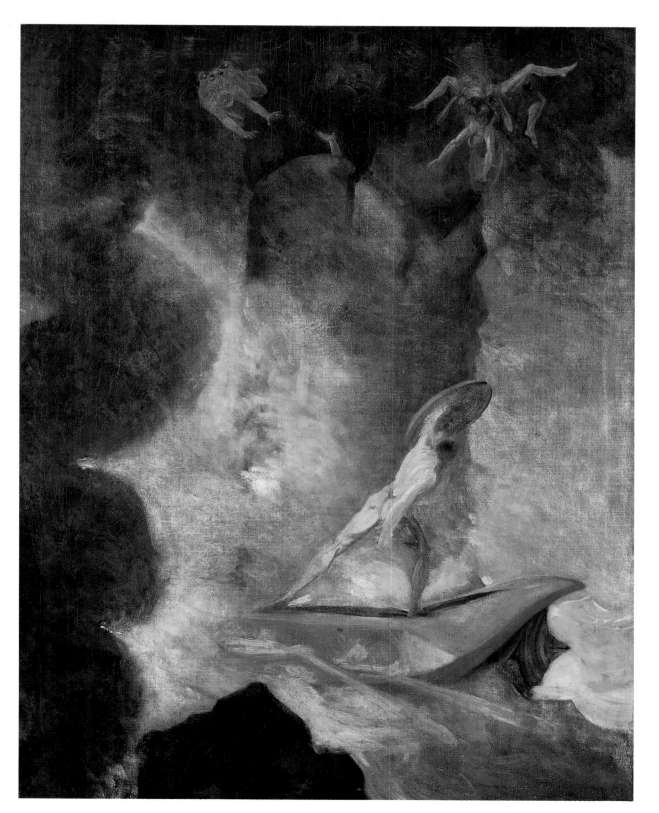

Johann Friedrich Overbeck

Lubeck, 1789–Rome, 1869

Overbeck is the key figure in the group of the Nazarenes, an unusual attempt to create an artistic community that might appear naïve today, but should in fact be considered an important current in nineteenth-century artistic research. Overbeck was another of the painters who grew up in the years of the French Revolution, receiving an artistic education of the academic type, and who were then forced to seek new forms of expression in the first decade of the nineteenth century in order to deal with a radically changed world. The choice made by Overbeck (then a student at the Vienna Academy) was very different from the ones taken, during those same years, by Goya, Friedrich and David: together with his friend Franz Pforr, Overbeck founded the *Lukasbrüderschaft*, or Brotherhood of St. Luke, which drew its inspiration directly from the religious confraternities of the Middle Ages. Driven by their strong leanings toward mysticism and Catholicism, Overbeck and Pforr moved to Rome in 1810 and settled in an abandoned monastery on the Pincio hill. They were joined by other German painters resident in Rome and set up a community on monastic lines. As a consequence of their long hair and absorbed demeanor, the members of this peculiar group came to be known as Nazarenes, a term that soon lost its originally derisory meaning. One characteristic theme of Overbeck's work is the harmony between the sunlit Humanism of Italy and the fascination of Gothic Germany, evoked by pictures of Goethe in the Roman countryside or of allegorical female figures. From the stylistic viewpoint, Overbeck and his companions looked back to the Italian art of the Quattrocento, in which they found not only a model of composition but also the religious attitude that was a goal shared by the whole of the group. Pforr's sudden and untimely death in 1812 left Overbeck in sole charge of the community: the painter deliberately adopted the style of fifteenth-century Umbrian and Tuscan frescoes, with sharply-defined outlines and vivid colors. Overbeck's hand is also clearly recognizable in the group's joint undertakings, such as the *Scenes from the Life of Saint Joseph* in Palazzo Zuccari and the luminous frescoes depicting episodes from *Jerusalem Delivered* in the Casino Massimo, begun in 1818 and not finished until 1830. The long time it took to represent the themes from Tasso's poem is a sign of the progressive difficulties encountered by the group of the Nazarenes, which in effect broke up after 1830, with the return of many artists to Germany and their dispersion amongst various cities. Overbeck's last masterpiece is a huge allegorical composition, the *Triumph of Religion in the Arts* (1840), now in Frankfurt and in a style that is an unmistakable homage to Raphael's frescoes in the Vatican.

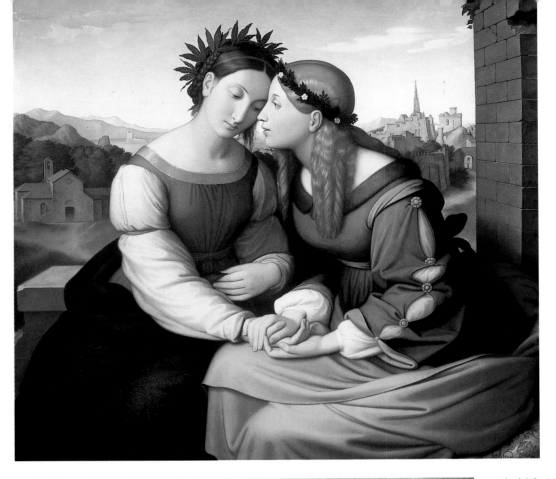

Friedrich Overbeck
Italy and Germany

1812–28
Oil on canvas,
37 × 41 in.
(94 × 104 cm.)
Neue Pinakothek, Munich

The very long time taken over this painting encompasses practically the entire history of the Nazarenes. The delicate embrace of the girls symbolizing the two nations can stand for the whole of the artist's cultural program.

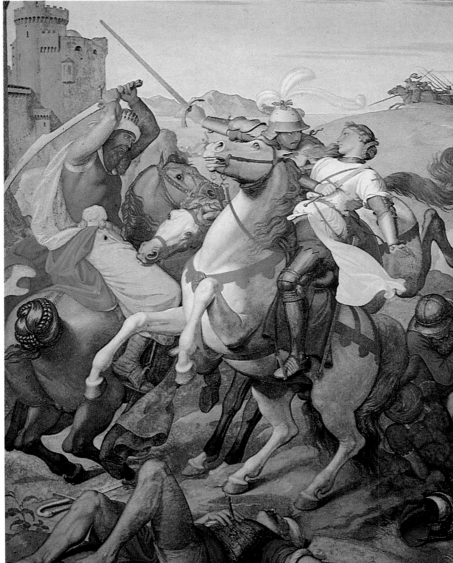

Friedrich Overbeck
Odoardo and Gildippe

1823
Fresco,
c. 118 × 82¾ in.
(c. 300 × 210 cm.)
Casino Massimo, Rome

Friedrich Overbeck
Portrait of Franz Pforr

c. 1810
Oil on canvas,
24½ × 18½ in.
(62 × 47 cm.)
Nationalgalerie, Berlin

Already suffering from the tuberculosis that was shortly to bring his life to an early end, the young and ill-starred painter Franz Pforr is looking out of a Gothic window. Overbeck, a close friend of Pforr's, with whom he founded the Nazarene movement, commenced the painting in 1810 but finished it after Pforr's death, inserting symbolic references to his untimely decease. Overbeck himself described the details of the portrait, which was intended to serve as a model for the painting and ideals of the Nazarenes: "He is wearing traditional German dress and standing in front of an open Gothic window, framed by a decoration in stone and surrounded by a vine. The inside of a room can be seen, with a young woman (probably his companion) seated at the back and knitting while she reads a religious book. "Behind we can see a Gothic city and further off the sea. The whole idea is to present him in a situation in which he might have felt totally happy."

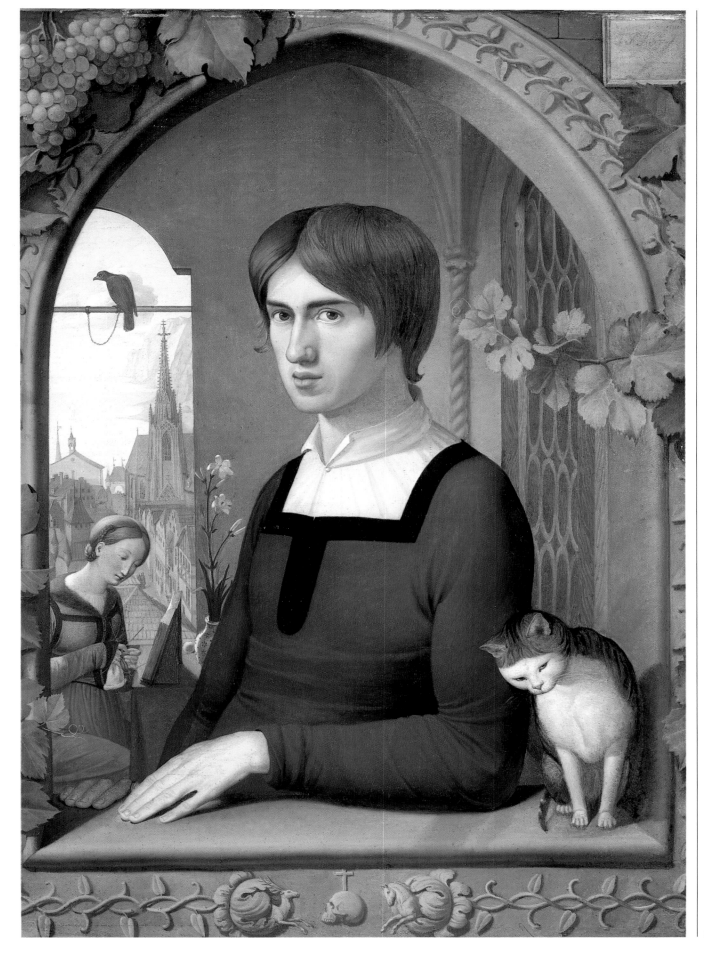

Karl Friedrich Schinkel

Neuruppin, 1781–Berlin, 1841

The inclusion of this great architect and set designer in a book devoted to painting may seem strange. But the inventiveness of his handling of form and the culturally important role he played in the development of the figurative and formal sensibility in nineteenth-century Germany make Schinkel a crucial figure, capable of crossing the boundaries between one art and another. Few other European artists have been able to find such an eclectic balance of the Neoclassical and the Neo-Gothic, with its hints of ancient Egypt and cosmic fantasies. Schinkel's activity as a painter and set designer was confined chiefly to his youth and early maturity, culminating in the extraordinary scenes for the Berlin production of Mozart's *Magic Flute* (1816), which immediately preceded the construction of his first important building, the Neue Wache (New Guard House) on Berlin's main street.

A pupil of the Neoclassical architect Gilly, Schinkel made the obligatory journey to Italy in 1803. His pictorial works should not be regarded merely as designs for buildings that were never constructed: they offer a singular blend of the open and luminous horizon of the "classical" landscapes of the seventeenth century with the presence of complicated Gothic buildings, complete with spires, pinnacles and rampant arches.

It is this dualism that expresses the unique character of Schinkel, and which is confirmed by his architectural work: poised between the only apparently opposite poles of references to ancient Greece (Schinkel went so far as to design an imperial palace to be built on the Acropolis in Athens) and the Neo-Gothic.

Karl Friedrich Schinkel
Gothic Church on a Rock above the Sea

1815
Oil on canvas,
28¼ × 38½ in.
(72 × 98 cm.)
Nationalgalerie, Berlin

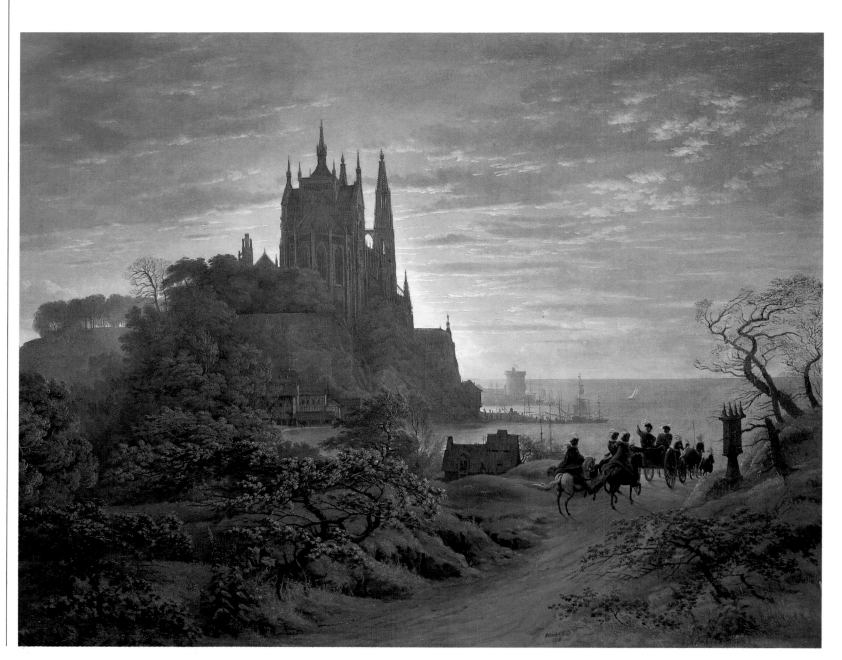

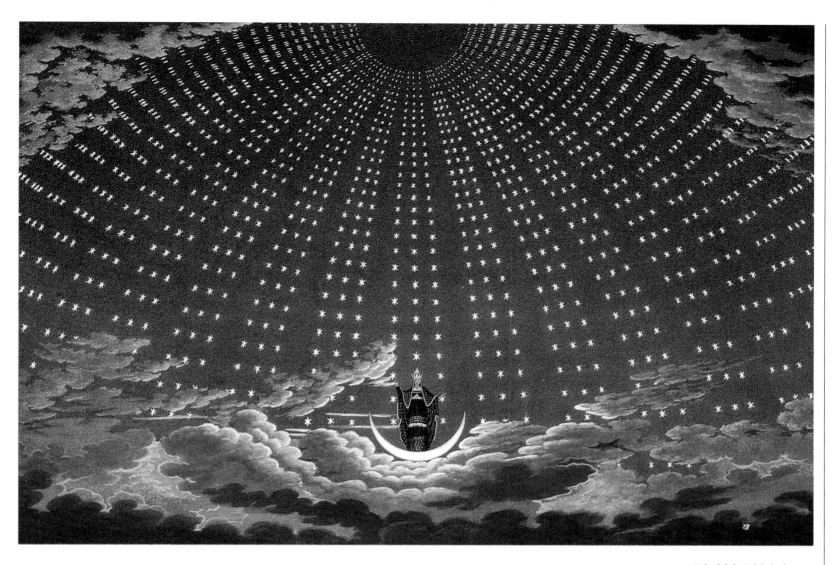

Friedrich Schinkel
The Queen of the Night

1815
Sketch on paper
Hochschulbibliothek,
Berlin

The most extraordinary
achievement of Schinkel's
work as a designer for the
theater was undoubtedly
the memorable scenery
for Mozart's *Magic Flute*.

Karl Friedrich Schinkel
Medieval City

1815
Nationalgalerie, Berlin

The spectacular, utopian
Gothic cathedral is brightly
lit against a cloudy sky,
traversed by a rainbow.

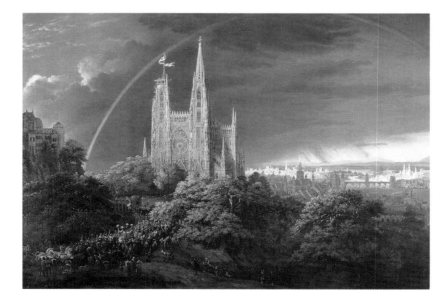

Romanticism

Caspar David Friedrich
Abbey in the Oak Forest (detail)
1809
Oil on canvas,
43½ × 67¼ in.
(110.4 × 171 cm.)
Charlottenburg Castle, Berlin

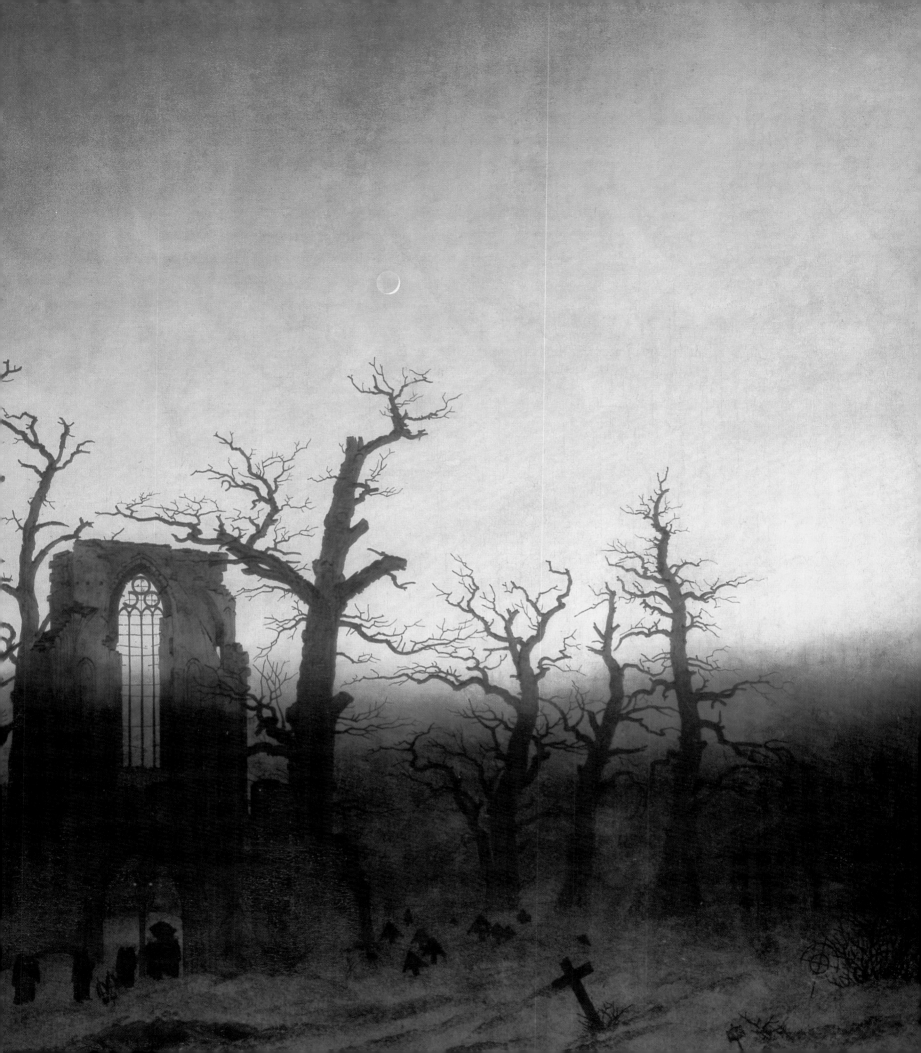

For some time now there has been a growing awareness of how unwarranted it is to view Neoclassicism and Romanticism as dialectical opposites. Today it is clear that the two movements were different fruit springing from a single root, and in many cases it is difficult to place works and artists precisely in one category or the other. The division used to be between the "good" and "bad," the "antiquated" and "modern," whereas, at least in the beginning, the two terms coexisted and overlapped. An extraordinary example of this is provided by Canova, once unjustly condemned as a banal Neoclassical artist. Yet when he saw the fragments of the Parthenon brought to London by Lord Elgin he was so deeply moved that he refused to restore or complete them, declaring Phidias's art "flesh, not marble." And then how can we define a writer like Goethe without running the risk of oversimplification or inaccuracy, especially when we recall that the cradle of Romanticism was the very German culture that had supported Neoclassicism? Yet it is undeniable that, especially after the battle of Waterloo, the collapse of Napoleon's imperial dream, and the return to a Europe of nation states, it is possible to distinguish with growing clarity the emergence and development of a new approach to painting. For one thing, the demand for sacred works of art almost totally vanished: religious pictures, their clients shaken by the closure of the orders and the crisis in the papacy, were replaced by great secular scenes, inspired by the new political and social values.

The principal themes of all Romantic art in Europe were the expression of feeling, the contemplation of nature, and the individual's dialogue with him or herself. They are to be found in the poems of Leopardi, Lamartine, Byron and Schiller, even though they never renounced the quest for an impeccable literary form. In the same way, the Romantic painters clearly showed that they had a technical and cultural background of the highest level. Yet the distinctive element with respect to Neoclassicism was their rejection of a single model, of a generic reference to Greco-Roman antiquity, in favor of a more direct and passionate investigation of the reality of their own country. This started out from merely aesthetic considerations, but soon developed into a precise political stand. The long history of European Romanticism is studded with dates that mark the common destiny of the continent and that had precise repercussions in each individual nation: the Restoration after the Congress of Vienna (1815), the first independence movements of 1820–21, the new uprisings of 1830, the attempted revolutions of 1848.

Thus, if we take a broad look at the development of the various movements and tendencies of European Romanticism, it is easy to distinguish the different lines of research undertaken by their exponents. In Germany the figure of Caspar David Friedrich represents a highly effective visual response to the philosophers of idealism and the great German poets of the age. Friedrich made a series of courageous and always consistent choices: he refused to make the journey of homage to Rome, inserted Gothic ruins in some of his paintings, looked at German landscapes from the viewpoint of Kant's aesthetics of the "sublime," and only depicted his figures from behind. By doing so, the painter forcefully and lyrically underlined his own German origin and deliberately set down his roots in a local artistic and cultural tradition. The same thing happened, though in a less explicit way, with the British painters. While perfectly conscious of the art of the past, Constable and Turner preferred to take their inspiration from the English countryside. Constable's insis-

John Constable
The Hay Wain
1821
Oil on canvas,
51½ × 73 in.
(130.5 × 185.5 cm.)
National Gallery, London

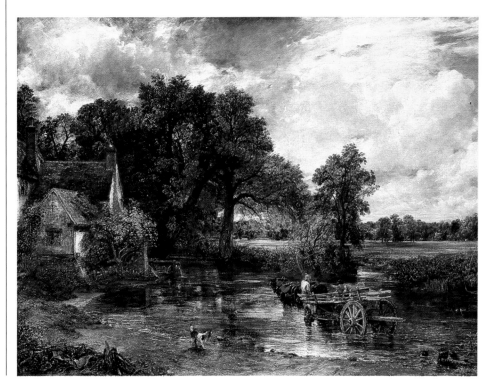

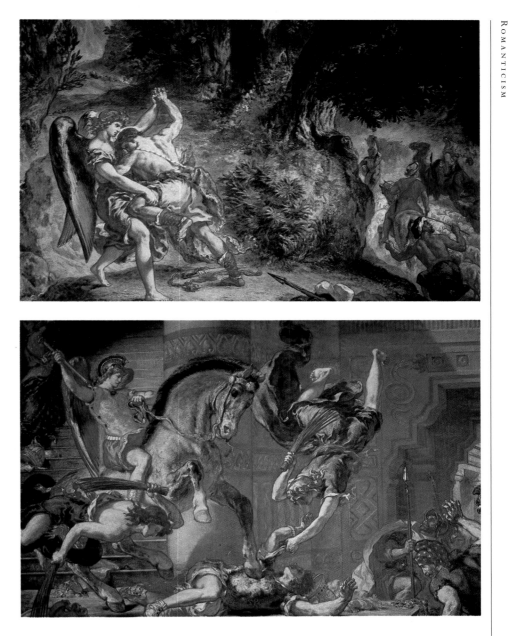

tence on painting a scene more than once from the same point of view is an interesting anticipation of what Monet and Cézanne were to do later on: the almost scientific attempt to analyze particular places and buildings under different light conditions, not so much in search of an improbable "objectivity," but as a constant verification of feelings. Turner, in spite of being a passionate lover of Italy, was the first artist to tackle one visual aspect of the new industrial civilization: steam. The appearance of a puffing train in one of Turner's last landscapes was a shocking innovation, especially when you think that the artist had started by painting Hannibal's elephants crossing the Alps. As was true for all the art of the nineteenth century and the historic avant-garde movements of the early twentieth century, Paris was the center of European attention. From this moment on, French painters were to constitute the backbone of art for almost a century. In the early decades of the nineteenth century, four great personalities (Géricault, Delacroix, Ingres and Corot) marked out the stages in the evolution of French art in memorable fashion. First of all, the unfortunate Géricault, who met an early death, took the bold step of giving a contemporary event (a shipwreck) the dimensions and tone of a great classical scene. *The Raft of the "Medusa"* (1819) is the symbol of an age that felt itself at the mercy of the waves, as the certainties of the past sank out of sight, but which also had faith that it would find safety in a new land. While Géricault rediscovered Caravaggio, the impetuous Delacroix looked back to Rubens and Titian, translating the ardor, inspiration and richness of color of these artists into an inflated and lush style of painting, blending strands of national liberty, rhetoric and exoticism. The artist's unrivaled fusion of color and sentiment was a human and artistic experience that was destined to leave a deep mark and stir controversy. The public was sharply divided, especially when the dynamic and disorderly Delacroix was contrasted with the calm composure and limpid, almost metaphysical rigor of Ingres. The absolute purity of Ingres's paintings, and in particular his adamantine and rapt portraits, may seem like the detachment of indifference, but in reality it was a refined achievement of mental concentration and technical skill, passed through the sieve of an eclectic comparison with the great artists of the past. Like Ingres, Corot loved Italy and its artistic tradition. Devoting himself chiefly to land-

scape, and initially influenced by the painters of the seventeenth century, Corot can be considered the precursor of the vogue for painting *en plein air* (in the open air), that emerged after 1860 with the arrival of the Impressionists. If Romantic painting should be seen not just as the result of artists finally being free to express their feelings, its spirit of national renewal was most apparent where independence was denied. This was the case in Italy, where writers, composers and painters shared in the growing sense of rebellion against foreign domination, though they still had to cloak contemporary reality in the smokescreen of a historical setting: thus Manzoni set *The Betrothed* in the seventeenth century, the protagonists of Bellini, Donizetti and Verdi's operas were almost always heroes and heroines from the distant past and Hayez took his inspiration from the Middle Ages. Yet it is easy to recognize the strength of these artists' feelings, which break through the blinkers of censorship and reach deep into the heart.

Eugène Delacroix
*Jacob and the Angel;
Heliodorus Expelled
from the Temple*
1850–61
Oil and wax on wall,
295¾ × 191 in. overall
(751 × 485 cm.)
Church of Saint-Sulpice,
Paris

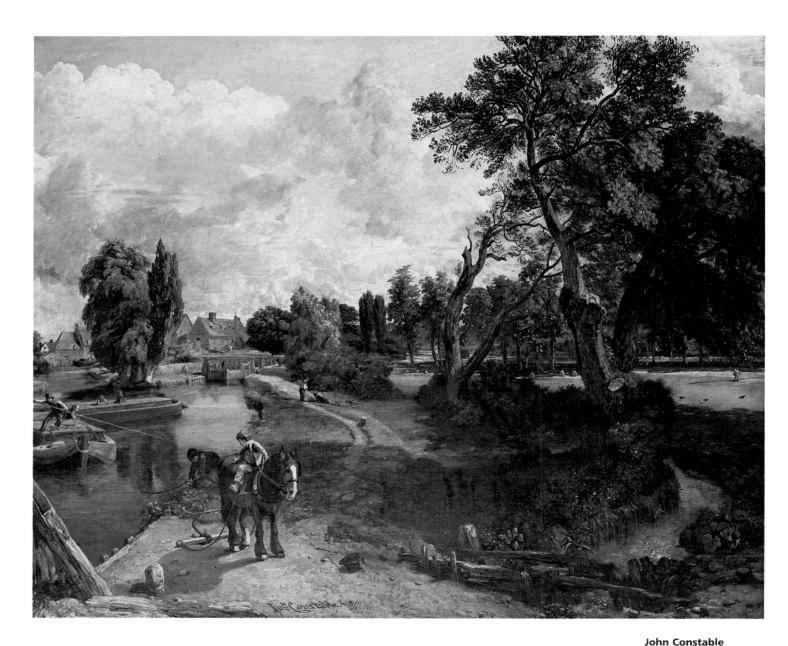

John Constable
The Mill at Flatford

1817
Oil on canvas,
39¾ × 50 in.
(101 × 127 cm.)
Tate Gallery, London

Most of Constable's landscapes are inspired by Suffolk, the county where the painter was born. Although he wanted to present a limpid and accurate image of the reality of nature, he was unable to conceal his feelings of affection for rural, often sunlit scenes, with the quiet presence of a few human figures.

John Constable

East Bergholt, 1776–London, 1837

With Constable the English school of painting took a decisive leap forward, placing itself on the cutting edge of European art in the early nineteenth century. From his childhood Constable, the son of a mill owner, showed a deep love for the countryside and the restful rural landscape (while his contemporary Turner preferred the sea and mountains). In 1799 he moved to London to attend the Royal Academy of Arts. Thus he acquired a thorough grounding in the history of landscape painting, paying particular attention to the seventeenth-century masters of the idealized "classical landscape," whose methods of composition he adopted: making drawings, taking notes and then making sketches from life, before painting the final picture in the studio. Constable's work is characterized by his insistence on returning to the same subjects, painting the same views of the countryside several times or repeated versions of monuments like Salisbury Cathedral, anticipating what Monet and Cézanne were to do several decades later. On the one hand Constable sought out real views, corners of Suffolk to depict in an "objective" way (though within the obvious limits of this definition), without resorting to particular effects or "picturesque" and evocative viewpoints. Yet, as in early Romantic English poetry, Constable looked for and found harmony in nature, which he investigated with patient care and an intense sense of involvement. His landscapes attracted attention abroad, especially after a show held in Paris in 1824, becoming an important model for the nineteenth-century interest in views of nature. But the painter did not achieve the success he deserved at home, partly because of his shy and reserved character, preferring the countryside to society life. Constable was not given a post at the Royal Academy until 1829, when his painting began to lose the clarity of earlier years.

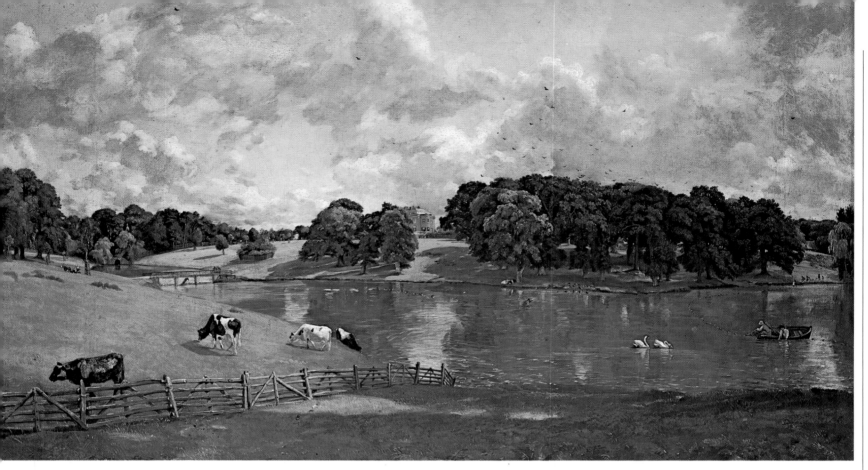

John Constable
Wivenhoe Park

1816
Oil on canvas,
22 × 39¾ in. (56 × 101 cm.)
National Gallery,
Washington

Along with Hampstead
Heath, this was Constable's
favorite piece of
countryside. In the various
versions of this subject, the
artist sought to approach
an "objective" vision of
reality, meticulous in every
detail and catching every
reflection of the light.

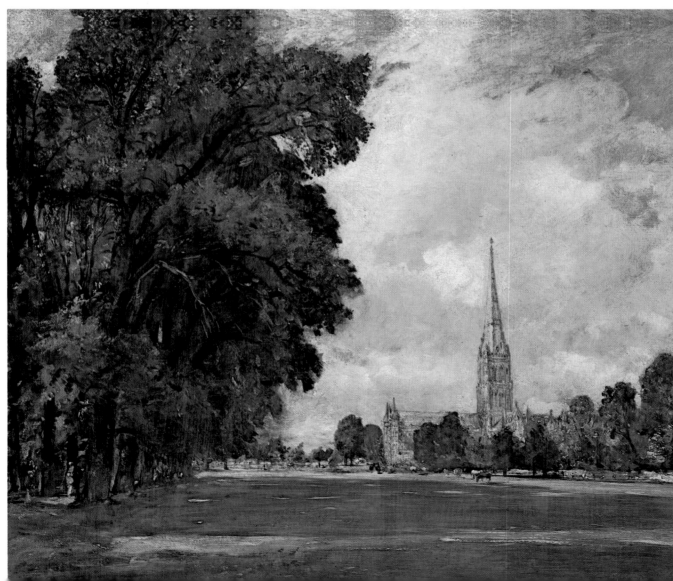

John Constable
*Salisbury Cathedral Viewed
from the Bishop's Residence*

1823
Oil on canvas,
28¾ × 35¾ in. (73 × 91 cm.)
National Gallery,
Washington

The pointed white outline
of the Gothic cathedral
stands out against
the green and shady
background of the garden.
It is possible to recognize
the influence of Canaletto's
views, which were well-
known in England.

Joseph Mallord William Turner

London, 1775–1851

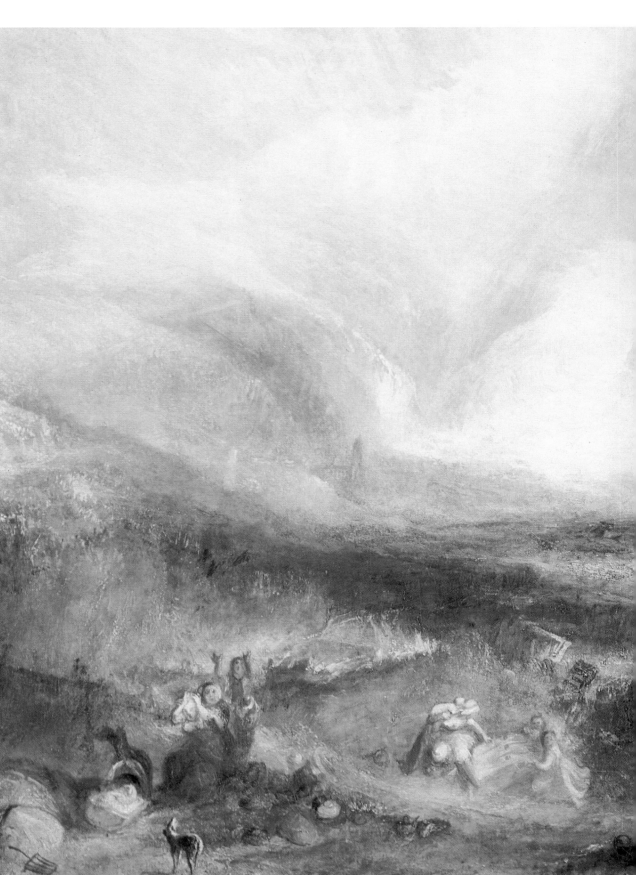

Gifted with a precocious and brilliant talent, Turner was able to find a highly unusual balance between his natural inspiration and a thorough and complete course of studies. Admitted to the Royal Academy of Arts at the age of only fourteen, Turner assiduously attended the courses of engraving, watercolor, topography, and finally painting, showing a distinct preference for the landscape. In spite of the pedantry and long-windedness of the lessons, the young Turner acquired an unexceptionable stock of technical skills. He studied and admired the great painters of the past and found the stimuli he needed to go beyond the imitation of nature and seek a freer and more personal means of expression. A very important factor in this process was the journey he made to Switzerland in 1803. Among its snowy peaks Turner experienced the feeling of the sublime, overwhelmed by the huge mountains and the extreme weather phenomena. During his early maturity Turner sought to reconcile the lessons of the past (in particular, the much admired Claude Lorrain, but also the seventeenth century Dutch landscapists) with his desire to experiment. Characteristic of this period are the themes of some of his landscapes, inspired by episodes from ancient history. In 1819 Turner's life and career reached a turning point: his first visit to Italy took him to Venice, where he was enthralled by the play of light on water, stone, sky and clouds. Although he admired the luminous skies of Rome and Naples, Turner nursed a special affection for Venice. He returned there several times, depicting radically different aspects of the city than those caught by Canaletto. In particular, the buildings reflected in the water are only vaguely recognizable, their outlines blurred in the light. Late in his career, Turner accentuated his research into the effects of mist and steam, eventually producing the first painting of a moving train.

William Turner
Snowstorm in Val d'Aosta
(detail)

1818
Oil on canvas,
36 × 48¼ in.
(91.5 × 122.5 cm.)
Art Institute, Chicago

A journey through the Alps made a deep impression on Turner. He was struck by the swirling of wind and snow, the unusual light and the uniformity of color under the falling snow rather than by the majesty of the mountains. He turned sharply away from the analytical precision of Constable in order to convey sentiments and emotions.

William Turner
The Fall of an Avalanche in the Grisons

1810
Oil on canvas,
35½ × 47¼ in.
(90 × 120 cm.)
Tate Gallery, London

In this early work we find, in addition to the reflection of an intense and firsthand experience, the influence of the aesthetic doctrine of the sublime. All through his life, Turner set out to express his understanding of philosophical theories and contemporary developments in literature in his paintings, presenting himself as an intellectual with a thorough grasp of English cultural life.

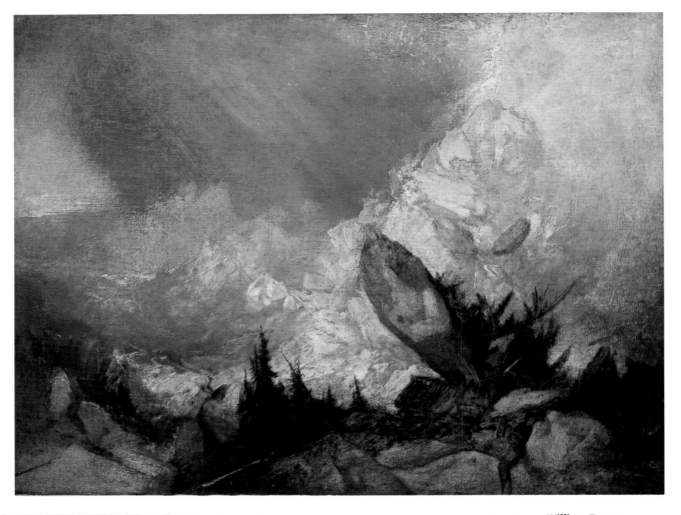

William Turner
Fiery Sunset

c. 1825–27
Watercolor on paper,
9¾ × 13¼ in.
(24.6 × 33.8 cm.)
Tate Gallery, London

Turner was more drawn to atmospheric effects than any other subject. His desire to depict suggestive moments of fusion between light, color, vapor and water led the painter to largely renounce the attempt to reproduce details and concentrate on the overall effect.

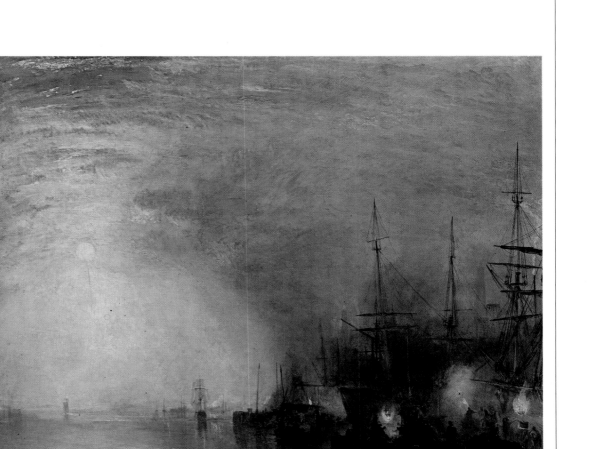

William Turner
*Stevedores Unloading Coal
by the Light of the Full Moon*

1835
Oil on canvas,
36¼ × 48½ in.
(92 × 123 cm.)
National Gallery, Washington

The world of ports, cargo ships, mysterious nighttime activities on the dockside or, by contrast, the perils of navigation, deeply attracted Turner. The element of water still plays the leading role in an adventure of light in which things and people are magically caught up.

Here we have another example of the poetic effect of moonlight, a theme that runs right through the art of the nineteenth century.

William Turner
*The Morning after
the Deluge*

c. 1843
Oil on canvas,
31 × 31 in.
(78.7 × 78.7 cm.)
Tate Gallery, London

The painting sets out to
represent the moment
when the sun breaks out
after the Flood. Looking
carefully, it is possible
to make out the hazy red
outlines of angels in flight.
But the subject is just a
pretext for tackling the
theme of the theory of
light. Turner explicitly
refers to Goethe's treatise
on color (translated into
English in 1840) in the way
he uses warm tones of
yellow and red to express
a moment of joy.

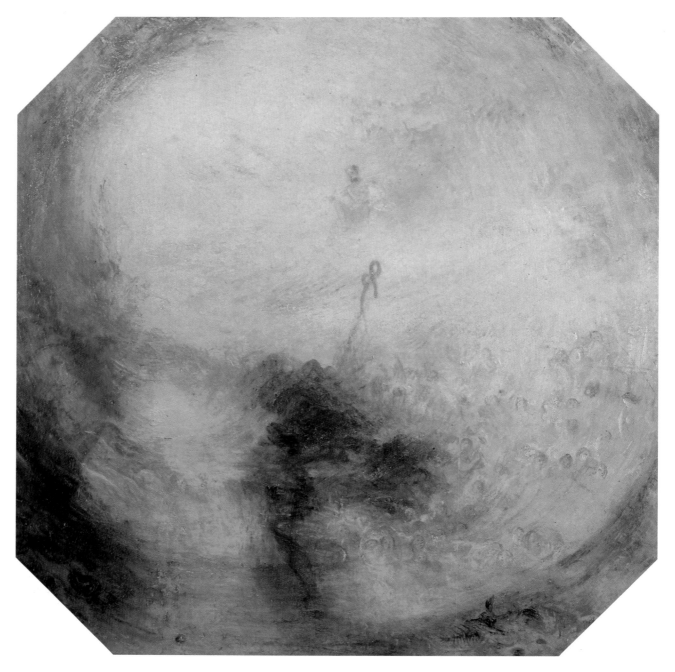

William Turner
*Rain, Steam and Speed.
The Great Western Railway*

1844
Oil on canvas,
38½ × 48 in.
(98 × 122 cm.)
National Gallery, London

In this work, one of Turner's
last major pictures, one
of the protagonists of
nineteenth-century industrial
production and life made its
first appearance in the history
of art: the steam train.

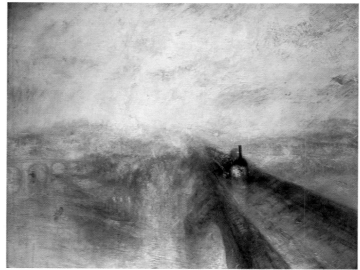

Caspar David Friedrich
The Crucifix in the Mountains

c. 1807
Oil on canvas,
45¼ × 43¼ in.
(115 × 110.5cm.)
Gemäldegalerie Neue
Meister, Dresden

With this painting
Friedrich earned himself
a place in the debate over
developments in art in the
early nineteenth century,
by urging a new
relationship with tradition
and nature. Setting the
picture inside
a carved and gilded frame,
Friedrich overturns the
concept of the altarpiece
by depicting a "mystical"
chain of wooded
mountains on which stands
a cross. The painter, taking
his cue from contemporary
German poetry, is
suggesting an attitude
of admiration and respect
for nature, capable of
conveying profound
emotions.

Caspar David Friedrich

Greifswald, 1774–Dresden, 1840

The most important exponent of German Romantic painting, capable of making artistic and existential choices of great courage, he was trained in the classical atmosphere of the Copenhagen Academy. In 1798 he moved to Dresden, where he became involved in a vibrant cultural, philosophical and literary environment centering on Goethe's poetry and the latest developments in idealism. The exceptional liveliness of the time and the desire to fix

the characteristics of an authentically "German" art led Friedrich to refuse to make the customary journey to Italy, placing him in open opposition to the Nazarenes, German painters active in Rome. In 1808 the artist underlined this choice in polemic fashion: asked to paint an altarpiece, he painted *The Crucifix in the Mountains*, a mountainous and deserted landscape containing nothing but a slender cross. Thus the traditional themes of sacred art gave way to the new Romantic awe of nature, in which admiration for the spectacles of the sea, mountains, mist and sun was mixed with a sense of human impotence.

Nature and its contemplation are the heart of Friedrich's pictures, sustained by a faultless handling of light. Human figures often appear, but always with their backs turned, in a thoughtful or even ecstatic attitude. With the passing of time, Friedrich's landscapes were enriched with more and more symbolic contents, to the point of using variations in light and situation to allude to the age of man. The rather rare architectural elements are confined to Gothic ruins and confirm the artist's radical choice: to spurn the Neoclassical backdrops of academicism for national settings, landscapes and sentiments.

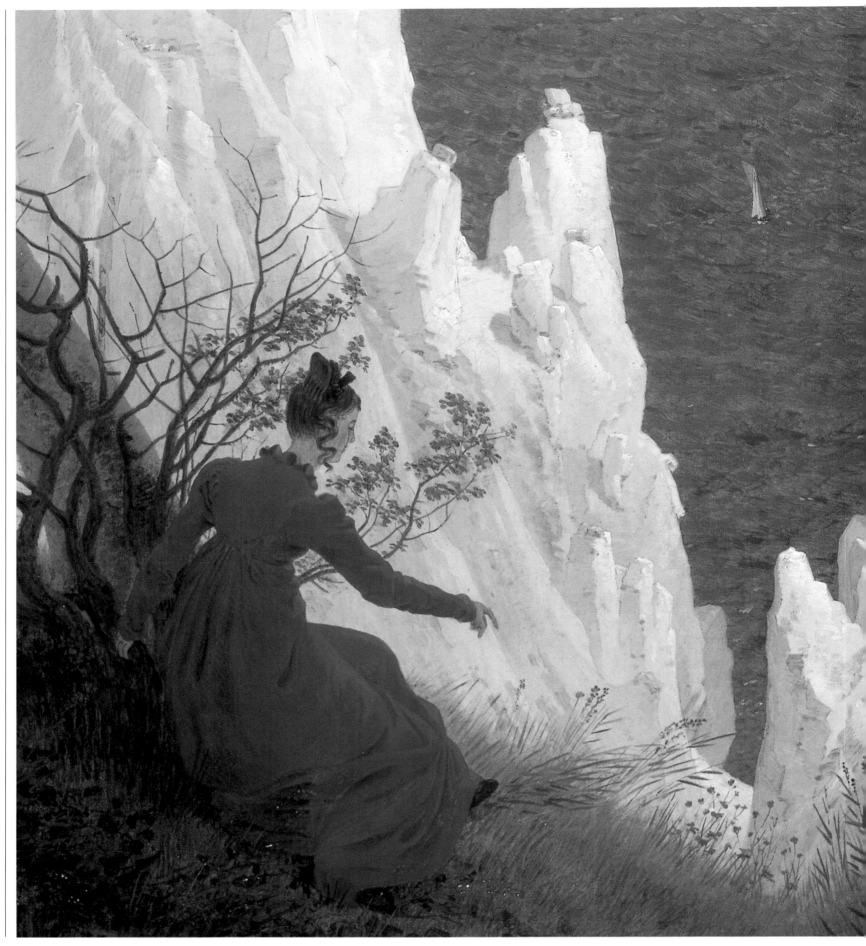

Caspar David Friedrich
Abbey in the Oak Forest

1809
Oil on canvas,
43½ × 67¼ in.
(110.4 × 171 cm.)
Charlottenburg Castle,
Berlin

Friedrich was able to
transfer the concepts of
German idealism and
Romanticism onto canvas.
A sense of the mystical,
of a great and universal
soul, pervades the world
of nature and it is the
individual's task to give
free rein to his or her
feelings, to share in this
mystery. *The Abbey in the
Oak Forest* conveys a feeling
of desolation. The bare
trees, almost killed by
the winter, look like the
tombstones of a graveyard
around the ruins of an old,
abandoned church, while
an extremely restricted
range of grays and browns
expresses a sense of
gloom. Like many
Romantic intellectuals
and poets, Friedrich was
fascinated by the infinite:
the gaze travels a long way,
eventually losing itself in a
thick mist that blurs the
horizon. In their perfect
immobility, Friedrich's
landscapes are spiritual
images, filled with
symbolic values.

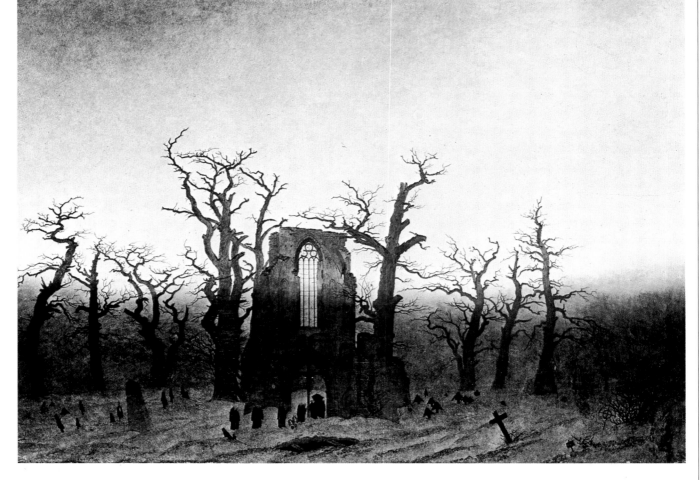

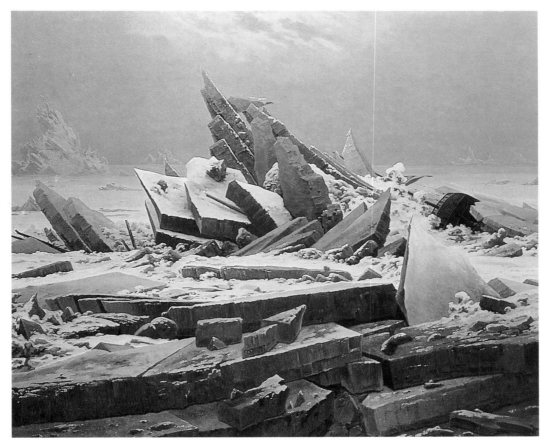

Caspar David Friedrich
*The Wreck of the
"Speranza"*

1824
Oil on canvas,
50½ × 38½ in.
(128 × 98 cm.)
Kunsthalle, Hamburg

An item of contemporary
news similar to the one
on which Géricault based
his *Raft of the "Medusa"*
suggested to Friedrich
this striking image of a ship
caught in the grip of the
ice.

On the facing page
Caspar David Friedrich
The White Cliffs of Rügen
(detail)

c. 1818
Oil on canvas,
35½ × 27½ cm.
(90 × 70 cm.)
Oskar Reinhart Foundation,
Winterthur

Caspar David Friedrich
The Sunset (Brothers)

1830–35
Oil on canvas,
9¾ × 12¼ in.
(25 × 31 cm.)
Hermitage, St. Petersburg

Even in paintings
of small size like this,
the German artist is able
to conjure up highly
evocative atmospheres.
Especially in the works
from the latter part
of his career, the muted
tones of the dying light
and the dark outlines
of the figures are obvious
symbols of death.

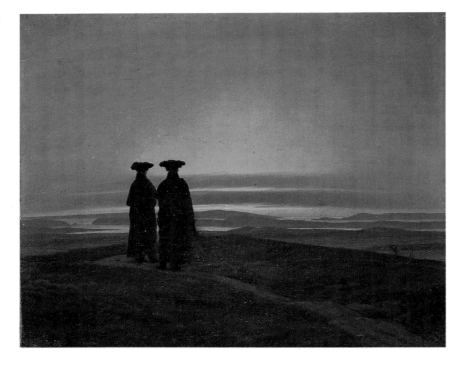

Caspar David Friedrich
Monk by the Sea

1808–10
Oil on canvas,
38½ × 50½ in.
(98 × 128 cm.)
Nationalgalerie, Berlin

This is Friedrich's most
"abstract" work, surprising
in its almost total lack of
form and color. A brooding
sky, covered with gray
clouds, looms over a thin
strip of sand, lapped by dark
waves. In this threatening
setting, the tiny figure
of a monk once again alludes
to the relationship between
the mystery of the divine
and nature.

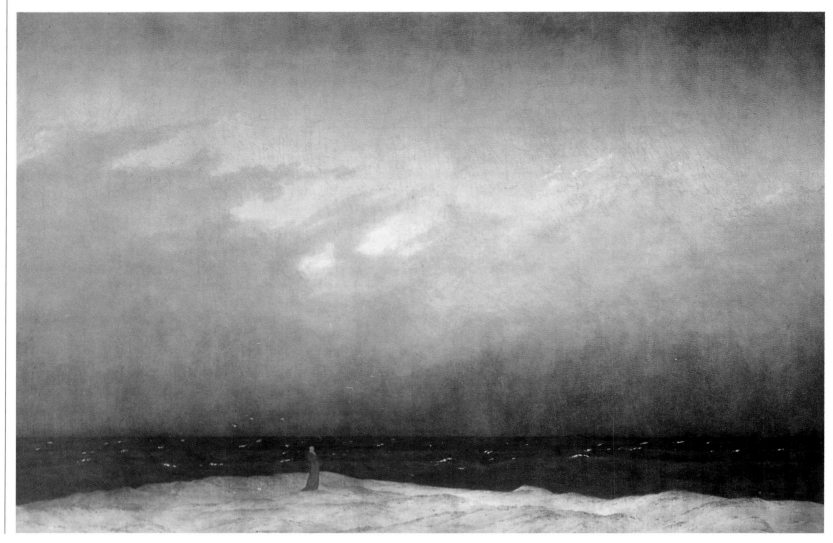

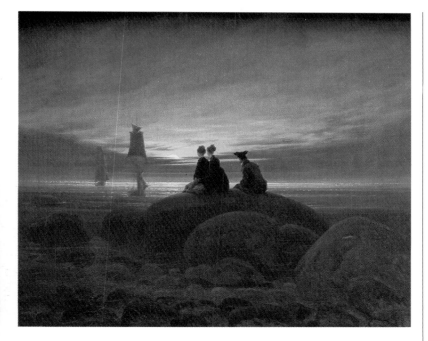

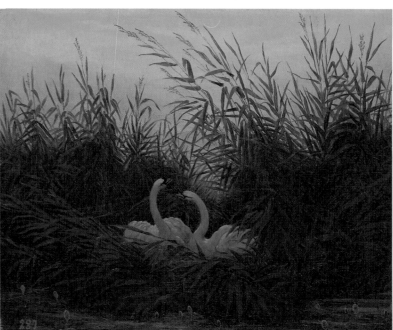

Caspar David Friedrich
Moonlight on the Sea

1822
Oil on canvas,
21¾ × 28 in.
(55 × 71 cm.)
Nationalgalerie, Berlin

The silence of the sea,
the moon and the night
are not undermined by
the presence of the figures
crouching on the rocks.
As always, Friedrich paints
them from behind, intent
on the contemplation
of nature.

Caspar David Friedrich
*Swans in the Reeds
at the First Light of Dawn*

1832
Oil on canvas,
13½ × 17¼ in.
(34 × 44 cm.)
Hermitage, St. Petersburg

A rare painting in which
Friedrich renounces the
panoramic point of view in
order to look closely, and
in silence, at the courtship
of two swans half-hidden
among the reeds of a pool.
Because of its atypical
character, the attribution
of this picture to the
painter has long been
controversial. In this
connection, it is worth
mentioning Friedrich's
reluctance to sign, list or
make his works identifiable
in any way.

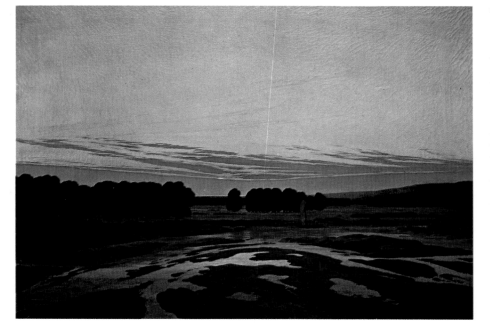

Caspar David Friedrich
The Great Marsh

1832
Oil on canvas,
29 × 40¼ in.
(73.5 × 102.5 cm.)
Gemäldegalerie Neue
Meister, Dresden

An extremely fascinating
canvas, using a carefully-
chosen range of colors,
capable of turning the
dismal expanse of stagnant
water into a mystical image
that reflects the red glow
of the sky and extends
for a boundless distance.

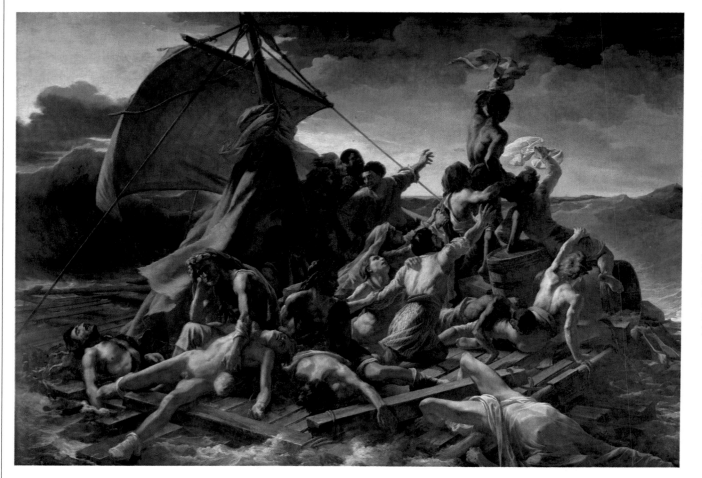

Théodore Géricault
The Raft of the "Medusa"

1818–19
Oil on canvas,
193¼ × 282 in.
(491 × 716 cm.)
Louvre, Paris

In 1816, the ship *Medusa* sank off the coast of West Africa. About 150 people were left drifting on an improvised raft and had to face many days at sea in conditions of terrible hardship. In the end only fifteen survived. Struck by this dramatic episode, which seemed like a metaphor for the ruinous fall of Napoleon, Géricault carried out meticulous research in order to depict the castaways in a painting of exceptional size and power.

Théodore Géricault

Rouen, 1791–Paris, 1824

An untimely death cut short the career of one of the most interesting and courageous of early nineteenth-century artists, perhaps the first to seek a compromise between the flawless technique and figurative culture of Neoclassicism and the early Romantic sensibility that was beginning to take its place. In spite of his short life, Géricault displayed an extraordinary capacity for the composition and execution of images, not just as a painter but also as an engraver and sculptor. Moving to Paris as a child, he received his training from artists working in the late eighteenth-century tradition, like Vernet and Guérin. While studying the masterpieces of the past in the Louvre, he attended meetings of the Jacobins and of soldiers returning from Napoleon's campaigns that were held in Guérin's studio. This stirred a desire for liberty in the young Géricault: not just personal and political freedom, but also an artistic one, that prompted him to look for new forms of expression. It is no accident that one of his favorite subjects was the horse, often frisky, rearing or at any rate brimming with energy. A journey to Italy in 1816 brought him into contact with the works of Michelangelo and Caravaggio, from which he acquired his fascination with the human body, dramatic handling of light, and capacity to take on monumental enterprises. Returning to Paris in 1817 and stimulated by his friendship with the young Delacroix, Géricault painted his greatest masterpiece, *The Raft of the "Medusa,"* exhibited at the Salon of 1819. The huge picture caused a sensation, becoming almost a symbol of a rudderless moment in history, when the end of the Napoleonic era opened up new horizons. Subsequent works revealed Géricault's strong interest in the world of medicine, both physiology (some of his studies of anatomical specimens or the severed heads of condemned criminals are truly macabre) and psychiatry: his portraits of mental patients are unprecedented in the history of art.

Théodore Géricault
*Portrait of a Mental Patient
(Mania for Military
Command)*

1822–23
Oil on canvas,
32 × 25½ in.
(81 × 65 cm.)
Oskar Reinhart
Foundation, Winterthur

Théodore Géricault
*Portrait of a Mental Patient
(Gambling Monomania)*

1821
Oil on canvas,
30¼ × 25 in.
(77 × 64 cm.)
Louvre, Paris

Théodore Géricault
*Portrait of a Mental Patient
(Monomania for the
Abduction of Children)*

1820–24
Oil on canvas,
25½ × 21¼ in.
(65 × 54 cm.)
Museum of Fine Arts,
Springfield

Théodore Géricault
*Portrait of a Mental Patient
(Obsessive Envy)*

1820–24
Oil on canvas,
28¼ × 22¾ in.
(72 × 58 cm.)
Musée des Beaux-Arts,
Lyons

Théodore Géricault
*Portrait of a Mental Patient
(Monomaniac, Thief,
Kleptomaniac and
Murderer)*

1821–24
Oil on canvas,
24 × 20 in.
(61 × 51 cm.)
Museum voor Schone
Kunsten, Ghent

The portraits of lunatics
painted by Géricault for
scientific as well as artistic
and symbolic purposes
make up a gallery of
exceptional interest. In
their evasive and intense
faces, the artist captures
moments of torpidity,
glazed expressions and
empty stares, but he also
presents a bleak and
disenchanted image of a
condition of alienation,
distance and solitude.
Just as the wreck of the
Medusa can be seen as a
comment on current
affairs, a symbol of
Napoleon's eclipse, the
monomaniacs are a
metaphor for and
exaggeration of ordinary
individuals, prisoners of
their vices and abandoned
to themselves.

Eugène Delacroix

Charenton-Saint-Maurice, 1798–Paris, 1863

The artist who is more representative than any other of French Romanticism was born to a family of high state officials (his father held important public posts) from whom he received a literary education of considerable depth. Trained in the studio of a Neoclassical artist, he formed a close friendship with Géricault around 1819, even posing for one of the figures in the *Raft of the "Medusa"* (p. 50), and Antoine-Jean Gros, famous for his huge history paintings. Another factor to bear in mind if we want to understand Delacroix is the great attention he paid to the masters of the past: Michelangelo's nudes, Titian's lush color and Rubens's exuberance of composition would remain constant points

of reference throughout his career. He made his official debut in 1822, and caused a sensation: *The Barque of Dante*, exhibited at the Paris Salon, immediately stirred interest in the young painter, who chose unusual themes and at once tried his hand at pictures of large size. With *Liberty Leading the People* (1830), Delacroix painted a genuine, though somewhat bombastic, "manifesto" of patriotic and revolutionary sentiments. All these works, painted during the early part of the artist's career, show a complete command of an extraordinary range of compositions. In 1832 Delacroix's style underwent a profound change, following a visit to Spain and Morocco. His contact with Goya's painting and the experience of Africa gave his work an even greater dramatic intensity and dynamism, often conveying a vibrant sense

of the erotic. Numerous paintings, drawings and watercolors from the 1830s record his journey, while the diary that the artist kept for many years offers a fascinating glimpse of the Romantic sensibility and ideals. Back in Paris and playing a leading role in cultural and literary circles alongside writers like Dumas, Baudelaire and Victor Hugo, Delacroix devoted himself to ambitious cycles of frescoes and decorations, including those of the Apollo Gallery in the Louvre and the church of Saint-Sulpice in Paris, his last work on a grand scale.

Eugène Delacroix
Women of Algeria

1834
Oil on canvas,
70¾ × 90¼ in.
(180 × 229 cm.)
Louvre, Paris

The exotic costumes, the eroticism of the dark and languid girls, and the cool shadows and dim lighting of the harem make this painting one of the earliest examples of Orientalism. Delacroix, at the peak of his artistic maturity here, boldly tackles an unusual theme, veined with a hint of forbidden sensuality.

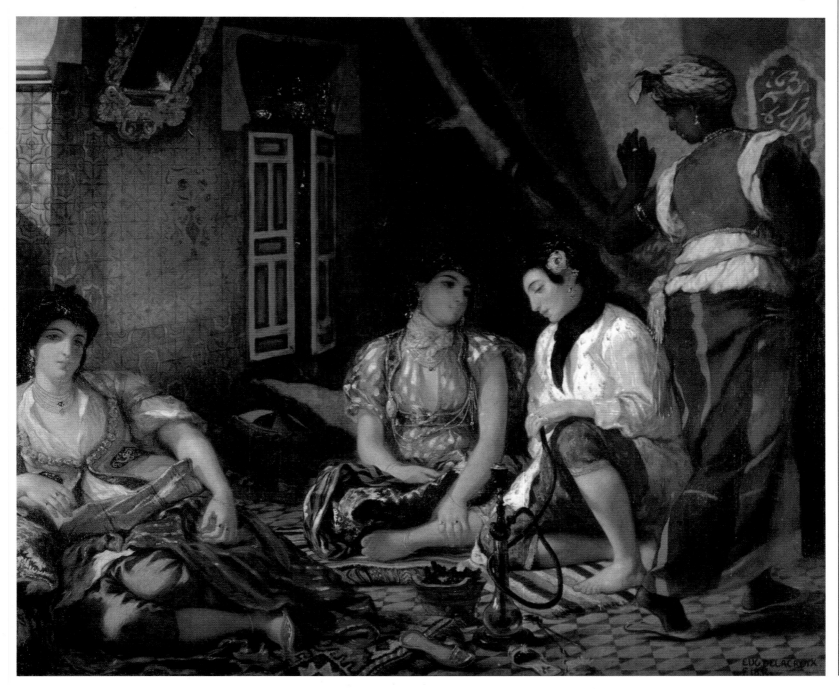

Eugène Delacroix
The Barque of Dante

1822
Oil on canvas,
70¾ × 94½ in.
(180 × 240 cm.)
Louvre, Paris

This was Delacroix's first work to make a great impact. The unusual and fascinating subject, the monumentality of the composition, the violent and contrasting handling of the paint, very different from the noble and statuesque calm of Ingres, caught the attention of the critics and public alike.

Eugène Delacroix
The Massacre at Chios

1824
Oil on canvas,
166¼ × 138½ in.
(422 × 352 cm.)
Louvre, Paris

Inspired by a dramatic episode in the Greek War of Independence against the Turks, which took place in April 1822, this enormous painting is one of Delacroix's most daring works. Deliberately setting aside any attempt at symmetrical composition, the painter illustrates a contemporary event, placing the emphasis on bloody effects of violence and brutality. The negative reaction of the official critics was countered by the enthusiasm of writers and intellectuals, including Victor Hugo and Dumas père: with this painting Delacroix made his "official" entry into the ranks of the Romantics.

Eugène Delacroix
Liberty Leading the People

1830
Oil on canvas,
102¼ × 128 in.
(260 × 325 cm.)
Louvre, Paris

In explanation of this large and controversial painting, Delacroix wrote: "If I have not won battles for my country, at least I shall paint for it." The painter had played a fairly lukewarm part in the popular uprisings in Paris in 1830 and, perhaps exaggerating his own role, portrayed himself in the figure of the man with a top hat. The fruit of a mix of Romantic and literary culture, the canvas is a singular blend of realism and propaganda, rhetoric and straightforward observation of contemporary events. Amidst the chaos of the barricades the heroine, embodying free France, appears semi-naked, wearing a Phrygian cap (a symbol of the French Revolution), and holding a flag in one hand and a gun in the other. Delacroix has transformed a battle scene into a collective event, a manifestation of the nation's destiny and history. Thus we are a long way away from Goya's vision, which had emphasized the tragic effect of war on the individual.

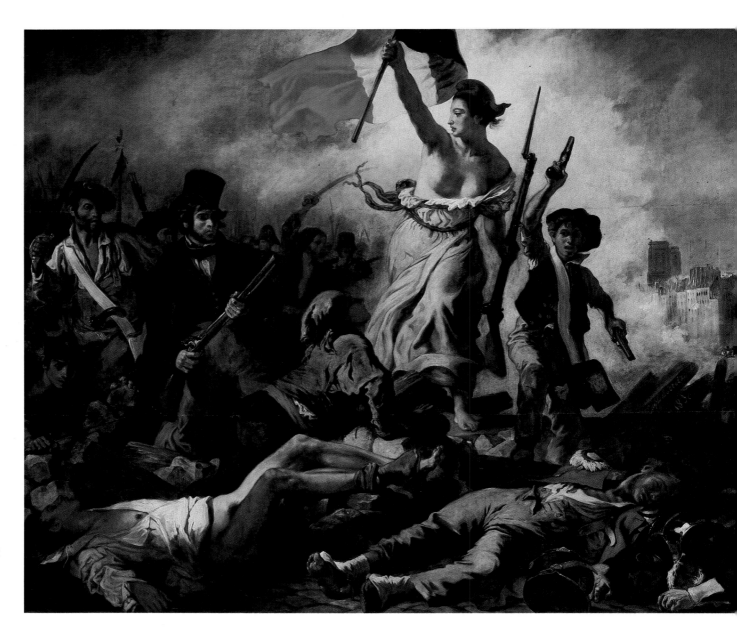

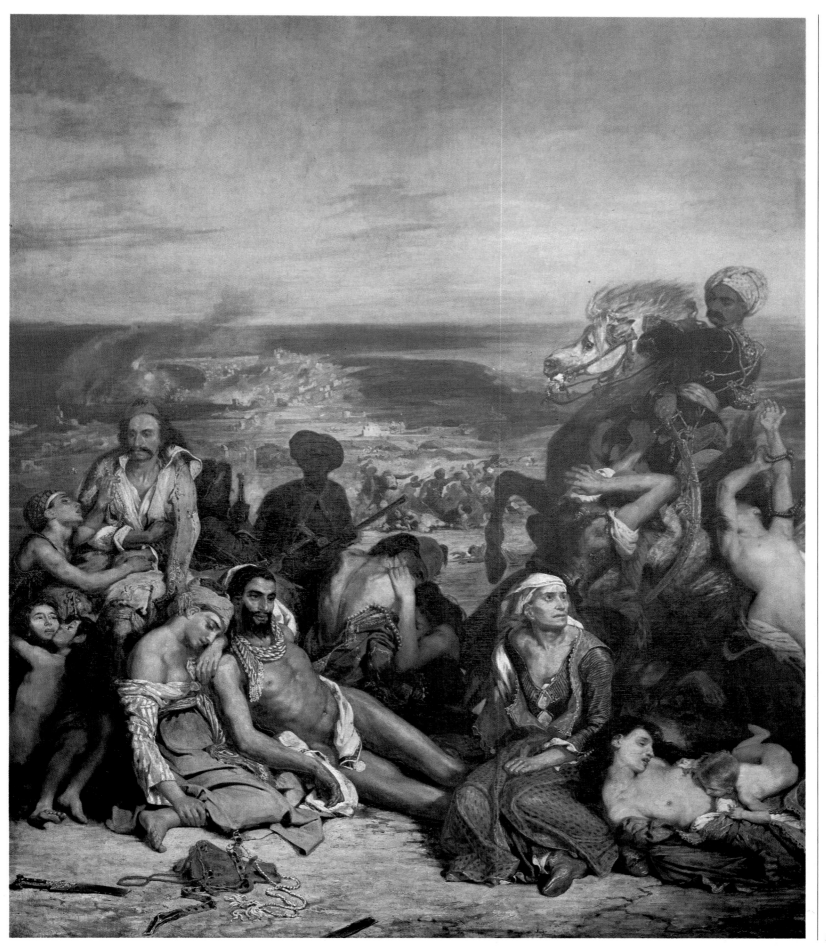

Eugène Delacroix
The Death of Sardanapalus

1827
Oil on canvas,
151½ × 195 in.
(385 × 495 cm.)
Louvre, Paris

A downright sumptuous
picture, it was painted in
the years when Delacroix's
rich and overflowing
Romanticism was at its
height. Inspired by a story
from the remote past (the
death of the Assyrian king
in the palace of Nineveh),
it became the occasion
for an open competition
between Delacroix and the
most extravagant of earlier
artists, in particular
Rubens. The painting is a
genuine orgy of colors,
gestures and amazing
displays of luxury, laid out
around the dying monarch,
reclining on a bed in the
background. The density
of color, the violent shifts
in tone and the painstaking
care over detail are
absorbed and almost
overwhelmed in an image
of spectacular expressive
force.

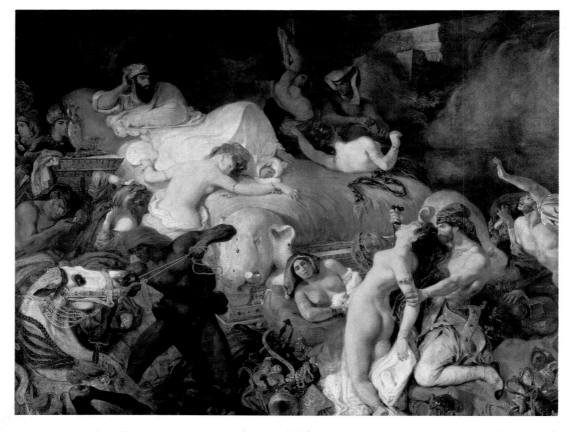

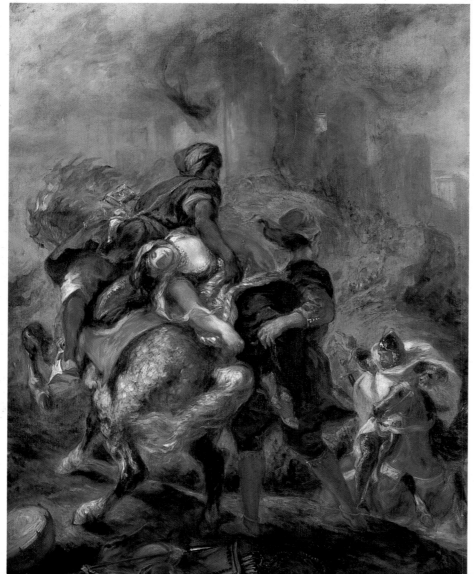

Eugène Delacroix
The Abduction of Rebecca

1846
Oil on canvas,
39¼ × 32¼ in.
(100 × 82 cm.)
The Metropolitan Museum
of Art, New York.
Catharine Lorillard Wolfe
Collection, Wolfe Fund,
1903

Swirling, eddying and
spectacular, this canvas is a
display of extraordinary
pictorial skills. Delacroix
took his inspiration from
a celebrated work
by Rubens, *The Rape
of the Daughters of
Leucippus*, striving to
outdo the prototype
in lavish ostentation.

Eugène Delacroix
A Moroccan and His Horse

1857
Oil on canvas,
22½ × 24 in. (57 × 61 cm.)
Szépmüvészeti Múzeum,
Budapest

Arab subjects, in the deliberately wild and suggestive exoticism typically inspired by the climate of the "return from Africa," occupy a very significant space in Delacroix's mature production. In the beginning, subjects of this type were a bold and controversial choice of field, amounting to a brusque rejection of Neoclassical models in favor of new visual frames of reference. In his old age, success and a degree of "professional" repetitiveness did not attenuate the impulsive energy of his work. Exoticism was a very popular current in nineteenth-century art and culture: leaving aside the extreme case of Gauguin, who went to live in Polynesia, many painters felt the need to make more or less long sea voyages, preferably along the southern coasts of the Mediterranean.

Francesco Hayez
Venice, 1791–Milan, 1882

Trained in Venice in the graceful style of the eighteenth century and the tradition of the Venetian school of painting, Hayez completed his artistic education with a stay in Rome under the wing of Canova. In 1820 he moved to Milan, which he made his home. He stayed in that city for the rest of his long career, becoming the director of the Brera Academy. The numerous stages in the development of Hayez's painting, covering a span of seven decades, coincide with the salient moments in nineteenth-century Italian art. Gifted with a perfect technique, clearly recognizable in his penetrating portraits, Hayez excelled in the composition of large historical scenes that are openly Romantic in tone. Esteemed at the Viennese court, the artist painted the emperor's portrait and frescoed his apotheosis on the ceiling of the Sala delle Cariatidi in the royal palace in Milan (destroyed in 1943), but later took a stand in favor of national independence. A leading figure in Milanese cultural life, where he was involved in debate with thinkers, writers and composers like Antonio Rosmini, Alessandro Manzoni and Gioacchino Rossini, Hayez introduced a moral and civil pathos into his work that was in tune with the Italian Risorgimento. Generations of Lombard painters, from late Neoclassicism to the Verism of the late nineteenth century, were trained at his school.

Francesco Hayez
Melancholy

1842
Oil on canvas,
53¼ × 38½ in.
(135 × 98 cm.)
Pinacoteca di Brera, Milan

Under the titillating guise of a dark-haired and solitary girl with blazing eyes, Hayez conceals a message of revolt. In fact the girl is an allegory of Italy, oppressed and humiliated by foreign rulers whose yoke she would like to throw off in an outburst of renascent pride. The painting was an immediate success: in fact Hayez went on to paint several versions of it.

Francesco Hayez
The Refugees from Prague

1830
Oil on canvas,
79¼ × 90½ in.
(201 × 230 cm.)
Pinacoteca Tosio
Martinengo, Brescia

The pictures reproduced
on this page are a sample
of Hayez's best-known
and most popular work:
his large canvases of
historical subjects. These
scenes "in costume," based
on heroic events in the
past, may be reminiscent
of choral passages in Verdi's
operas but, through his
great mastery of form, the
painter manages to use
them to put across
contemporary incitements
to rebellion against tyrants
and foreign domination.

Francesco Hayez
The Sicilian Vespers

1845–46
Oil on canvas,
88½ × 118 in.
(225 × 300 cm.)
Galleria Nazionale d'Arte
Moderna, Rome

An episode from the
Middle Ages (Palermo's

revolt against the French)
was repeatedly cited in the
Italian painting, music and
literature of the nineteenth
century. Hayez came up
with several intepretations
of it: this is the most
successful. Here the painter
finds an effective balance
between an undoubted
refinement of form and the
intensity of the passions.

Francesco Hayez
*The Last Moments
of Doge Marin Faliero*

1867
Oil on canvas,
111½ × 75½ in.
(283 × 192 cm.)
Pinacoteca di Brera, Milan

Although he spent most
of his life in Milan, Hayez
maintained strong ties
with Venice, his native city.
In his large historical
scenes in a Venetian
setting we find an echo
of the great painting
of the Serenissima
Repubblica, of which
Hayez felt himself to be
the direct heir.

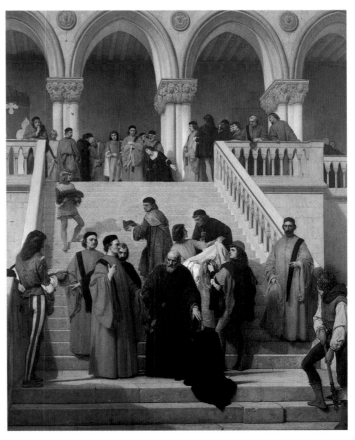

Francesco Hayez
The Kiss

1859
Oil on canvas,
44 × 34¾ in.
(112 × 88 cm.)
Pinacoteca di Brera, Milan

The open declaration of feelings and the exchange of signs of affection is one of the expressive characteristics of Romanticism. At first sight the strength of their passion seems to have induced these two lovers to cast aside all discretion. However, if we look carefully at the costumes they are wearing, especially the young man's red tights, pointed shoes and dagger, we realize that the scene is not set in the painter's own time, but in the Middle Ages. The strict conventions that ruled in art up until after the middle of the nineteenth century made any love scene set in contemporary reality appear "improper." Friend and portraitist of Alessandro Manzoni, Hayez too felt the need to place the filter of history between the subject of the work and the public. This distance made it easier to represent sentiments and effusions that would otherwise have been unacceptable, just as in the operas of Giuseppe Verdi written at around the same time.

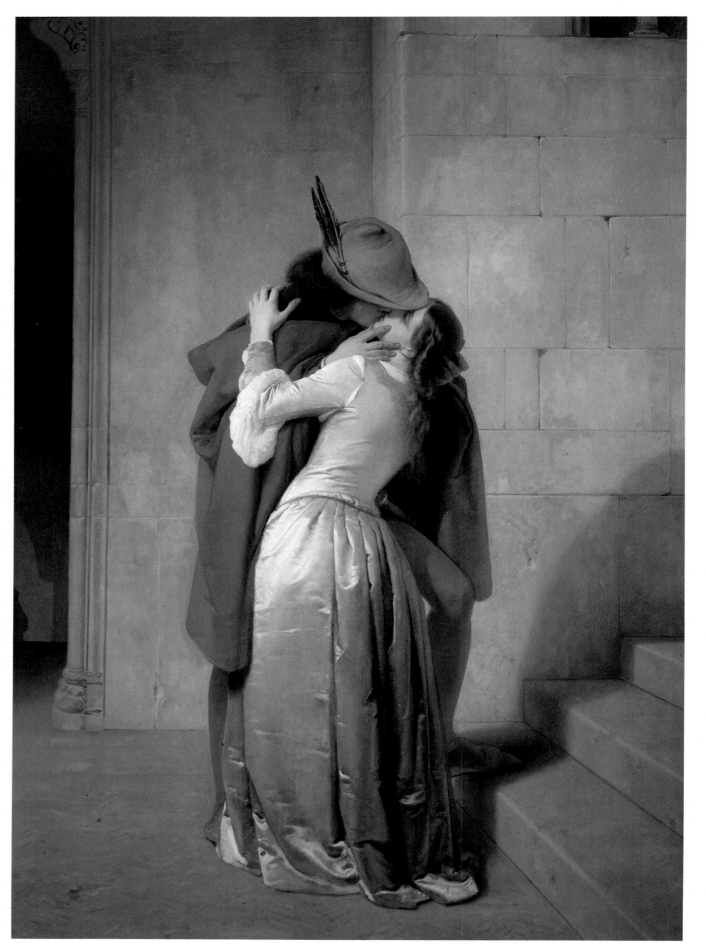

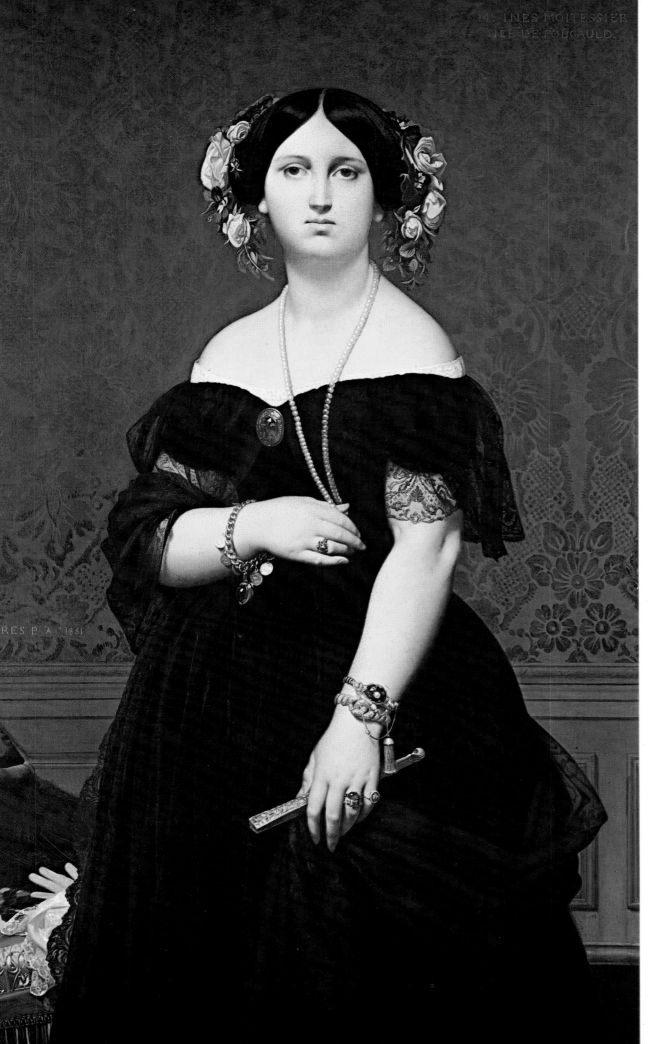

Jean-Auguste-Dominique Ingres

Montauban, 1780–Paris, 1867

The figure of Ingres dominates the scene of early nineteenth-century European art from the height of an absolute perfection of style and technique, but for a long time this has permitted only a partial appreciation of the artist. He has been criticized (and the same accusation was leveled against Canova, in even harsher terms) for a certain "coldness," a lack of emotional involvement in the work, as if the painter's work were confined to a quest for academic perfection. This is, of course, a grave misunderstanding. Ingres belonged to a generation full of doubts, of leaps forward and steps back: his art, though undoubtedly self-absorbed, is the expression of a search for higher, lasting values, within the bounds of a classical tradition of which Ingres felt himself the proud heir. In 1797, after studying at the Toulouse Academy, he became David's pupil and soon distinguished himself by his great skill and ability to compose imposing scenes on historical themes. It was with one of these that he won the prestigious Prix de Rome in 1801, earning himself the right to a period of study in that city. The campaigns waged by Napoleon (of whom Ingres painted a large formal portrait) prevented him from making the journey for several years, and he did not reach the city until 1806. Ingres stayed in Italy for eighteen years, first in Rome and then in Florence, entering into the heart of classical and Renaissance artistic culture and taking up its suggestions and influences in eclectic fashion. Working chiefly as a portraitist, he attracted attention with his first large female nudes, painted with a limpid rigor that was still capable of conveying a passionate sensuality. Returning to Paris in 1824, he showed a large picture at the Salon that was immediately acclaimed and held up in contrast to the early work of Delacroix, initiating a dialectical rivalry: Ingres was considered the champion of the academic tradition and was given official posts of growing prestige, while Delacroix embodied the new Romanticism. In reality, Ingres took the great myths of the past and gave them pictorial form, effectively blending a wide variety of references to tradition in which Raphaelesque elements frequently played a large part. Nor was his work always in line with "official" currents, as is demonstrated by his controversial return to Italy between 1835 and 1841. Alongside numerous portraits, paintings of historical or literary subjects and large commemorative compositions, he produced a great deal of graphic work.

Jean-Auguste-Dominique Ingres
Madame Moitessier

1851
Oil on canvas,
57½ × 39½ in.
(146 × 100 cm.)
National Gallery,
Washington

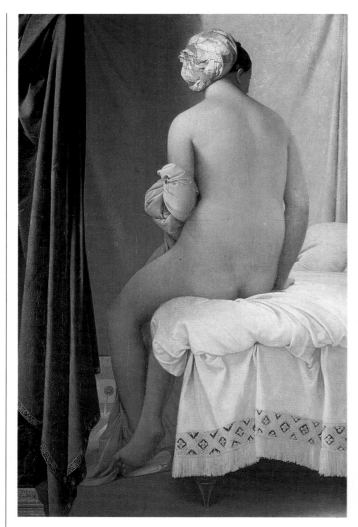

Jean-Auguste-Dominique Ingres
The Bather of Valpinçon

1808
Oil on canvas,
57½ × 38¼ in.
(146 × 97 cm.)
Louvre, Paris

Jean-Auguste-Dominique Ingres
La Grande Odalisque

1814
Oil on canvas,
35¾ × 64¼ in.
(91 × 163 cm.)
Louvre, Paris

The theme of the
"reclining Venus" is one

of the great classics
of art history, from
Giorgione and Titian
onward. To stay within
the period covered by
this book, the unbending,
classical pose of Ingres's
Oriental girl can be
compared with the
aggressive, provocative
attitude of Manet's
Olympia (p. 105).

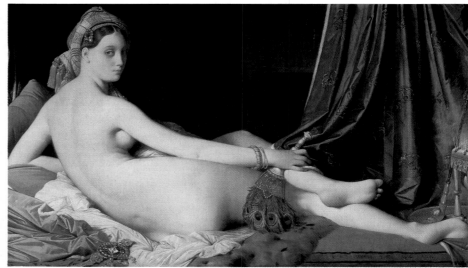

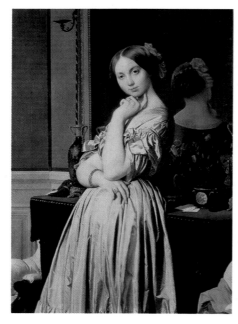

Jean-Auguste-Dominique Ingres
*Portrait of the Countess
of Haussonville*

1846
Oil on canvas,
51½ × 36¼ in.
(131 × 92 cm.)
Frick Collection, New York

Jean-Auguste-Dominique Ingres
Ruggero Setting Free Angelica

1819
Oil on canvas,
57 × 73½ in. (145 × 187 cm.)
Louvre, Paris

The subject is drawn from
Orlando furioso, but Ingres

does not have the flair
for literary illustration
of a Füssli or Blake:
for Ingres, this Renaissance
episode provides the
opportunity for a classic
contrast between the ugly
(the hippogriff, the sea
monster) and the beautiful
(the female nude, the profile
of the hero in armor).

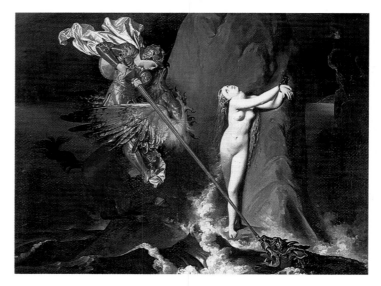

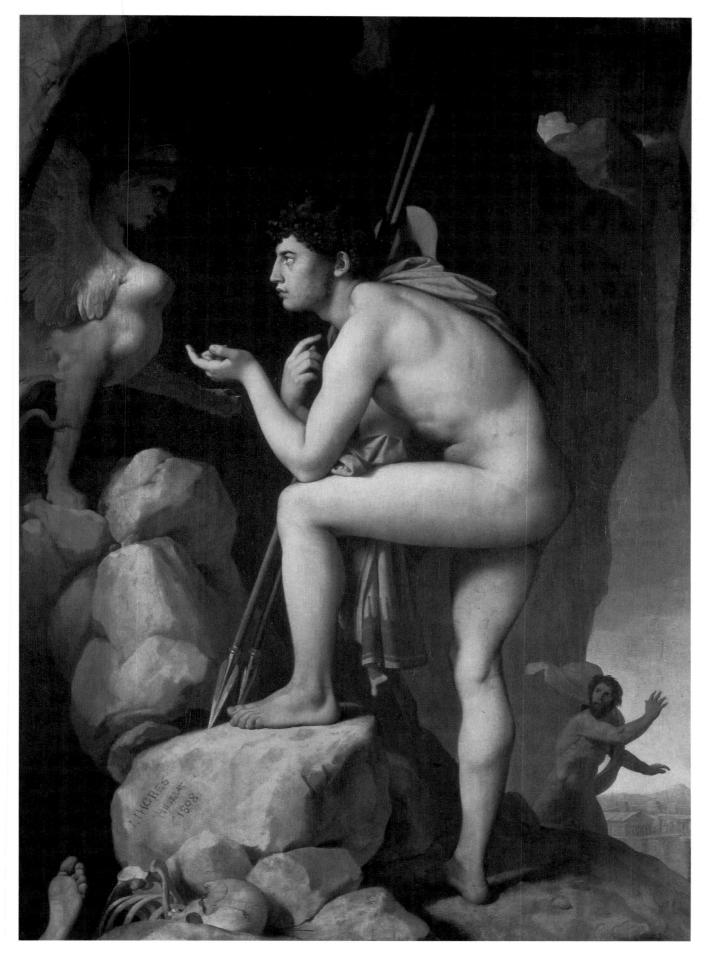

Jean-Auguste-Dominique Ingres
Oedipus Explains the Riddle of the Sphinx

1808
Oil on canvas,
74½ × 56¾ in.
(189 × 144 cm.)
Louvre, Paris

Ingres interprets the riddle of the Sphinx in a "timeless" manner of absolute clarity. It is no longer even possible to identify the stylistic references with precision. What remains is the forceful image of the contrast between a male nude with perfectly harmonious proportions and a mythical being, of ambiguous nature, worthy of the inventions of Gustave Moreau.

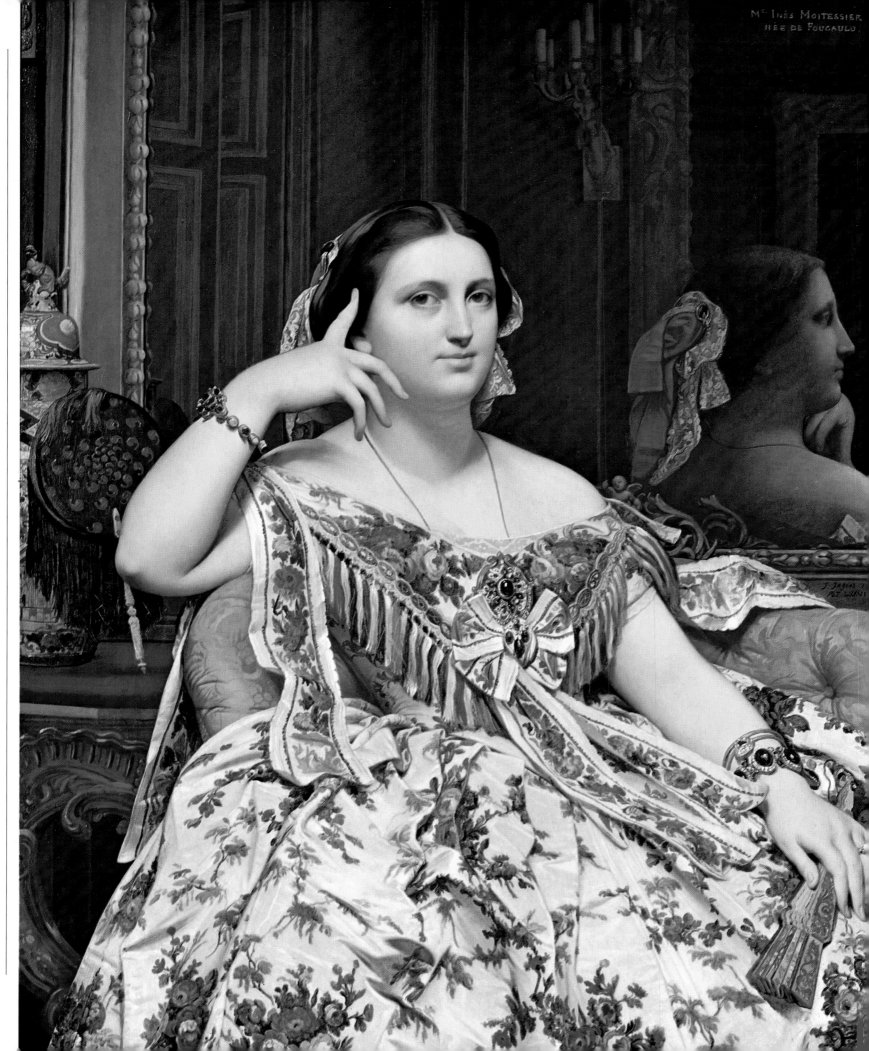

Jean-Auguste-Dominique Ingres
Madame Moitessier

1856
Oil on canvas,
47¼ × 36¼ in.
(120 × 92 cm.)
National Gallery, London

Ingres was repeatedly inspired by the Junoesque beauty of Madame Moitessier. Here the lady is wearing an exuberant patterned dress. The painter, under the spell of a flirtatious smile, willingly accepts the giddy challenge of a contest between art and nature, a mimesis that carries the observer along in a crescendo of virtuosity, amidst mirrors and flowers, porcelain and cushions, light and color, broad masses and minute details depicted with the skill of a miniaturist. In his earlier picture of the beautiful woman (p. 61), Ingres had concentrated on refined combinations of muted colors.

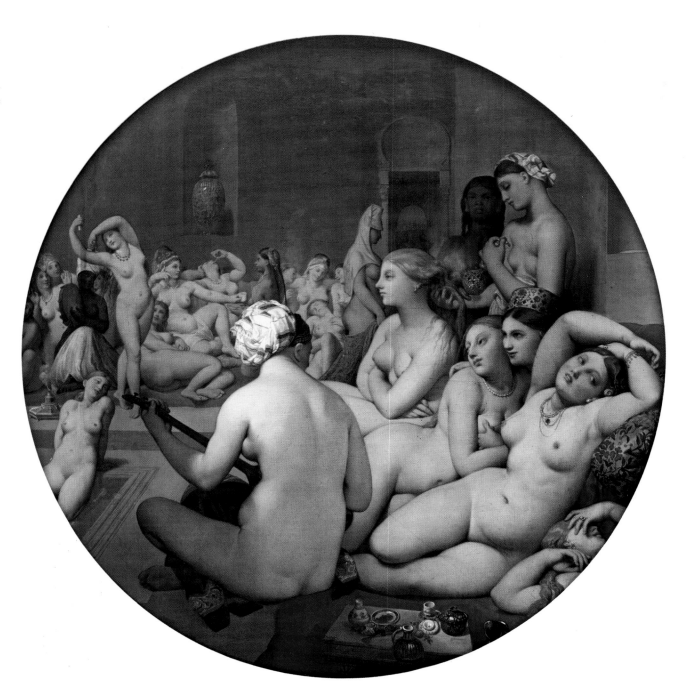

Jean-Auguste-Dominique Ingres
The Turkish Bath

1863
Oil on canvas,
diam. 43¼ in.
(110 cm.)
Louvre, Paris

Trying his hand at the treacherous format of the tondo, Ingres arranges a group of naked woman with undeniable attention to form, but also with an equally powerful sensuality. The figures of Ingres's bathers look motionless and monumental in the perfection of style attained by the painter. A purified form, an ideal of beauty pursued and achieved. There is nothing to suggest that paintings like these, through the reinterpretation of the Impressionists and Cézanne, would form the basis for such a "revolutionary" picture as Picasso's *Les Demoiselles d'Avignon*.

Camille Corot
The Forest of Fontainebleau

c. 1830
Oil on canvas,
69 × 95¼ in.
(175 × 242 cm.)
National Gallery,
Washington

Landscapes done directly
from nature, "sur le motif"
(painted on the spot), made
Corot one of the pioneers
in the representation of
light and the natural
surroundings which, passing
through the painters of the
Barbizon School, would
come into its own with the
Impressionists.

Jean-Baptiste-Camille Corot

Paris, 1796–1875

A refined master of landscape, Corot was
one of the nineteenth century's most
cultivated and gracious painters. His point
of reference was the art of the great
seventeenth-century painters: like Poussin
and Lorrain, Corot spent a long time in
Rome and other Italian cities. Corot's
career got off to a relatively late start and
his first truly interesting works date from
his first stay in Rome (1825–28). Financial
security allowed Corot to produce two
kinds of pictures: landscapes intended for
public show and the market, of a fairly
conventional character, and works
of smaller size but great freshness.

His landscapes and figures of peasant girls
are a mark of Corot's desire to capture
the reality of nature, clearing the way
for painting *en plein air*. Returning to
France, Corot found a new source of
inspiration in the Forest of Fontainebleau.
Following in his footsteps, many
French painters went to live at Barbizon.
Two further long stays in Italy rendered
Corot's style even more assured and
personal: the faultless handling of light
and full recognizability of the locations
never descend to the level of the picture
postcard, but always remain interpretations
of great lyrical force. Celebrated in his
homeland and incredibly prolific
(some five thousand pictures are now
believed to be his own work),
Corot continued with his free and
delightful investigation of the values
of light and color.

Camille Corot
Chartres Cathedral

1830
Oil on canvas,
25½ × 19¾ in.
(65 × 50 cm.)
Louvre, Paris

Once again, Corot is
at his most reflective and
balanced in his handling
of a theme that fascinated
nineteenth-century artists:
the Gothic cathedral. With
its apparent simplicity, the
church painted by Corot
is equidistant from the
Romantic and idealized
celebration of a national
style on the part of the

German Schinkel, the
Englishman Constable's
patient search for a solution
to the nagging problem of
representing light and shade,
architecture and nature,
van Gogh's desperate
agitation and Monet's
investigation of the way
light breaks down forms.

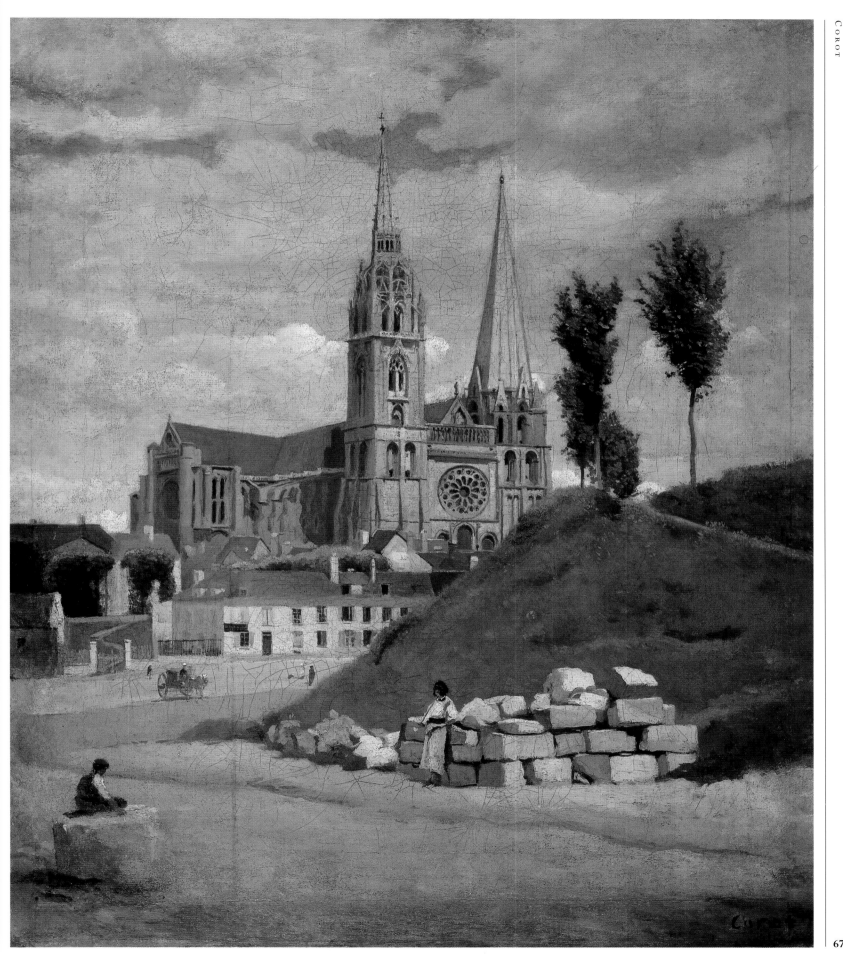

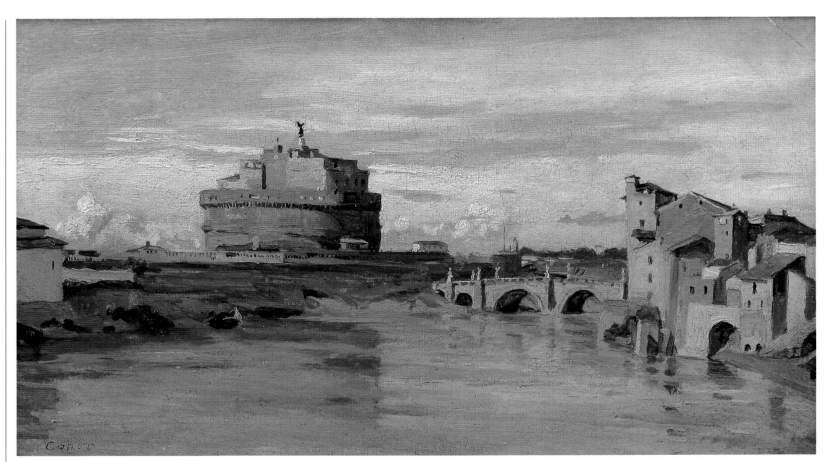

Camille Corot
*Castel Sant'Angelo
and the Tiber in Rome*

1826–27
Oil on paper mounted
on canvas,
10½ × 18¼ in.
(26.5 × 46.5 cm.)
Louvre, Paris

Camille Corot
The Bridge at Narni

1826
Oil on paper transferred
onto canvas,
14¼ × 18½ in.
(36 × 47 cm.)
Louvre, Paris

Many of the subjects
painted by Corot during
his stays in Italy match
the themes of eighteenth-
century *vedutismo*. Yet the
French painter gives a new
vibrancy to these views
through an unprecedented
sensitivity to the effects
of light. Both these small
pictures are sketches done
from nature in preparation
for larger compositions,
painted in the studio.

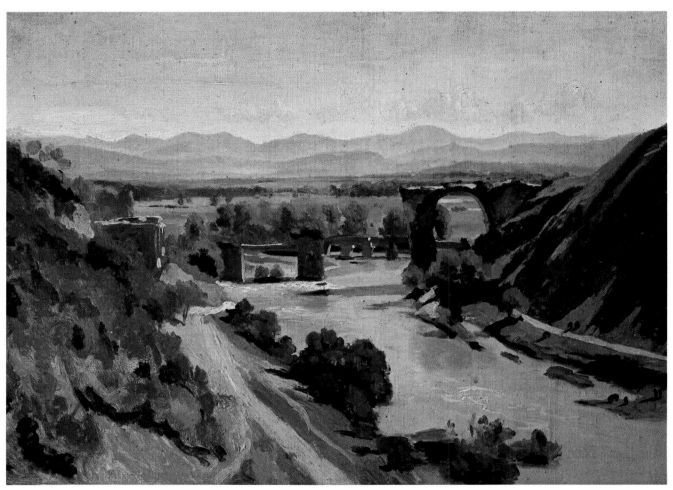

Camille Corot
View of Tivoli and the
Gardens of the Villa d'Este

1843
Oil on canvas,
18½ × 23¾ in.
(43.5 × 60.5 cm.)
Louvre, Paris

The vast Roman
countryside, the opening
up of the natural vista, the
colors and the light are still
reminiscent of the example
set by the "ideal landscape"
of the seventeenth century
and impart to Corot's
works a "classical filter"
of great refinement. Yet in
paintings like this it is
possible to see the influence
that Corot was to have on
landscape painting in the
late-nineteenth century,
and especially on Cézanne.

Camille Corot
Orléans, View
of Saint-Paterne

1830
Oil on canvas,
11 × 16½ in.
(28 × 42 cm.)
Musée des Beaux-Arts,
Strasbourg

Gothic monuments often
appear in Corot's views
of provincial France,
steeped in an atmosphere
of silence and serenity.

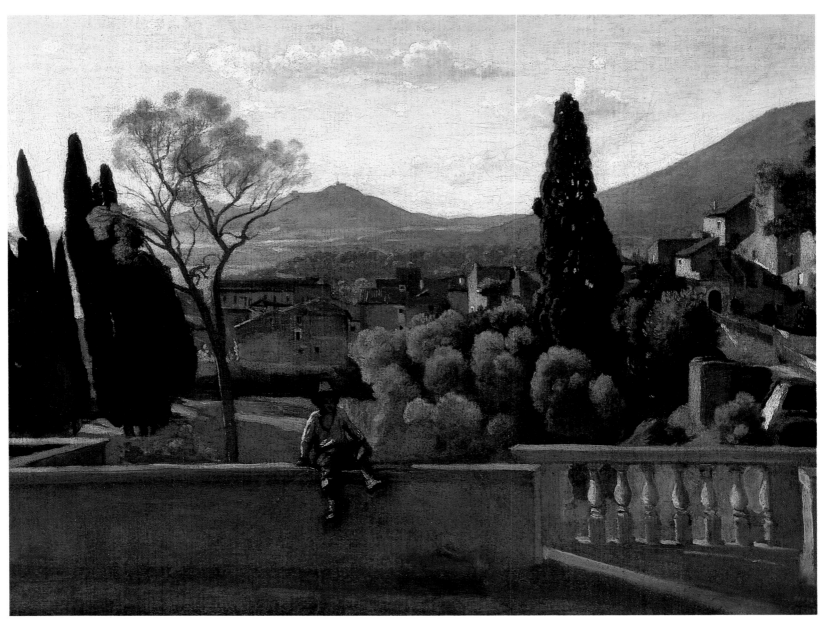

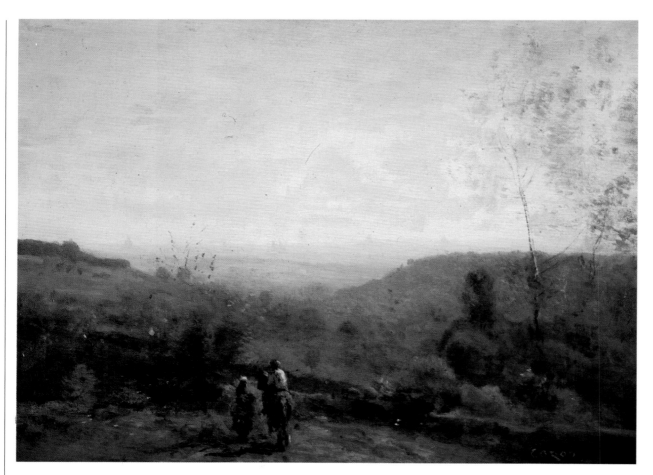

Camille Corot
The Horseman, Setting Sun

1853
Oil on canvas,
9¾ × 13¾ in.
(25 × 35 cm.)
Musée Fabre, Montpellier

In his more mature
production, Corot
rendered the light softer
and more opaque,
combining the effects
of overcast and damp
weather.

Camille Corot
Gust of Wind

1865–70
Oil on canvas,
15¾ × 22 in.
(40 × 56 cm.)
Louvre, Paris

A common subject
of Corot's later paintings,
the wind bending the trees
on a cloudy day, seems
to be the response of an
aging artist to the fresh
and luminous air brought
by the Impressionists.

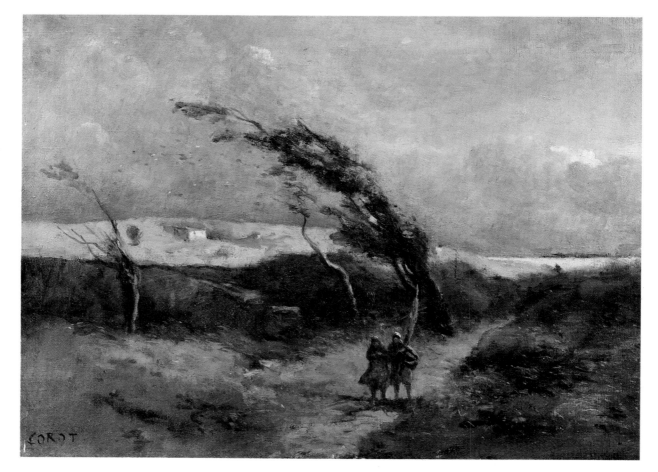

Camille Corot
Agostina

1866
Oil on canvas,
51¼ × 76¾ in.
(130 × 195 cm.)
National Gallery,
Washington

On his travels in Italy
Corot observed the
"local beauties" not only
of the landscape but also
among the country's
women, often portrayed
in costume but without
any folkloristic indulgence.
They are, on the contrary,
figures of intense
emotional vitality. In late
works like this one, we
find a hint of nostalgia
for the past.

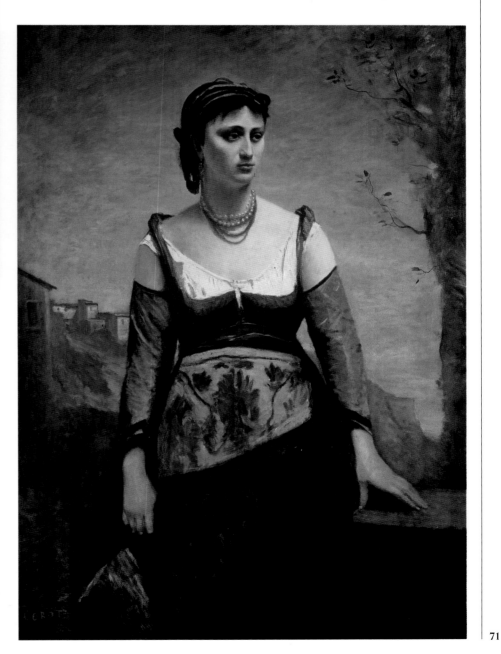

Camille Corot
The Woman in Blue

1874
Oil on canvas,
31½ × 19¾ in.
(80 × 50.5 cm.)
Louvre, Paris

A work from the very end
of the artist's career, when
he was almost eighty years
old, it is one of Corot's
most successful figure
paintings and can be
usefully compared with
pictures by Manet and
Degas from the same
period. The dominant
note of color lights up
the whole painting, which
depicts an absorbed and
pensive girl in the setting
of Corot's own studio.
It is an extraordinary
demonstration of the
elderly painter's creative
vitality, as he continued
to play his role of an
intelligent bridge between
the art of the past
and contemporary
developments: while
it is possible to discern
an echo of the eighteenth-
century portraits of
women by the English
artist Gainsborough, the
picture also reveals the
influence of Whistler's
handling of similar
subjects.

Reality

Romanticism was not an "avant-garde movement," with a date on which it was founded, a manifesto signed by its first representatives, and a course of development that can be traced in precise chronological or geographical terms. It was a vast and variegated current of thought, culture and feeling that spread through Europe for over half a century, reinvigorating much of the figurative arts of the nineteenth century and lending itself to local interpretations that sometimes differed widely from one another. Thus it can be argued that even the movements of the second half of the century, beginning with Impressionism, had their roots in Romantic ideas and the artist's new attitude toward nature and emotions. In spite of its great adaptability to situations and historical developments, however, Romanticism too gradually lost its impetus and turned into a "manner," an easy route to success. The initial element of open-mindedness, of youthful *Sturm und Drang* in rebellion against the suffocating teaching of the academies, tended to fade away, its place taken by a bourgeois acceptability that ensured painters' success on the market. The same was true for music, literature and furnishing. In opposition to this climate of reestablished harmony between the tastes of the public and those of somewhat banal artists, an independent and important tendency emerged within late Romanticism: Realism. The term is certainly a vague one. It is possible to speak of "realism" in relation to many moments in the history of art, from antiquity to Caravaggio. However, around the middle of the century and following the uprisings of 1848, the term came to be used in a very specific and openly contentious way. Relaunched by Baudelaire as a reaction to the cloying images, the facile and charming little pictures of the languid late-Romantic style, Realism was taken up in a brusque but grand and forceful manner by Gustave Courbet. In open conflict with the official critics and the public of the annual Salons, Courbet organized a counterproposal with his "Pavillon du Réalisme," a one-man show staged in a makeshift structure but in an extraordinarily effective manner. Over the decade from 1848 to 1857, Courbet challenged the prevailing currents and fashions by proposing a bold new model of the artist, directly involved in social or even political affairs, who set out to interpret concrete reality without rhetoric. The painter's "engagement" found expression in pictures of colossal size, wholly worthy of comparison with the great works of the past. Not infrequently, Courbet chose thorny, even obscene subjects, always with the aim of attacking bourgeois hypocrisy. The experience of other artists who embraced the cause of Realism from their own viewpoints was less intense on the personal plane but of great historical interest nonethe-

Ford Madox Brown
An English Autumn Afternoon, Hampstead–Scenery in 1853
1852–54
Oil on canvas,
28¼ × 53 in.
(71.7 × 134.6 cm.)
City Art Gallery,
Birmingham

Giovanni Fattori
*The Terrace at the
Palmieri Baths*
1856
Oil on panel,
4¾ × 13¾ in.
(12 × 35 cm.)
Galleria d'Arte Moderna,
Florence

less. Staying in France, we can compare the alternative approaches of Millet (who endowed peasant life with mystical and allegorical significance) and Daumier, a caustic caricaturist of politics and the legal profession but also a painter full of humane and sincere empathy for the disadvantaged. In other countries Realism touched on accents of considerable interest. In England Ford Madox Brown observed the other side of industrial civilization: that of the workers and emigrants, of those left without a job and those who had to travel far to find one. Although he chose social themes, he painted in a refined manner, aimed at a public of select connoisseurs, that was in tune with mid-nineteenth-century developments in English art and taste, dominated by the revival of styles and motifs from the past. In Italy the currents of Realism moved in step with the struggle for independence: especially after 1850, painters fought as volunteers or took part in Garibaldi's exploits, putting the experience of war down on canvas not in terms of heroic glorification or the rhetoric of independence, but as fatigue, dirt, blood and fear. Realism, which would find some important exponents in Italy at the end of the century, started out with intense scenes of military supply lines, scattered units, guard duty and light cavalrymen on patrol: the soldiers and wars of the present, which took the place of the Trojan War and pictures of the Horatii and Curiatii. Around 1860, the Caffè Michelangelo in Florence became the meeting place for a group of painters and writers who had undergone similar experiences and had the same ideals: out of this came the Macchiaioli, a group of mostly Tuscan artists who formed the first organized movement of Realism in Italy. Its main exponent was Giovanni Fattori, while the activity of the critic and dealer Diego Martelli led to an exchange of influences with other international tendencies.

In Germany the ideals of the Nazarenes were starting to fade. Around 1840 Cornelius and Overbeck produced their last works, of huge size but obsessed with the cele-

bration of a past that could never return. These majestic allegories also brought the great tradition of court art to an end: its place was taken by the Biedermeier style, a term that is applied chiefly to the simple, sturdy and comfortable furniture of the Restoration years, in clear contrast to the fragile and ornate Empire style. The German bourgeoisie no longer identified with Friedrich's uneasy Romanticism or the scenes of soaring architecture painted by Schinkel: it was looking for a comprehensible, concrete and straightforward type of painting, based on reality, that would present an image of German society. The greatest Realist painter in Germany was Adolf von Menzel: his career (from his participation in the uprisings of 1848 to teaching at the academy and from his visits to Paris to his celebration of engineering and technological progress) perfectly mirrors the evolution of the Realist movement.

The case of the "Wanderers" in Russia is different. Perhaps to an even greater extent than in the nations of Western Europe, Realism in Moscow and St. Petersburg was a movement of deep moral commitment. Russian artists felt the need to draw attention to the contradictions, atavistic traditions and difficulties of a vast country where serfs co-existed with an aristocracy that spoke French and looked toward Europe. Realism, in Russia, brought painters, writers and musicians together in a common project and represented an impressive effort to combine local culture with the most up-to-date ideas. Outstanding among the Russian artists of the mid-century was Ilya Repin, whose work left a deep mark on Russian figurative culture. Following his example, Realism was to become the "official" style of proletarian and Communist culture. Notwithstanding the exceptional experience of the Russian avant-garde movements in the early twentieth century, it was Repin's work that provided the model for the social allegories and glorification of the "heroes of labor" in Stalinist art, similar to the kind of images favored by Nazi propaganda.

Jean-François Millet

Gruchy, 1814–Barbizon, 1875

Raised in the country, Millet celebrated the simple and strong morality of rural life in epic, almost mystical tones, contrasting it with the confused and profane immorality of the city. Moving from Brittany to Paris in 1837, he studied the paintings in the Louvre at length, drawing inspiration from them for portraits and mythological pictures. His meeting with Daumier led him to devote himself to themes of social concern and his success was based on the presumed social and political messages of his scenes of peasant life. In 1848 Millet settled permanently in Barbizon, on the edge of the forest of Fontainebleau, in close proximity to the landscape painters of the local school but not directly linked with them. Millet's most characteristic work dates from the fifties: this was the period in which he painted his large and famous pictures of peasants: workers in the fields are glorified by compositions in which they are presented as heroic figures charged with pathos. From 1863 onward, following the example set by Théodore Rousseau, Millet too turned his attention to landscape, while in his later works the themes are imbued with Symbolistic values.

Jean-François Millet
Spring

1868–73
Oil on canvas,
33¾ × 43¾ in.
(86 × 111 cm.)
National Gallery,
Washington

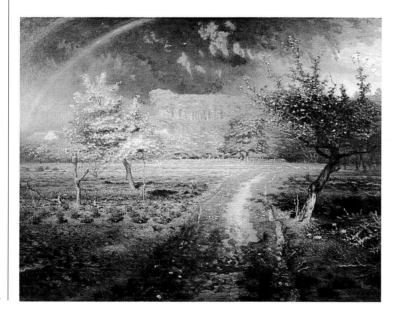

Jean-François Millet
The Angelus

1858–59
Oil on canvas,
33¾ × 43¾ in.
(86 × 111 cm.)
Louvre, Paris

A break from work in the fields for prayer inspired Millet to paint a picture of contemplative suspense. The image, which was to become famous and was often copied or parodied, clearly marks the point of contact between the Realism of the mid-nineteenth century and the subsequent mystical Symbolism of the Nabis. It is interesting to compare it with the similar atmosphere and human setting evoked by Segantini in his *Ave Maria at the Crossing* (p. 219).

Jean-François Millet
The Gleaners

1848
Oil on canvas,
21¼ × 26 in.
(54 × 66 cm.)
Louvre, Paris

The distant horizon and
the peace and quiet of the
fields bestow an aspect
of solemn and romantic
nobility on the poor
gleaners, their backs bent
in labor. Pictures like this
played an important part
in accustoming the public
to themes of social realism.

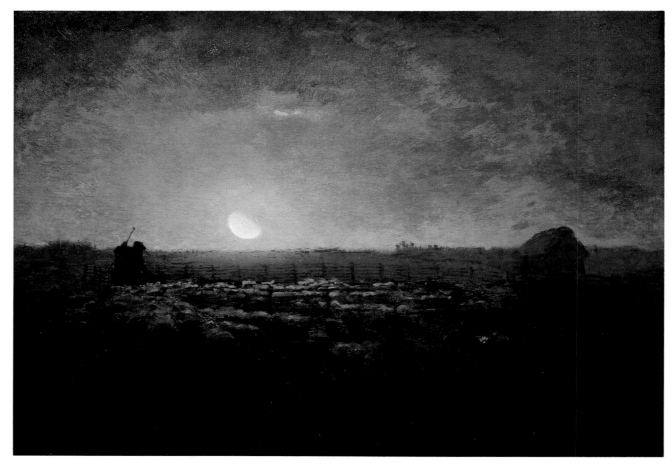

Jean-François Millet
The Sheep Pen. Moonlight

1861
Oil on panel,
15½ × 22½ in.
(39.5 × 57 cm.)
Musée d'Orsay, Paris

Millet's landscapes reveal
an ecstatic, contemplative
attitude toward nature,
clearly derived from
Romanticism. The
moonlight in this picture
and the rainbow in the one
on p. 76 are particularly
touching effects that
were a constant source
of inspiration for
nineteenth-century
painters and poets, up
until the rebellion of the
Futurists, who set out to
"destroy" moonlight.

Honoré Daumier

Marseilles, 1808–Valmondois, 1879

A versatile and ingenious artist, Daumier alternated his work as a painter with that of a satirical cartoonist and even a sculptor. In the early part of his career he faced serious economic difficulties and legal problems over his lampoons of King Louis-Philippe published in *La Caricature*, a weekly that was closed down by the censors in 1834. Up until 1860 Daumier devoted himself almost exclusively to charcoal drawing and lithography: he developed a sensitive mastery of light and shade and eventually decided to try its effect in oil painting. The result was excellent and totally original: renouncing his customary sarcasm, which found brilliant expression in his lithographs for the magazine *Charivari*, Daumier painted the trials and tribulations of the poor, exploring the world of third-class railroad cars, washerwomen and apprentices. Once again faced with financial problems, he was forced to give up painting and go back to producing lithographs for illustrated magazines. In 1866 his friend Corot gave him a small house in the country and Daumier went to live there. His last works include a series of interpretations of the story of *Don Quixote*.

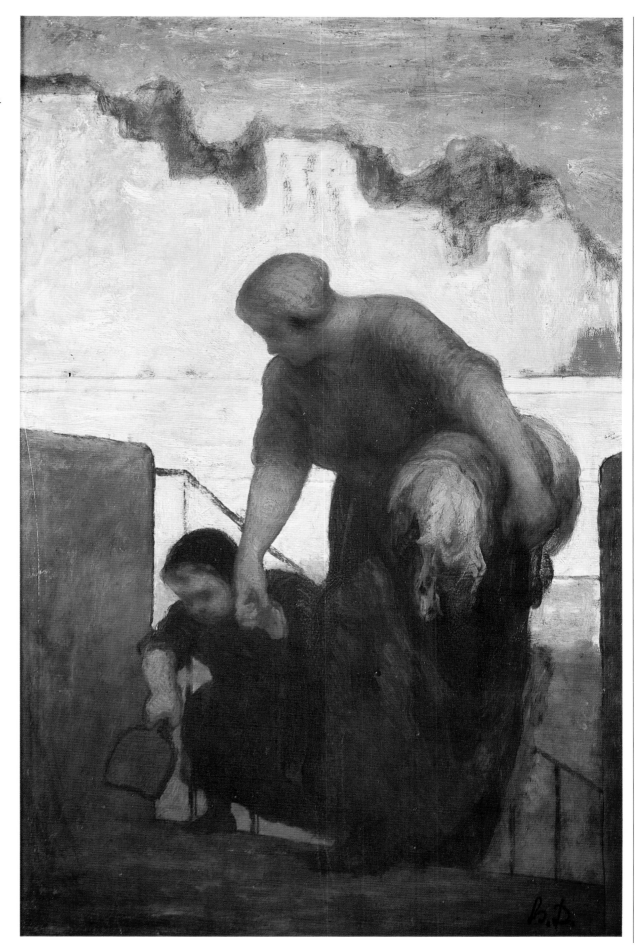

Honoré Daumier
The Laundress

1863
Oil on panel,
19¼ × 13 in.
(49 × 33 cm.)
Musée d'Orsay, Paris

Daumier did not paint many pictures. Little inclined to let himself be seduced by vivid color and bright light, Daumier transferred the expressive characteristics and techniques of engraving into painting. A sharp contrast between the illuminated and shaded parts of the picture renders the figures monumental, isolating them in the toil of their daily life.

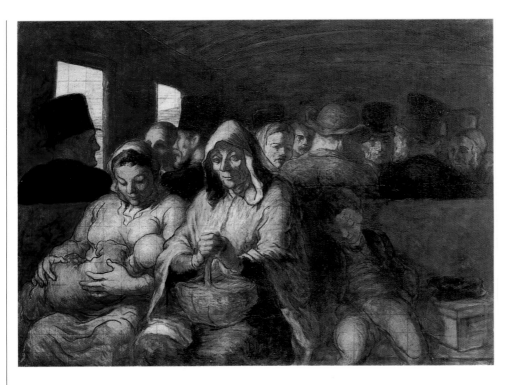

Honoré Daumier
The Third-Class Carriage

1862
Oil on canvas,
25½ × 35½ in.
(65 × 90 cm.)
The Metropolitan
Museum of Art, New
York. H.O. Havemeyer
Collection, Bequest
of Mrs. H.O. Havemeyer,
1929

Daumier's realism, which achieved effects of particular intensity thanks to his penetrating ability to sketch the features and outlines of his figures, tended toward a denunciation of social injustice, challenging both the censors and the traditionalist taste of the Parisian public and critics.
In the overcrowded third-class compartment, dimly illuminated by light from the windows, we can feel the weight of the fatigue and resignation caused by the hardships of daily life. There is nothing mystical or artificially pathetic in the picture: just an exhausting reality that is presented without allegories or allusions.

Honoré Daumier
The Chess Players

c. 1863
Oil on panel,
9¾ × 12¾ in.
(24.5 × 32.5 cm.)
Musée d'Orsay, Paris

In this painting it is possible to recognize a reflection of Daumier's activity as a draftsman: not just in the rapid and mordant characterization of the figures, but also in the witty resemblance between the two players and the chess pieces. The man in the shade is contrasted with his brightly-lit opponent, as if they were themselves "black" and "white." The figurative results achieved in pictures like this are extremely important, as they were an indispensable precedent to Cézanne's *Card Players* (p. 190).

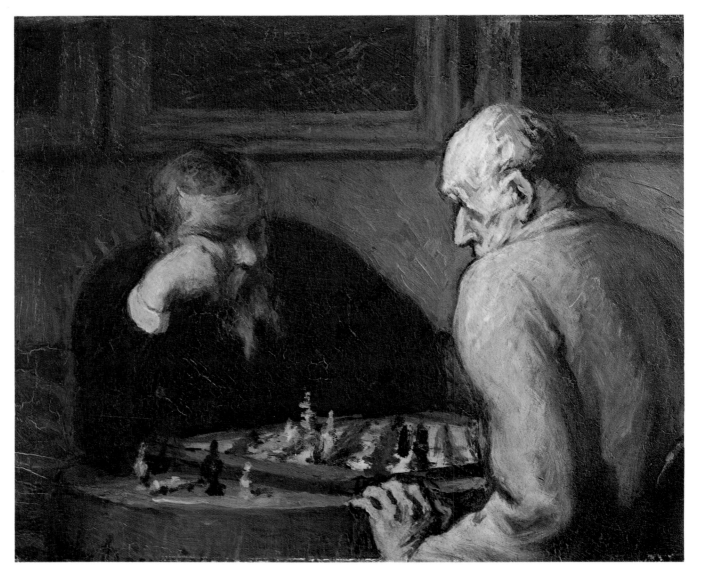

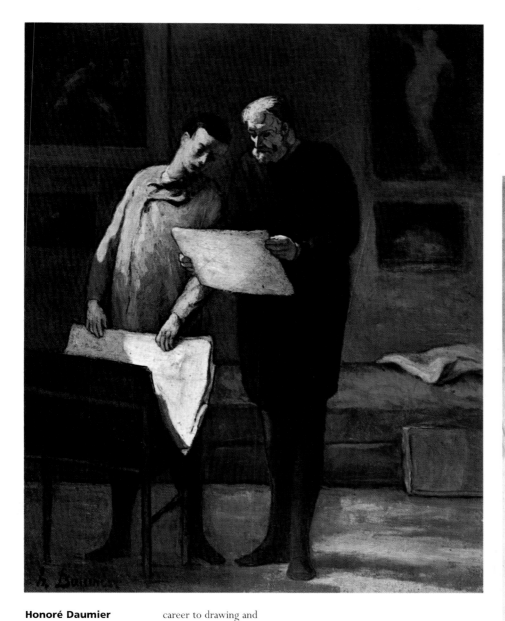

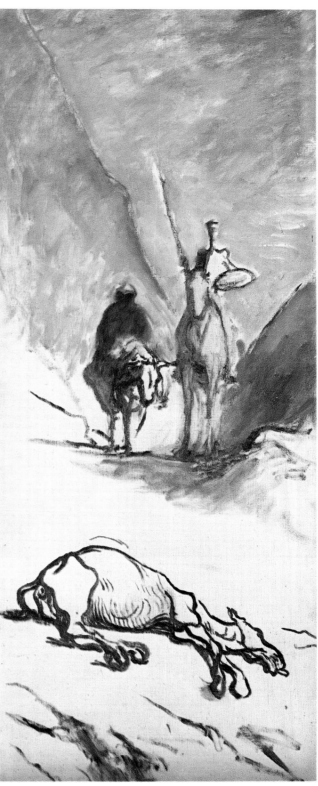

Honoré Daumier
*Don Quixote and
the Dead Mule*

1867
Oil on canvas,
9¾ × 12¾ in.
(24.5 × 32.5 cm.)
Louvre, Paris

The tragicomic
adventures of Don
Quixote were a constant
source of inspiration
for Daumier's late
paintings, extremely
dry and reduced to little
more than calligraphic
line.

Honoré Daumier
Advice to a Young Artist

1855–60
Oil on canvas,
16¼ × 13 in
(41 × 33 cm.)
National Gallery,
Washington

This painting is a sort
of self-tribute that
Daumier dedicated
to his work as a teacher
and his encouragement
of young painters, which
he carried out alongside
his favorite activity
of engraving. It should be
stressed once again, in fact,
that the artist, who
devoted almost the whole
of his somewhat troubled

career to drawing and
engraving, did not start
painting until late in life.
Here Daumier seems
to identify himself with
the no longer youthful
teacher who is carefully
examining his pupil's
work. The absorption,
solitude and atmosphere
of genuine delight in art
are evoked by an essential
style, in which the
influence of Rembrandt
is evident. And even this
reference to a very great
painter and engraver was
an expression, at bottom,
of his desire to find a way
to combine the arts of
painting and the print:
Daumier was preparing the
way for Toulouse-Lautrec.

Gustave Courbet
The Artist's Studio

1854–55
Oil on canvas,
141¼ × 235½ in.
(359 × 598 cm.)
Musée d'Orsay, Paris

Here the self-portrait
is transformed into
the manifesto of a new
perception of the role
of art and the artist in
society. Courbet is seated
at the easel and painting
a landscape. He is
surrounded by a nude
model, a white cat and
a child, all clearly
recognizable symbols
of purity and naiveté. Just
as in a grand Renaissance
composition, two
symmetrical groups
of figures are arranged
around the center
of the canvas (which is
also the most luminous
and brightly colored
point): on the right we
see the artist's relatives,
friends and collaborators;
on the left, people taken
from everyday life, an
expression of the eternal
conflict between winners
and losers, rich and poor.
The artist places himself
in the middle, as the
interpreter and mediator
of this reality: the painting
is charged with ideological
significance.

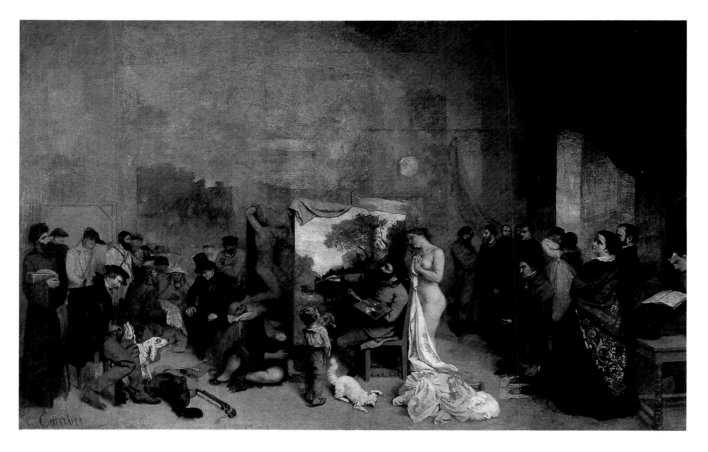

Gustave Courbet

Ornans, 1819–Vevey, 1877

A central figure in the history
of nineteenth-century painting, Courbet
marks the end of lyrical and literary
Romanticism and the start of a direct,
forceful and in some ways scandalous
interpretation of reality. An irregular and
unmethodical training led Courbet, who
moved to Paris in 1840, to spend more
time in the Louvre than at the studio of
some more or less talented artist. Courbet
keenly studied the great painters of the
past, concentrating chiefly on Rembrandt
and even making a trip to the Netherlands
to see more of his work at first hand.
After showing a few already very
interesting pictures at the Salons of 1844
and 1846, Courbet played a leading role
in the uprisings of 1848: it was at this time
that he began to paint scenes of huge size
with groups of life-sized figures, like the
Burial at Ornans. Courbet realized that he
had opened up a new direction: that of
Realism. And so, in polemical opposition

to official culture, he organized
one-man shows in which his gigantic
and dark pictures, free from any
indulgence in mysticism or
sentimentality, depicted everyday life
in energetic fashion.
In 1855 Courbet summed up the themes
and figures of his art in a vast composition,
The Artist's Studio. Shortly afterward he
painted *Young Women on the Banks of the
Seine*, a picture that scandalized the
bourgeois public. Courbet's life went
through another upheaval in 1871, when
the fifty-year-old painter took part in the
insurrection that established the Paris
Commune. Arrested after its fall, he was
sentenced to six months in prison. He was
tried again in 1874 and a heavy fine
imposed on him for his presumed role in
the destruction of the Vendôme Column:
he was forced to flee to Switzerland
and his works were sold at auction.
And so the life of an "accursed,"
non-rhetorical and powerful painter
came to an end, on a personal note
that likened his fate to that of his
beloved Rembrandt.

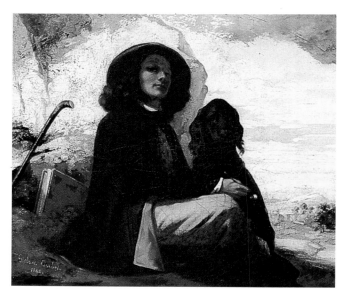

Gustave Courbet
Courbet with a Black Dog

1844
Oil on canvas, 18 × 22 in.
(46 × 56 cm.)
Musée du Petit Palais, Paris

The cocky attitude is
reminiscent of the early
self-portraits of
Rembrandt, the artist of
the past to whom Courbet
felt closest. The presence
of a dog is characteristic.

Gustave Courbet
Burial at Ornans

1849
Oil on canvas,
124 × 263 in.
(315 × 668 cm.)
Musée d'Orsay, Paris

Another canvas of
enormous size and another
decided statement.
With an indomitable spirit
of concreteness, expressed
through the life-size figures
and dark and earthy
colors, Courbet
orchestrates a parade
of peasants dressed in
black, minor notables,
stunned relatives, priests
and altar boys, while the
mystery of death hovers
over the narrow horizons
of a provincial graveyard.

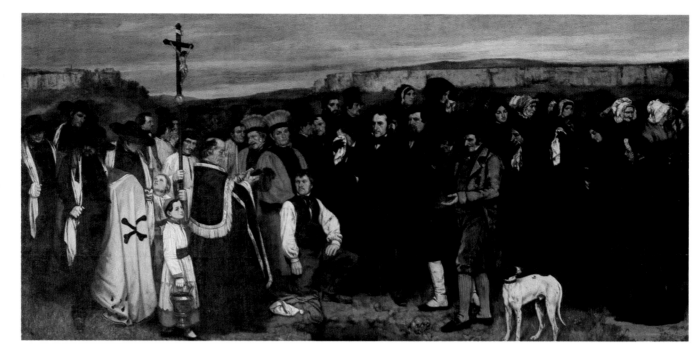

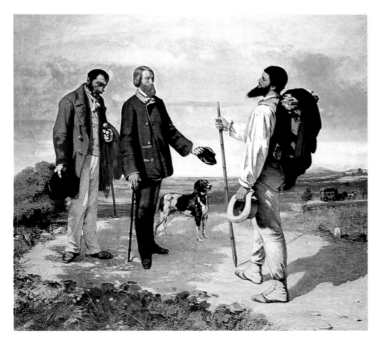

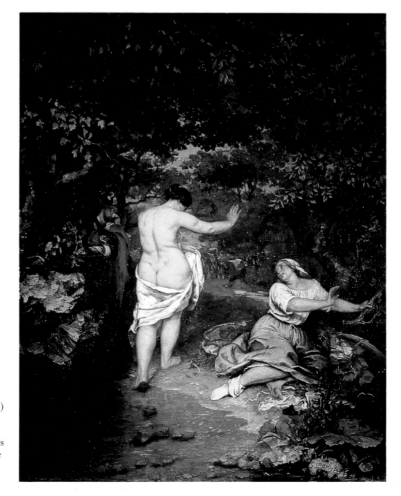

Gustave Courbet
The Meeting (Bonjour, Monsieur Courbet)

1854, Oil on canvas,
50¾ × 58¾ in.
(129 × 149 cm.)
Musée Fabre, Montpellier

Through this painting,
depicting an early-morning
meeting with the collector
Alfred Bruyas, Courbet
puts across a free-and-easy
image of the artist.
Refusing to shut himself up
in his studio, Courbet goes
in search of inspiration in
the open air, with his
painting equipment on his
back.

Gustave Courbet
The Bathers

1853, Oil on canvas,
89¼ × 76 in. (227 × 193 cm.)
Musée Fabre, Montpellier

Somewhere between Ingres
and Cézanne, here Gustave
Courbet depicts a majestic
and hefty nude.

Gustave Courbet
The Picnic

c. 1858
Oil on canvas,
81½ × 128 in.
(207 × 325 cm.)
Wallraf-Richartz Museum,
Cologne

The picture dates from
the end of the most intense
period of Courbet's career,
when his desire to tackle
explicitly "engaged" or
contentious subjects began
to fade and he started
to take on more bourgeois
themes. Here we see
a break for food during
a deer hunt: so we are
already within the realm of
sport and amusement that
was to become so popular
in Impressionist circles.

Gustave Courbet
The Stonebreakers

1849
Oil on canvas,
62½ × 102 in.
(159 × 259 cm.)
Formerly in the
Gemäldegalerie, Dresden

Unfortunately, this
extraordinary painting, one
of the earliest masterpieces
of social realism and an
open challenge to Millet's
romantic mysticism, was
destroyed during the
Second World War.

Gustave Courbet
The Wave

1869
Oil on canvas,
25½ × 34¾ in.
(65 × 88 cm.)
Brooklyn Museum,
New York

The remarkable pictures devoted to waves and stormy seas in the final phase of his career show us a surprising Courbet: the historic champion of Realism seems to be approaching abstraction.

Gustave Courbet
Small Seascape

1872
Oil on canvas,
12½ × 16¼ in.
(32 × 41 cm.)
Private collection

The stormy atmosphere, predominantly dark colors and solitude of the painter's seascapes accurately reflect his feelings after the events of 1871.

Gustave Courbet
Neuchâtel Lake

c. 1875
Oil on canvas,
19¾ × 23½ in.
(50 × 60 cm.)
Szépmüvészeti Múzeum,
Budapest

The picture was painted
toward the end of
Courbet's life and career,
when the artist, in grave
difficulties with French
justice because of his
participation in the
uprisings of the Commune
of Paris in 1871, was
forced to go into exile
in Switzerland.

Gustave Courbet
Woman with Parrot

1866
Oil on canvas,
51 × 77 in.
(129 × 195 cm.)
The Metropolitan
Museum of Art,
New York.

H.O. Havemeyer Collection,
Bequest of Mrs. H.O.
Havemeyer, 1929

The model, a young
Irishwoman with wild
red hair, appears in other
paintings by Courbet,
often of an erotic
character. For the

"right-thinking" public
of Paris, this foreign girl
represented the
quintessence of scandal.

Gustave Courbet
The Trout

1871
Oil on canvas,
21¾ × 35 in.
(55 × 89 cm.)
Kunsthaus, Zurich

The canvas, brutal in
its effect, is Courbet's
last "self-portrait,"

which he signed with
an explanatory phrase
in Latin: *Courbet in vinculis
faciebat*, "Courbet in chains
made it." Imprisoned and
then forced into exile, the
painter identifies with the
agony of a fish caught on
the hook, with no chance
of escape. The realism with
which the trout is depicted
is exceptional.

Ford Madox Brown

Calais, 1821–London, 1893

Though he trained and worked in England, Brown made long journeys on the Continent, studying the art of the past and entering into contact with the liveliest circles and movements in art. One of his most interesting encounters was with Overbeck's group of Nazarenes in Rome, who urged him to go back to the models of the fifteenth century. In this sense, Brown supplied the formal ideas that led to the formation of the Pre-Raphaelites, though he was never actually a member of Dante Gabriel Rossetti's Brotherhood. Brown's painting is composed of figures and setting that are clearly delineated by refined draftsmanship and illuminated by a precise and diffuse light. The spacious and well laid-out compositions hark back to the paintings of the Renaissance, including the much-admired Botticelli, from whom Brown also took the form of the tondo. His most important works were painted around 1850, when the artist was equally happy to tackle scenes drawn from ancient history and episodes of acute social relevance, playing an extremely prominent role in British intellectual debate.

Ford Madox Brown
The Last of England

1855
Oil on panel,
32¼ × 29½ in.
(82 × 75 cm.)
City Art Gallery,
Birmingham

The melancholy and tender image of two emigrants illustrates an unfamiliar aspect of industrial and working-class society in Imperial and Victorian Britain.

Adolf von Menzel

Wroclaw, 1815–Berlin, 1905

An artist of great significance in the German painting of the mid-nineteenth century, Menzel is the perfect representative of Biedermeier culture, of that bourgeois taste for a solid, concrete and agreeable realism that was reflected in the literature and applied arts of the time. The son of a lithographer, Menzel was a self-taught genius. Working initially as an illustrator, he started to paint around the age of thirty, adopting the serene manner of the Berlin school of Realism. After the critical phase of the revolutionary upheavals of 1848, Menzel embarked on an official career that culminated in his appointment as professor of painting at the Berlin Academy. During the fifties his work acquired greater breadth and complexity, as he moved away from bourgeois interiors to paint vast compositions set in the open air.
In 1867 he went to Paris, where he came into contact with the Impressionists, lightening his palette and painting the scenes of Parisian life that were beginning to meet with great success on the international market. Returning to Germany, Menzel spent the final part of his career as a painter investigating the world of work and industry, producing pictures of factories and steel mills with his customary sense of realism.

Adolf von Menzel
Religious Service at the Mission in the Buchenhalle near Kösen

1868
Oil on canvas,
28 × 22¾ in.
(71 × 58 cm.)
Szépmüvészeti Múzeum,
Budapest

Menzel's dignified realism found precise echoes in the bourgeois tastes of Prussian culture in the second half of the nineteenth century, in close parallel with the novels of Theodor Fontane.

Adolf von Menzel
Room with a Balcony

1845
Oil on canvas,
22¾ × 18½ in.
(58 × 47 cm.)
Nationalgalerie, Berlin

An interesting early work, painted with a wonderful freshness and freedom. Menzel sets out to show his dissatisfaction with the interpretation of the past offered by the Nazarenes and other Romantic movements. He paints an interior in the Biedermeier style with simplicity and warmth, creating effective plays of light and reflections.

Ilya Repin
Čugujev, 1844–Kuokkala, 1930

Repin is the most interesting and representative of the Russian painters of the nineteenth century. The meaty and vital realism of his pictures may appear in line with movements in Central and Southern Europe, but at home his work was initially seen as subversive, or at any rate very bold. In fact it is necessary to consider the vast gap in culture and technique that separated the paintings of Repin and the other nineteenth-century "Wanderers" (*Peredvizhniki* in Russian) from a tradition that still harked back to Byzantine art. Dissatisfied with the teaching in the academies, and above all irritated with the insistence on non-Russian themes, Repin gathered a group of artists around himself and became the leading figure in a cooperative on the Abramtsevo estate that later came to be known as the Society of Wandering Exhibitions. This group, flanked by writers like Tolstoy and composers like Mussorgsky, found a generous patron in Pavel Tretyakov, who organized many exhibitions and eventually created a museum in Moscow dedicated to Russian art. In reality, Repin only occasionally took part in meetings of the "Wanderers."

He made important journeys to Italy and France, especially during the crucial 1870s, and always kept in close touch with developments in European painting. For his subjects Repin chose scenes from Russian history, social themes and figures and activities drawn from modern life: it should be remembered that the tsar had only freed the serfs in 1861. Appointed professor at the St. Petersburg Academy, Repin had a decisive influence on the shift in Russian painting toward a popular and straightforward realism. After the avant-garde phase in the second decade of the twentieth century, his style was adopted as an "academic" model for official and propaganda painting, which was quite the contrary of Repin's intentions.

Ilya Repin
They Did Not Expect Him

1884
Oil on canvas
Tretyakov Gallery, Moscow

Repin's bourgeois paintings closely resemble the settings and characters described in the Russian literature and drama of the late nineteenth century.

On the facing page
Ilya Repin
Boatmen at the Ford

1872
Oil on canvas,
24½ × 38¼ in.
(62 × 97 cm.)
Tretyakov Gallery, Moscow

This type of painting, in which the heaviness of the figures' labor seems almost to distort their features but not to affect their inner dignity, provided a precise point of reference for the development of Socialist Realism. This was true not only in Russia but also, in varying forms, in a number of twentieth-century schools of painting in other countries that were also characterized by socialist or Communist ideals, up to the Mexican mural painters and the movements that followed the Second World War.

Ilya Repin
Rest

1882
Oil on canvas,
55 × 36 in.
(140 × 91.5 cm.)
Tretyakov Gallery, Moscow

Repin's great refinement found complete expression in the "bourgeois" paintings he produced in addition to his scenes of popular realism.

Giovanni Fattori

Livorno, 1825–Florence, 1908

A painter of great force but also deep feelings, and an excellent engraver, Fattori was one of the most important Italian artists of the nineteenth century. He spent the whole of his life in Tuscany but, through his contacts with the art dealer and critic Diego Martelli, was able to keep constantly abreast of developments elsewhere. As a result the research of the Macchiaioli (the group of which he was the most ardent and enduring spirit) was consciously carried out in parallel with that of the Impressionists and European Realism in general. After training first in Livorno, he moved to Florence to study at the academy there. His early paintings include huge pictures of historical subjects and his first portraits, a genre that he practiced throughout his life to great effect. His meeting with Signorini, Lega, and many other artists at the Caffè Michelangelo led Fattori to put aside the traditional chiaroscuro of Romanticism and go in for a more immediate style, based on a dynamic and realistic relationship between light and color: the *macchia* ("stain" or "blob"). Around 1860 Fattori applied this new technique to paintings of contemporary battles, represented with a profound and non-rhetorical sense of participation. These were followed by numerous scenes devoted to work in the fields, in which his love for the Maremma region and the bare coast around Livorno were combined with a human and social empathy for the toil of the peasants. Fattori's realism also found expression through his choice of colors imbued with light and a draftsmanship that inherits the tradition of Tuscan art. His inclination for painting in the open air and the great luminosity of his pictures may in part recall the parallel work of the Impressionists in Paris, but the robust brushwork, with synthetic "blobs" of color, is wholly original. After the seventies, when the Macchiaioli group began to break up, Fattori devoted himself chiefly to portraits and engravings.

Giovanni Fattori
On the Lookout

1872
Oil on panel,
14½ × 22 in.
(37 × 56 cm.)
Private collection, Rome

Fattori was an excellent painter of battle scenes. However, his personal experience as a soldier, involved in important phases of the Italian Risorgimento, led him to abandon any bombastic or bellicose attitude. His preferred subjects were soldiers on patrol or lookout in the dazzling sunlight of summer days in the countryside.

Impressionists

Pierre-Auguste Renoir
La Grenouillère (detail)
1869
Oil on canvas,
23¼ × 31½ in.
(59 × 80 cm.)
Pushkin Museum, Moscow

Claude Monet
Déjeuner sur l'Herbe
(The Picnic)
1865–66
Oil on canvas,
164½ × 59 in.
(418 × 150 cm.)
Musée d'Orsay, Paris

In 1874 the photographer Félix Nadar, one of the pioneers of the technical reproduction of images, allowed his studio in Paris to be used for an exhibition organized by Degas. It is a date that has gone down in history, marking the first joint show staged by a group of painters bound by ties of friendship and collaboration and sharing many ideals: Edouard Manet, Claude Monet, Pierre-Auguste Renoir, Alfred Sisley, Camille Pissarro and Paul Cézanne. The group did not yet have a name, in part because the artists had never felt themselves to be a "movement" in the proper sense of the word, with a theory to which all the members subscribed. Yet they were aware of the revolution that their paintings represented in the history of art. And so, almost as a joke, they accepted the label pinned on them by a disapproving critic: "Impressionists." The name derives from the title of one of Monet's pictures (*Impression. Soleil Levant*) and forcefully expresses a sense of spontaneity and participation in life.

In the same years in which French literature was gathering the fruits of Romanticism and Realism, producing unforgettable portraits of characters who played out the drama of their sentiments against the alternating backdrop of Paris and the countryside, the painters in Monet's group took delight in conveying emotions in their pictures through light and color, without the filters imposed by academicism and without any sense of subjection to an illustrious past. The term "Impressionists" reveals all of its perhaps involuntary force in its fundamental significance of catching the "impressions" that daily life offers to our hearts and senses. In addition, it has the advantage of underlining the important relationship with photography, in which the plate is "impressed" by light to produce an image.

Yet it should be remembered that the exhibition in 1874, far from marking the birth of Impressionism, came a fairly long time after the origin of the movement, which dated from around ten years earlier. At the beginning of the sixties the major artists in the group were young painters full of ideas who felt suffocated by an artistic training that was unexceptionable from the formal viewpoint but monotonous, pedantic and repetitive, dependent on the authority of the past. Meeting in the lecture rooms of the academy, Monet, Renoir, Sisley and Pissarro exchanged opinions and feelings, alternating visits to see the mas-

Edouard Manet
On the Beach
1873
Oil on canvas, 22 × 14 in.
(56 × 35.5 cm.)
Musée d'Orsay, Paris

Pierre-Auguste Renoir
Madame Monet with Her
Son in the Garden, 1874
Oil on canvas, 19¾ × 26¾ in.
(50.4 × 68 cm.)
National Gallery, Washington

Edgar Degas
At the Milliner's
c. 1883
Pastel on canvas,
31½ × 33½ in.
(79.9 × 84.8 cm.)
Thyssen-Bornemisza
Collection, Madrid

terpieces in the Louvre with observations on the expressive art of Courbet, the sensitive and probing work of Daumier and the refined landscapes of Corot and the other painters from the Barbizon School. They sought the opportunity—literally—to "come out into the open," laying claim to the right and pleasure of painting *en plein air*, in the open air, and abandoning the traditional mythological subjects and genre scenes to devote themselves to the scintillating reality of a Paris undergoing rapid change.

At the Salon of 1863 Edouard Manet, the most cultivated and "classical" of the future Impressionists, exhibited the *Déjeuner sur l'Herbe* (*Luncheon on the Grass*), one of his greatest masterpieces: openly inspired by one of Titian's compositions, Manet painted an agreeable picnic in a Parisian park, a group of young people relaxing on a Sunday. The homage to Renaissance art is couched in the most lofty and intelligent terms: not as imitation, but as a return to the spirit of freedom and truth in art.

With these premises, fortified by long meetings at the Café Guerbois, and supported by intellectuals and writers of the rank of Emile Zola, painters like Monet, Renoir and Sisley commenced their respective careers by devoting themselves first of all to the landscape, painted straight off *en plein air*, and not reworked in the studio. The excellent technical training they had received in their youth allowed the artists to make bold experiments, for instance in the representation of sunlight sparkling on water. They often worked together, sometimes even setting their easels side by side to compare their reactions to the same scene. Thanks to their feeling for light and the freshness of their compositions, the early landscapes of Monet, Renoir and Sisley represented a

Claude Monet
*Hôtel des Roches Noires
à Trouville*
1870
Oil on canvas,
32 × 23 in.
(81 × 58.5 cm.)
Musée d'Orsay, Paris

Federico Zandomeneghi
Along the Seine
1873
Galleria d'Arte Moderna,
Florence

Edouard Manet
The Lady of the Fans
1873
Oil on canvas,
44¾ × 65½ in.
(113.5 × 166.5 cm.)
Musée d'Orsay, Paris

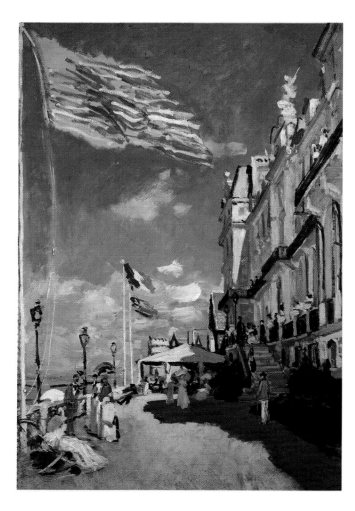

leap forward with respect to the precedent set by the Barbizon School, important though this was (an effective realism but one that was still based on late Romantic, contemplative schemes), opening the way for a new model of the relationship between the painter and nature. Very soon, moreover, they started to enrich their landscapes with figures, bringing them to life: this was the beginning of perhaps the most attractive current in Impressionist painting, reflecting the daily life of the Parisian bourgeoisie, the little pleasures of trips to the countryside, and the city's crowded streets.

Around 1865 a fundamental principle was established: the choice of subject should not be binding on the artist, but leave him free to convey his own "impressions" of any theme. This concept, for the moment still expressed in embryonic form, can be considered the foundation of modern painting. It was taken up and developed by all the avant-garde movements of the late nineteenth and early twentieth century. From the technical viewpoint, the parallel with developments in photography is interesting. The image is "impressed" on the photographic plate by light, which conditions and characterizes the end result. The Impressionist painters, influenced in part by recent scientific theories on the diffusion of light and the nature of vision, allowed light to act directly on the color, flooding their pictures with a luminosity that had never previously been seen: elimination of shades of gray, combination of complementary tints, and the frequent use of colored shadows were the principal innovations.

Today we find the canvases of the Impressionists delightful, to such an extent that they represent perhaps the most loved and best-known chapter in the entire history of art. But this popularity (which has had sensational repercussions on the number of visitors to exhibitions and the art market) contrasts with the far from favorable reactions of critics and gallery owners at the time. For many years the future Impressionists had to face decided hostility on the part of Parisian intellectual circles, with a few exceptions, and found it hard to sell their pictures. One great opportunity for the affirmation of the group was the Salon of 1868, where significant works were proposed, but the reaction of the critics was still one of fierce disapproval.

In spite of the difficulties, the group carried on with its search for a new kind of painting, ever fresher and more

Claude Monet
Rouen Cathedral at Sunset
1894
Oil on canvas,
39¼ x 25½ in.
(100 × 65 cm.)
Pushkin Museum, Moscow

luminous. It is interesting to note the dense web of interpersonal relationships that linked the Impressionists in mutual ties of sincere friendship, while their styles grew increasingly diverse and distinctive. It is a very serious mistake, or at least an error of superficiality, to regard Impressionism as a style of painting rather than as the sum of personalities that were at times very different. For example, it is evident that Monet's investigation of color was of little interest to Degas, who concentrated instead on drawing and composition. Likewise, Manet's roots in "Humanism" (the fruit of his long study of Renaissance painting and Goya) are different from Sisley's approach, influenced by English landscape painting. Again, their penetrating grasp of psychology induced the two women painters Mary Cassatt and Berthe Morisot to create pictures of gentle intimacy, wholly unlike the expansively public scenes of Renoir. For a few years, however, the solidarity of the group was able to withstand malevolent criticism, lack of success on the market and even the Franco-Prussian War of 1870, when one of its leading spirits, the painter Bazille, was tragically killed at the age of only twenty-nine.

At the beginning of the seventies, however, Impressionist works started to make their way into Parisian collections. The exhibition in Nadar's studio and the subsequent ones at Durand-Ruel's gallery (1876 and 1877) finally led to the movement's acceptance. This was confirmed by the series of shows held over the next few years and by a market that within a short time expanded to international proportions. The group was now fashionable and attracted new adherents, including contributions from painters outside France.

This success was achieved, however, at the very time when the movement was beginning to show the first signs of crisis, under the powerful influence of Cézanne and with Gauguin's flight into exotic mysticism, soon to be followed by the desperate energy of van Gogh. French painting was coming to another crossroads. Around 1880 a profound rethinking of the development of Impressionist painting started to take place.

The response to this from the artists who had been involved in Impressionism from the early years was not uniform. The different personalities, entering a more mature and thoughtful phase, began to diverge, going in new directions. The year 1880 should be seen (in hind-

Edgar Degas
Ballerina in Green
1877–79
Oil on canvas,
26 × 14¼ in.
(66 × 36 cm.)
Thyssen-Bornemisza
Collection, Madrid

only one of the "historic" exponents of Impressionism to really keep faith with its tenets, apart from the always consistent Pissarro, was Monet, one of whose paintings had given the movement its name. In fact Monet never stopped investigating the effects of light and color, insisting on the analysis of particular subjects (rocks, haystacks, the façade of Rouen Cathedral) at different times of day and under different atmospheric conditions. Following this road, which had become a solitary one, Monet withdrew from the Parisian scene and, in the silence of his flower-filled garden at Giverny, with its lily pond, took Impressionism to its extreme, unpredictable consequence: abstraction.

In partial compensation for the change of course in the Impressionist school after 1880, the circle of painters involved had expanded to a size that would have been unthinkable just a few years earlier, crossing national boundaries. The success of the exhibitions staged by Durand-Ruel, from 1876 onward, had created a great deal of interest among the public, collectors and other artists. Painters of various nationalities, from the United States to Russia, converged on Paris. One of the most interesting of these was the American Mary Cassatt, an artist of refined sensibility capable of taking an independent and lyrical approach to Impressionism. The daughter of a wealthy banker, Cassatt played an important role in spreading knowledge of the Impressionists in the United States through her father's friends, with effects that are still clearly recognizable today, not only in the continuity of the interest shown by collectors, but also in the presence of important masterpieces in North American museums. In this connection, the richest collection in the world is undoubtedly that of the Musée d'Orsay in Paris: inherited from the former Jeu de Paume museum, it is housed in a former station near the Seine in a groundbreaking design by the architect Gae Aulenti. Immediately after it, however, come the museums in Washington, New York, Chicago and other American cities. The fantastic collections assembled by the Russian businessmen Ivan Morozov and Sergei Shchukin are now divided between museums in Moscow and St. Petersburg. Within the space of a few years the demand for Impressionist pictures on the art market reached extraordinary proportions, while the creative energy of the idea behind them spread worldwide, supported by a popularity with

sight) as a truly radical turning point in French art: the light and agreeable charm of Impressionism rapidly gave way to harsher images, like those of van Gogh, to the bitter and yet lyrical irony of Toulouse-Lautrec, to the visions of Gauguin, to the emergence of the Nabis group led by Emile Bernard, and to the first examples of Symbolism. Above all, it was the high and poetic rigor of Cézanne that pushed the Impressionists to set aside their fascination with color and move toward a new form of painting, in which light and geometry, sensation and analysis gave rise to a different kind of art. Perhaps the

the public that has never been surpassed. In any case, even as the group began to break up, the activity and notoriety of the Impressionists represented yet another summons to Paris for artists, collectors, art critics and dealers from all over the world. There can be no doubt that it was in part due to the Impressionists that between 1870 and the First World War Paris became the world capital of art, assuming the role that Rome had had long ago. A journey to Paris became indispensable for any artist who wanted to compare his or her own style with that of the most advanced tendencies, and there was no great artist between the end of the nineteenth century and the beginning of the twentieth century who did not pay at least one visit to the French capital. For some, indeed, it became a permanent home.

In this connection, it is worth taking a careful look at a number of figures who provided a link between different countries, such as the critic Diego Martelli who served as an intermediary between Parisian circles and the group of Tuscan Macchiaioli. On the other hand, it also has to be remembered that Impressionism became a "vogue" after 1880. Reduced to an attractive but facile manner and supported by a market that tended toward the banal, "second-generation"—or secondhand—Impressionism certainly did not have the poetry and authenticity of the early days. It became an expression of a self-satisfied and superficial society, devoid of tension. It was for this very reason that the popular and much-imitated movement became the target for movements of profound renewal and antithetical artistic proposals.

Gustave Caillebotte
The Floor-Scrapers
1875
Oil on canvas,
40¼ × 57¾ in.
(102 × 146.5 cm.)
Musée d'Orsay, Paris

Edouard Manet

Paris, 1832–1883

Raised in the traditional environment of a well-to-do bourgeois family, given a classical education and groomed for a career in the navy, Manet obtained permission to devote himself to painting only on the condition that he pursue a regular course of academic studies. Thus he received an excessively restrictive formal training, within which he began to develop an at once rigorous and independent style of his own. In the fifties he made a thorough study of the masterpieces in the Louvre as well as repeated journeys to Italy, Flanders, the Netherlands and Germany to see the paintings of the great artists of the past firsthand. Manet's profound artistic culture was based on a few fundamental sources of inspiration: Titian, Rembrandt and, after an important visit to Spain, Goya and Velázquez. His contacts with Baudelaire and, more generally, the circles of literary Realism (Zola, Mallarmé) led him, from 1858 onward, to tackle subjects drawn from everyday life. The success of his picture *The Spanish Singer* (The Metropolitan Museum of Art, New York), exhibited at the Salon of 1861, was followed by the scandalized reaction of the right-minded public and critics to paintings that they considered provocative and outrageous. The biggest fuss erupted over two large and fundamental canvases painted in 1863 (*Le Déjeuner sur l'Herbe* and *Olympia*, both now in the Musée d'Orsay, Paris), dominated by imposing female nudes and rendered even more "modern" by the fact that they were openly based on themes and compositions by Titian and Giorgione.

This was one of the first "scandals" caused by an artist who was later be regarded as one of the Impressionists. The strong outline that detaches the figures from the ground, the use of black, and the expressive force of the figures would all be reinforced by Manet's journey to Spain: his full-length portraits are out-and-out tributes to Velázquez, while the Spanish tradition inspired pictures of unexpected violence, such as the series devoted to bullfighting or the *Execution of Emperor Maximilian* of Mexico.

During the seventies Manet had frequent contacts with the group of Impressionists. His palette grew lighter and he started to tackle subjects similar to those of other painters (Sunday trips along the banks of the Seine, scenes of cafés-chantants, waitresses in bars), but his style remained highly personal, drawing on a large range of cultural references. For Manet the confrontation with the tradition of painting and the human figure (he was also a penetrating portraitist) always took precedence and his attention remained centered on form and composition.

Edouard Manet
Boy with Sword

1861, Oil on canvas, 51½ × 36¾ in. (131.1 × 93.3 cm.) The Metropolitan Museum of Art, New York. Gift of Erwin Davis, 1889

The Salon of 1861 brought Manet his first public success: with a refined feeling for classical painting, the painter presented a series of portraits of standing figures, mostly in Spanish costumes, directly inspired by Velázquez. The artist's greatness lay in his ability never to turn his back on the lesson of the past, while bringing it to life by a sense of realism and burning immediacy.

Edouard Manet
The Dead Toreador

1865
Oil on canvas,
30 × 60¼ in.
(75.9 × 153.3 cm.)
National Gallery,
Washington

Wholly self-sufficient
in its crude realism, the
painting is actually only a
fragment: the upper part,
representing the bullfight,
is now in the Frick
Collection in New York.
It was Manet himself
who, dissatisfied with
the composition, split
the picture in two.

Edouard Manet
Le Déjeuner sur l'Herbe
(Luncheon on the Grass)

1863
Oil on canvas,
82 × 104 in.
(208 × 264 cm.)
Musée d'Orsay, Paris

A celebrated and
controversial masterpiece,
this painting immediately
divided the critics and
public. It marks a crucial
point in the history of art,
a deliberate turning away
from the schemes of
classical painting to present
a direct image of nature
and everyday life.

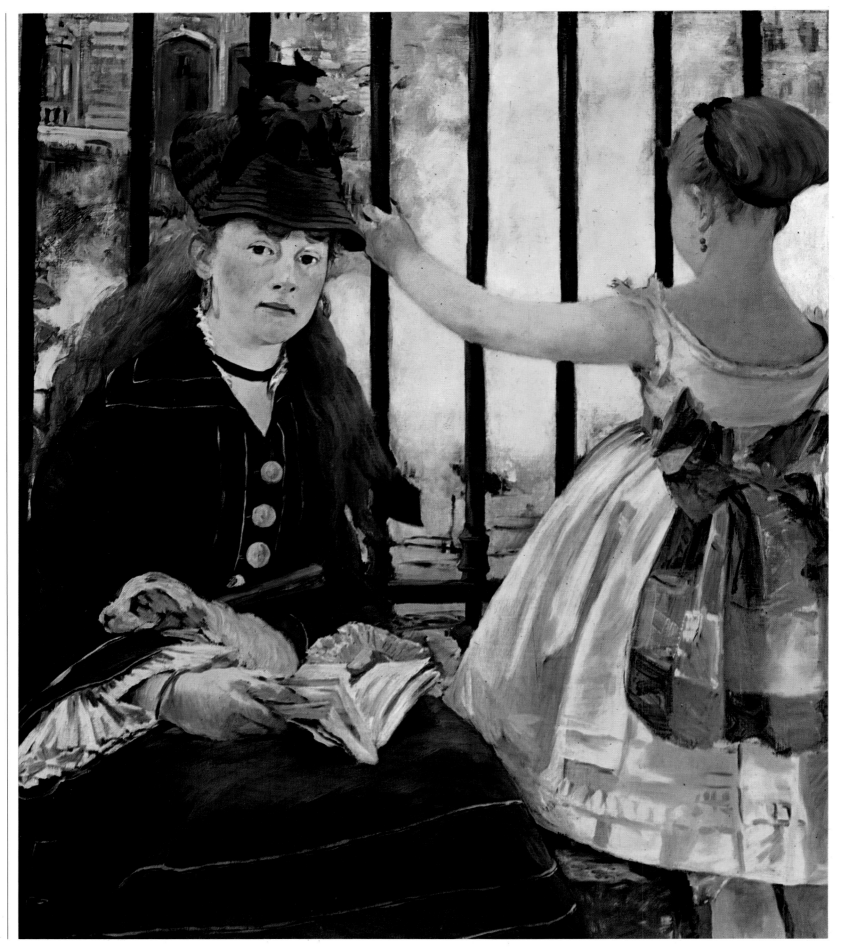

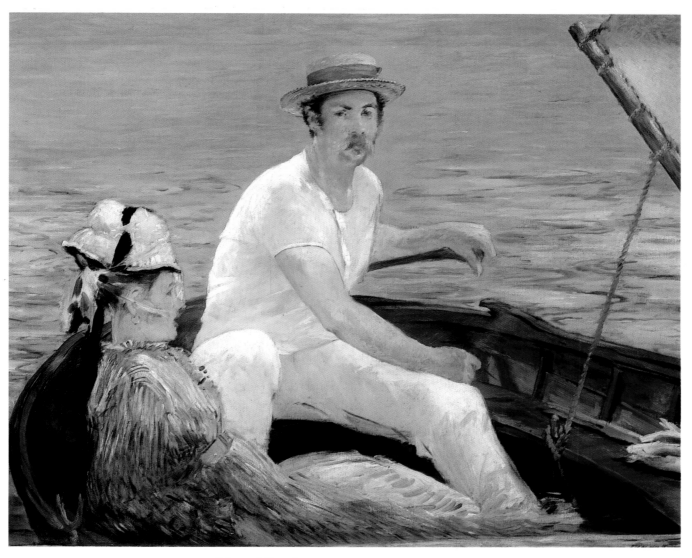

Edouard Manet
Boating

1874
Oil on canvas,
51¼ × 38¼ in.
(130.2 × 97.2 cm.)
The Metropolitan Museum
of Art, New York.
H.O. Havemeyer
Collection, Bequest
of Mrs. H.O. Havemeyer,
1929

The boat trip was one
of the Impressionists'
favorite subjects. In
contrast to Monet
and Renoir, Manet does
not seem particularly
interested in the effects
of light on water or
representation of the
landscape: his attention
is focused on the
composition of the
painting and the human
figures, depicted with a
touch of humor. In fact
the girl in the veil looks
somewhat perplexed
at the sailing skills
of the impromptu
Sunday skipper.

Edouard Manet
Saint-Lazare Station

1873
Oil on canvas,
36½ × 45 in.
(93 × 114 cm.)
National Gallery,
Washington

In the years of his closest
contact with the group
of Impressionists, Manet
too chose a more limpid
range of colors and painted
subjects drawn from
Parisian life. Yet the rigor
of composition and dignity
of form remained
impeccable.

Edouard Manet
Olympia

1863
Oil on canvas,
51¼ × 74¾ in.
(130 × 190 cm.)
Musée d'Orsay, Paris

A scandalous picture
par excellence, it can be seen
as a deliberate and
carefully thought-out
provocation. The large
canvas is laid out according
to precise rules, with exact
citations from Titian and
Goya: even the contrast
between the "white"
beauty and the "black" one
is a traditional one. Never
before, however, had a
prostitute been depicted in
such a direct, even brazen
manner. Manet is making
a lofty statement about
the supreme dignity
of art whatever its subject:
the figure and theme may
be salacious, but the
painting is of absolute
and intangible purity.

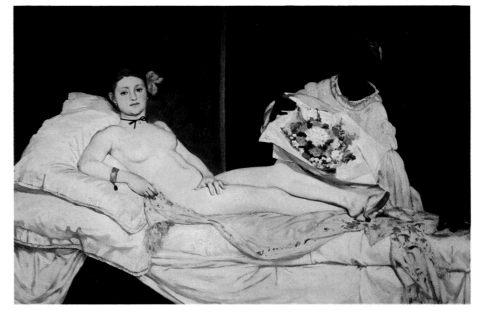

105

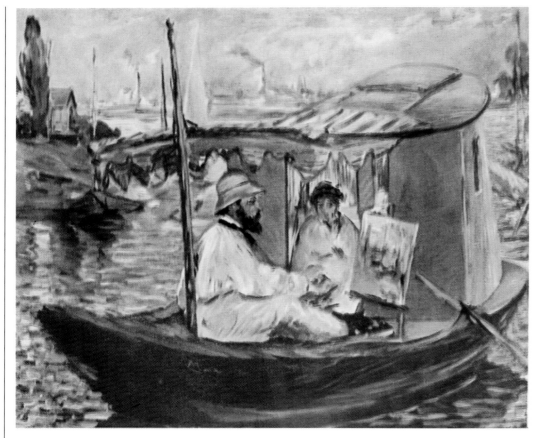

Edouard Manet
Monet Working on His Boat in Argenteuil

1874
Oil on canvas,
31½ × 38½ in.
(80 × 98 cm.)
Neue Pinakothek, Munich

A truly charming picture, painted directly from life, it is a testimony to the friendship that bound the various members of the Impressionist movement, especially during the first fifteen years of the group's activity. Manet presents a witty but carefully observed image of his colleague at work, surrounded by the iridescent reflections of the water.

Edouard Manet
The Waitress

1879
Oil on canvas,
30¼ × 25½ in.
(77 × 65 cm.)
Musée d'Orsay, Paris

A highly significant turning point in Manet's career came at the end of the seventies.
The painter started to take a new look at the denizens of Paris bars and shows, revealing an intimate and long-suffering side, full of humanity.
It was a direction that would lead to his last masterpiece, *A Bar at the Folies-Bergère* (p. 108).

Edouard Manet
Nana

1877
Oil on canvas,
59 × 45¾ in.
(150 × 116 cm.)
Kunsthalle, Hamburg

More than a decade after the "scandalous" *Olympia*, Manet returned to the theme of the "loose" woman: here he depicts the actress Henriette Hauser, nicknamed "Nana," one of the stars of Parisian nightlife.
The figure of the young woman in *déshabillé* makes the presence of a fully dressed man on the right pass almost unobserved.

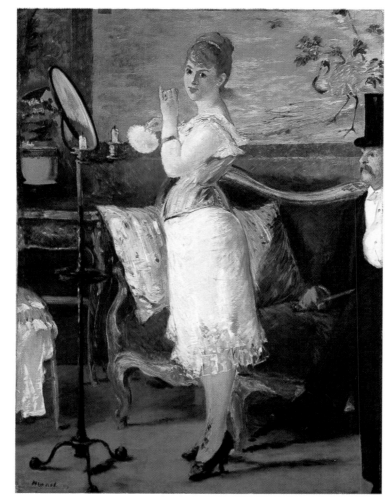

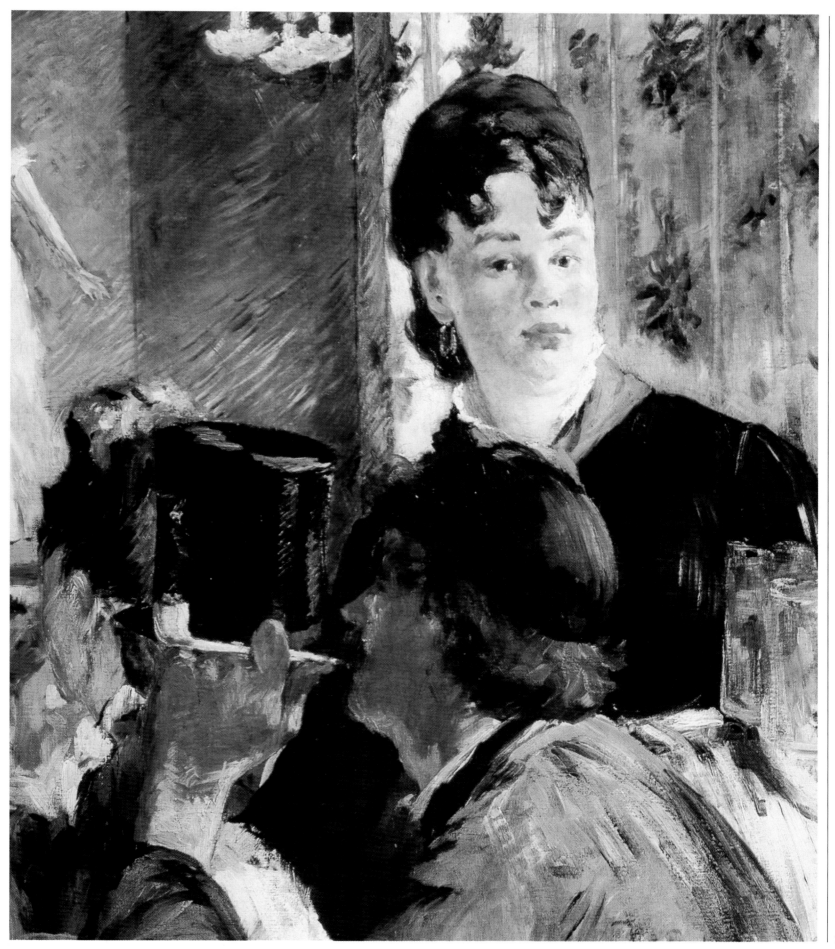

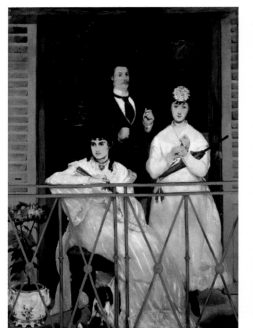

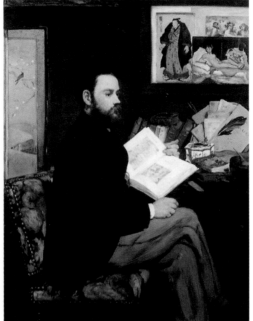

Edouard Manet
The Balcony

1868–69
Oil on canvas,
67 × 48¾ in.
(170 × 124 cm.)
Musée d'Orsay, Paris

One of Manet's most
famous pictures (even
made the subject of a
macabre parody by
Magritte), it is once again
inspired by a "classical"
precedent, taking up a
theme depicted by Goya.
While the Impressionists
on the whole tried to avoid
black, Manet resorted to
the contrast of black and
white fairly frequently,
using it to impart great
plastic force to his
subjects.

Edouard Manet
Emile Zola

1868
Oil on canvas,
57½ × 45 in.
(146 × 114 cm.)
Musée d'Orsay, Paris

The great writer, one
of the most important
novelists of the nineteenth
century, was one
of the few intellectuals
to support the artistic and
cultural renewal proposed
by the Impressionists. The
Japanese prints in the
background recall a
passion of nineteenth
century French collectors,
and one of the most
important sources of
inspiration for painting.

Edouard Manet
A Bar at the Folies-Bergère

1881–82
Oil on canvas,
37¾ × 51¼ in.
(96 × 130 cm.)
Courtauld Institute,
London

This is the painter's last
masterpiece and perhaps
one of the most intensely
poetic pictures of the whole
nineteenth century. The
setting is that of one of the
City of Light's most famous
nightclubs: we can hear
the buzz of the customers,
waiting for the next
performance, smell the
aromatic smoke of cigars,
and hear the bubbling of
champagne. Yet the whole
image is dominated by
the exhausted expression
of the young bartender,
a working-class girl who,
amidst the gleaming bottles
and glowing chandeliers,
lives in the inner shadow
of an unforgettable
loneliness and melancholy.

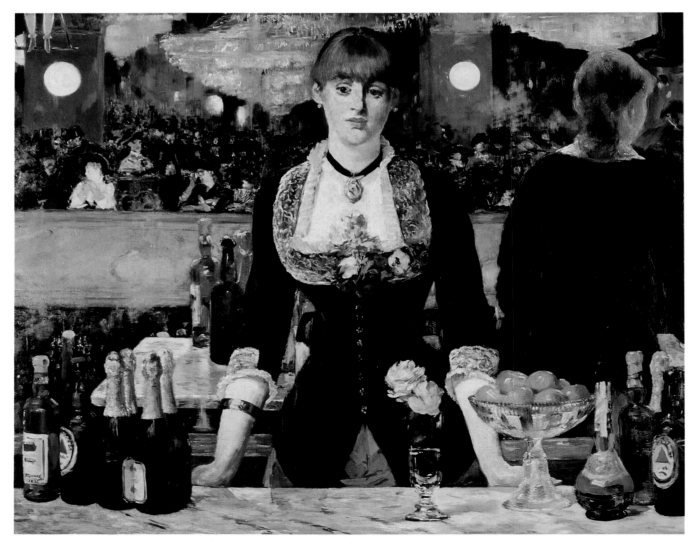

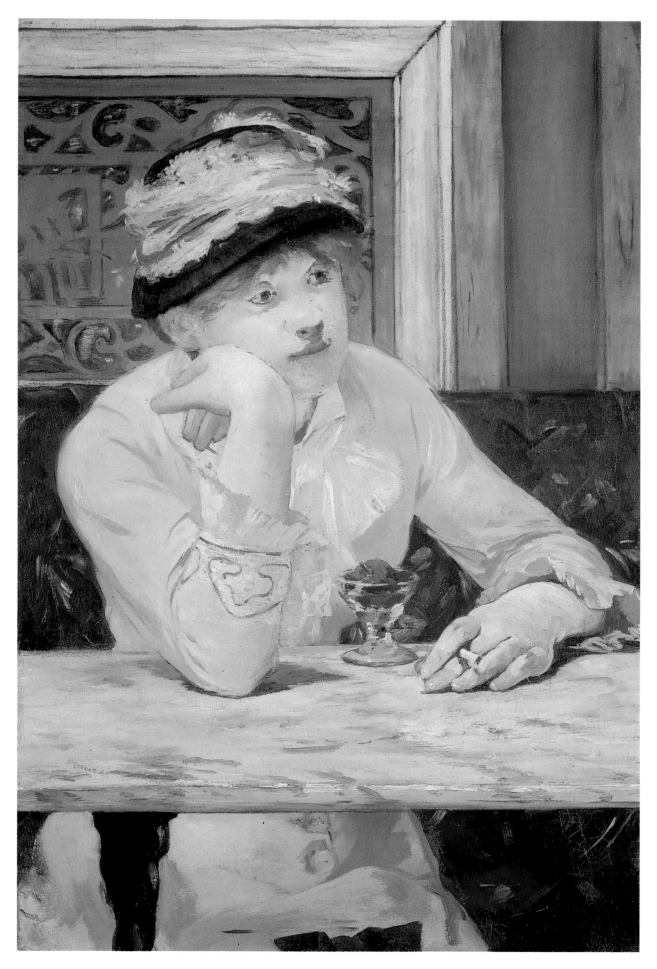

Edouard Manet
The Plum

1878
Oil on canvas,
29 × 19¾ in.
(73.6 × 50.2 cm.)
National Gallery,
Washington

While the group of Impressionists finally achieved the success with the public and on the market that it had long sought, Manet, from the height of his refined and disenchanted culture, seems to have anticipated them in discovering the other face of the Parisian entertainment world. Not just trips on the Seine, evenings at the theater and dance halls, but also a great deal of sadness and solitude. Toward the end of his life, Manet's painting tended to lose the black outlines that are so evident in the pictures of the sixties, under the influence of Spanish art. His palette, thanks to his contact with the Impressionists, was now based on pale colors (pinks, delicate shades of violet, oranges). Yet the structure of the composition remained very solid. Note how the girl's face is inscribed within a series of rigorously straight lines, which gradually restrict the space around her head and concentrate the observer's gaze, creating a refined contrast with the fresh and free handling of her features.

Claude Monet

Paris, 1840–Giverny, 1926

The youth of the painter who was destined to define the character and even the name of Impressionism was marked by a series of important encounters: first of all with the landscapist Eugène Boudin, from whom he imbibed a taste for painting the sea and water in general, and then, on his return to Paris in 1859, with Pissarro and the art of Courbet. After a first period devoted to landscape painting *en plein air*, Monet started to frequent Gleyre's studio, where he met his fellow students Renoir, Bazille

and Sisley. The friendship shared by these artists led to the birth of a movement of new ideas and passions. In the wake of the controversy aroused by Manet's *Déjeuner sur l'Herbe* in 1863, inspired by Renaissance art, Monet responded in 1865 with a painting of the same subject. This was followed by another entitled *Women in the Garden* (1866, Musée d'Orsay, Paris), in which the scheme of composition and above all the resplendent light and color invite us to "go out" of the museum and open ourselves to the delights of nature. Walks along the banks of the Seine prompted Monet to study the effects of light reflected on the water, making

delicate use of colored shadows and combining complementary colors. Without resorting to a "manifesto" or theoretical declarations, Monet was laying the foundations for a new movement in art, Impressionism. His painting *Impression: Sunrise* (1872, Musée Marmottan, Paris) gave the name "Impressionists" to the artists who took part in the exhibition held in the studio of the photographer Félix Nadar in 1874. The location was no coincidence: the relationship between Monet's painting and photography is very important, if you consider the way light "impresses" the photographic plate. During the seventies and over the following

decade Monet alternated scenes of Parisian life with increasingly deserted landscapes, continuing his research into the effects of color. The artist's relationship with nature, passionately experienced through the filter of color, became predominant when Monet decided to leave Paris for the country, moving to Giverny. Around 1890 Monet tried to organize his emotional reactions into groups of subjects, his famous "series," including those of Rouen Cathedral (1892–94), the banks of the Thames (1900) and the lily pond in his garden at Giverny. Monet painted this last group of canvases during the long years of his old age, from 1909 to his death in 1926.

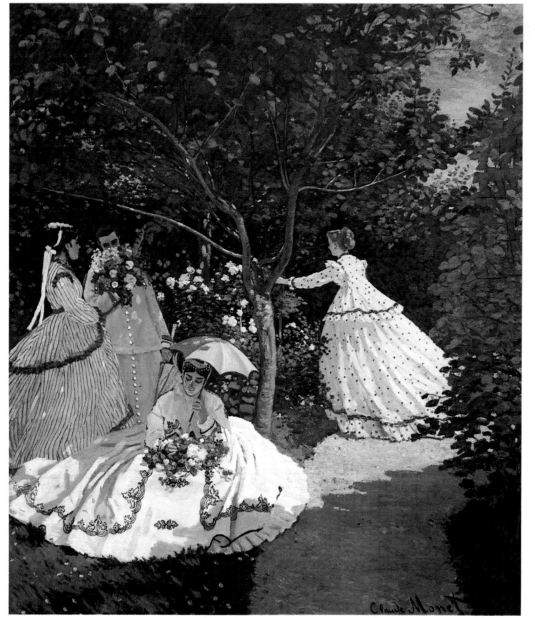

Claude Monet
*The Promenade
(The Stroll)*

1865
Oil on canvas,
36.5 × 27¼ in.
(93 × 68.9 cm.)
National Gallery,
Washington

Impressionist painting is loved and admired for its (at least apparent) simplicity. It appears to be a spontaneous and straightforward kind of art that is used to communicate feelings.

In reality, the painting of the Impressionists is also the product of intense thought. Evidence for this is provided by this canvas, a preliminary sketch for the group on the left of the *Déjeuner sur l'Herbe*, Monet's programmatic painting. The man is the artist Frédéric Bazille, a fellow student of Monet's and one of the founders of Impressionism. Bazille's career was brought to a tragic end in 1870, when he was killed at the battle of Beaune, during the Franco-Prussian War.

Claude Monet
Women in the Garden

1866–67
Oil on canvas,
80¾ × 100½ in.
(205 × 255 cm.)
Musée d'Orsay, Paris

The greatest masterpiece of Monet's early career, it marks the beginning of Impressionism in an unforgettable manner. The controversy stirred by Edouard Manet's painting *Le Déjeuner sur l'Herbe*

(p. 103) had given rise to a debate over the relative merits of the "museum" and "nature": Monet responded with extraordinary freshness of color and light, clearing the way for a new conception of painting.

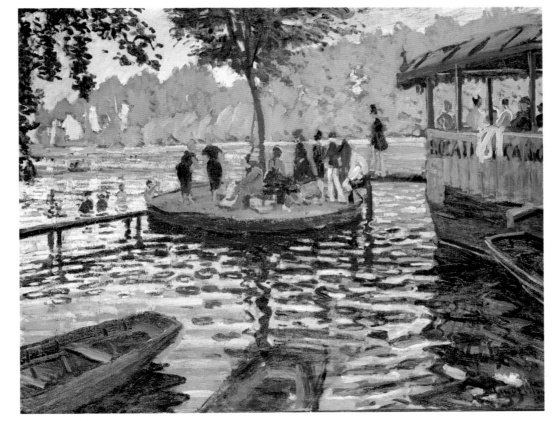

Claude Monet
Déjeuner sur l'Herbe
(*The Picnic*)

1866
Oil on canvas,
51¼ × 71¼ in.
(130 × 181 cm.)
Pushkin Museum, Moscow

Before setting to work
on the large canvas
(now broken up into
pieces), Monet painted this
preparatory sketch, which
has fortunately been well
preserved. In spite of its
limited dimensions, it is
still capable of conveying
the striking beauty of the
picture, with its play of light
and colored shadows,
filtered by the leaves on
the trees, turning around the
dazzling white at the center.

Claude Monet
La Grenouillère

1869
Oil on canvas,
29½ × 39 in.
(75 × 99 cm.)
The Metropolitan Museum
of Art, New York. Bequest
of Mrs. H.O. Havemeyer,
1929. The H.O. Havemeyer
Collection

The "island of frogs"
on the Seine was one
of the favorite destinations
for the Sunday walks
of Parisians, and it became
one of the preferred
subjects of the early group
of Impressionists. Amidst
the white sails in the
sunlight, the blue waters
under the branches,
the colored shadows,
the rustling of skirts and
the whispered gallantries,
Monet offers us a glimpse
of a Sunday in summer
in an age that appears
carefree and happy.

On the following pages
Claude Monet
Women in the Garden
(detail)

1866–67
Oil on canvas,
80¾ × 100½ in.
(205 × 255 cm.)
Musée d'Orsay, Paris

The close-up gives us
an insight into Monet's
technique, and in particular
his use of colored shadows,
painted in thick and rich
strokes of paint and not
with chiaroscuro.

111

Claude Monet
The Terrace at Sainte-Adresse

1866
Oil on canvas,
35¾ × 51¼ in.
(90.5 × 130 cm.)
The Metropolitan Museum
of Art, New York.
Purchased with special
contributions and purchase
funds given or bequeathed
by friends of the Museum,
1967

Thanks to this painting,
the summer resort of
Sainte-Adresse has become
one of the landmarks in
the history of art. With
all the immediacy of the
"impression," Monet shows
us the carefully-tended
flowers of this terrace
by the sea, while steamers
belch smoke on the
horizon. Once again,
however, the freedom
of composition and color
is underpinned by an
artistic intelligence of
great refinement: the
whole painting, in fact,
is based on harmonies
of white, blue and red,
the colors of the French
flag fluttering overhead.

Claude Monet
Saint-Germain l'Auxerrois

1866
Oil on canvas,
32 × 39 in.
(81 × 99 cm.)
Nationalgalerie, Berlin

The move from rural
landscapes to urban views
of Paris over the course of
the sixties was a decisive
stage in the development
of Impressionism.
Previously, in fact, the
country scenes painted
en plein air by Monet and
his companions (Renoir,

Sisley, Bazille) were only
a slight departure from
a tradition that had been
inaugurated by Corot
and the landscapists
of the Barbizon School.
Courageously shifting
his attention from the
countryside to Paris,
Monet maintained the
same freshness and
freedom in the handling
of light and color,
ushering in a new
genre that immediately
attracted other artists
and was to prove highly
successful over the
following years.

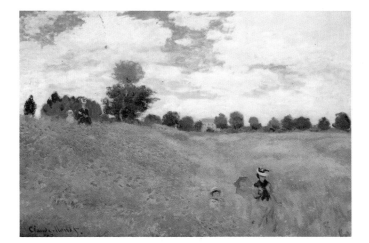

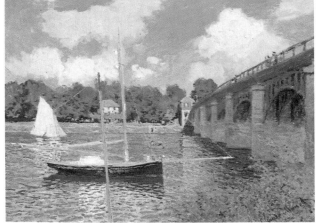

Claude Monet
The Bridge at Argenteuil

1874
Oil on canvas,
19¾ × 25½ in.
(60 × 79.7 cm.)
National Gallery,
Washington

Throughout his life, from
youth to extreme old age,
Monet was fascinated
by water, which was one
of his favorite subjects.

Claude Monet
Poppies

1873
Oil on canvas,
19¾ × 25½ in.
(50 × 65 cm.)
Musée d'Orsay, Paris

Monet's painting changed
almost imperceptibly,

year by year: if we look
carefully we can see
how his brushstrokes
gradually become wider
and denser, less precise
with respect to those
of the sixties.
The image comes out
slightly more blurred,
but the fusion of light and
color is still more striking.

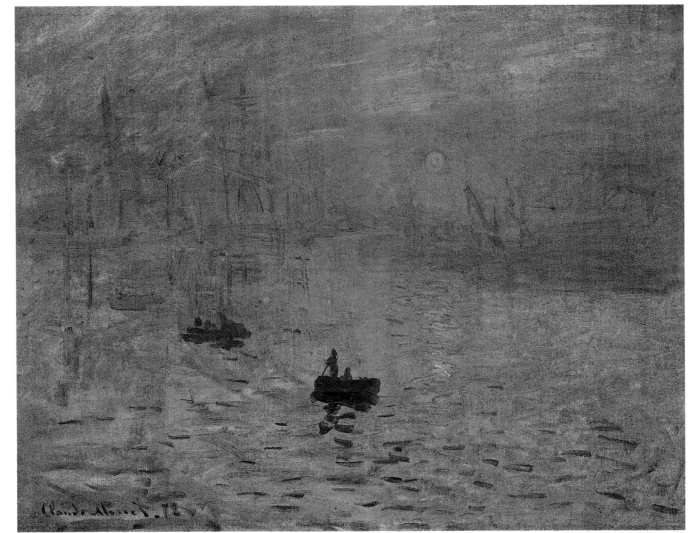

Claude Monet
Impression: Soleil Levant
(*Impression: Sunrise*)

1872
Oil on canvas,
19 × 24¾ in.
(48 × 63 cm.)
Musée Marmottan, Paris

Shown at the exhibition
in Nadar's studio in 1874,
this was the painting that
gave Impressionism its
name. Partly inspired by
Japanese prints, and partly
the fruit of Monet's
intense sensitivity, it is
yet another watery scene,
but at a very special time.
The rising sun alters all
the colors, steeping figures
and objects in a blur of
light, a magical effect that
lasts only a few moments
but which Monet is able to
capture and communicate.

Claude Monet
Saint-Lazare Station

1877
Oil on canvas,
32 × 39¾ in.
(81.9 × 101 cm.)
Fogg Art Museum,
Cambridge (Mass.)

"Discovered" by Turner in the Romantic era, the train was a very popular subject in nineteenth-century painting. The contrast between the light evanescence of whitish steam and the ponderous locomotive of black steel, the sense of mystery, of distant worlds, that hovers under futuristic canopies and the bustle of stations are all to be found in Impressionist painting as well, though depicted from very different viewpoints. Compare Monet's station with the picture of the same subject painted by Manet not long before (p. 104).

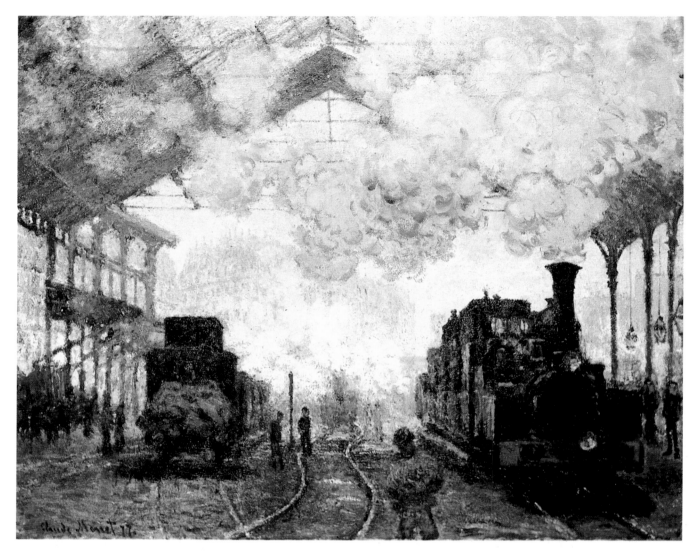

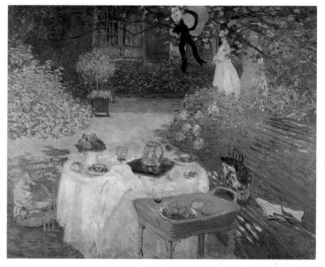

Claude Monet
Luncheon

c. 1873
Oil on canvas,
63 × 79 in.
(160 × 201 cm.)
Musée d'Orsay, Paris

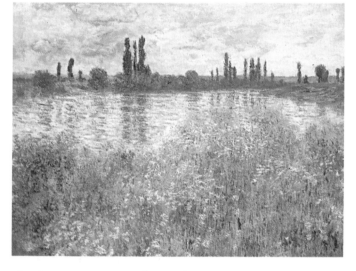

Claude Monet
The Banks of the Seine at Vétheuil

1880
Oil on canvas,
29 × 39½ in.
(73.4 × 100.5 cm.)
National Gallery,
Washington

From 1880 onward Monet painted numerous views of the banks of the Seine near the village of Vétheuil: repetition of the same subject, depicted at different times of day or in different seasons, was to become a characteristic feature of Monet's work.

Claude Monet
Woman with a Parasol
(*Madame Monet and Her Son*)

1875
Oil on canvas,
39¼ × 32 in.
(100 × 81 cm.)
National Gallery,
Washington

One of the most emblematic images of Impressionism, this picture of a charming young woman in a veil sheltering herself from the sun under a parasol is in reality a family portrait, depicting Monet's wife and small son. The idea of the composition is disarming in its simplicity, but the way in which it is handled is unforgettable. The harmony of the colors, all pale tones, reaches a peak in this picture that was perhaps never surpassed.

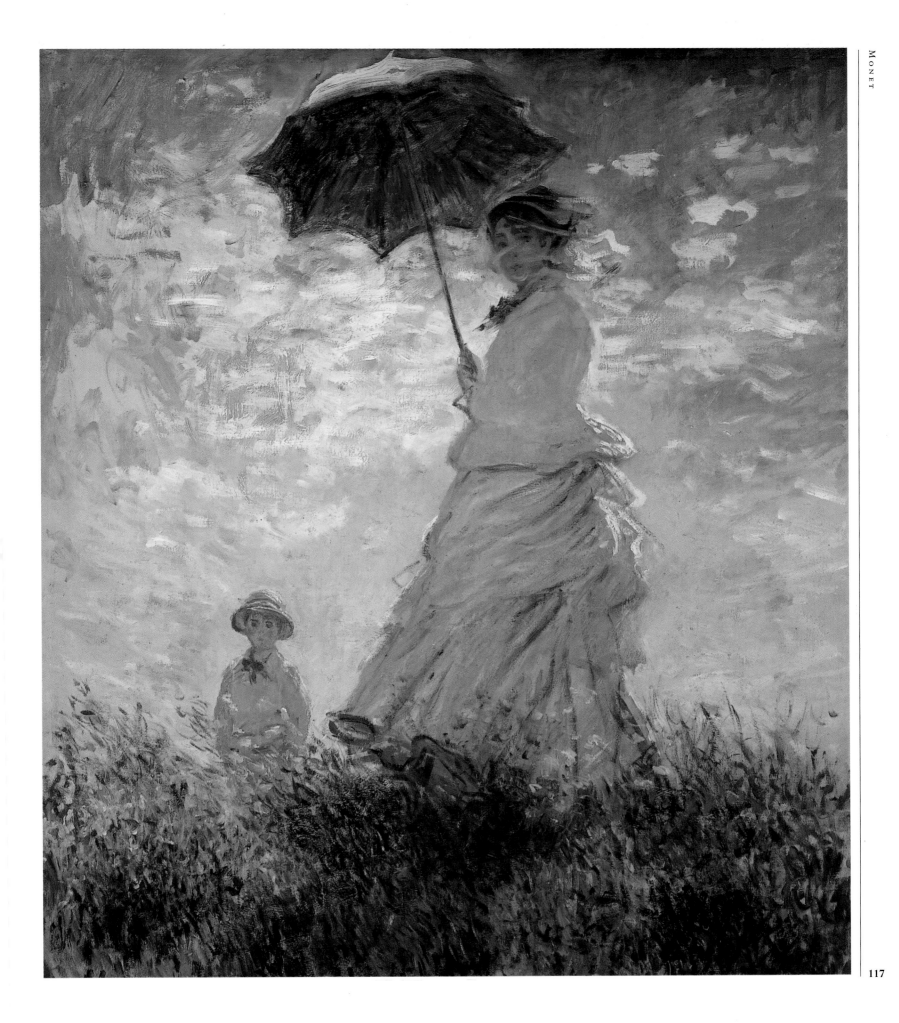

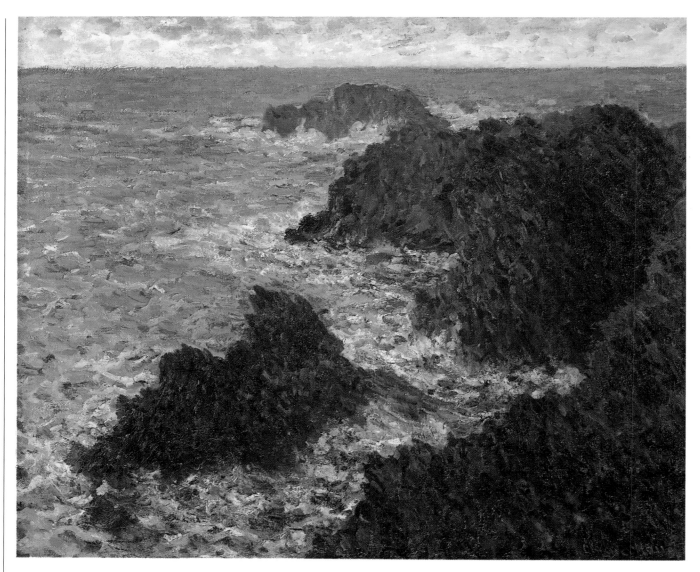

Claude Monet
Rocks on Belle-île

1886
Oil on canvas,
25½ × 32 in.
(65 × 81.5 cm.)
Musée d'Orsay, Paris

In the latter part of his career, Monet moved away from the other artists in the group to conduct a passionate and solitary research of his own. Year after year, he chose a number of specific subjects and painted them in different seasons and under different conditions of weather and light. It is interesting that he returned to scenes of water, but no longer set on the quiet banks of the Seine: a series of great vitality—so much so as to make one think of Expressionism—is the one devoted to rocks pounded by the waves, with the white foam of the sea and a sort of mist blurring the outlines.

Claude Monet
Haystacks

1890
Oil on canvas,
23¾ × 39½ in.
(60.5 × 100.5 cm.)
Musée d'Orsay, Paris

The series that Monet devoted to haystacks, yellow shapes drenched in sunlight, is perhaps less well-known than those of the rocks or Rouen Cathedral. Yet this group of paintings also offers moments of powerful suggestion, largely due to the artist's ability to maintain a balance between a wholly realistic representation and an evocation of feelings.

Claude Monet
White Water Lilies

1899
Oil on canvas,
35 × 36½ in.
(89 × 93 cm.)
Pushkin Museum, Moscow

In the sentimental geography of famous locations in the history of art, Monet's garden at Giverny holds a very special place. For about thirty years, as he grew increasingly old, fragile and solitary, Monet painted its flowers, leaves and shadows, concentrating on the area around the lily pond, spanned by its so-called "Japanese bridge." Monet knew the garden like the back of his hand, tending it with great care. And so, each year, he saw and painted the water lilies as they slowly unfolded. But the flowers gradually lost their character as plants, turning into pure evocations of color that border on abstraction.

Pierre-Auguste Renoir

Limoges, 1841–Cagnes-sur-Mer, 1919

Born into a family of craftsmen, his entry
into the art world was a difficult one,
comparable to that of an apprentice
in the Renaissance. Before starting to paint
on canvas, in fact, the young Renoir was
obliged to work as a decorator of porcelain
and textiles. Entering the Ecole des Beaux-
Arts in 1862, he became a fellow student
of Monet and Sisley at the teaching studio
run by Marc-Gabriel Gleyre. The
suffocating academicism of the Ecole,
contrasting strongly with the realism
professed by Courbet and developments in
landscape painting *en plein air*, induced
Renoir and his companions to lighten their
palettes and take their inspiration directly
from reality, not only where the subjects
were concerned but also (and no less
importantly) in their choice of colors
and tones. His family origins and lifestyle
led Renoir to paint the locations and
figures typical of Sunday outings by the
Parisian *petite bourgeoisie*: open-air dances,
meeting places, boat trips and the parks
along the Seine. During the sixties Renoir
experimented successfully with the use
of colored shadows, which proved
particularly effective in landscapes.
At the memorable exhibition held at
Nadar's studio in 1874, Renoir showed
La Loge (*The Theater Box*, Courtauld
Institute, London), demonstrating his
exceptional talent as a portraitist,
especially of young women and children.
His way of painting faces is highly
characteristic, using brilliant light to
accentuate the eyes and lips and leaving
the rest of the features almost neutral.
Among his Parisian paintings, the *Moulin
de la Galette* (1876, Musée d'Orsay, Paris)
has rightly become a symbol of *joie de vivre*.
The year 1881 marked a significant turning
point in Renoir's career. A long journey
through Central and Southern Italy
brought him into contact with the classical
painting of the Renaissance and Hellenistic
art, impelling him to produce more
carefully-considered compositions. Thus
the spontaneous and delightful images
of nature as it appears to the eye gave way
to sweeping compositions of volumes
(especially women's bodies, increasingly
often nude and of ample, almost
Rubensian, proportions), in a color that
was still very luminous but less brilliant
and light in tone. In his old age a
progressive form of arthritis confined
him to a wheelchair: in order to paint,
Renoir was obliged to tie the brushes
to his fingers. Even under these conditions,
he went on painting to the end,
courageously producing paeans to youth
and the beauty of women set in the
dazzling light of the Côte d'Azur.

Pierre-Auguste Renoir
*Dance at the Moulin
de la Galette*

1876
Oil on canvas,
51¼ × 69 in.
(130 × 175 cm.)
Musée d'Orsay, Paris

A favorite haunt of
the lower middle-class,
the Moulin de la Galette
was the most typical
of the Sunday rendezvous
in nineteenth-century
Paris. For Renoir, who
came from a humble
family, the outdoor
dancing, tables laden with
refreshments and summer
dresses worn by the girls
were a genuine delight.
Renoir joyfully immersed
himself in the buzz of
voices, rustle of clothing
and laughter, presenting
an image of carefree
happiness. The picture,
one of the most famous
of all Impressionist works,
was painted at perhaps
the most original and
important stage of Renoir's
career, when he developed
the interests he shared
with other artists in the
group (subjects drawn
from daily life, colored
shadows, painting in
the open air) into
an independent style
characterized by its
unmistakable brushwork,
rich and dense in color.

Pierre-Auguste Renoir
The Canoeists' Luncheon

c. 1879
Oil on canvas,
21¾ × 26 in.
(55 × 66 cm.)
Art Institute, Chicago

Renoir's brushwork is
dense and rich, seemingly
able to capture the light
within the paint itself.
For many years, the artist's
favorite subjects were
scenes set in bars and
meeting-places on
the banks of the Seine.
Relaxed poses and natural
rather than conventional
gestures augment the
sense of reality taken
from life. The rapport
with the river also
becomes the source
of luminous reflections,
which spread throughout
the picture.

Pierre-Auguste Renoir
La Loge (The Theater Box)

1874
Oil on canvas,
31½ × 24¾ in.
(80 × 63 cm.)
Courtauld Institute,
London

The man who appears
in the picture, scrutinizing
the fashionable audience
of the Opéra through his
opera glasses, is Edmond,
the painter's brother.
He is accompanied
by the splendid model
called Nini, whose
freshness is enhanced by
the lights of the theater.
The girl's eyes, smile and
strings of pearls glitter
against her youthful face
and neck. The flower
set in the neckline of her
dress is a *tour de force*
of painting.

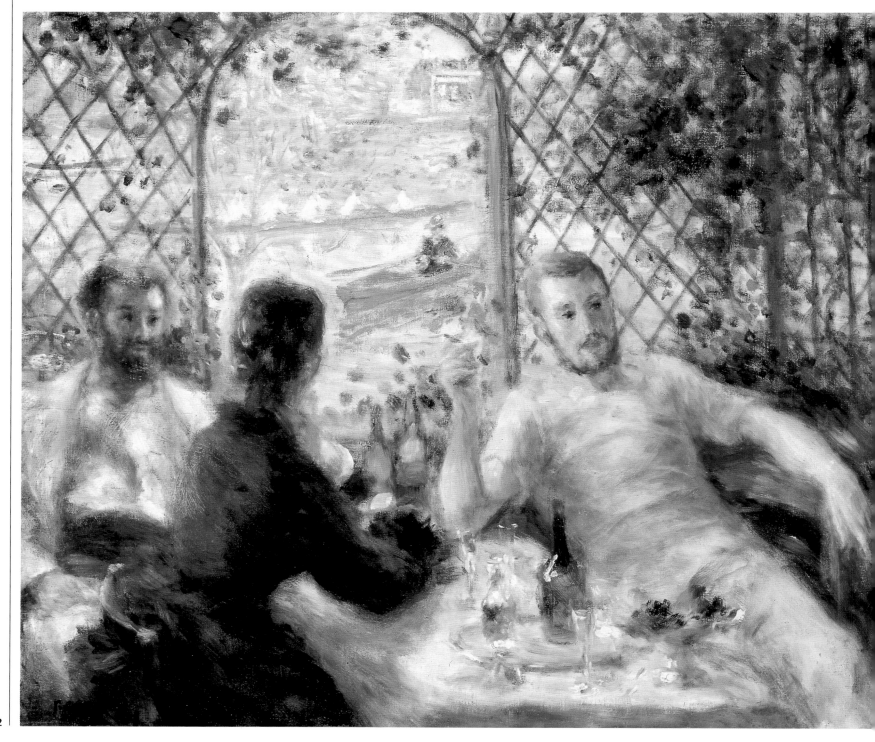

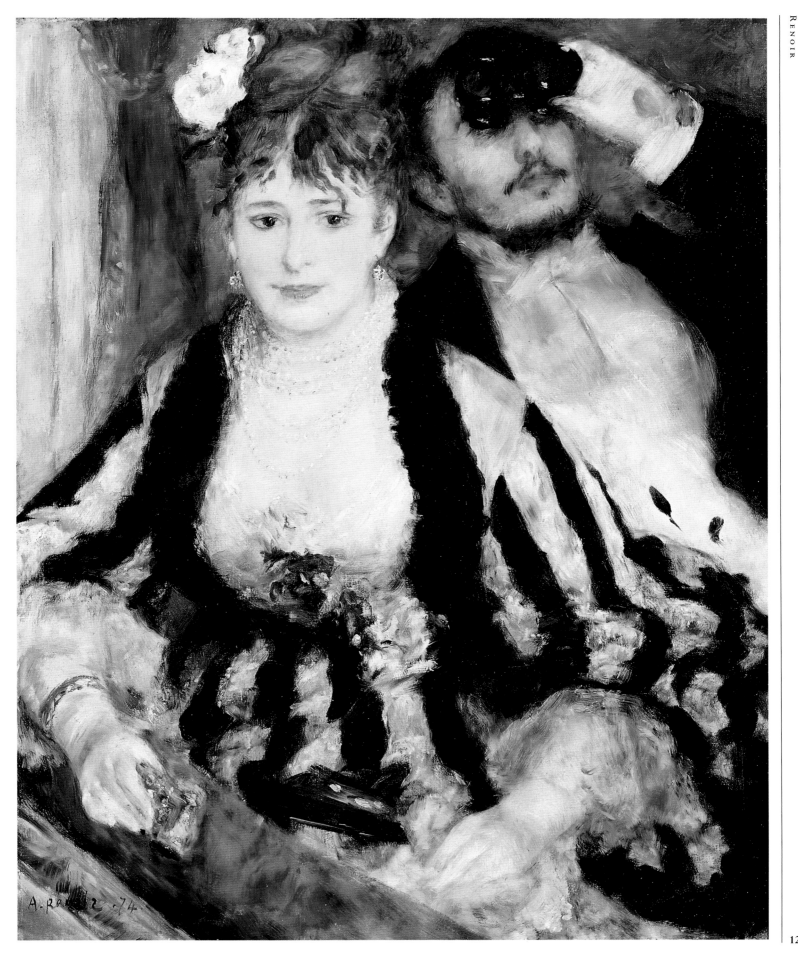

Pierre-Auguste Renoir
Little Girl with Watering Can

1876
Oil on canvas,
39¼ × 28¾ in.
(100 × 73 cm.)
National Gallery,
Washington

In Renoir's long and
brilliant output of
portraits, children hold
a very important place.
In the entire history
of art, few painters have
been able to capture the
innocent and joyful
expressions of children
with such tenderness.
Avoiding the forced and
unnatural poses inflicted
on children in so many
"formal" portraits, whether
paintings or photographs,
making them look like
tailor's dummies, Renoir
allowed them to play,
laugh, talk and move
freely. In this work,
considered one of
the artist's greatest
masterpieces, Renoir
has found an enchanting
harmony between the light
and colors of a garden
filled with flowers
(typically Impressionist)
and the pretty little girl
with blond hair and an
embroidered dress. The
child is holding a tiny
watering can with pride,
as if taking credit for the
flowering of the garden.

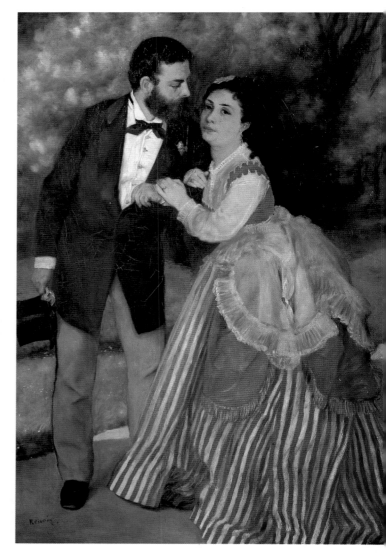

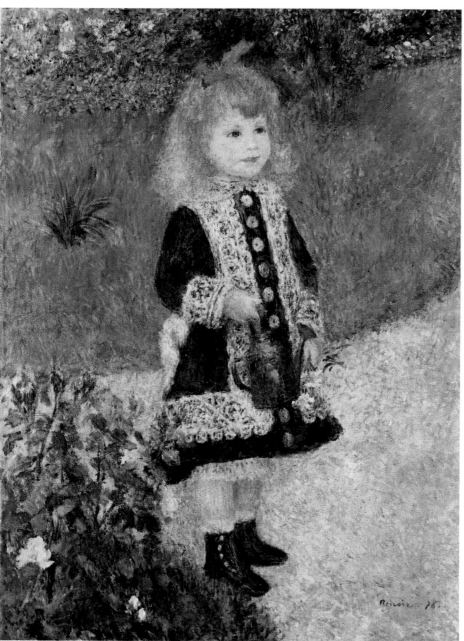

Pierre-Auguste Renoir
*The Painter Sisley and His
Wife*

1868
Oil on canvas,
41¾ × 29¼ in.
(106 × 74 cm.)
Wallraf-Richartz Museum,
Cologne

This intimate and
spontaneous portrait,
free of all formality and
unnecessary frills and
enlivened by the colored
stripes of the young
woman's dress, was
painted early in Renoir's
career. Unlike the portrait
of the little girl with a
watering can, the figures
here still have firmly
defined volumes. The
picture is also an
interesting historical
document: it represents
the painter Alfred Sisley
and his wife and records
the years of greatest
solidarity in the group
of Impressionists.

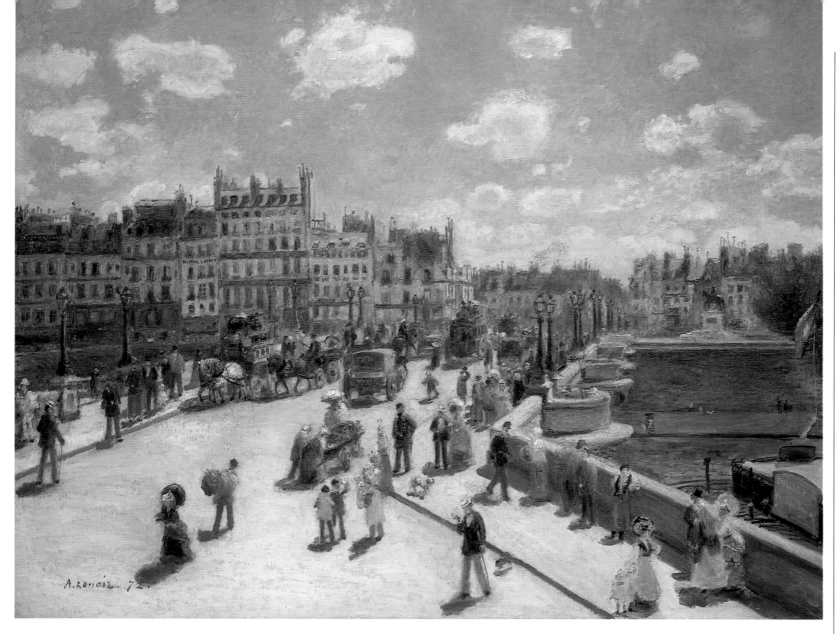

Pierre-Auguste Renoir
The Pont Neuf, Paris

1872
Oil on canvas,
29½ × 36½ in.
(75 × 93 cm.)
National Gallery,
Washington

Renoir painted relatively
few urban views of Paris,
usually preferring people
to landscapes. When he
did paint the city, he chose
well-known landmarks,
flooded with light and
animated by the movement
of people and vehicles.

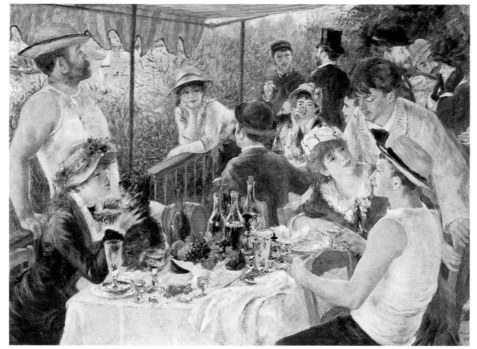

Pierre-Auguste Renoir
*The Luncheon of the
Boating Party at Bougival*

1880-81
Oil on canvas,
51¼ × 69 in.
(130 × 175 cm.)
Philips Collection,
Washington

The fact that Renoir
painted pictures of similar
subjects over a span of
several decades allows us
to gain a very clear idea
of the evolution of his
style. From the *Dance
at the Moulin de la Galette*,
wholly steeped in the spirit
of Impressionism, there
was a gradual shift to more
rounded and solid forms,
in softer, less vivid colors.

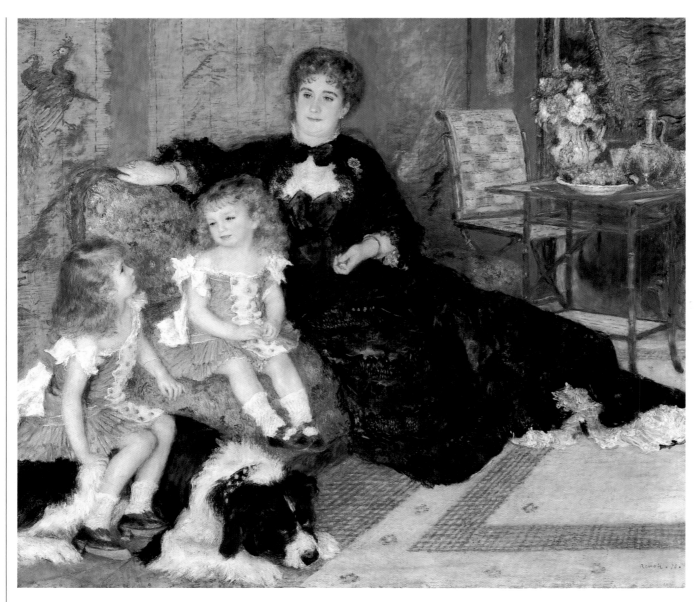

Pierre-Auguste Renoir
*Madame Charpentier
and Her Children*

1878
Oil on canvas,
60½ × 74¾ in.
(154 × 190 cm.)
The Metropolitan Museum
of Art, New York. Wolfe
Fund, 1907. Catharine
Lorillard Wolfe Collection

This portrait of a woman
and her two children
belongs to the same
stylistic period and shares
the same atmosphere
of family joys as the
*Little Girl with a Watering
Can* (p. 124). In this larger
painting Renoir is once
again able to create a
fascinating equilibrium
between the spontaneity
of the attitudes and
expressions (including
those of the large and hairy
dog lying on the carpet)
and a carefully thought-out
and executed composition.

Pierre-Auguste Renoir
*A Dance in the Country
A Dance in the City*

1883
Oil on canvas,
70¾ × 35½ in. each
(180 × 90 cm. each)
Musée d'Orsay, Paris

The two pairs of dancers
epitomize the two souls
of Renoir's painting:
popular and refined,
interested in the
amusements of both lower
and upper middle class,
capable of spontaneous
smiles and gestures
of perfect etiquette.

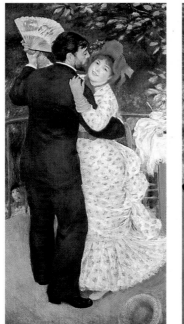
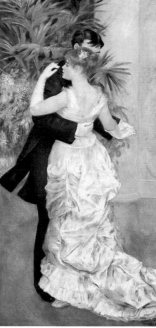

Pierre-Auguste Renoir
Girls at the Piano

1892
Oil on canvas,
45½ × 35½ in.
(116 × 90 cm.)
Musée d'Orsay, Paris

The balance of form, color, and light in Renoir's painting was undermined after the eighties, chiefly as a consequence of his visit to Italy. His encounter with Titian's painting and experience of Mediterranean light induced Renoir to dilate the volumes of his figures and make his brushstrokes richer and more curved, using denser paint. This was a consequence of his rejection of Impressionism: Renoir's desire to renew his style inevitably resulted in a loss of its original grace, in scenes and compositions that grew increasingly heavy. Only his favorite themes of childhood, as in this case, retain a joyful and soft delicacy.

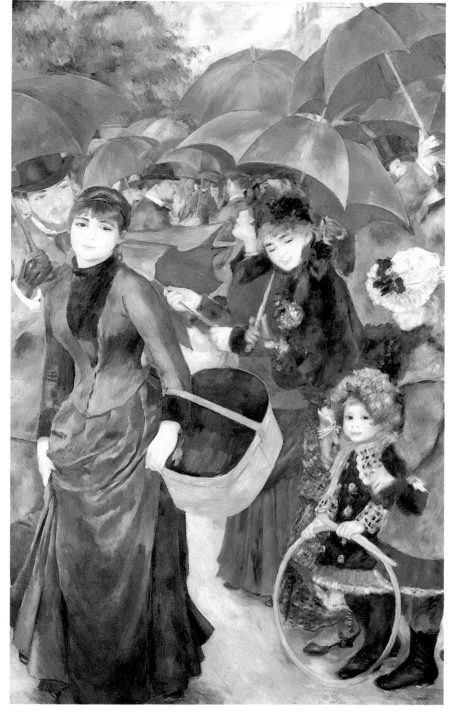

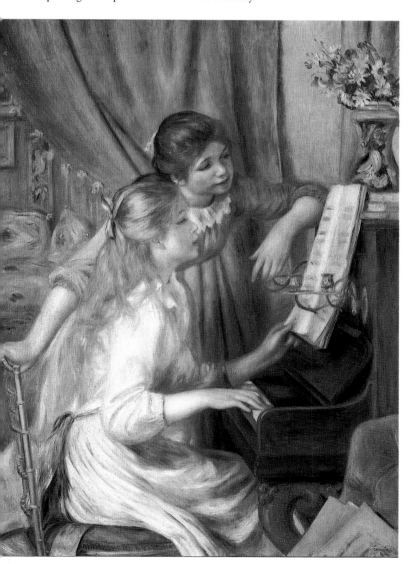

Pierre-Auguste Renoir
Umbrellas

c. 1885
Oil on canvas,
70¾ × 45¼ in.
(180 × 115 cm.)
National Gallery, London

This is one of Renoir's most successful paintings after the breakup of the Impressionists. With an extraordinary sense of chromatic harmony, the painter has based the whole of this picture on the bluish-gray tone of the open umbrellas and most of the clothing. But this dominant color is brightened by the faces of the young women, the crepe bonnet of the girl on the far right and, above all, the charming blond child with a hoop, the true center of the artist's attention.

Alfred Sisley

Paris, 1839–Moret-sur-Loing, 1899

Though his parents were British, Sisley
was born in Paris where his father ran
a commercial business. However, he
received his training in England, where he
made a particular study of Gainsborough's
cold tones and brushwork and the
landscapes of Constable and Turner.
Returning to France in 1862, he
developed an intelligent blend of the
figurative culture he had absorbed in
London and the French tradition of Corot
and the Barbizon School. His friendship
with Monet, Renoir and Pissarro soon
led him to experiment with color.
Together with Monet, he decided to paint
in the open air. For a while, Monet and
Sisley painted the same views and
compared the results. Sisley soon showed
a preference for a range of cold colors,
in which greens and blues dominated:
an expression of his great intellectual
control, which never allowed him
to abandon himself to pure contemplation
of the landscape. In 1871, after his father's
death, Sisley went to live in the
countryside and led a very secluded
existence in which he was forced to move
frequently because of financial problems.
In general, the sobriety of Sisley's palette
and his unusually autumnal and subdued
vision of the region around Paris served
as a valuable counterbalance to the
sometimes overly pretty painting
of his French colleagues. Yet this also
partly explains his relative obscurity
and lack of success on the market.
In 1882 he settled permanently at Moret.
The small town surrounded by greenery
and its Gothic church became Sisley's
favorite subject toward the close
of his life, almost as a belated response
to the series of views his friend Monet
had devoted to Rouen Cathedral.

Alfred Sisley
Road at Hampton Court
(detail)

1874
Oil on canvas
Neue Pinakothek, Munich

Though he lived and
worked mostly in France,
Sisley never lost contact
with England and it was
there that he painted
some of his most successful
pictures.

Alfred Sisley
*Ernst Hoschedé's Garden
at Montgeron* (detail)

1881
Oil on canvas,
22 × 29¼ in.
(56 × 74 cm.)
Pushkin Museum,
Moscow

The painting, purchased
from Durand-Ruel's
gallery by the celebrated
Muscovite collector
Ivan Morozov, provides
an example of Sisley's
deeply poetic vision
of the landscape, in which
he chose to paint subdued
and provincial subjects

where figures are few
and far between.
The light and color are
restricted to generally cold
tones, which evoke the
cool weather and breezes
of "in-between" seasons.

Alfred Sisley
Flood at Port-Marly

1876
Oil on canvas,
23½ × 32 in.
(60 × 81 cm.)
Musée d'Orsay, Paris

This is one of the painter's best-known and most successful works: the flooded countryside presents a scene appropriate to his invincibly gloomy temperament. Once again, Sisley shows himself to be an excellent painter of water, though not with the sparkling reflections to be found in the work of Renoir or Monet. Rather, he depicts it as a quivering expanse of gray tones, reminiscent of English painting between the eighteenth century and Romanticism.

Alfred Sisley
Saint-Mammés, Gray Weather

c. 1880
Oil on canvas,
21½ × 29¼ in.
(54.8 × 74 cm.)
Museum of Fine Arts, Boston

Sisley's typical use of broad brushstrokes is clearly visible in this painting, especially in the sky. In the latter part of his career, the painter went to live in the country, troubled by constant economic difficulties and poor health. His death in 1899 brought the Impressionist period to a definitive close.

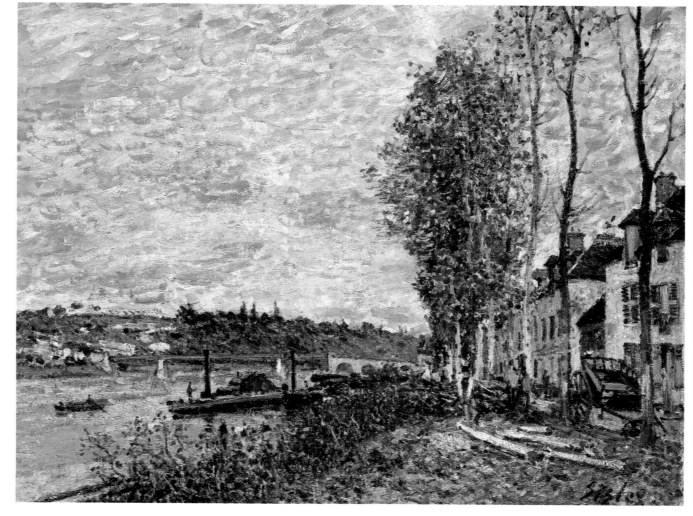

Mary Cassatt

Allegheny City (Pa.), 1844–Château de Beaufresne, 1926

The life and career of Mary Cassatt is one of the most interesting chapters in the history of Impressionism. Trained in painting in the United States, where she received a correct but monotonous academic education, she decided to complete her formation in Europe. In Paris, where she was supposed to be deepening her understanding of the great painters of the past by copying their masterpieces in the Louvre, she came to the attention of Degas: under the skin of an American student lay the soul of a great artist. In Degas's company, Mary Cassatt frequented and painted the world of the Opéra, though she seemed to show more interest in the audience that crammed the boxes than in the singers and dancers on the stage: *At the Theater*, of 1879, is considered her masterpiece. The artist's style is characterized by her graphic skill. She used her forceful and clear draftsmanship to investigate the people of Paris at the end of the nineteenth century, looking at Sunday pastimes, trips to the seaside and moments of family life. Mary Cassatt, like many of the Impressionists, showed great interest in Japanese prints and this found effective expression in some of her paintings of naturalistic subjects, like birds in flight. Though she went back to the United States occasionally, she settled in France, where she died at the age of over eighty.

Mary Cassatt
The Boating Party

1893–94
Oil on canvas,
35½ × 46¼ in.
(90.2 × 117.5 cm.)
National Gallery,
Washington

The only American artist to show with the Impressionists, Mary Cassatt played a decisive role in bringing works by French artists to America, through her friendship with high-placed associates of her banker father.

Mary Cassatt
At the Opéra

1880
Oil on canvas,
31½ × 25½ in.
(79.9 × 64.7 cm.)
Museum of Fine Arts,
Boston

This splendid painting
can be compared without
any embarrassment to
the theater scenes of the
greatest French masters,
from Renoir to Degas.
Mary Cassatt always
paid attention to the thrill
of emotion, to typically
female subtleties of
psychology. We can see,
in fact, how the situation
depicted by Renoir in the
Theater Box (p. 123) has
been turned almost on its
head. There the painter's
brother had his opera
glasses trained on the
audience, while here
the young woman,
concentrating on the
action on stage, is being
scrutinized in turn by a
man in the background,
clearly more interested
in the attractive member
of the audience than
in the performance itself.
The sharp profile and
photographic angle are
features shared with
Degas, but it is also
possible to discern hints
of Daumier's graphic
work.

Berthe Morisot

Bourges, 1841–Paris, 1895

A highly gifted and extremely sensitive painter, she was one of the most diligent and consistent participants in the group of Impressionists and their exhibitions. Entering Corot's studio along with her sister Edma in 1862, she served a long apprenticeship, working chiefly on landscapes painted directly from life. Eventually she started to show a few works at the Paris Salons. In 1868 she met Manet (she was later to marry his brother) and came into contact with the Impressionists. From that moment on Berthe Morisot's painting underwent a marked change: in addition to landscapes she began to depict domestic interiors, figures from everyday life, aspects of reality and the typical activities of women. The quiet and subtle tone of Morisot's pictures brought a light and yet penetrating note into the work of the Impressionists. From 1875 up until her death, Morisot kept faith with the fundamental characteristics of Impressionism, while gradually inserting a greater dignity into her compositions.

Berthe Morisot
The Mirror

1876
Oil on canvas,
30 × 21¼ in.
(76 × 54 cm.)
Thyssen-Bornemisza
Collection, Madrid

Morisot was a painter of great importance within the Impressionist movement. In contrast to the joyful and animated work of Renoir and Degas, the painter concentrated on moments of tenderness, silence and intimacy. Many of her pictures represent domestic interiors, in which she repeatedly portrayed her sister and other relatives. Her refined technique and suffused intimacy anticipate the work of Vuillard and Bonnard.

Berthe Morisot
Two Sisters

1869
Oil on canvas,
20½ × 32 in.
(52.1 × 81.3 cm.)
National Gallery,
Washington

The delicacy of Berthe
Morisot's brushwork
added a touch of levity
and elegance to the
Impressionist group, of
which she was a member
right from the outset.
The pale shades of color
fill the interior with a
diffuse luminosity, while
a web of psychological
implications is woven
between the two sisters,
who look alike.

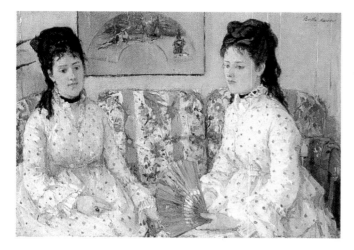

Berthe Morisot
Reading

1869–70
Oil on canvas,
39¾ × 32 in. (101 × 81 cm.)
National Gallery,
Washington

The two women in the
picture are the painter's
mother and sister.
Although she had shown
great courage in choosing
the profession of artist, an
unusual move for a girl
from a good family, Berthe
Morisot was the antithesis
of the "bohemian" painter:
on the contrary, her works
reflect the peaceful and
well-to-do environment
to which she belonged.

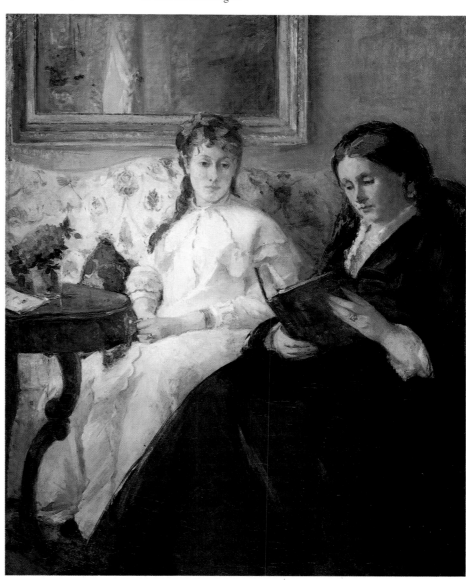

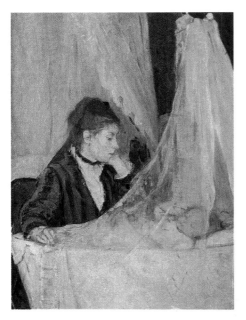

Berthe Morisot
The Cradle

1872
Oil on canvas,
22 × 18 in.
(56 × 46 cm.)
Musée d'Orsay, Paris

Perhaps it is no
coincidence that two
women, Mary Cassatt
and Berthe Morisot,
should have reached the
peak of artistic excellence
at the moment when
Impressionism was at the
height of its development.
Nor were they the only
significant female figures:
the name of Suzanne
Valadon immediately
springs to mind. But it was
a phenomenon limited to
the realm of painting, with
no parallels in the French
literature or music of those
years. Thanks to the work
of these two great
artists, the whole of the
Impressionist movement
discovered a whole world
of affections, acts of
tenderness and interests
that were practically
unknown to male society.
In this painting, as in many
of Morisot's works, the
darkest note is provided
by the young woman's hair,
gathered up on top
of her head.

135

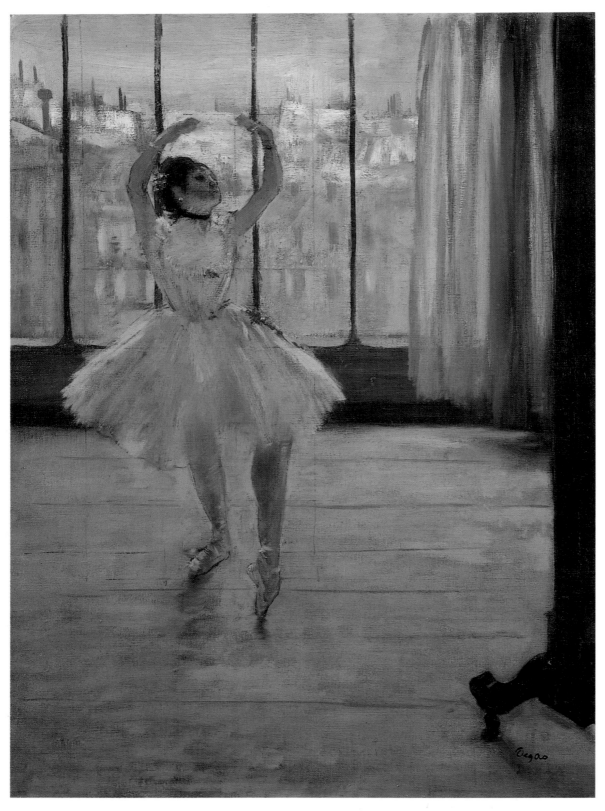

Edgar Degas
Paris, 1834–1917

The son of a banker of noble origins (his surname was written de Gas until the painter decided to adopt a less pretentious form), he received a strict classical training. Degas is often described as "the most Parisian of the Impressionists." In reality, he remained on the edges of the group: Degas chose to go in a direction of his own, showing little interest in nature and instead paying great attention to the expressions, gestures and emotions of human figures, especially women. This choice was strongly influenced by his love for the Italian painting of the Renaissance, which he studied through visits to the Louvre and a long stay in Tuscany. During the sixties, when he found himself at the heart of Parisian artistic life, he made friends with Manet, with whom he shared a classical education and elevated culture. Degas was also attracted by forms of expression that had only recently been introduced into Paris, such as Japanese prints and photography. At the beginning of the seventies, when the Impressionist group was already firmly established, Degas concentrated on two of his favorite subjects: the worlds of the theater (musicians, singers and above all dancers) and horse racing. He preferred the lights of the Opéra and the sporting and fashionable atmosphere of the Longchamp racecourse to popular dances at the Moulin de la Galette. After a visit to New Orleans (1873), Degas started to draw inspiration from the simple daily life of washerwomen, housemaids and seamstresses in their modest apartments. In his inquiry into the human body, he investigated the attitudes of laundresses and women combing their hair or washing themselves in a tub. Partly as a consequence of failing eyesight, which was eventually to lead to blindness, Degas made his brushwork rapid, almost cursory, and in the end took to modeling in clay and wax.

Edgar Degas
Ballerina in the Photographer's Studio

1875
Oil on canvas,
25½ × 19¾ in.
(65 × 50 cm.)

Pushkin Museum,
Moscow

This splendid painting, with its masterly harmony of grays and blues, combines two of Degas's main interests: the limber movements of the ballerina and his love of photography. Degas, an extremely refined draftsman, did not share the Impressionist's fascination with light and color: what interested him rather was the subtle point of contact between movement and balance displayed by a ballerina on point, while the recent development of photography suggested new and unpredictable angles for the image. The view of the roofs of Paris seen through the windows is memorable.

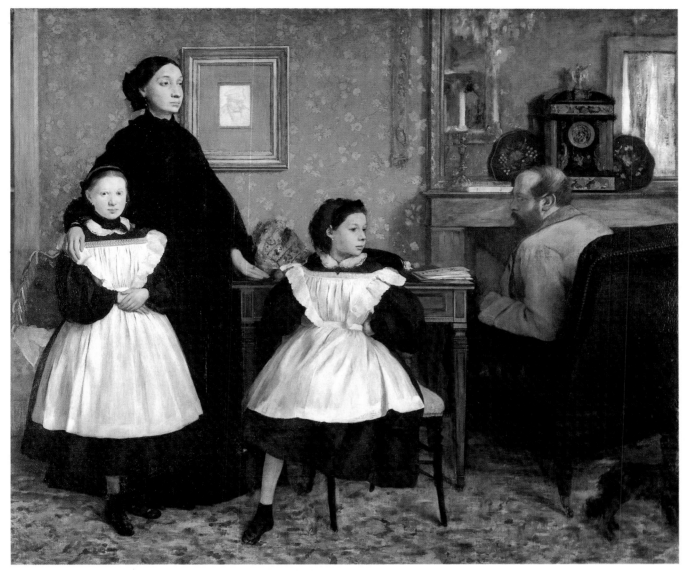

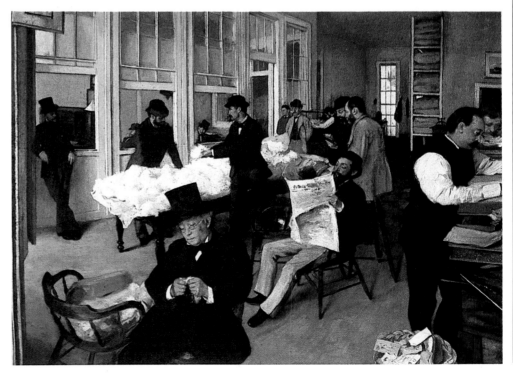

Edgar Degas
The Bellelli Family

1858
Oil on canvas,
78¾ × 98½ in.
(200 × 250 cm.)
Musée d'Orsay, Paris

This is perhaps the finest
work of portraiture of the
nineteenth century. Here
Degas depicts his Italian
relatives, taking his
inspiration from the
Renaissance style of
painting to produce a
composition of absolute
dignity and serenity.
The figures are painted in
the setting of their home,
with expressions that are
at least partly natural. It is
precisely the skillful blend
of spontaneity and artifice
that contributes to the
exceptional fascination
of this picture, rigorous
and free at one and the
same time. At a leap Degas
went beyond his previous
cultural references (from
Ingres to the old masters
he had seen in the
Louvre), earning himself
a place as one of the most
interesting figures in late
nineteenth-century art.

Edgar Degas
New Orleans Cotton Office

1873
Oil on canvas,
28¾ × 36¼ in.
(73 × 92 cm.)
Musée d'Orsay, Paris

The painting is the most
important result of Degas's
sole visit to the United
States. The long and deep
diagonal perspective gives
the scene the appearance
of a newspaper illustration,
taken on the fly like a
picture in a photographic
reportage. This helps
to explain why some
of the figures are "cut off"
by the edges of the canvas.

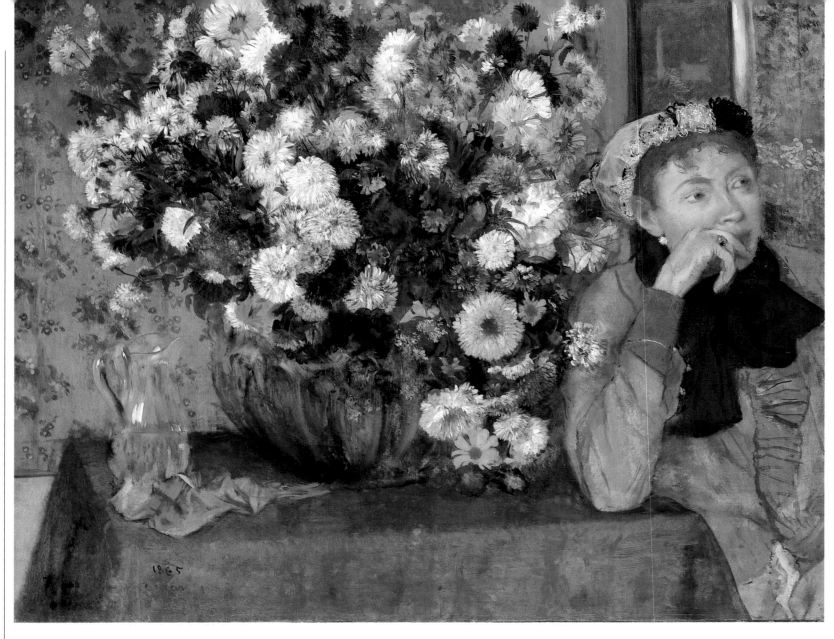

Edgar Degas
*Woman Seated Beside
a Vase of Flowers
(Madame Paul Valpinçon?)*

1858
Oil on canvas,
29 × 36½ in.
(73.6 × 92.7 cm.)
The Metropolitan Museum
of Art, New York.
H.O. Havemeyer
Collection, Bequest of
Mrs. H.O. Havemeyer, 1929

Degas was a great
draftsman: indeed, his
fondness for graphic art
was one of the reasons for
his partial detachment
from the Impressionists.
Nevertheless, the explosion
of colors in this vase of
flowers demonstrates the
completeness of the means
of expression available to
the painter.

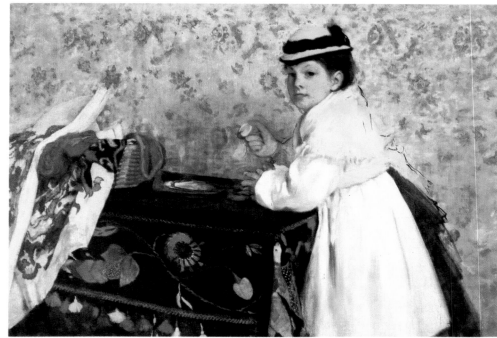

Edgar Degas
*Portrait of Hortense
Valpinçon*

1871
Oil on canvas,
28¾ × 36¼ in.
(76 × 110.8 cm.)
Institute of Arts,
Minneapolis

The spontaneous vivacity
of the little girl, who is
distracted only for a
moment from her game,
is portrayed by Degas
with delightful and tender
feeling. This was achieved
in part through a cut and
format that were decidedly
unusual in comparison
to traditional portraiture.

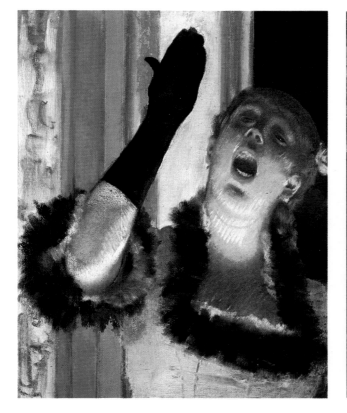

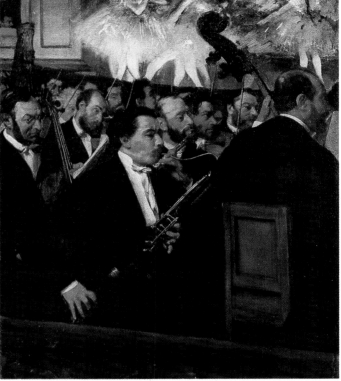

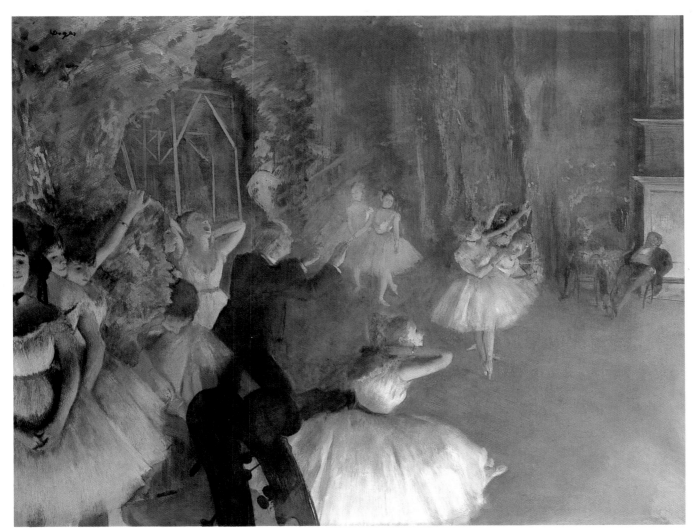

Edgar Degas
Singer with a Black Glove

c. 1878
Oil on canvas,
20¾ × 16¼ in.
(53 × 41 cm.)
Fogg Art Museum,
Cambridge (Mass.)

Edgar Degas
The Orchestra of the Opéra

1869–70
Oil on canvas,
22¼ × 18¼ in.
(56.5 × 46.2 cm.)
Musée d'Orsay, Paris

Edgar Degas
The Rehearsal of the Ballet Onstage

1874
Oil and watercolor on
paper mounted on canvas,
21½ × 28¾ in.
(54.3 × 73 cm.)
The Metropolitan Museum
of Art, New York.
H.O. Havemeyer
Collection, Gift of Horace
Havemeyer, 1929

An assiduous frequenter of
the Opéra, the aristocratic
Degas did not participate
in popular dances or
Sunday outings on the
Seine. His favorite milieu
was the world of the
theater, surrounded
by the stars of the ballet,
the players of the orchestra
and famous singers.
Perhaps the most effective
of his paintings are the
ones that do not represent
a moment in the
performance of an opera,
concert or ballet, but
rehearsals, dance schools,
the choreographer giving
advice. Degas makes us
breathe the always frantic
and excited atmosphere
that precedes the opening
night, taking us behind the
wings to show us the
myriad personages
of the theater.

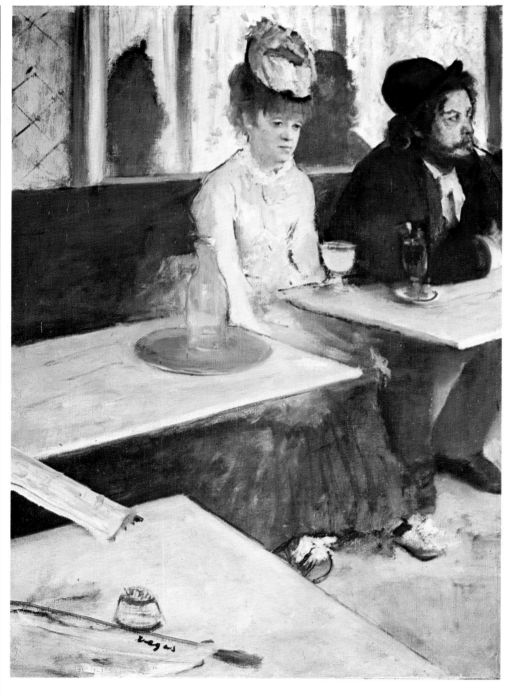

Edgar Degas
Absinthe

1875–76
Oil on canvas,
36¼ × 26¾ in.
(92 × 68 cm.)
Musée d'Orsay, Paris

The memorable exhibition held in Nadar's studio in 1874 marked the apex of the Impressionist movement, but at the same time the end of the most creative period for some of its artists. For Degas, however, a whole new era commenced after that date. He started to paint his first "genre" pictures, including this unforgettable, desolate image. In the squalid surroundings of a bar, we are confronted with the lack of any human prospects on the part of a confused young woman, lost in a solitude and emptiness that seem to expand to fill the space around her. The painting is reminiscent of the work of Daumier, at once incisive and humane.

Edgar Degas
Diego Martelli

1879
Oil on canvas,
43¼ × 39¼ in.
(110 × 100 cm.)
National Gallery of Scotland, Edinburgh

The Italian art critic, a leading light in the group of Tuscan Macchiaioli and responsible for an intelligent dialogue between the Italian artists and developments in Paris, is portrayed by Degas from an unusual point of view, looking downward from above. The massive and rather portly body of the bearded Martelli seems to be compressed by this perspective, which also draws attention to the red lining of the slippers. On the other hand, it also emphasizes the papers scattered on the table, an unequivocal sign of his intense and fruitful activity as a man of letters.

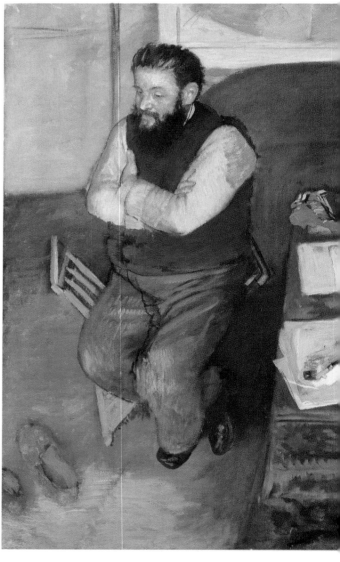

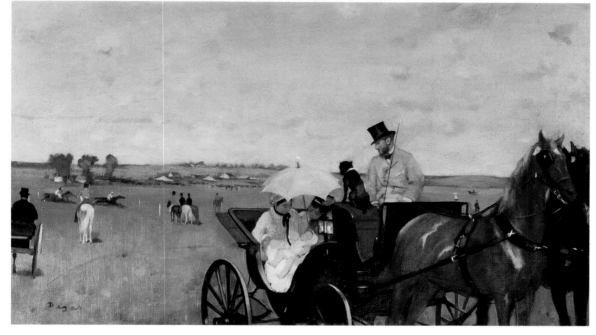

Edgar Degas
The Racetrack

1877–80
Oil on canvas,
17¾ × 23½ in.
(45 × 60 cm.)
Musée d'Orsay, Paris

This canvas offers a
powerful insight into
the relationship between
Degas and photography.
Without resorting
to the transparence
and shimmering luminosity
of the painting of the other
Impressionists, Degas
neatly captures an image,
freezing it in time, without
being concerned about
the drastic interruption
of outlines or figures.

Edgar Degas
Repasseuses
(Two Laundresses)

1884–86
Oil on canvas,
30 × 32 in.
(76 × 81 cm.)
Musée d'Orsay, Paris

As the years went by,
Degas tended to shift
his attention away from
sophisticated and elegant
circles and toward the
world of ordinary people.
The attitudes of the two
laundresses, one bending
over to press down on
the iron, the other
yawning, are certainly not
very refined. And yet the
nobleman Degas presents
us with an image that is
anything but vulgar: rather
it is filled with a sense
of human kinship and
truthfulness.

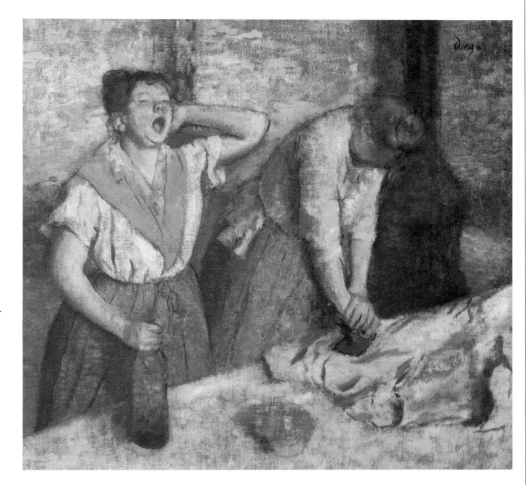

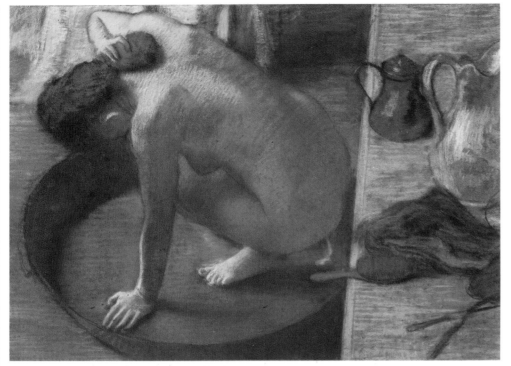

Edgar Degas
The Tub

1884–86
Pastel,
23½ × 32¾ in.
(60 × 83 cm.)
Musée d'Orsay, Paris

The intimate pictures
of women washing
themselves in tubs formed
a radical alternative to the
ballerinas in supple attitudes
of just a few years earlier.
Degas broadened his view
of the female world,
investigating the natural
elegance of the gestures
and body of a young
woman. This was a passage
of great cultural refinement,
but also an innovation from
the viewpoint of technique:
partly through the influence
of Toulouse-Lautrec and
partly as a consequence
of his failing eyesight, Degas
began to paint in pastel,
renouncing gradations of
color.

Edgar Degas
*Maid Combing Woman's
Hair*

c. 1892–95
Oil on canvas,
45 × 57½ in.
(114 × 146 cm.)
National Gallery, London

The few but extremely
beautiful pictures that
Degas painted in his old
age are often moving.
Owing to his poor
eyesight, the artist was
frequently forced to
give up painting for sculpture,
using his hands to mold
the figures. In his paintings
he diminished the role
played by color, favoring
clearly distinguishable
outlines. This surprising
picture was long believed
to be unfinished: yet it is
actually a chromatic
invention of remarkable
power, clearing the way
for the now imminent
emergence of Matisse
and the Fauves.

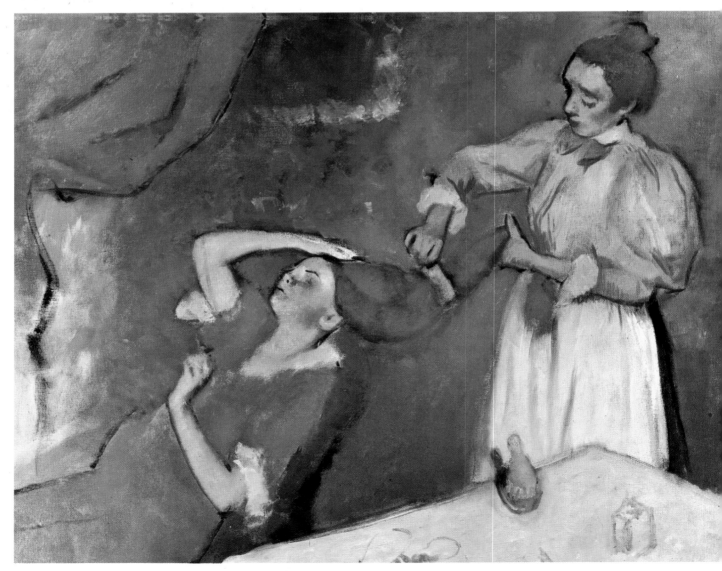

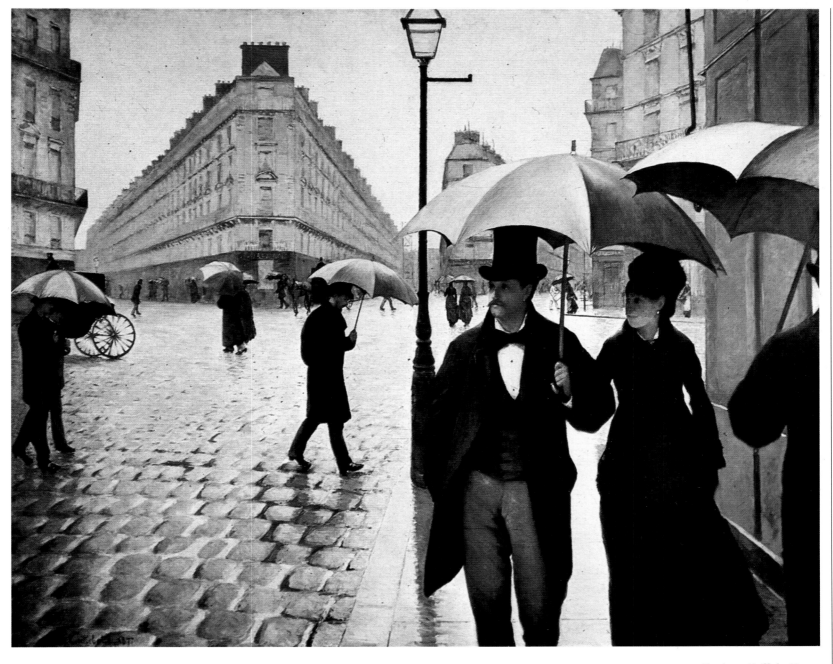

Gustave Caillebotte
Paris, A Rainy Day

1877
Oil on canvas,
83½ × 108¾ in.
(212.2 × 276.2 cm.)
Art Institute, Chicago

The streets of Paris
were no less lively in bad
weather, but Caillebotte
(unlike Renoir and Pissarro
when painting under
similar conditions) takes
advantage of the gloom
to concentrate on the
robust characterization
of his figures.

Gustave Caillebotte

Paris, 1848–Gennevilliers, 1894

A figure perhaps unjustly undervalued
by the general public, he is a painter of
great interest, occupying a unique position
within the Impressionist movement.
He was invited to join the group by
Monet in 1874, on the occasion of the
historic exhibition in Nadar's studio.
Caillebotte, while adopting the clear
light, brilliant colors and (at least in part)
themes from bourgeois life so dear to the
Impressionists, never turned his back on
his original influences, which came not so
much from landscape painting *en plein air*
as from the Realism of Courbet. The
Floor-Scrapers (1875) is Caillebotte's most
emblematic work, achieving a fine balance
between the effect of the light entering
through the window and the dark outlines
of the workers. Monumental figures
were to remain a constant feature of his
painting, setting it apart from the other
work shown at the Impressionists' joint
exhibitions, in which he participated
regularly up until 1882. It is interesting
to note, however, that after the group
had more or less broken up, Caillebotte
too began to paint the sort of landscapes
around the Seine and Argenteuil that
had been characteristic of the initial phase
of the movement.

Camille Pissarro

Saint-Thomas (Danish West Indies), 1830 –Paris, 1903

Settling in France in 1855, Pissarro kept faith throughout his career with the official definition of a painter of landscapes "from life," interested in direct representation of the visual phenomena that unfolded before his eyes. The initial influence of Corot and the Barbizon School gave way, around 1861, to a more up-to-date and stimulating interaction with Monet and Cézanne, with whom he took part in a historic exhibition at the Salon des Refusés in 1863.
Pissarro declared that he wanted to eliminate black and dark shadows from his landscapes. For this reason

he left Paris for the countryside, moving first to Pontoise and then to Louveciennes. After 1870, when cracks began to show in the solidarity of the Impressionist group, Pissarro saw himself as the custodian of the movement's original spirit.
Opposed to experimentation (apart from a brief dabble in Pointillism), the traditionalist Pissarro became an important point of reference for younger artists. The rural scenes of the sixties gradually gave way to urban views, culminating in his large pictures of boulevards, painted after his return to Paris in the last decade of the century. Pissarro's work at the end of his career remained consistent with that of his debut as he continued to apply the ideas of the Impressionists, using colors taken directly from life and vibrant light.

Camille Pissarro
Apple Picking

1888
Oil on canvas,
23½ × 28¾ in.
(60 × 73 cm.)
Museum of Fine Arts,
Dallas

Pissarro's paintings of figures deserve more attention than they have received. They are filled with poetry and feeling, and are much more open to experimentation with new styles than are his better-known landscapes, which keep strictly to the tenets of Impressionism. In this work, perhaps rather naive in its dreamy idealization of country life, Pissarro adopts the technique of Pointillism.

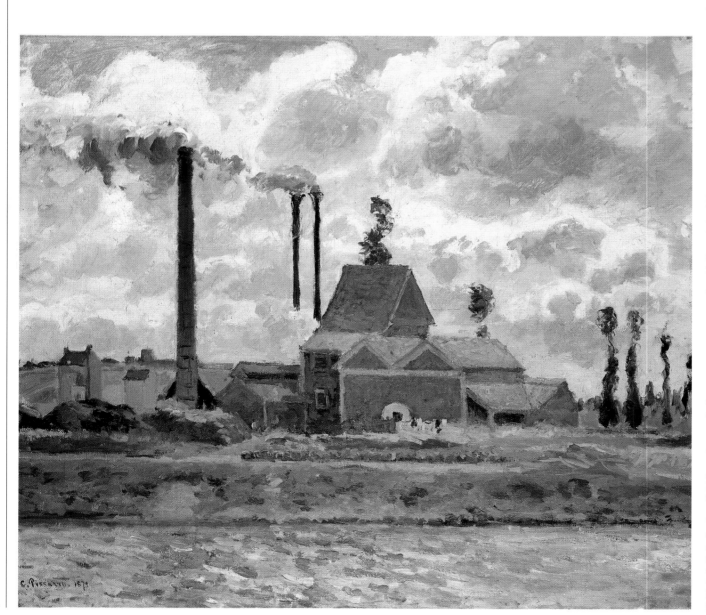

Camille Pissarro
Factory near Pontoise

1873
Oil on canvas,
18 × 21½ in.
(45.7 × 54.6 cm.)
Museum of Fine Arts,
Springfield (Mass.)

This painting gives a clear idea of the influence exercised by Pissarro on the development of the younger artists who adhered to the Impressionist movement, including Cézanne.

Camille Pissarro
Avenue de l'Opéra.
Morning, Effect of Snow

1898
Oil on canvas,
25½ × 32¼ in.
(65 × 82 cm.)
Pushkin Museum, Moscow

Views of Paris were no
doubt the subject that
Pissarro found most
congenial. The title gives
us the location, the time
of day and the weather
conditions: the painter was
fond of precision, seeking
a balance between freedom
of expression (in the
unrestrained brushwork)
and fidelity to the scene.

Camille Pissarro
La Côte du Jallais, Pontoise
(Jallais Hill, Pontoise)

1867
Oil on canvas,
34¼ × 45¼ in.
(87 × 114.9 cm.)
The Metropolitan Museum
of Art, New York. Bequest
of William Church
Osborn, 1951

Pissarro has perhaps been
more highly esteemed as a
teacher and promoter of
cultural events than as a
painter. Yet his rendering
of the landscape is a
"manual" of painting *en plein
air* and the Impressionist
fascination with light.

Federico Zandomeneghi

Venice, 1841–Paris, 1917

He is the only Italian painter, apart from de Nittis, who can truly be considered an exponent of Impressionism. To be strictly accurate, Zandomeneghi's participation in the Parisian group was limited to a well-defined period of his life and his career as a painter, which commenced with his training at the academy in Venice. Motivated by deeply patriotic feelings, Zandomeneghi took part in Garibaldi's expedition of the Thousand. Later he joined the group of Tuscan Macchiaioli, many of whom, like Fattori, had also taken part in the wars of independence. Despite a long stay in Tuscany and his friendship with Diego Martelli, Zandomeneghi stuck essentially to the themes of social realism, with overtones of human sympathy. In 1874 he moved to Paris and came into contact with the Impressionists: his palette grew lighter and his figures took on greater consistency, even in his portraits, while his views of the City of Light and the parks along the Seine were fully in line with developments within the group. Returning to Italy, Zandomeneghi began to investigate new techniques of expression in 1880, conducting precocious experiments with Divisionism and introducing pastels to create new and interesting color effects.

Federico Zandomeneghi
The Curl

1885
Oil on canvas,
35 × 18½ in.
(89 × 47 cm.)
Pinacoteca di Brera, Milan

Through the good offices of Diego Martelli, Zandomeneghi was able to spend an important period of his career in Paris, where he developed links with the Impressionists. His taste for venturing into the rooms of young women intent on looking after their appearance was perfectly in keeping with the later developments in the painting of Degas, the artist with whom Zandomeneghi formed a fertile friendship.

Federico Zandomeneghi
Place d'Anvers in Paris

1880
Oil on canvas,
35 × 18½ in.
(102 × 136 cm.)
Galleria Ricci Oddi,
Piacenza

The beautiful squares of Paris, sunlit and crowded with nurses and children, constitute one of the most vivid and successful aspects of Zandomeneghi's painting. In this canvas, one of the painter's masterpieces, it is possible to detect a move toward the effects produced by Pointillism, one of the currents that emerged out of Impressionism. This picture was painted at the end of the artist's long stay in Paris and just before his return to Italy, where he helped to spread the taste for Impressionism.

Symbolists

Paul Gauguin
Aha Oe Feii? (What, Are You Jealous?)
1892
Oil on canvas, 26 × 35 in. (66 × 89 cm.)
Pushkin Museum, Moscow

Gustave Moreau
The Itinerant Angel
1881
Watercolor
Musée Moreau, Paris

N ew requirements emerged in the panorama of European art toward the end of the nineteenth century, as a consequence of the radical changes that were taking place in the realm of philosophical and scientific thought. A mechanistic view of the world was giving way to a relativistic conception that left no room for a unitary interpretation of reality: Schopenhauer's work *The World as Will and Idea* stands at the beginning of this line of thought, which set out to demonstrate the folly of any attempt to confine reality within a system based on the logic of clear and distinct categories. Reality is what one sees, but it is also what escapes one's direct and immediate perception. From this perspective, Freud's *Interpretation of Dreams*, published in Vienna in 1900, helped to clarify the link between what is conscious and what is unconscious, and how this shapes the complex layers of the ego.

In parallel with this, the Impressionist movement, based on the idea of art as representation, was replaced as the dominant tendency in European art by Symbolism, which emerged out of the need to use *symbols* to reveal all those things whose reality is undeniable even when they cannot be seen.

In 1886, the year in which the adventure of painting *en plein air* ended with the eighth and last Impressionist exhibition, the writer Jean Moréas published his manifesto of Symbolism in the literary supplement of the newspaper *Le Figaro*. Different lines of research emerged within the movement, in so far as the artists who belonged to it came from different artistic backgrounds while sharing the same belief that painting, having lost its traditional social function, had to take on the role of communicating the underlying reality of existence. The view of art as nature gave way to that of art as symbol. What was new in Symbolism was the idea that any form represented in the work of art did not signify itself alone, but possessed an infinite number of meanings beyond itself, establishing a relationship between what is visible and what is beyond vision. In fact the word symbol, from the Greek συν–βαλλειν (to throw together), signifies something linked to something else and, at the same time, suggesting something different from itself.

The Symbolist movement was given a significant impetus in 1889 by the publication of Henri Bergson's *Essay on the Immediate Data of Consciousness*, which opened the way for

Vincent van Gogh
The Potato Eaters
1885
Cloth mounted on panel,
28¼ × 36½ in.
(72 × 93 cm.)
Rijksmuseum Kröller-Müller,
Otterlo

the affirmation of spiritual values and criticized scientific procedures and truths. Bergson came up with the notion of duration, i.e. the simultaneous presence of past and present in the consciousness. This was the same year that Paul Gauguin arrived in Paris and the exhibition he staged at the Café Volpini marked the moment of Symbolism's greatest prominence in the art world.

Ever since 1886 Gauguin, based in the Breton village of Pont-Aven, had been carrying out research that, without rejecting the achievements of the Impressionist experience in the field of perception, led to a type of figuration in which physical reality and the reality of the imagination were equally concrete. Yet Gauguin was well aware that in modern society there was no longer space or time for the imagination. Underlying this attitude was a strong ethical component that brought him temporarily close to van Gogh, whom Gauguin admired though without wishing to pursue the same artistic direction.

In fact, while Gauguin was conducting his research at Pont-Aven, van Gogh went to the Provençal city of Arles, in 1888, where he tried to put into effect his utopian plan of creating a community of "Impressionists of the South," together with Gauguin himself, with the aim of renewing the very foundations of art. Driven by an absolute demand for truth, van Gogh embarked on a sort of tragic challenge of reality that brought him to the point of madness and death. He tackled reality head on, without judging it, but trying to seize hold of it with the materials and means at his disposal as a painter and a human being. His portraits are emblematic of this: the figures are set motionless at the center of the canvas, with no relation to the surrounding space; the colors are bright and yet the picture emanates a sense of tragedy that derives from the artist's awareness of the unbridgeable gap between self and other. It is a fact that, while van Gogh in Arles was discovering the moral principle of what was to become Expressionism, Gauguin in the picturesque setting of Pont-Aven discovered its technical principle. Alluding to medieval stained-glass windows, in which every area of color was bounded by a metal strip (*cloison*), Gauguin coined the term *Cloisonnisme*, which he used to indicate the need to bring out the color and simplify the form, in order to attain a "synthesis of form and color."

One member of the group of young painters who gath-

Maurice Denis
Homage to Cézanne
1900
Oil on canvas,
70¾ × 94½ in.
(180 × 240 cm.)
Musée d'Orsay, Paris

ered around Gauguin in Pont-Aven was Paul Sérusier. When he returned to Paris at the end of 1888 he passed on Gauguin's teachings to the second generation of Symbolist artists, who would later adopt the name of the Nabis (from the Hebrew word *navi*, meaning "prophet"). The programmatic manifesto of the movement, *Définition du Néo-Traditionnisme*, was published in 1890 in the magazine *Art et Critique*, edited by the theoretician of the Nabis group, Maurice Denis. Denis, who was also a talented writer, set out to promote a close collaboration between art and literature and to propose, at the same time, a revaluation of the decorative arts. He went on to become the champion of a modern form of sacred art. Themes drawn from the Bible, mythology and history are also to be found in the Symbolist work of Gustave Moreau, this time distinguished by a tone that is at once sensual and mystical. Convinced that painting had to retain an air of mystery, disconcerting observers by keeping them at a distance, he filled his canvases with a host of symbols, going so far as to include a hieroglyphic script. Arnold Böcklin belonged to the same generation as Moreau and like him held a dominant position in the history of

the art of the imaginary in the late nineteenth century, while remaining essentially extraneous to the morbid and disquieting atmosphere of French Symbolism. The ambiguity that arose out of the contrast between dream and reality, out of figures that were at once mythical and realistic, frozen in a disturbing immobility, was the mark of his Symbolism. It was a style that owed a great deal to the lesson of the Italian primitives, and it was to them, in the same years, that the group of Victorian English painters known as the Pre-Raphaelite Brotherhood looked back. Its main representatives were Dante Gabriel Rossetti, John Everett Millais and William Holman Hunt.

The movement's theorist was John Ruskin who, following the negative reactions of the public and critics to Rossetti's work *Ecce Ancilla Domini*, shown in April 1850 at the Portland Gallery, and Millais's *Christ in the House of His Parents*, exhibited subsequently at the Royal Academy, gave them his authoritative support, ensuring the Pre-Raphaelites' success. The bewilderment stemmed from the fact that fundamental moments in Christian history were represented as if they were genre scenes, stripped of the sacred atmosphere that surrounded them in the

collective imagination. In spite of Ruskin's defense, Rossetti never showed his work in public again. He also avoided religious subjects and gave up oil painting for drawing and above all watercolor. He did not go back to painting in oil until after 1860, when the first phase of the Pre-Raphaelite movement could be considered at an end. Rossetti would still be the dominant figure in the following decade, when he painted almost exclusively portraits of women, the first artist to identify what was to become one of the key motifs of Symbolist culture. Within an iconography that set the seal on the painter's last years, Rossetti utilized powerful metaphors that were to become typical of Symbolist language, dropping the sentimental attitude of late Romanticism and creating female figures with tormented expressions that were a prelude to the anguished images of Munch.

The process of rejection and transcendence of realism, through recourse to myth, was also characteristic of another naïf painter, Henri Rousseau, whose work represents a unique and separate experience in the figurative culture of the French avant-garde. When looking at an apocalyptic allegory like *War* (1894), which the "ingenuous" Rousseau composed in the descriptive manner of popular prints, it is impossible not to see premonitory signs of the reality that Picasso was to capture in his *Guernica*. To view the myths of modern civilization through the eyes of the bewildered primitive, Rousseau had no need to leave Paris, unlike Gauguin, who was forced to seek refuge on Tahiti, in order to denounce the folly of Western civilization.

Henri Rousseau
Horse Attacked by a Jaguar
1910
Oil on canvas,
35½ × 45¾ in.
(90 × 116 cm.)
Pushkin Museum, Moscow

153

Vincent van Gogh

Groot Zundert, 1853–Auvers-sur-Oise, 1890

The son of a Protestant pastor, he studied theology as a child and then, in 1869, went to work for the art dealers Goupil and Co., first in The Hague, then at the London branch and finally in Paris until 1876, when he was fired. In 1878, after repeated but vain attempts to fit into the world of work, in which he was hampered by his inability to accept the rules of society, he decided to go to Belgium to do missionary work. The following year, however, he was dismissed by the religious authorities for his literal interpretation of Christian

teaching. Yet it was here, among the miners of the Borinage region, that he discovered his vocation for painting. In the faces of those men, ravaged by the pain and toil of their lives spent in the harsh conditions of the coal mines, he recognized the living image of Christ's suffering and everything that he saw automatically became part of his artistic imagery. His early work, with its marked social content, is clearly derived from the Realism of the second half of the nineteenth century, and in particular Daumier's ability to accentuate expression to the point of distorting reality. In February 1886 he was called back to Paris by his brother Theo. At that time debate was raging over the future course

of Impressionism, but van Gogh became only partially involved. In 1888 he moved to Arles, in the South of France, where he was dazzled by the light of the Mediterranean and his style was enriched with new colors, transferred onto canvas in separate brushstrokes laden with paint. Gauguin came to stay with him in Arles, but the friendship between the two painters lasted only a few dramatic months. Tormented by recurrent bouts of anxiety and fits of self-destructive violence, van Gogh left Arles the following year and admitted himself for treatment at the mental hospital in Saint-Rémy. His work grew feverish and passionate: into every subject, and not just his numerous

self-portraits, he poured all the drama of his complex existential crisis. In May 1890 he left Saint-Rémy for Auvers-sur-Oise, where he was a guest of Doctor Gachet. Here, after a short period in which he seemed to be recovering, he started to suffer from increasingly frequent attacks of madness. These found expression in a visionary style of painting of unprecedented violence. In July of the same year, in a field of ripe wheat flooded with sunlight, the artist shot himself.

Vincent van Gogh
The Bridge at Langlois

1888
Oil on canvas,
19½ × 25¼ in.
(49.5 × 64 cm.)
Wallraf-Richartz Museum,
Cologne

This is one of several
pictures van Gogh painted
of a drawbridge, in a
technique that is already
remote from the earlier
Parisian paintings: the very
clear-cut divisions of the
space and the stylized
brushstrokes are
reminiscent of Japanese
prints.

Vincent van Gogh
Portrait of Père Tanguy

1887–88
Oil on canvas,
25½ × 20 in.
(65 × 51 cm.)
Private collection

Père Tanguy was an art
dealer who supplied the
artist with material: not
just canvases and paints
but also Japanese
woodcuts, much in vogue
among the Impressionists.

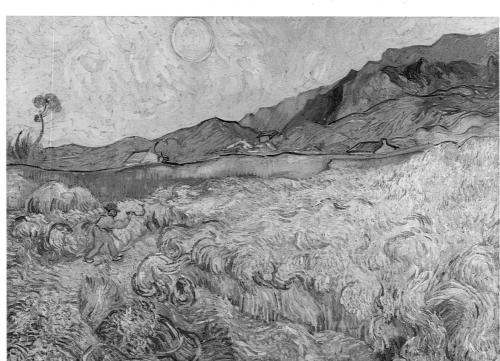

Vincent van Gogh

The Reaper

1889
Oil on canvas,
23½ × 28¾ in.
(59.5 × 73 cm.)
Rijksmuseum Vincent
van Gogh, Amsterdam

The picture was painted
in the fall, during the
artist's stay at Saint-Rémy-
de-Provence, where he had
voluntarily entered a
hospital.

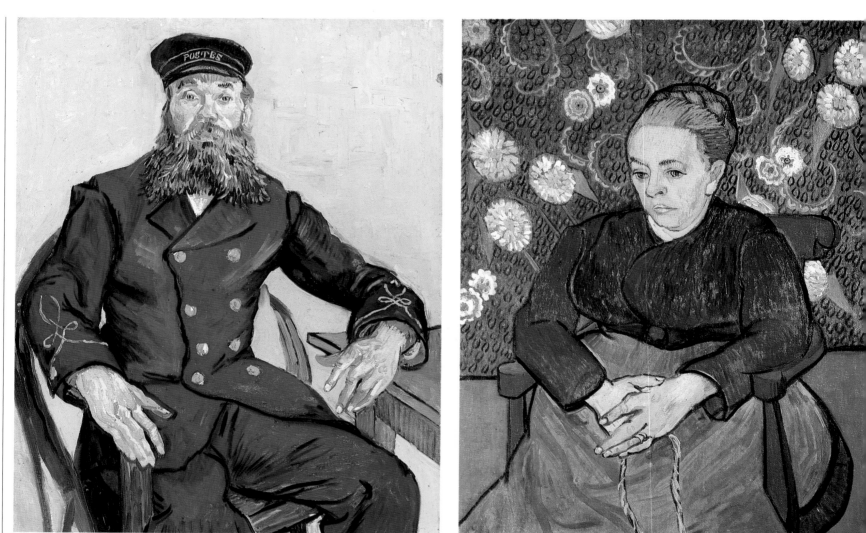

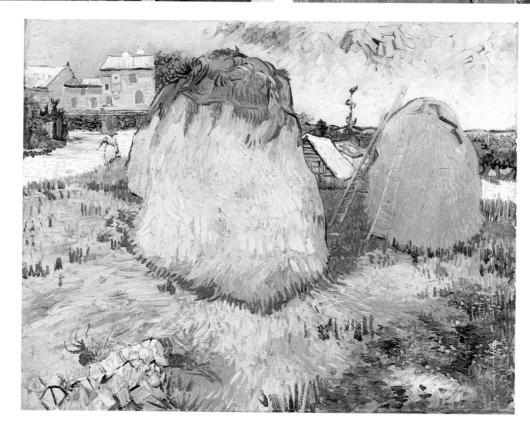

Vincent van Gogh
Portrait of Joseph Roulin

1888
Oil on canvas,
32 × 25¾ in.
(81.2 × 65.3 cm.)
Museum of Fine Arts,
Boston

This is the first and largest
of six portraits of Roulin
the postman, painted in
Arles between July 1888
and April 1889.
The man, with his high
forehead, small gray eyes
and thick beard, embodies
the Provençal type: a
person with a dignified
appearance, wise and
with a good heart.

Vincent van Gogh
La Berceuse

1888–89
Oil on canvas,
36½ × 28¾ in.
(92.7 × 72.8 cm.)
Museum of Fine Arts,
Boston

There are five versions
of the portrait of Madame
Roulin, all with the same
pattern of wallpaper in the
background, a motif that
also appears in some of the
portraits of her husband.

Vincent van Gogh
Haystacks near a Farmhouse

1888
Oil on canvas,
28¾ × 36½ in.
(73 × 92.5 cm.)
Rijksmuseum
Kröller-Müller, Otterlo

The series of wheat fields
and other farm scenes was
painted during van Gogh's
stay at Arles, where he had
moved from Paris.

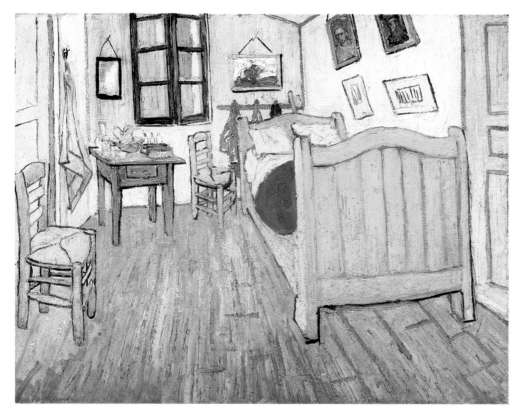

Vincent van Gogh
The Artist's Room in Arles

1888
Oil on canvas,
28¼ × 35½ in.
(72 × 90 cm.)
Rijksmuseum Vincent
van Gogh, Amsterdam

Based on three pairs
of complementary colors,
red-green, yellow-violet
and blue-orange, it
was a painting very dear
to the artist, who thought
that it represented the
highest expression of his
pictorial language. He
wrote: "It seems to me
that the technique is
simpler and more
energetic. No more
dotting, no more hatching,
nothing, just uniform
colors in harmony."

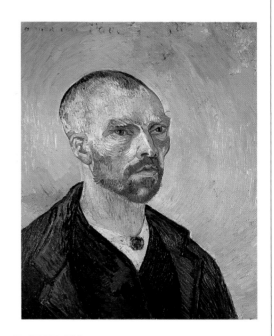

Vincent van Gogh
The Night Café

1888
Oil on canvas,
27½ × 35 in.
(70 × 89 cm.)
Yale University Art
Gallery, New Haven

A haunt of vagabonds and
failed artists looking for
solace, the interior of this
café is dominated by the
looming presence of a
billiard table. Behind it,
the owner of the café,
dressed in white,
constitutes a sort of visual
pause in the midst of
the vivid and exaggerated
tones of the rest of the
picture.

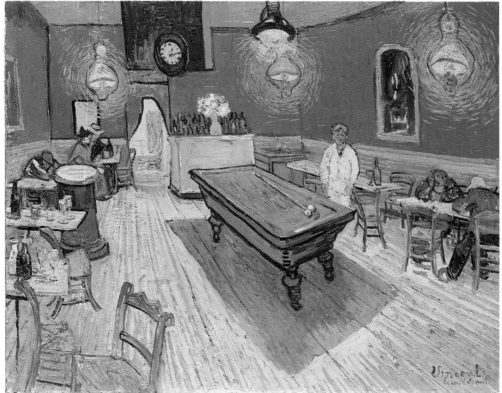

Vincent van Gogh
*Self-Portrait with Shaved
Head*

1888
Oil on canvas,
24½ × 20½ in.
(62 × 52 cm.)
Fogg Art Museum,
Cambridge (Mass.)

After the failure
of his attempt to set
up a community of
"Impressionists of the
South," with Gauguin
as the director, all that
remained of the idea was
a number of self-portraits
painted by the two men,
following a custom
widespread among
Japanese artists. Here
van Gogh portrays
himself in the manner
of a Buddhist monk.

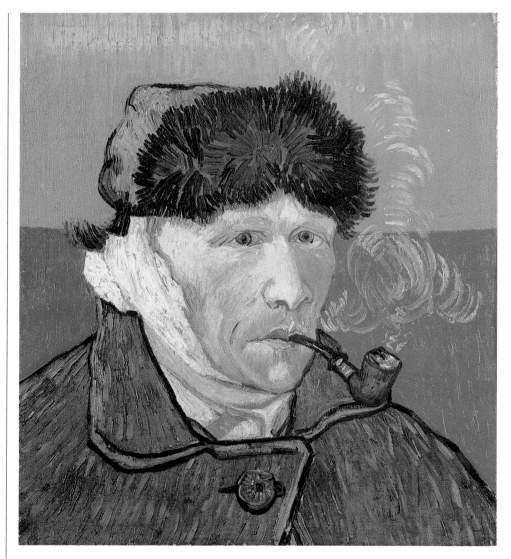

Vincent van Gogh
*Self-Portrait with Pipe
and Bandaged Ear*

1889
Oil on canvas,
20 × 17¾ in.
(51 × 45 cm.)
Private collection

The artist painted this
famous self-portrait in
front of a mirror. We know
this from the fact that the
bandage covers his right
ear, when it was actually
the left one that he cut off
with a razor following an
argument with his friend
Gauguin.

Vincent van Gogh
Wheat Field with Crows

1890
Oil on canvas,
20 × 40½ in.
(50.5 × 103 cm.)
Rijksmuseum Vincent
van Gogh, Amsterdam

This is van Gogh's last
work and spiritual
testament. Unlike his
earlier views of similar
subjects, the wheat field
does not convey a sense
of sunlit brilliance.
The dramatic and
gloomy tones of the
picture are accentuated
by the ominous flight
of crows and the
angry and uneven
brushstrokes.

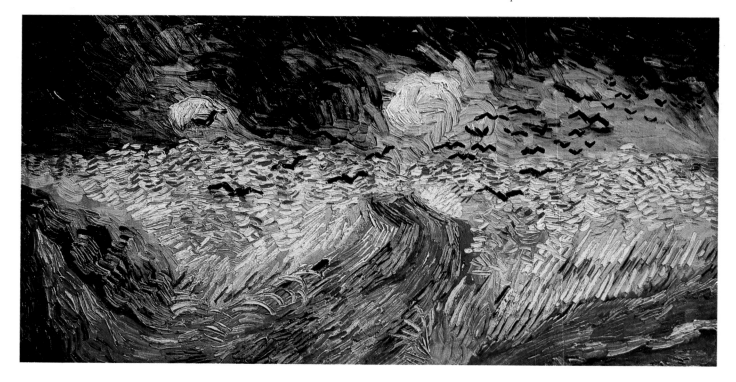

Vincent van Gogh
The Sower

1888
Oil on canvas,
25¼ × 31¾ in.
(64 × 80.5 cm.)
Rijksmuseum
Kröller-Müller, Otterlo

A predominantly
monochromatic
composition, based on
shades of yellow, the
brilliant color that
van Gogh used so
obsessively.

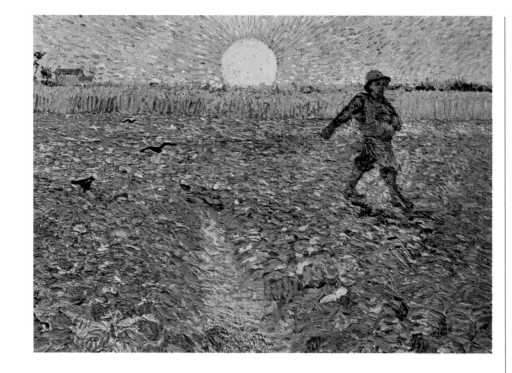

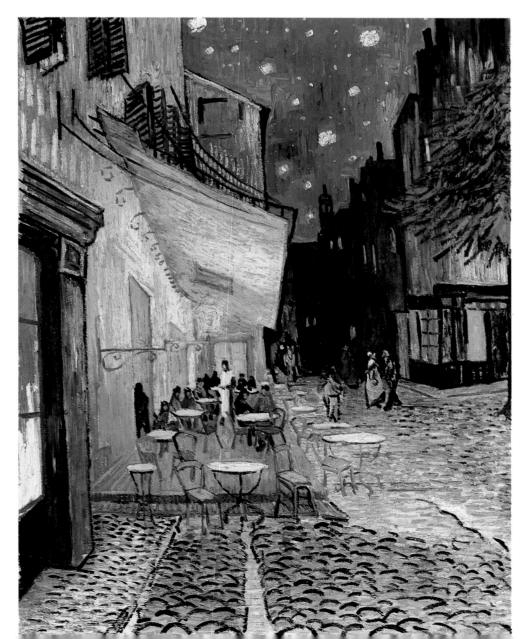

Vincent van Gogh
*Terrace of the Café
on the Place du Forum*

1888
Oil on canvas,
32 × 25¾ in.
(81 × 65.5 cm.)
Rijksmuseum
Kröller-Müller, Otterlo

This is one of the earliest
pictures painted at Arles.
The space is sharply
subdivided: in the
background on the right
we see a dimly-lit group
of houses under a vivid
starry sky; on the left-hand
side of the canvas, in full
light, the café terrace
with its empty tables.

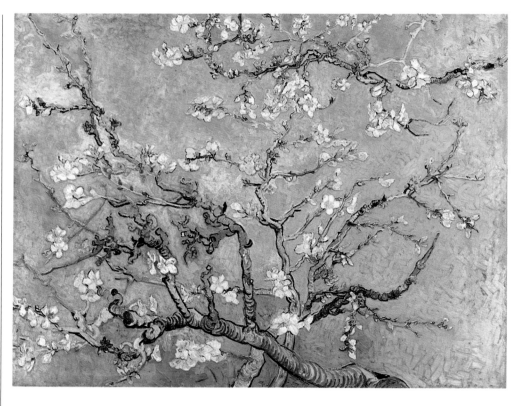

Vincent van Gogh
Church at Auvers

1890
Oil on canvas,
37 × 29¼ in.
(94 × 74 cm.)
Musée d'Orsay, Paris

The artist's personal
approach to the
representation of this
landscape is evident from
the emphatic and irregular
brushstrokes used for the
sky and vegetation.

Vincent van Gogh
*Almond Branches
in Blossom*

1890
Oil on canvas,
29 × 36¼ in.
(73.5 × 92 cm.)
Rijksmuseum Vincent
van Gogh, Amsterdam

The picture, painted
by van Gogh to celebrate
the birth of his nephew,
shows the influence
of Japanese prints, even
though he avoids excessive
stylization.

Vincent van Gogh
Sunflowers

1889
Oil on canvas,
37½ × 28¾ in.
(95 × 73 cm.)
Rijksmuseum Vincent
van Gogh, Amsterdam

One of the artist's most
famous paintings, it has an
absolutely traditional
scheme of composition.
Its extraordinary effect
derives from the
combination of colors,
almost all based on shades
of yellow, and the fact that
the light does not come
from outside, with the risk
of dulling the tones, but
shines from within, making
the colors more powerful.

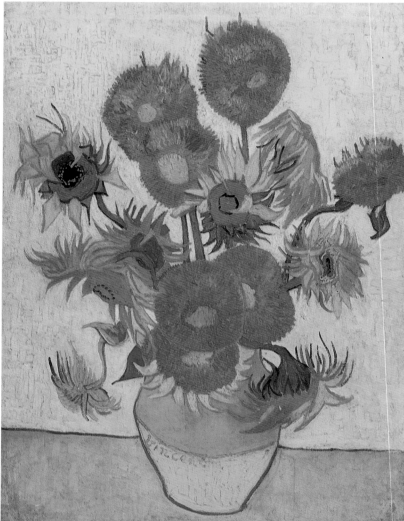

Vincent van Gogh
Self-portrait

1890
Oil on canvas,
25½ × 21¼ in. (65 × 54 cm.)
Musée d'Orsay, Paris

Between 1885 and 1890
van Gogh painted around

thirty-seven self-portraits.
The eyes staring out
of the picture, the lined
face and the unkempt red
beard around the mouth
convey a palpable sense
of the existential anguish
that has gripped the artist.

Vincent van Gogh
Prisoners Exercising

1890
Oil on canvas,
31½ × 25¼ in.
(80 × 64 cm.)
Pushkin Museum, Moscow

In a space hemmed
in by high walls of red
and blue brick, men
are walking round and
round, constantly retracing
their steps in a sort of
never-ending ring. Their
faces appear to express the
suffering that lies at the
root of human existence.

P Gauguin, 96

Paul Gauguin

Paris, 1848–Marquesas Islands, 1903

Inclined to adventure by temperament
and family tradition, Gauguin started
to paint in his free time while working
as a stockbroker. Continually beset by
financial problems, Gauguin saw Paris
as a suffocating prison filled with
hypocrisy, from which he tried to escape
in any way possible. His first flight was to
Pont-Aven in Brittany, in 1885: an obscure
village in a poor farming region, which he
made into one of the principal centers of
late nineteenth-century art. Spurning the
Impressionist fascination with light and
nature, Gauguin set out to simplify forms
into large, flat areas of color separated
by distinct outlines, used unnatural colors
and abandoned perspective. His objective
was to go beyond the sensory limits of
Impressionism, with the avowed intention
of seeking "suggestion rather than
description" and therefore shifting
attention from the physical world to that of
the mind. Faraway places, uncontaminated
by civilization, exercised a powerful
fascination on the artist. After a brief stay
in Panama in 1887, and then on
Martinique, he returned to Pont-Aven
and, in the boarding house run by Madame
Gloanec, assembled an eclectic group of
young artists and intellectuals, including
Maurice Denis and Emile Bernard.
Out of the quest for a fusion between
natural and supernatural came a new
style, Synthetism, the vehicle for an anti-
naturalistic and symbolic vision. In 1888
he went to stay with van Gogh in Arles,
but their friendship ended in a quarrel
and Gauguin was forced to flee. He
returned to Pont-Aven, only to set off
once again in search of uncorrupted places.
Taking refuge on Tahiti, surrounded by
the bright colors of the tropics and
the beautiful dark-skinned girls of
Polynesia, Gauguin gave vent to all his
passion for the exotic and primitive,
which he observed with a sense of ecstatic
contemplation as if it were the image of a
lost paradise. Yet his primitivism should not
be seen as a form of exoticism, however
cultivated and eclectic, but as an ethical
need to get away from modern society,
where there was no longer room or time
for the imagination. The arrival of
electricity on Tahiti and his continual
financial problems drove him further
and further from civilization, as far
as the Marquesas Islands, where
he died in 1903.

Paul Gauguin

*Te Tamari No Atua
(Nativity)*

1895–96
Oil on canvas,
37¾ × 50½ in.
(96 × 128 cm.)
Neue Galerie, Munich

On more than one
occasion the scenes and
figures he painted on
these remote islands
referred to religious
themes from the European
artistic tradition: in this
picture, a representation
of the Nativity appears
alongside the figure
of a woman sleeping
on a bed. In September
1895, after his lack
of success in Paris,
Gauguin returned
to Polynesia.

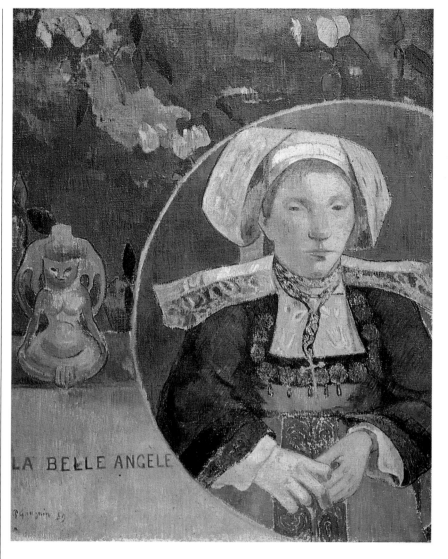

Paul Gauguin
La Belle Angèle

1889
Oil on canvas,
36¾ × 28¾ in.
(92 × 73 cm.)
Musée d'Orsay, Paris

Painted during his stay at
Pont-Aven, it is a portrait
of Marie-Angèlique Satre,
daughter of the owners of
a bistro close to Madame
Gloanec's boarding house,
where the artist was living.
The figure set inside a
tondo, unconnected with
the flowers in the
background, recalls the
style of Japanese prints,
much in vogue at the time.

Paul Gauguin
*The Vision After
the Sermon*

1888
Oil on canvas,
28¾ × 36¼ in.
(73 × 92 cm.)
National Gallery
of Scotland, Edinburgh

His first painting of a
religious subject, it
represents a turning point
in Gauguin's artistic
production: it is the
earliest example of a new
style, Synthetism, in which
the picture contains a real
plane (the Breton women
kneeling in the
foreground) and an
imaginary plane (the
biblical story of Jacob
wrestling with the angel).

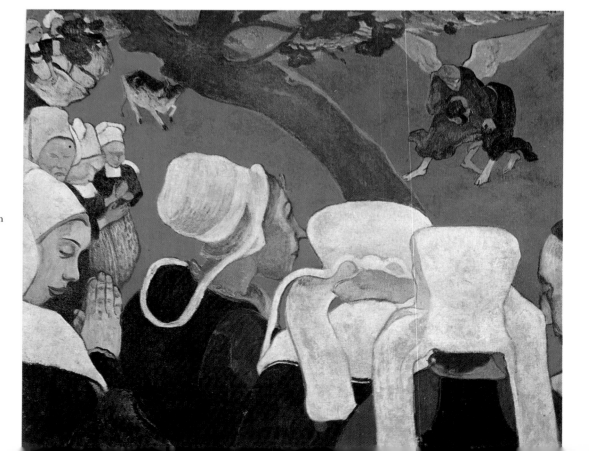

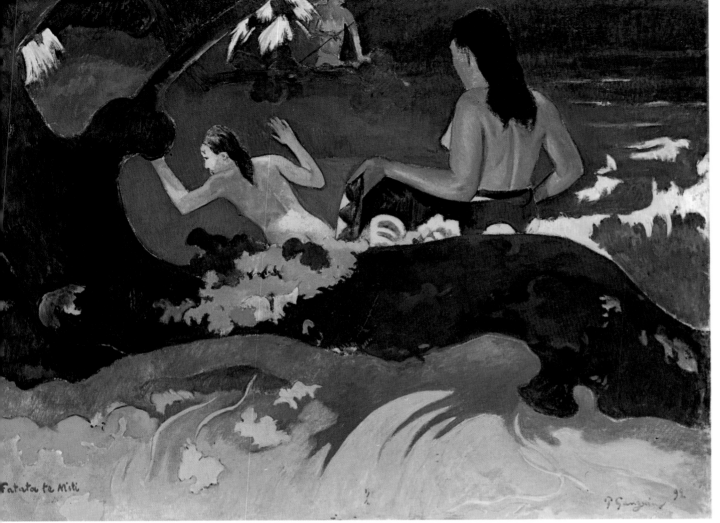

Paul Gauguin
Fatata Te Miti
(*By the Sea*)

1892
Oil on canvas,
26¾ × 36¼ in.
(68 × 92 cm.)
National Gallery,
Washington

Painted during his first stay
in Polynesia, it is a highly
decorative genre scene.
On the other side of
a tree trunk that cuts the
composition into two parts
of contrasting colors, two
naked women are about
to jump into the sea.
The presence of a man in
the background underlines
the fact that a sense
of modesty was unknown
on Tahiti.

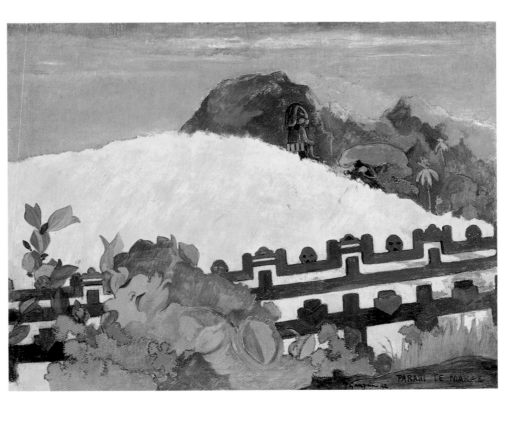

Paul Gauguin
Parahi Te Marae
(*There Is the Temple*)

1892
Oil on canvas,
26¾ × 35¾ in.
(68 × 91 cm.)
Philadelphia Museum
of Art, Philadelphia

Behind a fence with a
geometric design and
decorated with miniature
skulls, the picture is
dominated by a hill of an
intense yellow color. At
the top sits the statue of
a Polynesian deity, which
bestows a sense of mystery
on the composition.

Paul Gauguin
Parau Api
(Two Seated Tahitian Women)

1892
Oil on canvas,
26½ × 35¾ in.
(67 × 91 cm.)
Gemäldegalerie Neue
Meister, Dresden

Among the subjects
that derived from his
observation of native life,
one of the most common
was the representation
of women in static poses,
displaying their habitual
calm and placidity.

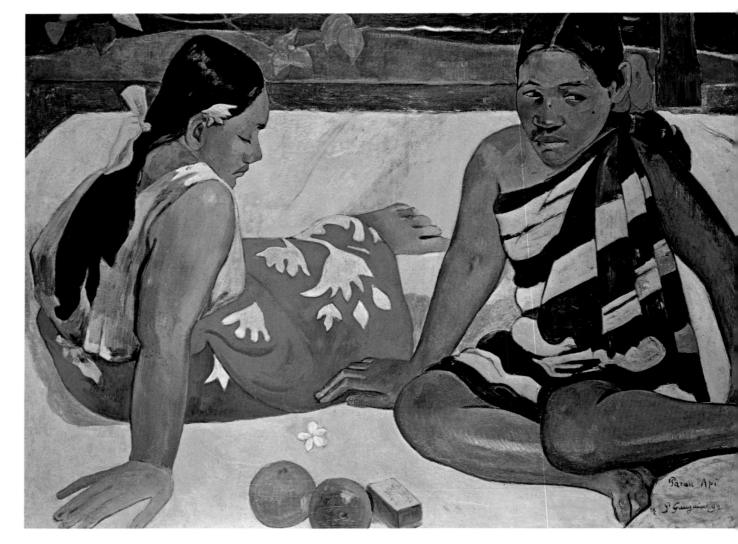

Paul Gauguin
Riders on the Beach

1902
Oil on canvas,
26 × 30 in.
(66 × 76 cm.)
Folkwang Museum, Essen

The view of riders
seen from behind
in the background of
an undefined landscape
is reminiscent of Degas's
pictures of the *Races
at Longchamp*, while
the colors are closer
to those used by Picasso
in his contemporary
Pink Period.

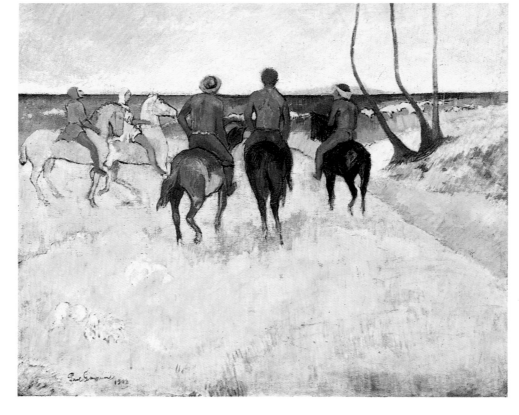

Paul Gauguin
The White Horse

1898
Oil on canvas,
55 × 35¾ in.
(140 × 91 cm.)
Musée d'Orsay, Paris

This is the first in a series
of pictures tackling the
theme of man and horse
that Gauguin painted
in his late maturity.
Here two naked men
on horseback and a horse
with its head bowed
standing in the shallows
of a pool of water
fill the space of a scene
which is characterized
by the freedom and
delicacy of their attitudes.

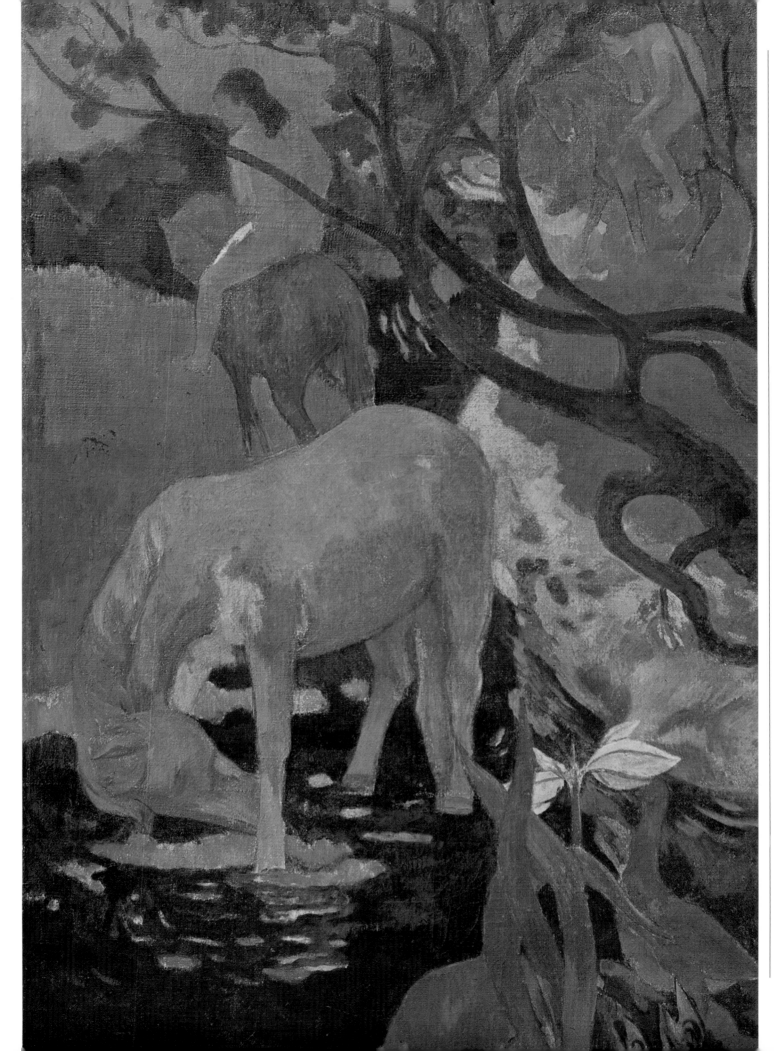

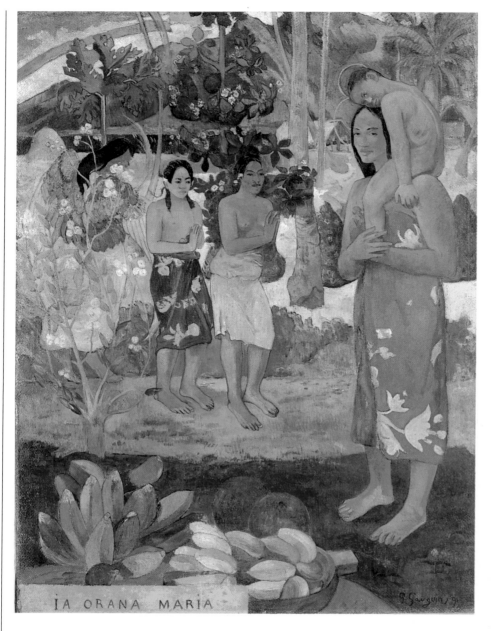

Paul Gauguin
Ia Orana Maria (Ave Maria)

1891–92
Oil on canvas,
44¾ × 34½ in.
(113.7 × 87.7 cm.)
The Metropolitan Museum
of Art, New York.
Bequest of Sam
A. Lewisohn, 1951

In a Polynesian landscape,
underlined by the exotic
still life in the foreground,
an angel with yellow wings
indicates the presence
of Mary with the Child
riding on her shoulder
to two young women.
The scene testifies
to the cultured nature
of Gauguin's primitivism.

Paul Gauguin
*Nave Nave Mahana
(Holiday)*

1896
Oil on canvas,
37½ × 51¼ in.
(95 × 130 cm.)
Musée des Beaux-Arts,
Lyons

During his second stay
on Tahiti, his production

was dominated by
compositions with many
figures, arranged with a
special feeling for their
decorative effect. Here we
see seven Tahitian women
and a child on the tree-
lined banks of a stream.
The monumentality
of the figures is attenuated
by the rhythmic pattern
of the curved lines
of the trees.

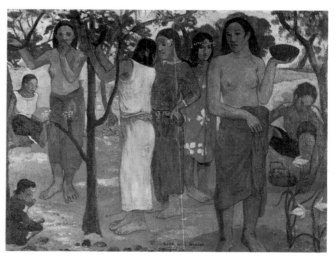

Paul Gauguin
*Where Do We Come From?
Who Are We?
Where Are We Going?*

1897–98
Oil on canvas,
26¾ × 35¾ in.
(139 × 374.5 cm.)
Museum of Fine Arts,
Boston

In this large canvas blue
and green spaces dotted
with areas of brown and
linear arabesques without
an expressive function
appear to be translating
the performance of a
symphony into pictorial
language.

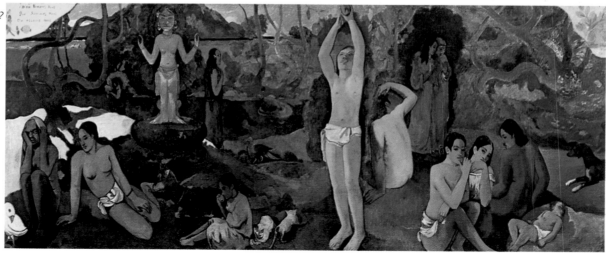

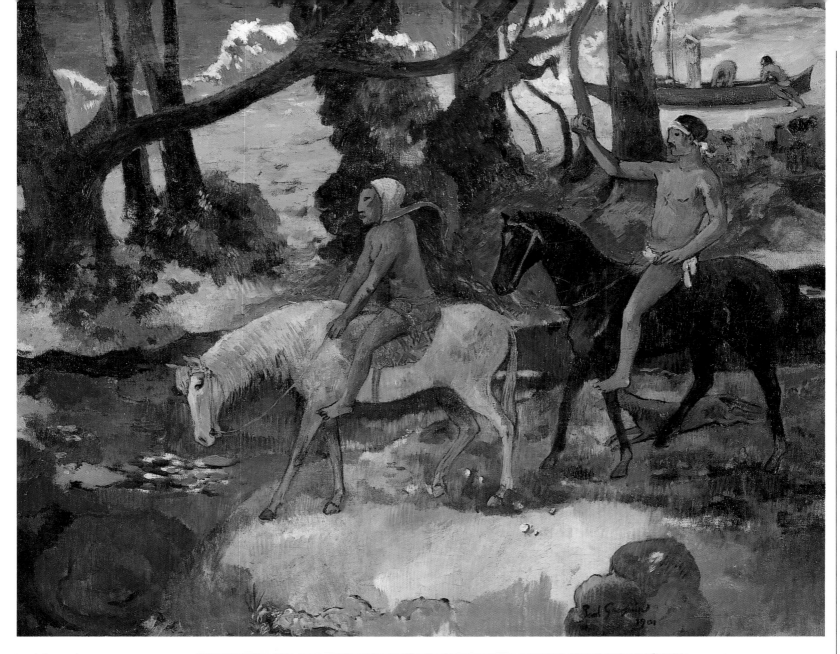

Paul Gauguin
Ford

1901
Oil on canvas,
30 × 37½ in.
(76 × 95 cm.)
Pushkin Museum, Moscow

Here we return to the
theme of riders, so popular
with Gauguin toward the
end of his life. The bright
colors help to create the
atmosphere of a mythical
landscape, in which it is
possible to discern the
influence of Dürer's
celebrated engraving
*The Knight, Death and
the Devil*, of which Gauguin
possessed a reproduction.

Paul Gauguin
Otahi (Sola)

1893
Oil on canvas,
19¾ × 28¾ in.
(50 × 73 cm.)
Private collection, Paris

Gauguin portrays a woman
crouching on the sand,
her head propped on her
hands. It is a variation
of a drawing by Degas,
intended to show that a
nude depicted from behind
can be just as revealing
of personality and social
condition.

Maurice Denis
September Evening

1910
Oil on canvas,
25¼ × 36½ in.
(64 × 93 cm.)
Musée de Brest, Brest

Figures seen in languid
positions fill the
foreground of this painting
in which we can discern
the tendency toward
transposition of the ideal
into figures, settings
and situations drawn
from everyday life.

Maurice Denis

*Granville, 1870–Saint-Germain-en-Laye,
1943*

The founder and leading light of the Nabis
group, he combined his activity as a painter
with that of theorist and art critic: in
1890 he published the movement's
manifesto in the magazine *Art et Critique*.
Thus he exercised an influence on the
numerous men of letters with whom he
came into contact, as well as on artists.
The decisive influence on his development
came not from his studies at the Académie
Julian in Paris, but from his meeting with
Gauguin and the critic Emile Bernard, at
Pont-Aven in 1888. Here, together with
Sérusier and Bonnard, he worked in close
contact with nature, seeking not to record
its appearance but to re-create its inner
essence. Consequently Denis renounced
the Impressionist premises of his style

and chose to place the emphasis on
decoration, laying on the paint in flat
areas of color with clear outlines. In his
manifesto of Symbolism, Denis reminded
painters that "a picture—before being a
war horse, a nude, or an anecdote of some
sort—is essentially a flat surface covered
with colors assembled in a certain order."
The simplicity of the themes chosen
by the Nabis (very different from the
sophisticated work of Parisian artists), the
use of pure colors and Gauguin's emphasis
on morality induced Denis to give the
group a mystical connotation. The
peremptory character of their pictorial
representations, their fondness for allusive
scenes and mysterious landscapes and the
idealization of their figures place Denis
and his group at the origins of European
Symbolism. Thus his most mature manner,
in which the forms of objects, landscapes
and figures are reduced to colored
silhouettes, can be regarded as the

precursor of abstractionism. Toward
the end of the century, after a visit
to Italy where he was able to study the
work of the Renaissance masters, Denis
adopted a more monumental approach.
A new chapter in the evolution of
his style opened, with an inclination
toward sumptuous decoration and the
depiction of classical, mythological and
religious themes. In 1913, returning
to the tradition of large-scale mural
painting, he decorated the dome of the
Théâtre des Champs-Elysées in a manner
inspired by a complacent and intellectual
type of Catholic mysticism.
This work and his subsequent decoration
of the Petit Palais made the artist popular
with the public as an illustrator of sacred
themes. Denis, who was deeply religious,
had always shown great interest in
the genre of sacred art, going so far
as to found the "ateliers de l'art sacre"
with Rouault.

Maurice Denis
April

1892
Oil on canvas,
14¾ × 24 in.
(37.5 × 61 cm.)
Rijksmuseum
Kröller-Müller, Otterlo

Graceful young women, depicted in stately poses with suspended gestures, as if frozen in a remote time, result in an elegant composition that is "minimalist" in its symbolism.

Maurice Denis
Green Beach

1909
Oil on canvas,
38¼ × 70¾ in.
(97 × 180 cm.)
Pushkin Museum, Moscow

The picture testifies to the artist's gradual return to naturalism, which commenced around the end of the 1890s. The flat colors, sharp outlines and figurative simplicity hark back to the Italian primitives, but are also an anticipation of the forms of abstractionism.

173

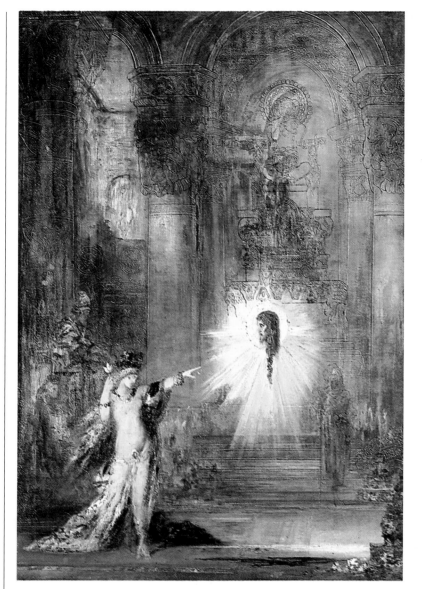

Gustave Moreau
The Apparition
(*The Dance of Salome*)

1876
Oil on canvas,
56 × 40½ in.
(142 × 103 cm.)
Musée Moreau, Paris

A characteristic feature
of Moreau's painting is
the highly personal blend
of biblical themes and
elements drawn from
mythology. Here, at the
center of the composition,
we see the decapitated
head of the Baptist,
surrounded by a halo of
light to signify that his
thoughts and words will
go on living after his death.
The female figure
on the left-hand side
of the picture creates an
atmosphere that is sensual
and mystical.

Gustave Moreau
Paris, 1826–1898

With the encouragement of his family,
and in particular his father Louis Moreau,
a Neoclassical architect, he decided
on a career in art. In 1846 he was admitted
to the Ecole des Beaux-Arts in Paris, but
the decisive influence on his formation
came from the journey he made to Italy.
Between 1857 and 1859 he visited Rome,
Florence, Milan, Venice and Naples,
collecting material for the future:
drawings, watercolors and copies of works
from antiquity and by the primitives and
Renaissance painters. In Rome he attended
figure classes at Villa Medici, the seat of
the Academy of France, explored churches
and ancient ruins and studied the works
of Leonardo, Raphael and Correggio. But
the real revelation of his stay in Italy was
the Venetian painter Carpaccio, who
was little appreciated at the time. Moreau
was fascinated by the grace, charm and
purity of his pictures and, above all, by
their Venetian tonality. In order to study
Carpaccio, he spent three months in
Venice, dividing his time between the
Scuola di San Giorgio degli Schiavoni and
the Gallerie dell'Accademia. Moreau
started to be successful in 1864, when
he exhibited *Oedipus and the Sphinx*
at the Salon. The powerful symbolism
of the painting fascinated the emperor's
cousin, Prince Napoleon, who bought it.
The following year the artist received the
official seal of approval: one of his paintings
shown at the Salon was acquired by the
State. Yet the critics were perplexed
by his work and his large canvases, for the
most part ignored by dealers and
collectors, did not meet with the public's
approval. Moreau, greatly disturbed by the
violent events of the Franco-Prussian War,
decided to undergo treatment at the spa
of Néris-les-Bains, which specialized in
the cure of nervous disorders. When he
recovered, he dedicated himself with new
energy to his work and it was in these
years that his style reached its peak: the
figures are imbued with a strong symbolic
charge, the naturalism is overwhelmed by
the delirious fantasy of the whole, the
chiaroscuro fades into golden shadows and
the representation is overlaid with a mesh
of arabesques. Pictures like *Salome*, *Galatea*,
The Apparition and *The Unicorns* were
destined to shape the taste of an entire
generation, influencing the Decadent
Movement. In his maturity the artist began
to keep records of his works, in the form
of tracings, drawings and replicas in oil
or watercolor, nursing the idea of turning
his house into a museum, which is what
he did in 1895.

Gustave Moreau
The Unicorns

c. 1885
Oil on canvas,
45¼ × 35½ in.
(115 × 90 cm.)
Musée Moreau, Paris

Here history and myth are
fused in a suggestive way:
a pattern of arabesques
is superimposed on the
colored parts, filled with
delicate shades, and the
end result is a conscious
and deliberately unfinished
effect, lending an unusual
transparence and freshness
to the painting.

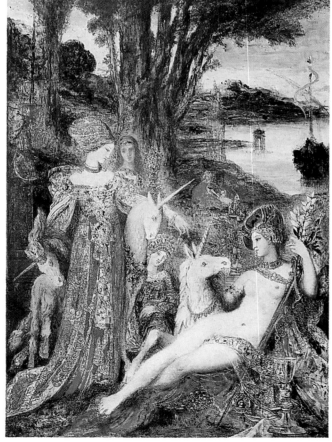

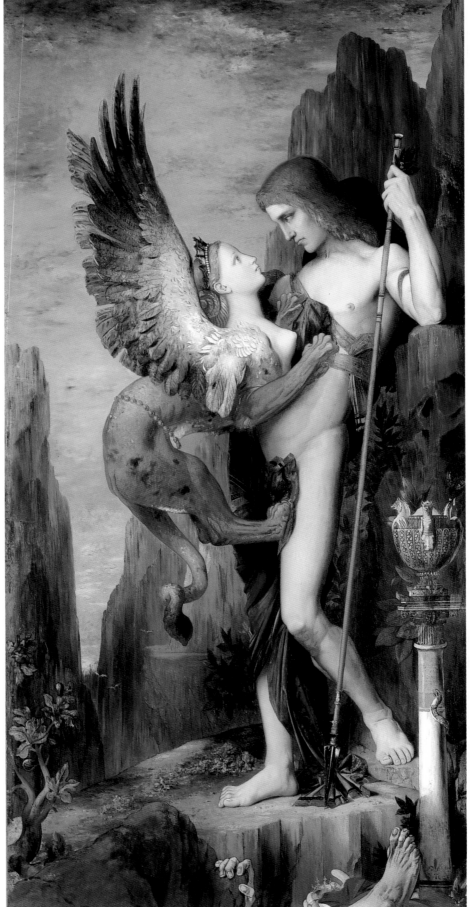

Gustave Moreau
Oedipus and the Sphinx

1864
Oil on canvas,
81¼ × 41¼ in.
(206.4 × 104.8 cm.)
The Metropolitan Museum
of Art, New York. Bequest
of William H. Herriman,
1920

This painting derives
from a rapid sketch,
reworked at great length.
The work marked the
beginning of Moreau's
success, as it was bought
by Prince Napoleon when
it was exhibited at the
Salon of 1864.

Arnold Böcklin

Basel, 1827–San Domenico di Fiesole, 1901

Trained at the Düsseldorf Academy, the young Böcklin traveled to Brussels, Antwerp and Paris for the purposes of study, and then moved to Rome in 1848. Here the impact of the ancient world served as a powerful stimulus to his imagination, as is apparent from paintings like *Roman Landscape* (1851) and *Centaur and Nymph* (1855). In 1860 he was appointed to the chair of Painting at the Weimar Academy, but in 1862 he was back in Rome, going on to visit Naples and Pompeii. The experience was to have a decisive influence on his later work. In 1866 he returned to Basel and then spent the years from 1871 to 1874 in Munich. Finally, he went to Florence, staying there for a decade (1874–84) and eventually returning to spend the last years of his life in Fiesole. The course of his artistic development was a singular one, distinguished by a Symbolism that owed nothing to the morbid and uneasy climate of the French movement, but stemmed from a mixture of myth and reality, past and present, in the ambiguous atmosphere of an allusive use of symbols that recalls the Wagnerian synthesis of the arts. According to Böcklin, every picture had to tell a story, to make the observer think as if it were a poem and to leave the impression of a piece of music.

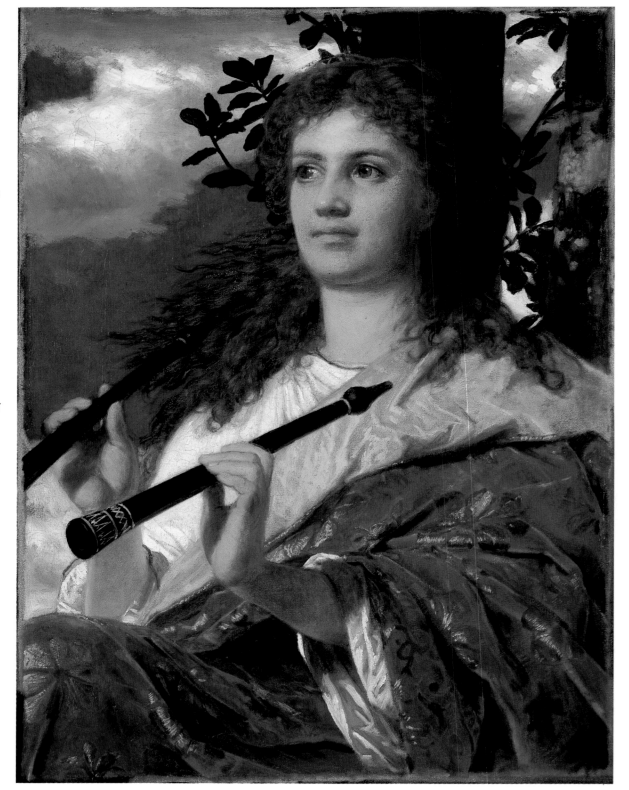

Arnold Böcklin
Anacreon's Muse

1873
Oil on canvas,
31 × 23½ in.
(79 × 60 cm.)
Aargauer Kunsthaus, Aarau

Painted during the years of intense creativity that he spent in Munich, from 1871 to 1874, the work is a homage to music and poetry, as embodied by the Greek lyric poet Anacreon. The female figure of the muse is depicted with realism and academic precision, showing how Böcklin's painting represents a quite unique aspect of the fantastic art of the end of the century, shunning the suggestive effect of the vague and indistinct.

Arnold Böcklin
The Island of the Dead

1880
Oil on canvas,
43¼ × 61 in.
(110 × 155 cm.)
Kunstmuseum, Basel

The landscape is frozen
into a disquieting
immobility, outside
real time and space.
The neutral brown
of the rocks and the
leaden gray of the sky
and sea make the luminous
white figure in the boat
stand out strongly.

Arnold Böcklin
The Sacred Wood

1882
Oil on canvas
Kunstmuseum, Basel

The extraordinary power
of Böcklin's pictorial work
stems from the ambiguity
of the contrast between
realistic figures and
classical settings, between
the concreteness of reality
and the timelessness of
myth.

177

Arnold Böcklin
Prometheus

1882
Oil on canvas
Barilla Collection, Parma

A reexamination of Greek myth played a large part in Böcklin's production after his journey to Italy, and in particular his visit to Naples and Pompeii. Here the tale of Prometheus gives rise to a composition in which the luminosity of the Mediterranean myth is blended with Northern European phantoms and shadows, in a dimension of space and time poised between dream and reality.

John Everett Millais

Southampton, 1829–London, 1896

A member of the Pre-Raphaelite Brotherhood, he was one of the movement's most gifted exponents and his works quickly gained the favor of the critics and public. Between 1850 and 1860 Millais painted some of the most significant of all Pre-Raphaelite works, such as *Ophelia*, a picture of the Shakespearean heroine that was shown at the annual exhibition of the Royal Academy of Arts in London in 1852. Glaring contradictions soon emerged within the group, but Millais was able to fuse the romantic medievalism of Rossetti with the hyperrealism of Hunt, with the common intent of challenging

academic art. The following year, however, he was elected an associate member of the aforementioned academy in London and entered the painting establishment. As the Pre-Raphaelite Brotherhood broke up, Millais, relying on the popularity he had already attained and attracted by the idea of making easy money, rapidly gave up the narrative genre and the group's rigid and severe technique to paint sentimental subjects and society portraits. From the sixties onward he produced pictures in decidedly Victorian taste, achieving economic success and greater popularity than his colleagues, who had remained faithful to the principles of the group even after its dissolution. In 1863 he was made a full member of the Royal Academy and in 1896, the year of his death, received its highest accolade when he was appointed its president.

John Millais
Ophelia

1852
Oil on canvas,
30 × 43¾ in.
(76 × 111 cm.)
Tate Gallery, London

The protagonist of this moving picture, inspired by one of Shakespeare's plays, is Ophelia, depicted at the moment of her suicide, a desperate gesture to which she is driven by the apparent madness of her beloved Hamlet.

Not just the subject but even the flowers and plants, reproduced with botanical accuracy, are drawn from the text of the play, where the willow is associated with abandoned love, the nettle with sorrow and the daisy with innocence. It is said that, to make the picture as realistic as possible, the model Elizabeth Siddal had to pose in a tub filled with water heated by oil lamps from below. She became seriously ill as a result.

Dante Gabriel Rossetti

London, 1828–Birchington-on-Sea, 1882

The son of an Italian political exile, he was a painter, a poet and the translator of Dante's *Vita Nuova*. He was also one of the founders of the Pre-Raphaelite Brotherhood, a movement that was descended from the German Nazarenes and adopted their program of a return to the stylistic simplicity, purity and feeling for nature typical of pre-Renaissance art. Rossetti, together with Holman Hunt and John Everett Millais, took his inspiration from the Middle Ages and set out to create a truthful and deep-felt kind of painting. He started by illustrating literary texts, such as Goethe's *Faust* and Poe's *The Raven*, showing a preference for drawing as a free and immediate technique. Between 1848 and 1850 he painted two oils with religious subjects, *The Girlhood of Mary* and *Ecce Ancilla Domini*, both now in the Tate Gallery, London. Critics took offence at the domestic setting, analytical representation and painstaking detail, considered inappropriate to a sacred scene. Queen Victoria even asked to view them in private so that she could judge their provocative character for herself.

In 1853 cracks started to appear in the Brotherhood: Rossetti's medievalism clashed with Hunt's analytical realism and Millais's Victorian taste. After 1860 the movement entered a second phase, distinguished by its smooth and flowing lines, defined as "soft edge." Rossetti now shifted his attention from the Middle Ages to the art of the High Renaissance and, in particular, the great portraits of the sixteenth century. His art found its most significant expression in female figures, angelic girls or perverse creatures, women of an imposing, distant beauty, imbued with an inaccessible fascination. Rossetti's woman was half goddess and half *femme fatale*, on the one hand an idealized figure derived from Dante and Stil Novo poetry and on the other a sensual source of evil. in his maturity, the artist's favorite model was Jane Burden, the wife of his friend William Morris, a languid creature with an enigmatic face for whom he nursed an exclusive passion right up until his death.

Dante Gabriel Rossetti
Ecce Ancilla Domini

1850
Oil on canvas,
28¼ × 17 in.
(72 × 43 cm.)
Tate Gallery, London

The picture aroused the hostility of the public and critics alike, who were unable to accept such a plain vision of a sacred event. The strongest reaction came from Charles Dickens, who described the work as "repellent and revolting."

Dante Gabriel Rossetti
The Wedding of Saint George and Princess Sabra

1857
Watercolor,
13½ × 13½ in.
(34.3 × 34.3 cm.)
Tate Gallery, London

Following the hostile reaction of the critics to his works, Rossetti abandoned oil painting in the fifties and devoted himself exclusively to drawing and watercolor. He also turned away from religious themes in favor of subjects drawn from Dante or medieval tales of chivalry.

Dante Gabriel Rossetti
Mona Vanna

1866
Oil on canvas,
35 × 34 in.
(88.9 × 86.4 cm.)
Tate Gallery, London

Defined by the painter himself as a "Venetian Venus," the picture displays distinctly Venetian characteristics: the woman's pose, the color, the brushwork and the elaborate clothing hark back to the portraits of Titian, Lotto and above all Sebastiano del Piombo (for instance *La Fornarina* in the Uffizi).

Henri Rousseau
The Snake Charmer

1907
Oil on canvas,
65 × 70¾ in.
(165 × 180 cm.)
Musée d'Orsay, Paris

The painting recalls an
engraving by Gauguin
shown at the Salon
d'Automne in 1906.
Here the exotic landscape
is inserted in a complex
structure, illuminated by
a cold light that is reflected
in the water. The figures
are flat and motionless
silhouettes, immersed in a
monumentality that has no
depth, while the landscape
is that of a fantastic and
unreal forest.

Henri Rousseau
The Exotic Jungle

1909
Oil on canvas,
55¼ × 50¾ in.
(140.5 × 129 cm.)
National Gallery,
Washington

The painting belongs
to the series of exotic
landscapes that became
almost virtuoso exercises
between 1908 and 1910.

Henri Rousseau, called Le Douanier

Laval, 1844–Paris, 1910

Rousseau is a truly unique figure in the
panorama of art at the turn of the century.
For a long time artists, critics and the
public were divided into two distinct
camps: was his simple and primitive
painting really a naïve form of expression,
or was its apparent simplicity the fruit
of a calculated choice? A petty official in
the Paris toll office (whence his nickname
of *Le Douanier*, or "the Customs Officer"),
he started to paint at the age of forty,
producing still lifes and landscapes in
which the representation of reality relied
on the exact reproduction of individual
details, ignoring the spatial relations
of perspective. Self-taught, he obtained
permission to copy works in the Louvre
and other museums in 1884 and
exhibited his first pictures at the Salon
des Indépendants in 1886. Initially his
works were ridiculed by the critics, but
his style was soon recognized as original
and modern and his paintings aroused the
interest of Impressionists, Symbolists and
even Picasso, who in 1908 held a banquet
in his studio in Rousseau's honor. The
support of intellectuals and artists like
Apollinaire, Gauguin and Picasso made him
a famous painter, a rallying point for the
avant-garde and, perhaps involuntarily,
for those opposed to it.

Henri Rousseau
War

1894
Oil on canvas,
55¼ × 50¾ in.
(114 × 105 cm.)
Musée d'Orsay, Paris

Exhibited at the Salon
des Indépendants in 1894,
the painting aroused
surprise and perplexity, but
also gained the support of
writers and artists, such as
Alfred Jarry and Picasso. In
this apocalyptic allegory a
female figure, bearing a
sword and torch, rides a
black horse beneath pink
clouds and above a heap of
corpses, torn by crows.

Henri Rousseau
The Repast of the Lion

c. 1904
Oil on canvas,
63 × 44¾ in.
(160 × 113.7 cm.)
The Metropolitan Museum
of Art, New York. Bequest
of Sam. A. Lewisohn, 1951

His new way of
approaching an exotic
theme provoked lively
reactions from the critics,
who accused the artist of
sharing the rigid mentality
of Byzantine mosaicists.
Yet the bold use of color
and the lack of geometric
perspective, a consequence
of Rousseau's being self-
taught, are extremely
modern elements.

183

Post-Impressionists

Paul Cézanne
Bathers (detail)
1873–77
Oil on canvas,
15 × 18 in. (38.1 × 46 cm.)
The Metropolitan Museum of Art, New York.
Bequest of Joan Whitney Payson, 1975

Henri de Toulouse-Lautrec
The Singer Yvette Guilbert
1894
Pastel and tempera on
cardboard, 22½ × 16½ in.
(57 × 42 cm.)
Pushkin Museum, Moscow

Around 1880, the Impressionist movement began to run out of steam. To be sure, many of its protagonists went on painting. Some of them, like Pissarro, remained scrupulously faithful to the tenet of capturing the "impression" of light and color; others, like Monet, went their own, solitary way, carrying out research that led to exciting results, verging on abstraction. The echo of Impressionism would go on ringing until the first decade of the twentieth century, but it was almost drowned out by the clamor of new stimuli and fascinating proposals, some of them far more decisive and enduring than the sophisticated ideas of the Nabis and Symbolists.

One name stands out above all others: that of Paul Cézanne. Within the limited horizons of a quiet and secluded life in the provinces, Cézanne wrought, work after work, one of the greatest revolutions in the history of art. Cézanne too passed through an Impressionist period, but soon became aware of the limitations to which the movement was inevitably subject. Therefore, choosing a restricted range of subjects (landscapes, human figures, still lifes), he began to analyze reality through the dual filter of a complex figurative culture and a quest for geometric synthesis. Without the subjects ever losing their perfect recognizability, Cézanne's paintings turned into images based on a carefully-calculated balance of line and color, anticipating all the avant-garde movements of the twentieth century: Cubism, Futurism and Expressionism have a common root in Cézanne's extraordinary artistic experiment. It is significant that Cézanne, while appreciated by his fellow painters and a few connoisseurs, was essentially undervalued during his lifetime, only to be sensationally rediscovered at the great retrospective staged in Paris after his death, in 1907. In fact, one of Cézanne's great merits lies in not having fallen into the trap of catering to the taste of the general public, which was fascinated by the scenes painted by the Impressionists, by the brightly-illuminated gardens, the glitter of the balls, the seductive allure of Parisian life. On the contrary, even in its choice of subjects, Cézanne's art is far from "charming": he preferred force to delicacy, energetic intervention to idle contemplation.

The simplification of his vision does not signify an impoverishment—from the strictly technical viewpoint,

Cézanne was a highly sophisticated artist. The same can be said of Georges Seurat, who died at an early age but not before he had laid the foundations of a highly successful movement, known as Pointillism or Divisionism. Seurat's rare but wonderful paintings, viewed cursorily and from a distance, may appear to represent a sort of continuity with Impressionism: the same luminosity, the same outdoor subjects, the same Sunday strolls through the parks on the outskirts of Paris. Yet Seurat actually turned the premises of Impressionism on their head. The scenes are not painted "from life" but painstakingly studied; the figures are not in movement but in perfect and absolute stasis (to such an extent that they call to mind Piero della Francesca); above all, the colors are handled in a new way. A keen student of the science of optics and the physics of vision, Seurat broke down each chromatic tone into a myriad tiny points of color, each distinct and separate from the others and laid on with scrupulous care. The path trodden by Seurat was followed by his disciple Signac, who was drawn chiefly to seascapes and the colors of the Mediterranean coast, and then by other painters who gave rise to a variety of movements in Europe with similar technical characteristics. In Italy, for example, the technique also known as Divisionism was based on the division of colors into individual strokes of paint. It is interesting to note that the Italian version of Divisionism was applied to pictures of very different

Paul Cézanne
Woman with a Coffee Pot
1890–94
Oil on canvas,
51¼ × 37¾ in.
(130 × 96 cm.)
Musée d'Orsay, Paris

Gaetano Previati
Triptych of the Day
1907
Oil on canvas,
50 × 35¾; 50 × 51¼;
50 × 35¾ in.
(127 × 91; 127 × 130;
127 × 91 cm.)
Camera di Commercio,
Milan

Paul Signac
The Milliners
1885
E. Bührle Collection, Zurich

content: for Pellizza da Volpedo and Morbelli it was suited to a compassionate and angry social realism, which sometimes found expression in paintings of very large size. Segantini and Previati, on the other hand, used it for scenes of fanciful symbolism, sumptuous evocations in vivid color or rarefied mountain landscapes. No less interesting were the developments in Germany, where the figure of Lovis Corinth was dominant, or in England, the elected home of the American artist James Whistler, a highly gifted and refined portraitist of Victorian society. This was also the climate in which Pablo Picasso received his training, at Malaga.

Returning to France, the work of Henri de Toulouse-Lautrec has to be seen in the same context. The infirmity that made him an invalid from childhood left a deep mark on his life, but the force of his art is overwhelming. Toulouse-Lautrec, who came from a family of ancient and noble lineage, descended into the scandalous setting of Paris's "red-light" districts: brothels, lowly dancehalls and vaudeville shows. Toulouse-Lautrec also attended the Opéra, had friends in high places and carefully selected the clothes he wore over his deformed body, and yet his

Edouard Vuillard
Annette's Pap
1901
Oil on panel,
13¾ × 24½ in.
(35 × 62 cm.)
Musée de l'Annonciade,
Saint-Tropez

most vivid works remain linked to that other, rather tawdry world: throbbing with life, it was a world that he portrayed with rapidity and force through his incisive draftsmanship. Toulouse-Lautrec should also be remembered for his inexhaustible capacity for experimentation with new pictorial and graphic techniques, mixing oil and pastel, often using unreal colors to create the effect of electric lighting and studying the production of color prints. He was the first artist to develop the theme of the advertising poster.

Cézanne and Toulouse-Lautrec were the dominant figures in French art over the last two decades of the nineteenth century: Seurat completed the trio of great experimenters in painting. Alongside them, however, existed a series of other artists and movements, perhaps less gifted and pioneering in their work but destined to leave a significant mark. This was the case with the movement known as Postimpressionism, which, as its name suggests, saw itself as a development and continuation of Impressionism. Its chief exponents were Bonnard and Vuillard, painters with a deep understanding of figurative culture and an exquisite feeling for light and color. The two artists, moving along parallel paths, produced some of the most delicate images in turn-of-the-century painting, especially when they silently depicted the intimate and joyous secrets of family life.

Viewed as a whole, the panorama of European art at the end of the nineteenth century has a disjointed appearance, split up into a series of proposals and tendencies. Out of Impressionism, the point of reference for everybody, came a gamut of still confused alternatives. With hindsight, the presence of such exceptionally innovative figures as Cézanne makes the end of the nineteenth century look like a period of great ferment. And yet, while there were indeed a number of great masters at work within European artistic culture, the overall climate in painting tended toward a fairly monotonous conformity, favoring the repetition of successful formulas. Against the background of rapid historical and social change, these two factors (the impetus toward the new and the dissatisfaction with a production that tended to grow banal) hint at the radical upheavals that were about to take place in the world of painting.

Pierre Bonnard
Nude at the Mirror
1931
Oil on canvas,
60¾ × 41 in.
(154 × 104 cm.)
Ca' Pesaro, Venice

Paul Cézanne

Aix-en-Provence, 1839–1906

As with many of the leading figures in the history of art, the importance of Cézanne only came to be understood rather late, around the beginning of the twentieth century. But his influence, which can immediately be recognized as the basis of the Cubist movement, has been fundamental on the whole of that century's painting. Born into a wealthy bourgeois family in Provence, he went to school with Emile Zola and then commenced a career in banking. Eventually, however, his own desire to become an artist managed to prevail over his father's doubts, and, in 1861, he moved to Paris, at the crucial moment of the transition from the Realism of Courbet to the Impressionism of Monet. Cézanne, who from the outset showed an independent preference for great rigor of composition and little inclination to abandon himself to the Impressionists' taste for pure light and color, made a thorough study of the works of Manet, with whom he shared a great respect for the art of the past. The initial vigor of his brushwork, with its broad strokes of dark color, gradually became more controlled and fine. Persuaded by Pissarro to lighten his palette and devote himself to landscape painting *en plein air*, Cézanne spent time at Auvers-sur-Oise near Pontoise and, with the intention of "doing Poussin again, from nature," inserted human figures, such as the first *Bathers*, into his landscapes. It was during this period that he started to conceive the landscape not as an "impression" of color, but as a mental construction of regular geometric solids (cubes, spheres and cylinders). He took part in the historic exhibition of 1874, but after a series of disappointments at the shows of the seventies, gradually distanced himself from the movement (partly for reasons of character) and left Paris for the provinces. On the estate at L'Estaque he began to restrict the number of his subjects: portraits of himself and members of his family, still lifes with apples and other banal objects, card players. He painted repeated views of certain places, such as the Mont Sainte-Victoire. In his creative solitude, Cézanne abandoned Impressionism completely in favor of a totally new conception of painting. His concrete and solid synthesis of form and color represents a link between the classical painters of the Renaissance and developments in contemporary art. Much admired by painters but little known to the public, Cézanne began to attract attention after an exhibition organized by the art dealer Ambroise Vollard in 1895. In 1907, one year after his death, the artist was celebrated at a retrospective that confirmed his role as the precursor of twentieth-century art.

Paul Cézanne
The Card Players

1890–92
Oil on canvas,
17¾ × 22½ in.
(45 × 57 cm.)
Musée d'Orsay, Paris

Patient, thoughtful, solitary and silent, card players exercised a strong fascination on Cézanne. It is likely that the painter identified with these figures and their unhurried reflection on ordinary numbers and shapes, seeking winning combinations and new solutions to the same old problems.

Paul Cézanne
The Gulf of Marseilles Seen from L'Estaque

1883–85
Oil on canvas,
28¾ × 39½ in.
(73 × 100.3 cm.)
The Metropolitan Museum of Art, New York.
H.O. Havemeyer Collection, Bequest of Mrs. H.O. Havemeyer, 1929

This landscape clearly reveals the distance that separates Cézanne from the Impressionists. It is hard to imagine a less seductive view of the Côte d'Azur, with a nondescript village dominated by an incongruous chimney stack facing onto a smooth and motionless sea. Although the light and color belong to the Impressionist repertoire, Cézanne has already begun to head down another road.

Paul Cézanne
The House of the Hanged Man

1873
Oil on canvas,
21¾ × 25¾ in.
(55.5 × 65.5 cm.)
Musée d'Orsay, Paris

In his rural landscapes, nearly all set in the environs of Aix-en-Provence, Cézanne soon began to express a sense of disquiet and dissatisfaction, a spirit of inquiry that shattered the luminous certainties of Impressionism. He tended to simplify the forms into geometric patterns, even though his handling of atmospheric light remained exuberant and vivid.

Paul Cézanne
The Pipe Smoker
1890–92

Oil on canvas,
35¾ × 28¼ in.
(91 × 72 cm.)
Pushkin Museum, Moscow

From the eighties on
Cézanne carefully selected
his subjects, concentrating
on just a few themes that
he investigated over
and over again. The solitary
and sleepy pipe smoker
is one of the most
characteristic, providing
the artist with the
opportunity to construct a
motionless human figure
around a rigorous set of
geometric volumes, though
without impairing the
psychological and physical
characterization of the
sitter. The painting used
to belong to the Russian
collector Sergei Shchukin
who, together with
Ivan Morozov, made
such a decisive contribution
to the arrival of important
works by contemporary
French artists in Moscow,
offering Russian painters
the chance to examine
first hand the evolution
of painting from
Impressionism to Cubism,
with justified emphasis
on Cézanne.

Paul Cézanne
Mont Sainte-Victoire

1885–87
Oil on canvas,
25½ × 32 in.
(65 × 81 cm.)
Stedelijk Museum,
Amsterdam

The stumpy and massive
profile of the mountain
that was visible from the
windows of Cézanne's
studio is a looming
presence in all the mature
and late work of the artist,
who never tired of
depicting it in different
ways. The sequence
of pictures of Mont
Sainte-Victoire shows a
progressive abandonment
of the attempt to
reproduce reality
in favor of a calculated
disintegration, until the
landscape turns into a
mere pretext for exercises
in composition.

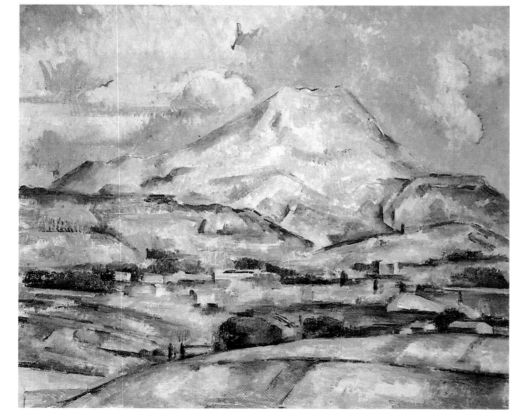

Paul Cézanne
Peaches and Pears

1890–94
Oil on canvas,
24 × 35½ in.
(61 × 90 cm.)
Pushkin Museum, Moscow

The still lifes, constructed
out of ordinary objects in
daily use, clearly reveal the
innovative character of
Cézanne's art. The choice
of objects and the layout
of the composition go back
to the historical roots of
the genre in France, and
in particular the delicate
works of Chardin. Their
representation, on the
other hand, is completely
different from that of the
past. Renouncing any
attempt to mimic the
appearance and texture
of the various surfaces,
as well as linear
perspective, Cézanne
reconstructs the fruit
and other objects along the
lines of regular geometric
solids, pointing the way
to Cubism.

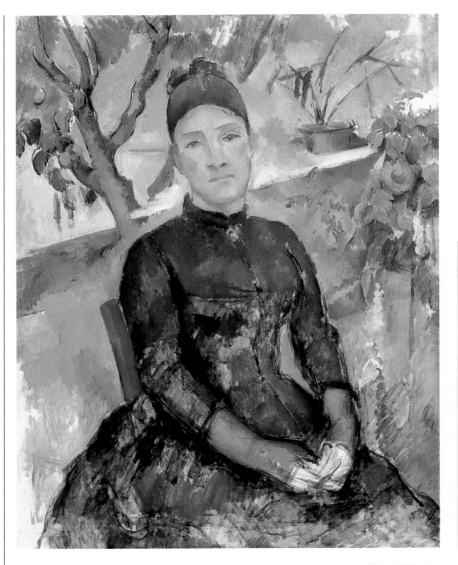

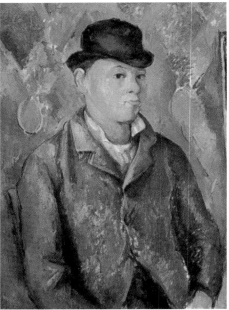

Paul Cézanne
The Artist's Son, Paul

1890
Oil on canvas,
24 × 18½ in.
(61 × 47 cm.)
National Gallery,
Washington

From the early portrait
of his father onward, the
faces of Cézanne's closest
relatives appear frequently
in his paintings. Portraying
members of his family
allowed the artist to
concentrate on the
disposition of masses in the
picture and the psychology
of the sitters. In this
portrait of his son (also
called Paul), he appears to
sense the difficulty of a not
entirely serene relationship
with his father.

Paul Cézanne
*Madame Cézanne
in the Conservatory*

1891
Oil on canvas,
36¼ × 28¾ in.
(92 × 73 cm.)
The Metropolitan Museum
of Art, New York. Bequest
of Stephen C. Clark, 1960

In his portraits Cézanne
achieved a perfect accord
between the mental
construction of the
volumes and the subtle
communication of feelings.
In this unforgettable
picture of his wife, perhaps
his greatest masterpiece in
the field of portraiture,
the diffuse lighting, pots of
verdant plants and flowers,
and diagonal point of view
create a scene of great
fascination and depth,
presenting us with the
figure of an intense and
intelligent woman that
leaves a lasting impression.

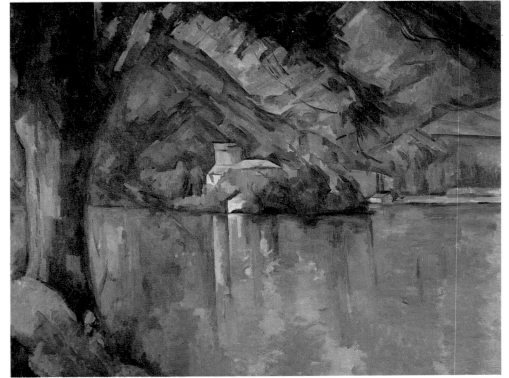

Paul Cézanne
Annecy Lake

1896
Oil on canvas,
25¼ × 32 in.
(64 × 81.3 cm.)
Courtauld Institute,
London

Many of Cézanne's
landscapes are similar
in their compositional
structure and handling
of light: a dark wing
(blue-green) in the
foreground and an opening
toward the center, through
which we can see a
building or some other
illuminated geometrical
element, much lighter
in tone than the foliage.

Paul Cézanne
Aix-en-Provence

1887
Oil on canvas,
31½ × 39¼ in.
(80 × 100 cm.)
Wallraf-Richartz Museum,
Cologne

The large landscapes of Cézanne's maturity, with their broad and open spaces, make clear the meaning of the goal that the artist had set himself: "doing Poussin again, from nature." The reference to the great painter of the eighteenth century is apparent in the distant viewpoint, which offers a sweeping panorama of a landscape flooded with light and constructed out of an alternation of buildings and clumps of trees. This compositional structure is enhanced by the brilliance of the colors, at a time of day that is represented with passionate care. These two underlying choices (a formal confrontation with the models of the past and the luminosity proper to nature) would remain generic characteristics, applicable to other painters as well, if Cézanne did not combine them with an exceptional ability to synthesize volume and color. Such landscapes were to exercise a decisive influence on the art of the twentieth century, from the Cubists to Giorgio Morandi.

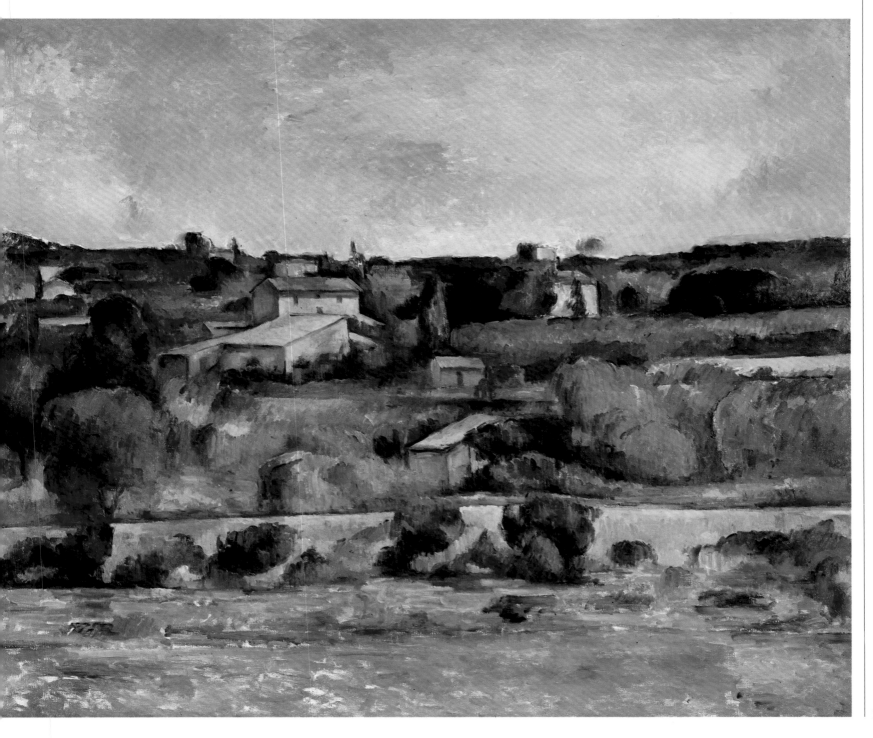

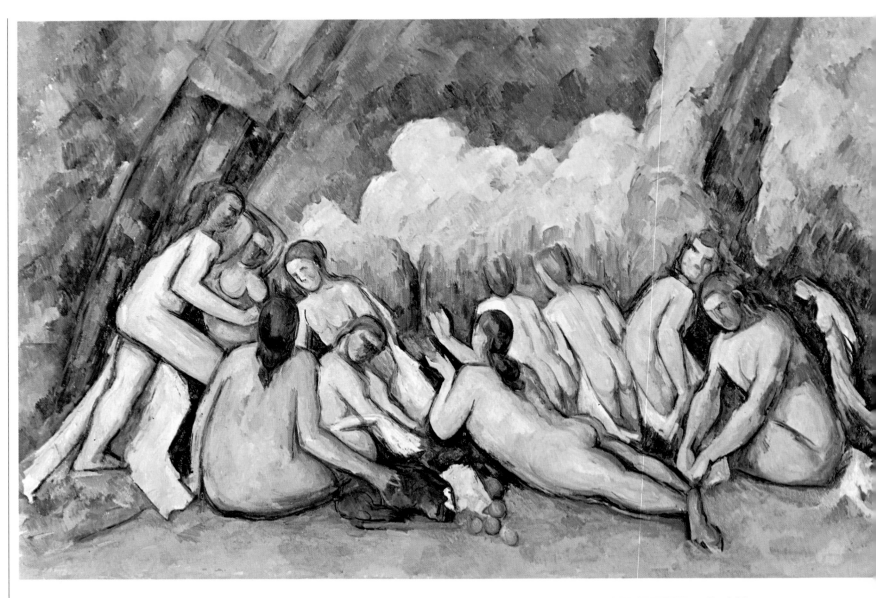

Paul Cézanne
Large Bathers

c. 1900–06
Oil on canvas,
50 × 77¼ in.
(127 × 196 cm.)
National Gallery, London

The imposing nude female figures, illuminated by the light filtering through the fronds of the trees and reflected from the waters of a pool, are inspired by a long series of precedents that commenced with the mythological scenes from the Renaissance of Diana bathing. Cézanne, confirming his key role in the history of modern painting, anticipates not only the simplification of volumes typical of Cubism but also the graphic insistence on outlines of Expressionism.

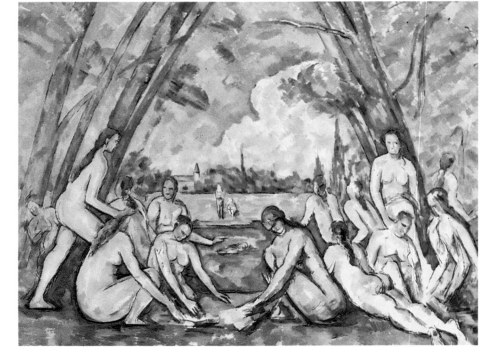

Paul Cézanne
Large Bathers

1898–1905
Oil on canvas,
75 × 80¾ in.
(190.5 × 205 cm.)
Philadelphia Museum
of Art, Philadelphia

The numerous variations on the theme, often on a large scale, constitute an extremely closely-knit series, painted over a fairly short span of time. It is an excellent demonstration of Cézanne's capacity to concentrate on one theme, tackled analytically in a quest for an ever more effective solution, with the patience and meticulousness of a chess player.

Paul Cézanne
Mont Sainte-Victoire

1905
Oil on canvas,
23½ × 28¾ in.
(60 × 73 cm.)
Kunsthaus, Zurich

With the passing of the years, the geological solidity of the mountain and the landscape at its foot tended to decompose into broad and regular strokes of color, with some parts of the canvas even left unpainted.

Paul Cézanne
Mont Sainte-Victoire and the Viaduct of the Arc River Valley

1906
Oil on canvas,
32 × 25¾ in.
(81.5 × 65.4 cm.)
The Metropolitan Museum of Art, New York.
H.O. Havemeyer Collection, Bequest of Mrs. H.O. Havemeyer, 1929

On the left we see once again the now familiar outline of Mont Sainte-Victoire, but in this case Cézanne broadens the view to take in the valley, discovering an effective visual motif in the long pale line of a railroad viaduct. This distinct and regular feature forms a right angle with the trunk of the tree in the middle, establishing a geometric structure that organizes the space of the landscape.

Paul Cézanne
*Mont Sainte-Victoire
Seen from Lauves*

1902–04
Oil on canvas,
27½ × 35¼ in.
(69.8 × 89.5 cm.)
Philadelphia Museum
of Art, Philadelphia

Yet another variation
on the theme of the
painter's favorite
mountain. Unlike in the
other works, Cézanne here
chooses a fairly dark range
of colors.

Paul Cézanne
Château Noir

1904
Oil on canvas,
29¼ × 38¼ in.
(74 × 97 cm.)
National Gallery,
Washington

The impression of
a dense and tangled forest,
rendered almost
impenetrable by the
splendid cool and deep
tones of the foliage, is
actually the outcome
of a calculated geometric
construction. The tree
trunks are in fact arranged
in a regular and well-
proportioned pattern.
The road on the left and
the spur of rock on which
the castle stands form two
almost symmetrical
diagonals, in a matching
orange that forms a
glowing patch of color
between the light
in the background and
the shadows cast in
the foreground.

Pierre Bonnard
The Open Window

1912
Oil on canvas,
29¼ × 44½ in.
(74 × 113 cm.)
Musée des Beaux-Arts,
Nice

This charming picture sums up many of the characteristics of Bonnard's painting: his ability to capture a vast amount of light, the silent and shady interiors of houses, the flowering of gardens in the summer.

Pierre Bonnard

Fontenay-aux-Roses, 1867–Le Cannet, 1947

After playing a leading role in the debate over developments in Post-Impressionism and promoting a significant reexamination of the questions of color and drawing, Bonnard made a conscious decision not to proceed along the road of the avant-garde, choosing instead to pursue his own investigation of poetics. Abandoning his legal studies to enter the Ecole des Beaux-Arts, Bonnard was decisively influenced by his contact with the Nabis group, which centered around the figures of Gauguin and Maurice Denis. Bonnard fully shared the movement's artistic ideals but did not let himself get caught up in its exaggerated mysticism, limiting his participation to the purely pictorial aspects. A regular contributor to the influential *Revue Blanche*, during the last decade of the century he defined the areas of color on his figures and descriptive elements with great intellectual rigor, abandoning chiaroscuro and the soft play of shadows dear to the Impressionists. His tranquil images of an intimate and affectionate way of life are profoundly different from the lively pictures of popular dances and houses of prostitution produced by Toulouse-Lautrec over the same period. Along with Vuillard, Bonnard painted bourgeois interiors, lingering over the hidden corners of everyday life: his use of a soft and sinuous line made him a forerunner of Art Nouveau. After a period of reflection on Impressionism during the first few years of the twentieth century, when Bonnard returned to themes of city life, the rapid emergence of the avant-garde movements drove him into a sort of voluntary exile, seeking the bright colors and light of the Mediterranean. Moving to Le Cannet, Bonnard concentrated on just a few subjects (conversations in the garden, the body of his companion, modestly laid tables, simple landscapes, domestic interiors like the bathroom or kitchen). Right up until his death he went on conjuring up the colorful mystery that is concealed in the folds of daily life.

Pierre Bonnard
Summer in Normandy

c. 1912
Oil on canvas,
45 × 50½ in.
(114 × 128 cm.)
Pushkin Museum,
Moscow

The quiet and restful atmosphere of the natural setting, based on a refined gradation of shades of green, finds a perfect psychological resonance in the delicate exchange between the two figures in the foreground. A splendid example of harmony between form and color, subject and light, this painting was bought in Paris by Ivan Morozov in 1913: an enthusiast for Bonnard's painting, and well aware of its ornamental value, the Russian collector invited the artist to Moscow a few years later, to paint some decorative panels.

Pierre Bonnard
Nude Against the Light

1919–20
Oil on canvas,
47¾ × 15 in. (121 × 38 cm.)
Nationalmuseum,
Stockholm

Bonnard's nudes appear
to be taken by surprise in
the intimacy of the home.
For these scenes, which
recall the late works of
Degas, Bonnard used his
wife as an involuntary
model. Note the effective
mixture of various
techniques, from Pointillism
to the reference to the Nabis,
fused into a personal style.

Pierre Bonnard
Interior

1920
Oil on canvas,
28¼ × 20 in.
(72 × 51 cm.)
Nationalmuseum,
Stockholm

It is the richness of color
that imparts such
fascination to Bonnard's
domestic interiors, often
illuminated by large
windows that open onto
the landscape. With great
delicacy and sensitivity, he
gently probes the habits of
daily life, while hinting at
that vague sense of mystery
and solitude that can
sometimes come over us at
home. Objects, furniture,
crockery and descriptive
details take the observer
right into the heart of a
neat and welcoming house,
cared for by the hands of a
woman with good taste.

Edouard Vuillard

Cuiseaux, 1868–La Baule, 1940

After initial academic training, Vuillard's style developed rapidly under the influence of a series of important encounters. Vuillard became one of the principal figures in the debate over the course to be taken by art after Impressionism. Through Emile Bernard and Paul Sérusier he came into contact with the Nabis, forming a lasting friendship with Bonnard. Together they argued that the successor to Impressionism should not be Symbolism but a refined and highly sensitive style known as Intimism. The use of areas of flat color (typical of the Nabis) gradually gave way to a revival of the traditional values of perspective. Vuillard's favorite subjects were tranquil scenes of family life, often set in rooms lit by electric light. Like his friend Bonnard, Vuillard also tried his hand at large-scale works and decorative panels. In these types of composition it is possible to clearly follow the development of his style, from the time of his membership of the Nabis, when he painted ornamental pictures in two dimensions, influenced by Japanese prints, to his later manner in which forms and colors were represented in affectionate and serene compositions.

Edouard Vuillard
Café in the Bois de Boulogne

c. 1898
Oil on cardboard,
19 × 20 in.
(48 × 51 cm.)
Musée des Beaux Arts et d'Archeologie, Besançon

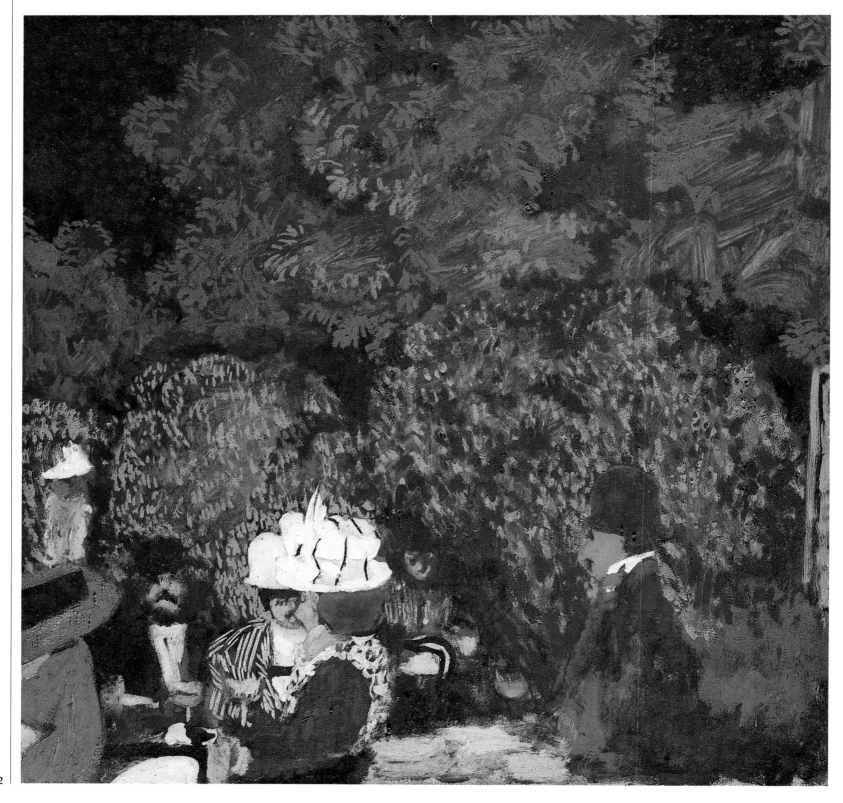

Edouard Vuillard
Public Gardens

1894
Distemper on canvas,
triptych,
83½ × 31½; 83½ × 59¾;
83½ × 31½ in.
(212 × 80; 212 × 152;
212 × 80 cm.)
Musée d'Orsay, Paris

The three subjects of the
composition (*The Nurses*;
The Conversation; *The Red
Umbrella*) also correspond
to the theme the "Three
Ages of Man," with ages
progressing from left to
right.

Edouard Vuillard
In the Garden

1895–98
Oil on canvas,
20 × 32¾ in.
(51 × 83 cm.)
Pushkin Museum, Moscow

The Impressionist style has
now been transformed into
an innovative blend of light
and color.

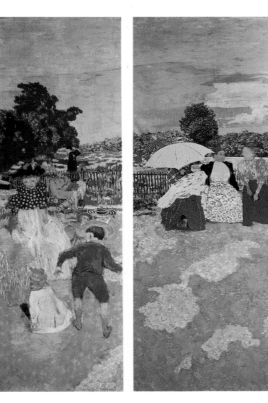

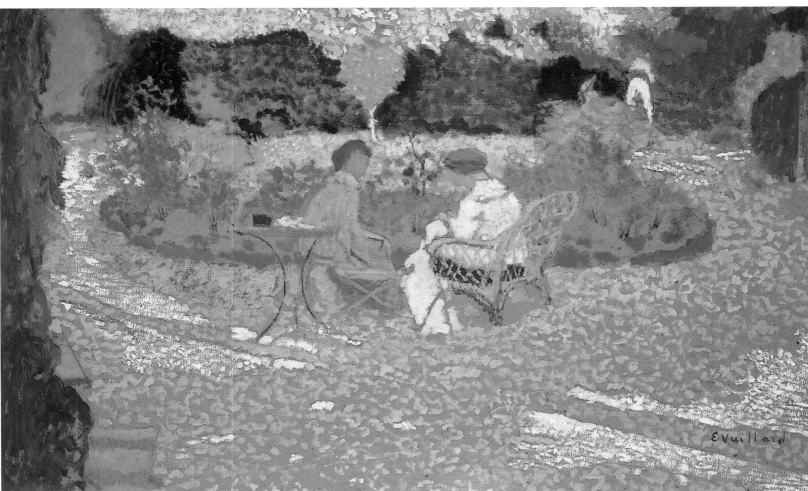

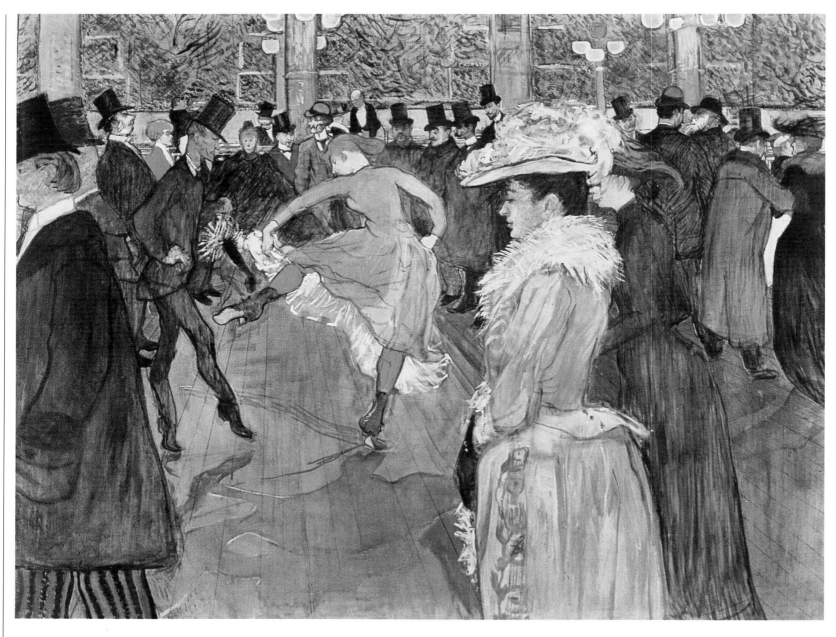

Henri de Toulouse-Lautrec
Dance at the Moulin Rouge

1890
Oil on canvas,
45½ × 59 in.
(115.5 × 150 cm.)
Private collection,
Philadelphia

Henri de Toulouse-Lautrec

Albi, 1864–Malromé, 1901

Born into one of the oldest aristocratic families in France and inclined by family tradition to the noble pursuits of hunting and riding as well as to an amateur dalliance with drawing, Toulouse-Lautrec was afflicted by a series of infirmities from childhood. Aggravated by falls from his horse, his physical handicap stunted his growth and shaped his destiny. Leaving the provinces and his prospects of leading the life of a gentleman, Toulouse-Lautrec moved to Paris, where he took academic courses in painting but was drawn to the work of the Impressionists, sharing their

taste for the representation of reality and fondness for Oriental prints. He grew particularly close to Degas, who was then concentrating on his ballerinas and laundresses, painted with sympathy and none of the distortion of caricature. Over the same period as van Gogh, Toulouse-Lautrec too found his own way to go beyond Impressionism, studying and developing the instruments of line, graphics and simplification of expression. The scion of the noble Toulouse-Lautrec family found his inspiration in popular, even disreputable settings: cafés-chantants, brothels, squalid dancehalls and suburban circuses. In the last decade of the nineteenth century, thanks to technical improvements in color printing, Toulouse-Lautrec produced paintings, drawings, lithographs and advertising posters:

different means of expression, often combined to their mutual advantage, in an art of great freedom that did not hold back from ticklish subjects and displayed an unprecedented aggressiveness. Over his all too short career, Toulouse-Lautrec laid the foundations for important developments in art: on one hand, with his abandonment of Impressionism, he became a source of inspiration for the Expressionists; on the other, the skillful fusion of images, words and color in his prolific output of posters and illustrations made Toulouse-Lautrec the originator of a new genre, that of advertising and commercial art.

Only a few years had gone by since Renoir painted his pictures of dances at the Moulin de la Galette and other *petit bourgeois* haunts in Paris, yet Toulouse-Lautrec's interpretation is quite different. Instead of the typical *joie de vivre* of the Impressionists, we perceive a sense of strain, uncertainty and the unspoken.

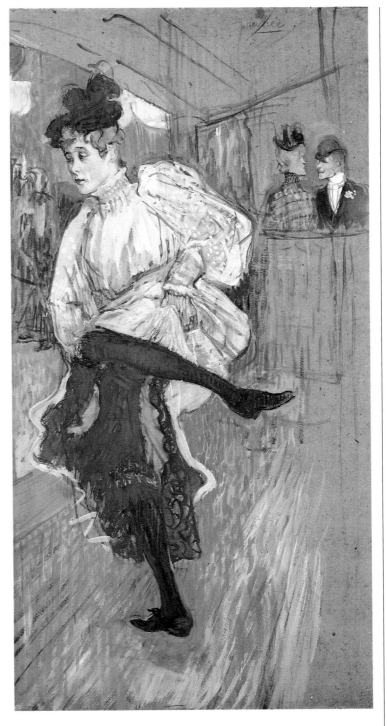

Henri de Toulouse-Lautrec
The Redhead

1889
Oil mixed with turpentine
on cardboard,
26½ × 21¼ in.
(67 × 54 cm.)
Musée d'Orsay, Paris

Toulouse-Lautrec's work is characterized by his free-and-easy and yet incisive draftsmanship. Thanks to this gift, the artist was able to create unforgettable images of women. In this case, Toulouse-Lautrec manages to give a character, an expression and a well-defined personality to a seated figure viewed from the back. The picture, also known by the title *La Toilette*, belongs to the series called *Elles*: portraits of prostitutes, painted with great respect and empathy.

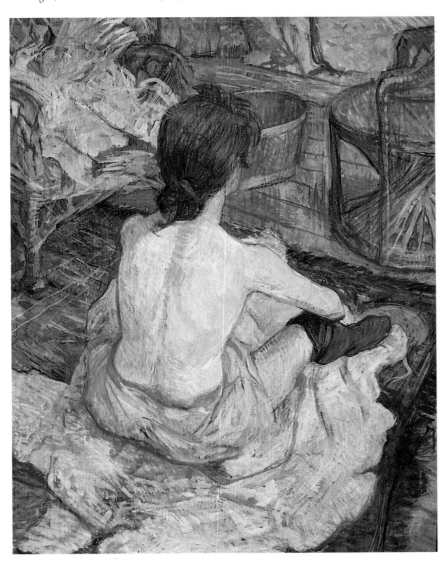

Henri de Toulouse-Lautrec
Jane Avril Dancing

1892
Oil mixed with turpentine
on cardboard,
33¾ × 17¾ in.
(85.5 × 45 cm.)
Musée d'Orsay, Paris

Jane Avril was one of the most popular vaudeville artists in Paris. Toulouse-Lautrec painted many pictures of her, as well as a series of advertising posters, true prototypes of today's commercial art. The painter was fascinated not just by the performances but also by the woman herself, and both sides of her character are revealed in this picture: a limber dancer who astonished the public and a woman whose face bears the hallmarks of a complex and sensitive personality.

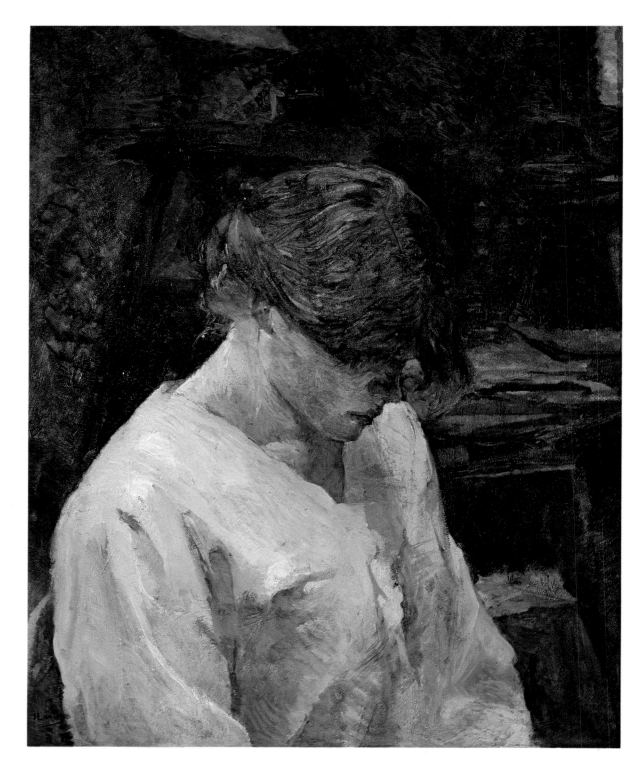

Henri de Toulouse-Lautrec
Redhead in a White Blouse

1889
Oil on canvas,
23½ × 19 in.
(60 × 48 cm.)
Thyssen-Bornemisza
Collection, Madrid

Toulouse-Lautrec is all too often seen merely as an entertaining illustrator of life in *fin-de-siècle* Paris: balls, shows, evenings at the theater, laughter and applause at the performances of cabaret artists, dancers and *chansonniers*. Yet this is just one side of the painter's work: his portraits of women, alone and silent, are perhaps even more intense and personal.

Moments of reflection, clouds passing through the mind, fleeting shadows on the face. These moments are captured by Toulouse-Lautrec with an extraordinary sensitivity, using new means of expression that are particularly evident in the close combination of line and color.

Henri de Toulouse-Lautrec
The Salon on Rue des Moulins

1894
Pastel,
52½ × 45¼ in.
(132.5 × 115.5 cm.)
Musée Toulouse-Lautrec, Albi

Thanks to Toulouse-Lautrec, the red divan in the *maison close*, or brothel, on Rue des Moulins in Paris has become one of the most characteristic locations of late nineteenth-century painting. It is easy to imagine some of the scenes from the great French novels of that time in this setting. In the room, brightly-lit and furnished with an ostentatious and somewhat kitsch luxury, several prostitutes are waiting for their clients. Without the slightest hint of caricature or cartoon, Toulouse-Lautrec portrays a group of real and living women. The picture seems to offer us fleeting glimpses of their personal histories, as the painter captures with great refinement their expressions of embarrassment, indolence, boredom and fatigue.

Henri de Toulouse-Lautrec
La Goulue Entering the Moulin Rouge

1891
Oil on cardboard,
31½ × 23½ in.
(80 × 60 cm.)
Museum of Modern Art,
New York

During the time he spent in the twilight world of brothels and nightclubs, Toulouse-Lautrec came to know and understand the minds and feelings of the singers and prostitutes, women who were often anything but "lighthearted" or "giddy." The most direct literary parallel is with some of the more celebrated and moving of Maupassant's short stories. However, it is hard to resist the temptation to compare this deliberately emphatic entrance of one of the most famous *femmes de vie* in Paris with the stroll of the unforgettable Gradisca in Federico Fellini's *Amarcord*. In both cases the protagonist is walking arm-in-arm with two companions, displaying a mixture of obligatory exhibitionism and inner thoughts, which not even the heavy makeup and showy clothes can conceal.

Henri de Toulouse-Lautrec
The Clowness Cha-U-Kao

1901
Oil on cardboard,
25¼ × 19½ in.
(64 × 49 cm.)
Musée d'Orsay, Paris

Another notable figure in the world of minor Parisian cabaret, the lady clown was a Junoesque woman who performed exotic dances in nightclubs of dubious reputation. Following in the footsteps of Degas, Toulouse-Lautrec takes us into the dancer's dressing room, at the very moment when she is struggling to do up her costume. The painting is a superb example of Toulouse-Lautrec's rapid and incisive manner, which allows him to capture his subject in a few effective lines and convey a sense of vibrant vitality.

Henri de Toulouse-Lautrec

An Examination at the Faculty of Medicine

1901
Oil on canvas,
25½ × 32 in.
(65 × 81 cm.)
Musée Toulouse-Lautrec,
Albi

Toulouse-Lautrec was fascinated by the world of medicine. This painting, the last work of his short and ill-starred life, records the disputation of the thesis of one of the artist's closest friends at the Sorbonne.
Steeped in an atmosphere of austerity and concentration, the density of the color and the subdued lighting create a profoundly different effect to that of his pale pastels of female figures.

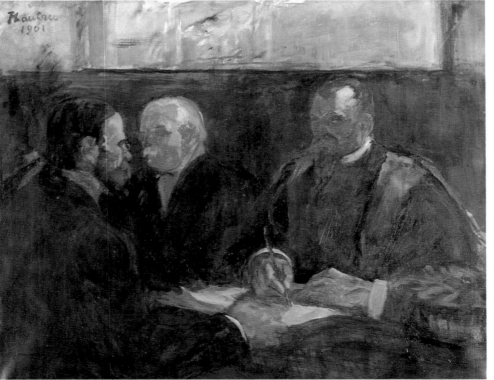

Henri de Toulouse-Lautrec

The Two Friends

Oil on cardboard,
32 × 23½ in.
(81 × 59.5 cm.)
Musée Toulouse-Lautrec,
Albi

In no way conditioned by social conventions, the painter was able to depict the embarrassing subject of female homosexuality with his customary frankness, exercising careful control of line and color. Here too, Toulouse-Lautrec draws on the memory of Courbet's concrete and explicit realism, while from the strictly formal viewpoint the influence of Degas is evident.

209

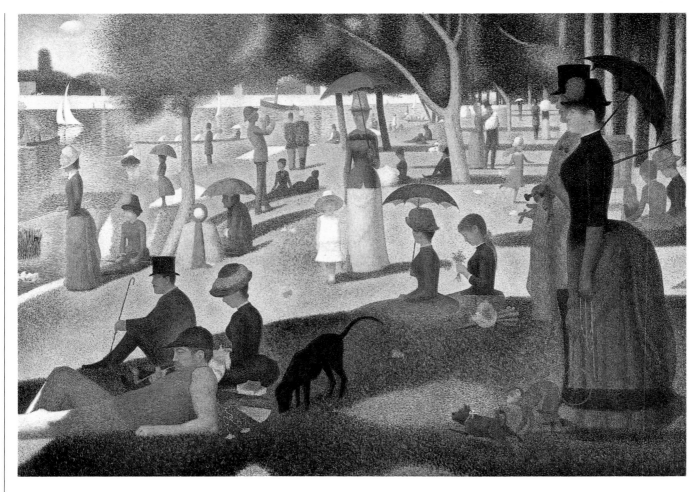

Georges Seurat
Sunday Afternoon on the Island of La Grande Jatte

1884–86
Oil on canvas,
79¼ × 120 in.
(201 × 305 cm.)
Art Institute, Chicago

Completed at the end of a long succession of drawings, sketches, studies and trials, this large picture is a key work in the history of painting. The subject and the diffuse luminosity may be reminiscent of Impressionism, but the technique and the balanced rhythm of the composition are in complete contrast to the efforts to capture the moment made by Monet and his colleagues. Seurat has created a stately, carefully-considered scene, turning on the frozen monumentality of the figures. The sacred immobility of their attitudes has suggested a comparison with the fifteenth-century images of Piero della Francesca. The paint is laid on the canvas in a myriad of little touches, tiny points that form an almost imperceptible passage between light and shade.

Georges Seurat

Paris, 1859–1891

The cultivated, refined and intellectual product of a good family, Seurat shot through the history of art like a blazing but unfortunately short-lived meteor: death took him at the age of thirty-two, cutting short a process of technical and aesthetic evolution that had only just begun. Seurat painted only a few pictures, in part because of the extreme slowness of the technique he adopted, the huge scale of the paintings themselves and the lengthy and well-documented preparation he carried out. Initially influenced by Millet's sweeping scenes of mystical realism, Seurat then embarked on an intense scientific investigation of the physics of light and color, comparing his results with those of photography and researchers into the phenomena of perception. With *La Grande Jatte* (1886), Seurat produced a seminal masterpiece. The color is handled in a totally new way, broken down into an infinite series of tiny points, each one separate and detached. Called Pointillism, this technique enhanced the effect of light and shade and provided the model for a "scientific art" based on a thorough grasp of the principles of optics. His subsequent paintings continued this approach, applying it to performances in the street and circus, but the process was interrupted by his dramatically early death.

Georges Seurat
Sunday in Port-en-Bessin

1888
Oil on canvas,
25½ × 32 in.
(65 × 81 cm.)
Rijksmuseum Kröller-Müller, Otterlo

Seurat's technique of painting was developed from a precise study of the science of vision and explicitly based on the physiochemical process by which light "excites" the grains of silver on a photographic plate, fixing the image.

Georges Seurat
Bathers at Asnières

1884
Oil on canvas,
79¼ × 118½ in.
(201 × 301 cm.)
National Gallery, London

A large and extremely
ambitious painting, it
continues along the poetic
and stylistic road opened
up by *La Grande Jatte*,
with a fixity of gesture
that here verges on the
metaphysical.

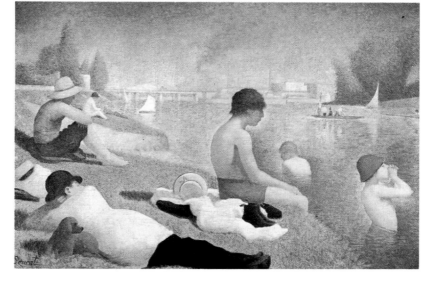

Georges Seurat
*Seascape at Port-en-Bessin,
Normandy*

1888
Oil on canvas,
25½ × 32 in. (65 × 81 cm.)
National Gallery,
Washington

Seurat's motionless and
contemplative seascapes

can be contrasted with
the totally opposite ones,
throbbing with color,
painted by Monet over
the same period. The
method adopted is
analytical and strictly
scientific, but Seurat is
well aware of the result,
which is so cerebral
and calculated that it
anticipates abstract art.

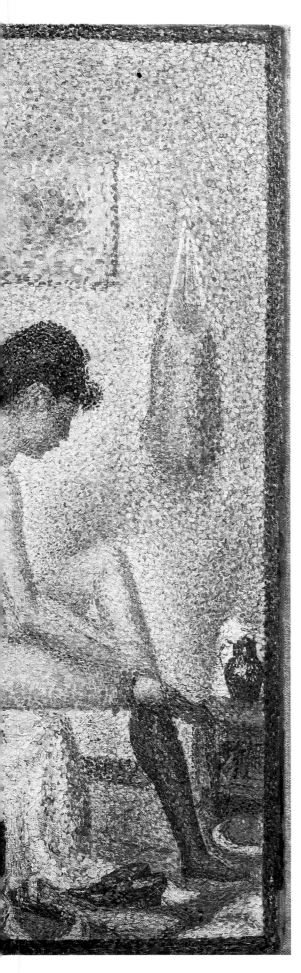

Georges Seurat
The Models
(second version)

1888
Oil on canvas,
15½ × 19¼ in.
(39.5 × 49 cm.)
Berggruen Collection,
Geneva

A small but delightful preparatory study for the large picture now in the Barnes Foundation at Merion, Pennsylvania, the canvas has a moving and pure freshness. Seurat was conscious of the novelty of his experiment and the poetic effects of the Pointillist technique. This justifies the blatant citation of his own work by the inclusion of part of *La Grande Jatte*, on the left. The models getting ready to pose form a delicate scene, based on the compromises inherent in a studied spontaneity: in fact, while the painter pretends to depict the women in relaxed attitudes, each figure is actually analyzed with great care.

Georges Seurat
The Circus

1890
Oil on canvas,
72¾ × 59¾ in.
(185 × 152 cm.)
Musée d'Orsay,
Paris

Left unfinished due to the artist's premature death (and therefore of great interest to a study of his technique of painting), this picture testifies to the rapid and surprising development of Pointillism on the part of its inventor. From the vibrations of the afternoon light that illuminates the park in *La Grande Jatte*, Seurat has moved on to the electric and unnatural brilliance of the colors of the circus, where the gestures, expressions and attitudes are all deliberately strained.

Paul Signac
The Large Pine,
Saint-Tropez

1909
Oil on canvas,
28¼ × 36¼ in.
(72 × 92 cm.)
Pushkin Museum, Moscow

Paul Signac

Paris, 1863–1935

A student of architecture, Signac commenced his career as an artist like so many other dilettantes, painting on the banks of the Seine. Invited to show his work at the Salon des Indépendants in 1884, he quickly became one of the most prominent figures of the new generation. In 1886 he adopted the Pointillist technique developed by Seurat, enthusiastically embarking on research into the division of color and producing theoretical writings of some value. This analysis translated into a style of painting in which Seurat's "point" was transformed into a small spot or stroke of color, similar to that used by the Italian Macchiaioli. Around 1890, prompted by a powerful desire to travel, he explored the coasts of the Mediterranean, from the Côte d'Azur to Venice and Constantinople: according to contemporary calculations, this entailed passage on no less than thirty-two different boats. Signac was responsible for the "discovery" of Saint-Tropez as a tourist resort. Beaches, sand dunes, seascapes and sailboats became his favorite subjects. His meeting with van Gogh in 1889, Seurat's premature death in 1891 and his substantial independence of the Parisian art world led Signac to develop a style of his own, known as Neo-Impressionism. In doing so, Signac left a profound mark on French and Belgian painting: in 1904 the young Matisse asked to come and study with him at Saint-Tropez. In his later years, after the emergence of Cubism, Signac's brushstrokes grew broader, rectangular and more detached from one another, with the result that they no longer allowed the reconstruction of the form through the optical superimposition of the colors.

Signac's evolution in the early years of the twentieth century was influenced by his relationship with the Fauves. Remaining faithful to a compositional structure based on the interweaving of vivid colors, the artist made the tones even brighter, introducing unreal shades that can be compared with the work of painters like Dufy and Derain.

214

Giovanni Boldini

Ferrara, 1842–Paris, 1931

A successful portrait painter, with a special talent for evoking the fresh beauty of young women, Boldini studied art first at Ferrara and then in Florence, where he frequented the Macchiaioli and the Caffè Michelangelo circle, commencing to build a reputation as a portraitist. But the fundamental influence on his development came from the journey he made to Paris in 1867, where he was greatly impressed by Manet's large, full-length portraits. A subsequent trip to London introduced him to the art of Gainsborough and the English portraitists of the eighteenth century, whose rapid and brilliant brushwork he adopted.

In 1871 Boldini settled permanently in Paris, where he was initially obliged to make his way by painting small landscapes and views with figures in costume.

Gradually earning himself a place within the Parisian art world, Boldini produced his finest and most skillful work, portraits of women painted with long and swift brushstrokes. These "fashionable" images, testimonies to the climate of the *belle époque*, are certainly effective, though not devoid of a certain self-satisfied virtuosity, in which young and brilliant members of high society appear in elegant poses, swathed in silk.

Giovanni Boldini
Portrait of Marquess Casati

1914
Oil on canvas,
53½ × 69¼ in.
(136 × 176 cm.)
Galleria Nazionale d'Arte
Contemporanea, Rome

Boldini's succulent and virtuoso brushwork evokes slashes of light and rustles of silk. The style of the Ferrarese painter recalls the contemporary literature of Decadentism, in which an indisputable and admirable formal ability tended to repeat tried-and-tested formulas.

Gaetano Previati

Ferrara, 1852–Lavagna, 1920

An interesting exponent of Symbolism, open to influences from abroad, Previati was one of the most typical representatives of the Italian Divisionist movement, whose technique became the main point of reference after the death of Segantini. The artist's formation was given a decisive impetus in Milan, not just through the courses he followed at the Brera Academy but also through his contacts with the Lombard *Scapigliatura* movement. After working intensely on the illustration of books by Alessandro Manzoni and Edgar

Allan Poe, Previati began, around 1890, to carry out technical and expressive research into the "division of color." Unlike Segantini, who was drawn chiefly to landscape, Previati chose images with a strong symbolic content, inspired by sentimental, allegorical or religious themes, using a diffuse light with effects of transparence that were to have a significant influence on the Futurists. Subsequently he tackled subjects drawn from history, and in particular episodes and figures from the Baroque period, whose opulence Previati evoked brilliantly. After 1900 Previati painted cycles of pictures and works on a grand scale, accompanied by treatises and writings of a theoretical character.

Gaetano Previati
The Day Awakens the Night

1905
Oil on canvas,
70¾ × 82¾ in.
(180 × 210 cm.)
Museo Revoltella, Trieste

Previati had a perfect grasp of the Divisionist technique and made virtuoso use of luministic effects and imperceptible shifts of color to produce scenes of intensely symbolic suggestion. The composition blends literary references with the undeniable flavor of a fashionable illustration. In fact he had experimented with the application of Divisionism to the engravings that he made to accompany precious editions of celebrated novels and short stories.

Angelo Morbelli

Alessandria, 1853–Milan, 1919

The recent critical revaluation of Morbelli, and the notable increase in the value of his works on the international art market, do justice to one of the most interesting Italian artists of the last two centuries. Without resorting to literary symbolism or paternalistic pieties, Morbelli set out to draw attention to the dramatic human and social problems of post-unification Italy. His training at the Brera Academy in Milan was influenced by late Romantic realism. He immediately started to paint pictures inspired by the themes of modern life and progress, such as the *Stazione Centrale* now in the Galleria d'Arte Moderna, Milan. Around 1890 Morbelli joined the group of Divisionists, adapting the technique to subjects intended to denounce injustice, with particular regard to the life of farm laborers and the loneliness and squalor of the charitable old people's home in Milan. Toward the end of his life, when the new style of the Futurists began to spread, Morbelli devoted himself chiefly to landscape painting, without abandoning the Divisionist technique.

During the most intense period of his career, corresponding to the last decade of the century, Morbelli's work reached a level on a par with the finest examples of late nineteenth-century European art. Few other painters were able to interpret the themes of social deprivation, old age and solitude with as much empathy and such freedom from rhetoric. The dusty light of his pictures, handled with great sensitivity, can be linked directly with Seurat's painting.

Angelo Morbelli
In the Rice Field

1898–1901
Oil on canvas,
72 × 51¼ in.
(183 × 130 cm.)
Museum of Fine Arts,
Boston

The Lombard painter devoted some of his finest works to the theme of the *mondine*, the young women who spent hours and hours in the water planting and harvesting rice. The precedent set by Millet is clearly discernible, but Morbelli dispenses with the aura of mysticism that made the scenes of the late Romantic French painter all too literary, even idealized. Morbelli was far more interested in social criticism of undeniably harsh working conditions.

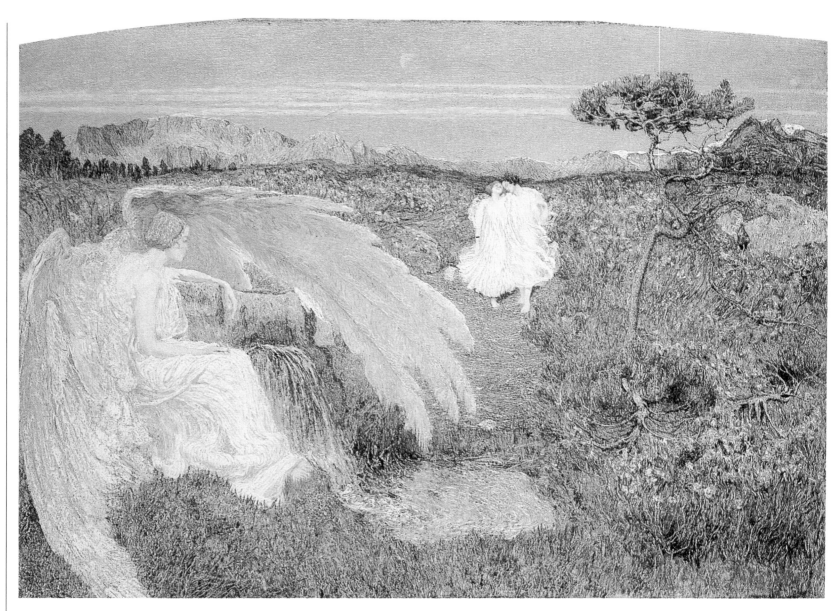

Giovanni Segantini

Arco, 1858–Schafberg sul Maloja, 1899

In a century that abounded in artists who led "romantic" lives, the story of Segantini's development and career provides one of the most typical examples. His restless character was apparent from his early youth (part of it spent in reform school) and found its first outlet during the years he studied at the Brera Academy in Milan. Here he acquired the style of the Lombard naturalism of the second half of the nineteenth century, but was unable to find a place for himself in the art world. Segantini could not bear city life and, with the help of the painter and writer Vittore Grubicy, moved to the provinces in 1881. In the hills of Brianza he painted his first scenes of peasant life and a number of landscapes. The limpid panoramas he glimpsed from the heights of the Grison mountains persuaded him to adopt the Divisionist technique, which conferred an unusual, diffuse luminosity on his pictures. Around 1890 his views of the Alps and images of life in the fields began to turn

into allegories of a moral or symbolic character, imbued with a strong sense of religious mysticism. Segantini's style, made up of sinuous lines and elegant figures, had features in common with Art Nouveau, but the painter made no attempt to establish contact with other artists or movements. He increasingly withdrew into a solitary meditation, seeking moral purity and clear horizons in the high mountains, right up to his final work, the *Triptych of the Alps*, left unfinished and now in the museum devoted to the painter at Saint-Moritz. Through his sometimes dramatic combination of Alpine landscapes and symbolic elements (in parallel to and even in anticipation of Hodler), Segantini effectively represented the apprehensions of the late nineteenth century, that sense of a rejection of progress which made the passage between the two centuries a particularly difficult threshold to cross.

Giovanni Segantini
Love at the Fountain of Life

1896
Oil on canvas,
27¼ × 39½ in.
(69 × 100 cm.)
Galleria d'Arte Moderna,
Milan

Giovanni Segantini
Ave Maria at the Crossing

1886
Oil on canvas,
33 × 25¼ in.
(84 × 64 cm.)
Private collection,
Sankt Gallen

This picture combines three different elements (in a manner that is highly effective from the poetic viewpoint). First of all, an experimental technique of

The artist himself described this painting as representing "the playful and carefree love of the female and the pensive love of the male, bound together by the natural impulse of youth and springtime. An angel, a

painting based on the presence of countless tiny points of "divided" color, not mixed on the palette but capable of creating the illusion of a variegated tint. Secondly, the choice of a rural landscape, deliberately remote from the settings of city life. Finally, the golden and tranquil light of sunset, accompanied by a prayer, which bestows a mystical quality on the painting. The flock of sheep on the boat

mystic and suspicious angel, spreads his great wing over the mysterious fountain of life. The water flows from the living rock, both symbols of eternity."

crossing the calm waters of the lake can be seen as a symbol of the common destiny of humanity, entrusted to a good shepherd in its passage through the world. At the same time, Segantini wants to present a highly suggestive image of the profound serenity and morality of rural life, unaffected by the growing industrialization of the cities and linked to the eternal rhythms of nature.

Giuseppe Pellizza da Volpedo

Volpedo, 1868–1907

After studying at academies all over Italy (Milan, Florence, Rome, Bergamo) and a visit to Paris in 1899, the Piedmontese painter settled in Milan, where he joined up Segantini, Morbelli and Previati to form the Divisionist group. Endowed with an extremely refined technique incorporating the latest developments elsewhere in Europe, which he used to capture the vibration of light, Pellizza da Volpedo tackled a wide range of themes and genres, including still lifes and portraits. In some of his paintings we find a reference to the suggestive and literary atmospheres of Symbolism. A painter of remarkable versatility, Pellizza found his fullest and most personal expression in realism with a social background, of which he was an important exponent at the international level. Prompted by his reading of Marx and Engels, the artist worked for many years on his masterpiece *The Fourth Estate*, producing several versions before completing the definitive one in 1901. The picture has the peremptory monumentality of Courbet, but updated to take account of the growing pace of industrialization. The painting's lack of success at the Venice Biennale embittered the last years of Pellizza's life, spent in Rome. During the first decade of the twentieth century, Pellizza's Divisionism exercised a significant influence on Giacomo Balla and the other young painters who were to make up the Futurist movement.

Giuseppe Pellizza da Volpedo

Lovers' Stroll

c. 1902
Oil on canvas,
diam. 39¼ (100 cm.)
Pinacoteca Civica,
Ascoli Piceno

The main exponent of Italian Divisionism, Pellizza da Volpedo did not hesitate to use the new technique to reinterpret the light, color and subjects dear to the Impressionists. In this case, the format of the tondo, not an easy one to handle, lends itself to a sophisticated sequence of planes of luminosity at different depths.

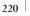

Giuseppe Pellizza da Volpedo
The Fourth Estate

1898–1901
Oil on canvas,
112¼ × 213¾ in.
(285 × 543 cm.)
Galleria d'Arte Moderna,
Milan

Completed after a decade of trials and modifications, the primary aim of this huge painting is to underline the almost menacing presence of a new social class: the workers. The development of industry in Northern Italy in the last few years of the nineteenth century resulted in a massive migration of workers from the countryside to the new city suburbs, with a series of economic, social and urban consequences. The painting represents a solid array of people advancing from a background where we can sense the presence of a verdant landscape, with a progressive lightening of the colors toward the front. The presence of a woman with a baby in the front row of figures reminds us that the problem of social integration did not regard the workers in the factories alone but the whole of their families. The title refers to the French Revolution at the end of the eighteenth century, when the "Third Estate" (middle-class) had overturned the privileges of the aristocracy and clergy: defining the industrial working class as the "Fourth Estate" signified an awareness of the emergence of a new situation. The picture has been used repeatedly in the propaganda of a variety of parties, but in reality it has no precise political message. Rather, it is a serious reflection of a social and humanitarian character. The two earlier versions are on a similar scale.

James Abbot McNeill Whistler

Lowell, 1834–London, 1903

A painter, theorist and dandy of great international success, who had close contacts (as well as fierce disputes) with men-of-letters and musicians, Whistler had an enviably open-minded attitude toward culture and a wealth of artistic experience. After learning the rudiments of art in the United States, he went to Paris in 1855, where he was particularly attracted by the polemical and powerful realism of Courbet. Over the following years he drew close to the early Impressionists, with whom he shared a taste for linear design and the richness of Velázquez's color. The great Spanish painter was to remain a strong influence throughout Whistler's career and he too proved an excellent portraitist. Whistler stayed in contact with the Impressionists in Paris even when he moved to London. It was here that he spent the greater part of his career, introducing the characteristics of Impressionism into Great Britain, along with a style of painting that had no need to be passed through the filter of history. This brought him into open conflict with official British culture, which showed a distinct preference for the Pre-Raphaelites and the Gothic Revival. From the sixties onward, Whistler gave titles to his portraits and landscapes that made no mention of the person or place depicted but described them as "symphonies" or "nocturnes," adding the predominant colors. Becoming an influential figure in the international Symbolist movement, Whistler chose an elegant way of signing his paintings, with the figure of a butterfly.

James Whistler
Symphony in White, No. 1: The White Girl

1862
Oil on canvas,
84¾ × 42½ in.
(215 × 108 cm.)
National Gallery,
Washington

We are indebted to Whistler for the most seductive and rarefied image of high society in the Victorian era. A world of conventions and refined formality, laid over the top of repressed impulses and curbed but still discernible emotions. Whistler was conscious of the subtle divide between the true-to-life portrait and the intellectual image. Many of his paintings are not named after their subjects but given musical titles with a reference to the dominant color or tone.

James Whistler
Nocturne in Blue and Gold:
The Old Battersea Bridge

1872–75
Oil on canvas,
26¾ × 19¾ in.
(68 × 50 cm.)
Tate Gallery, London

A splendid landscape
painter, Whistler brought
together many different
elements of nineteenth-
century European art
and combined them
in an intelligent way.
Even in the titles of his
landscapes the painter
referred to the prevalent
tones of the picture.
His views of London are
explicitly related to the
work of Turner, to whose
influence is due the hazy,
almost foggy effect that
blurs the outlines. On the
other hand, the panorama
of the Thames overlaps
with that of the Seine at
the end of the nineteenth
century. Monet painted
several pictures of the
Houses of Parliament
in Westminster. Whistler,
with his refined, almost
decadent technique, served
as a link between the late
Romantic period and
the "mental" landscape
of the avant-garde
movements.

The Age of Crisis

Gustav Klimt
Music (detail)
1895
Oil on canvas,
14½ × 17¾ in. (37 × 45 cm.)
Neue Pinakothek, Munich

The last lights of the empire still shone in Vienna, on the new avenues of the Ring and in the ballrooms where people danced the waltz. Franz Joseph's capital wanted to appear the very image of Habsburg continuity and tradition, a perfect synthesis of solidity and gaiety, a fixed point of reference in European history and geography. It was, at least in part, a deceptive image; worse, an illusion soon to be shattered. For some time the Austro-Hungarian Empire had been trying to stem the tide of insidious tensions, while wars of national independence were eating away its territories (as in the case of Lombardy and Veneto). The main political problem became that of the tenacious preservation of boundaries, especially in the turbulent Balkan region. Yet Vienna was undoubtedly one of the most glittering and cosmopolitan capitals of continental culture, contending for primacy with Paris. The music of Johann Strauss and Gustav Mahler, the refinement of the new design coming out of the Wiener Werkstätte, the massive solidity of the eclectic architecture of the great buildings erected on the Ring and the developments in literature, drama, philosophy and medicine formed a backdrop to the evolution of an extremely important school of painting.

Klimt's art clearly reflects the gleams and shadows of the declining empire, whose noble and nostalgic decadence was also the cradle of Freud's psychoanalysis. Klimt passed through the obligatory stages of academic training and the painting of official allegories, while revealing an exceptional talent. The turning point in his art came during the last decade of the century, when he became the founder of the "Sezession," applying to art a term that was frequently used in the politics of the states huddled under the wings of the Habsburg eagle. In 1898 the beautiful building intended to house its temporary exhibitions was erected to a design by the architects Olbrich and Wagner. Named after the movement, it was crowned with a delicate, gilded metal cupola and decorated inside with the *Beethoven Frieze*, painted in 1902 by Klimt. The building stands just a few paces from the seat of the Academy of Fine Arts, cumbersome symbol of a pompous and rhetorical culture. From that moment on Klimt led the way toward a resplendent and decorative style of painting, gleaming with gold and shot through with echoes of classical and Byzantine art, references to Japanese prints and to the linear style of Art Nouveau, intellectual and precious and yet pervaded by a subtle feeling of unease, quite different from the French currents of Post-Impressionism. Skillfully mixing memories of Egyptian art with the spirals of Thonet chairs, the distant past with the "fashionable" present, and using an elegant and well-modulated line, Klimt painted female figures of mysterious and ingratiating charm.

Klimt's work is a superb expression of the end of an era. The artists who followed his example, on the other hand, would be agonized witnesses to the *finis Austriae*, the sinking of the dynasty into the mud of the trenches of the First World War that was described with such masterly skill by writers like Robert Musil and Joseph Roth. The human drama and neurosis of Egon Schiele and the melodramatic, almost Baroque density of Kokoschka already fall within the horizon of Expressionism. The all-consuming and desperate eroticism of Schiele, most evident in his unsurpassable watercolors, his determination to seize hold of life, represents one of the most moving

James Ensor
The Scandalized Masks
1883
Musées Royaux
des Beaux-Arts, Brussels

226

Oskar Kokoschka
The Annunciation
c. 1911
Oil on canvas,
32¾ × 48¼ in.
(83 × 122.5 cm.)
Museum am Ostwall,
Dortmund

episodes in European art in the buildup to the war.

If Vienna was the point of reference for the new science of psychoanalysis and its reflections in art, similar developments were taking place elsewhere in Europe. The feeling of crisis, the collapse of nineteenth-century certainties, the impotence of positivism in the face of hypocritical patterns of behavior, and the tangled web of the unconscious had a powerful precedent in van Gogh. But these circumstances took on a more conscious, less impulsive and yet equally anguished character in artists working a long way from the principal centers of art and culture and belonging to traditions that began unexpectedly to converge. The case of the Norwegian painter Edvard Munch is exemplary. In the transparent and gelid atmosphere of the north, Munch uncovered feelings of anguish, envy and loneliness. His contorted and terrible painting *The Scream* has become the symbol of the existential crisis through which Europe passed at the end of the century, but Munch's art went even further, in parallel with the plays of his fellow countryman Ibsen: he probed the dramas that lay beneath bourgeois life, that undermined the psyche behind the façade of respectability and domestic tranquility. His uninhibited use of swirling lines and unreal colors made Munch one of the freest and most pungent spirits in late nineteenth-century art.

There are similarities between Munch's isolation and the voluntary exile of the Belgian painter James Ensor, who chose to live and work in Ostend, on the windswept coast of the gray North Sea. For Ensor, an indefatigable polemicist, almost everyone wore a mask, sometimes grotesque, sometimes tragic, at other times pathetic. In a biting style that is in some ways reminiscent of Toulouse-Lautrec but which can also be traced far back to the Flemish precedents of Bosch and Bruegel, Ensor staged tragicomic scenes in miniature of inimitable originality.

Natural settings underwent an abrupt change in the work of the Swiss artist Ferdinand Hodler, famous chiefly for the patriotic allegories he painted on large panels, but particularly interesting for the pictures in which his confident line and harsh color gave rise to compositions laden with symbolic, insidious, at times even macabre allusions. Munch, Ensor and Hodler have to be considered fundamental in their roles as precursors of Expressionism and as outstanding artists within their respective national environments. On the other hand, they chose solitary paths, without forming organized schools or movements. Theirs were lofty and at least for the moment isolated voices, expressions of the general sense of unease at the end of the century. Very soon, just after the turn of the century, the crisis of the age and the need for a new and more violent means of artistic expression would find a stauncher and more cohesive manifestation in Paris, in the Fauvist group gathered around Matisse, and in Germany, with the movements of Kirchner and Kandinsky.

James Ensor
Ostend, 1860–1949

A voluntarily isolated and unconventional artist, Ensor was a figure of great significance in the European painting that came after Impressionism. Making his debut in the crucial 1880s, he came into direct contact with the leading currents of the time, from Symbolism to Decadentism, but quickly went in a direction all of his own, explicitly detached from groups and movements and openly challenging the views of the art critics. In a surprising anticipation of what would later be known as Expressionism, Ensor peopled his pictures with grotesque and troubled figures, often wearing bizarre or macabre masks. His skeletons and harridans, clowns and demons can be interpreted as so many satires of bourgeois hypocrisy. The climax of this ironic and yet disquieting painting, at times even obsessive in the suffocating presence of the sneering and unrecognizable faces that throng his pictures, was reached in Ensor's masterpiece, the *Entry of Christ into Brussels* (1888), an extravagant and singular painting of overwhelming chromatic force. Every now and then, even Ensor permitted himself a break by painting or drawing solitary landscapes. After the turn of the century the creativity and potency of the Belgian artist's images tended to fade.

James Ensor
Little Church of Mariekerke

1901
Oil on canvas,
21¼ × 26½ in.
(54 × 67 cm.)
Museum voor Schone
Kunsten, Ostend

Ensor's pale and tenuous landscapes represent an interval of silence and poetry in the noisy, brightly-colored and lively comedy of the world staged by the artist. The delicate composure of the scene is still reminiscent of Corot.

James Ensor
Theater of Masks

1908
Oil on canvas,
28¼ × 33¾ in.
(72 × 86 cm.)
Thyssen-Bornemisza
Collection, Madrid

A characteristic example
of the Belgian artist's
taste for illusion and bitter
irony, in which it is not
easy to tell whether
the "masks" are worn by
the actors on the stage or
the people in the audience.
James Ensor turns the
relationship on its head,
challenging the public
to look at itself without
hypocrisy.

James Ensor
Entry of Christ into Brussels

1888
Oil on canvas,
100 × 169¾ in.
(254 × 431 cm.)
Musées Royaux
des Beaux-Arts, Antwerp

The painter's greatest
masterpiece, the work
harks back to the
sixteenth-century models
of Bosch and Bruegel in its
horror vacui, with the main
subject (Christ is in the
background, underneath
the banner with the
inscription "Vive la
Sociale") almost suffocated
by an overflowing mass
of humanity, made up of
caricatured faces, macabre
apparitions parading like
mannequins.

229

Ferdinand Hodler

Bern, 1853–Geneva, 1918

Hodler's work occupies a unique position in the European art of the late nineteenth century, standing somewhere between Symbolism, the last current of historical and nationalist painting and the beginnings of Expressionism. Hodler is considered one of the painters who was best able to interpret the landscape of Switzerland and the country's pride in its strength and freedom, through a line of bounding energy and sharp and limpid colors. Hodler received his training in Geneva, in an environment permeated by Symbolist ideas, while his style appears to hark back directly to the Northern European graphic art of the Renaissance, in particular Holbein. Hodler painted his most significant works during the last decade of the century: portraits of women, mountainous landscapes with a rarefied and transparent atmosphere and above all elongated canvases representing allegorical subjects, with figures repeating supple gestures, forming a choreography of absorbed rhythms.

Ferdinand Hodler
The Sacred Hour I

1910
Oil on canvas,
69 × 30¼ in.
(175 × 77 cm.)
Argauer Kunsthaus, Aarau

The painting is a large-scale preparatory sketch for a huge mural. His elongated, sinewy figures, imbued with a piercing sense of disquiet, bring Hodler close to the grand themes of Central European Expressionism. However, the Swiss painter's work stands out clearly for its dazzling gleams of light, inspired by the high mountains. While his figures are defined in a realistic manner, with sharply incised expressions, features and outlines, the Alpine landscapes tend to summarize the image in terms of the drastic contrasts between the blue-white of the ice and snow and the dark outcrops of rock.

Ferdinand Hodler
The Night

1890
Oil on canvas,
45¾ × 117¾ in.
(116 × 299 cm.)
Kunstmuseum, Bern

Hodler's symbolism found expression chiefly in broad compositions of a dreamlike or mystical flavor, with motionless human figures arranged in refined linear rhythms. The frightening apparitions can be linked to the sense of apprehension that overtook artists at the end of the century, from Austria to Norway.

Ferdinand Hodler
The Stekhorn Range

1913
Oil on canvas,
25½ × 34¾ in.
(65 × 88.5 cm.)
Kunsthaus, Zurich

To a certain extent Hodler has become Switzerland's "national painter." His views of the mountains and some of his more sober and forceful figures have proved extremely popular in the country, a fact that is underlined by their appearance on bank notes and postage stamps.

Edvard Munch
Red and White

1901
Oil on canvas,
36½ × 49 in.
(93 × 124.5 cm.)
Munch Museum, Oslo

In Munch's painting,
which was strongly molded
by the artist's personal
experience, we can discern
a desire to create order
and clarity: the white
and red of the dresses
worn by the two girls
are laid on as compact
and violent patches of
color, in marked contrast.

Edvard Munch

Löten, 1863–Ekely, 1944

The artist who gave voice to the cry of
anguish of a humanity trapped in solitude
was trained at the school of drawing in
Oslo. His early works were still influenced
by nineteenth-century Naturalism, but
already revealed a desire to probe the
intimate secrets of their subjects. The
journeys he made to Paris (1885) and then
again to France, as well as Germany and
Italy, were fundamental. So, despite living
in Norway, Munch was in constant contact
with the contemporary avant-garde.
Also inspired by the plays of his fellow
countryman Ibsen, Munch embarked
on a course of intense research in the
closing decade of the century, venturing
into the depths of the human psyche.
Munch combined a tight, continuous and
undulating line with an unreal, vivid and
forced color to produce unprecedented
effects. Among his principal works it is
worth mentioning, in addition to the
celebrated *Scream* (1892), the unfinished
Frieze of Life (begun in 1893). This includes
the symbolic scene of *The Dance of Life*,
dominated by brilliant colors and the
disquieting reflection of the moon in the
sea. His paintings were accompanied by a
vast output of graphic work, part of it
intended as illustrations of contemporary
poems. In 1908 Munch suffered a serious
nervous breakdown, from which he slowly
recovered, though his painting never
regained its previous expressive force.

Edvard Munch
Jealousy

1895
Oil on canvas,
26½ × 39¼ in.
(67 × 100 cm.)
Historical Museum,
Bergen

The powerful tensions that
ran through the painter's
mind (eventually leading to
the nervous breakdown
that interrupted his career
in 1908) were clearly
apparent not only in his
choice of subjects and
technique, but also in some

of his self-portraits. Here
we are presented with the
image of a deeply troubled
man, racked by feelings of
jealousy, offering a naked
and moving glimpse of his
inner being.

Edvard Munch
The Scream

1893
Tempera on panel,
32¾ × 26 in.
(83.5 × 66 cm.)
Nasjonalgalleriet, Oslo

A work symbolic of
anguish and pain, it was
described by Munch
in the following words:
"One evening I was
walking along a path.
On one side was the city
and below me the fjord.
The sun was setting, the
clouds were tinged blood
red. I felt a scream running
through nature; I could
almost hear it. I painted
this picture, painting the
clouds like real blood. The
colors were screaming."
Like van Gogh, Munch
handled color with
the force born out of
desperation, laying it on
in long and livid bands.
The unbroken lines tighten
like a noose around the
figure's head, while his
features are distorted to
the point of paroxysm.

Edvard Munch
Anguish

1894
Oil on canvas,
37 × 28¾ in.
(94 × 73 cm.)
Munch Museum, Oslo

A procession of spectral white figures dressed in black stands out against a fiery and claustrophobic background, made up of long and undulating bands like the sunset that lights up the sky in *The Scream*. Here even the bourgeois clothing worn by the figures underlines the artist's relationship with Scandinavian playwrights like Strindberg and Ibsen.

Edvard Munch
Moonlight

1895
Oil on canvas,
36½ × 43¼ in.
(93 × 110 cm.)
Nasjonalgalleriet, Oslo

Yet another nineteenth-century interpretation of the full moon. Munch shows us its light reflected in the waters of the North Sea, in a natural setting framed by the straight and dark trunks of trees. The motionless, deserted shoreline is lapped by the calm water of the sea, on which the reflection of the moon assumes a "solid" form that recurs several times in the Norwegian artist's paintings.

Edvard Munch
The Kiss

1898
Oil on canvas,
39 × 32 in.
(99 × 81 cm.)
Nasjonalgalleriet, Oslo

Munch inserts a morbid note even into scenes of intimate affection. The pair of lovers have taken refuge in a corner of the room, away from the window where they might be revealed to prying eyes. Note the profound difference between this "Ibsenesque" interior, with its atmosphere of tension and impending drama, and the far more serene and cheerful vision of Vuillard and Bonnard over the same period.

Edvard Munch
The Dance of Life

1899–1900
Oil on canvas,
48½ × 74 in.
(123 × 188 cm.)
Nasjonalgalleriet, Oslo

The painting was part of a more ambitious project, a large ornamental frieze that was supposed to depict the stages in human life. The work was never finished, but significant parts of it have survived.

Edvard Munch
Four Girls on the Bridge

1905
Oil on canvas,
49½ × 49½ in.
(126 × 126 cm.)
Wallraf-Richartz Museum,
Cologne

The best-known side of
Munch is undoubtedly that
of the tormented author
of *The Scream* and other
pictures with a strong
psychoanalytical impact.
Even in his apparently
more tranquil paintings,
however, there is a sense
of extraordinary tension,
conveyed by pictorial
means of great originality.
Here the luminous tones
of the brief Nordic
summer are caught in a
"timeless" image, in which
the season of good weather
corresponds to a mood of
nostalgia for lost youth,
for bright colors, beauty
and the sun. As in the films
of Ingmar Bergman,
biography is mixed up
with reminiscence, the
present with the past, in a
superimposition of intense
sensations and emotions.

235

Gustav Klimt

Vienna, 1862–1918

To comprehend the gilded and glittering refinement of Klimt's art it is perhaps necessary to go back to the work of his father, a goldsmith and engraver. The young Gustav quickly made a name for himself as a talented decorator of theaters and baths, with allegorical scenes of pleasing ornamental effect. This sort of activity was to characterize Klimt's production for a long time, up until such fundamental and highly innovative works as his decoration of the great hall of Vienna University (1893), the allegory of Beethoven for the exhibition of the "Sezession" (1902) and the extraordinary frieze for the Palais Stoclet in Brussels (1909–11). By the beginning of the twentieth century Klimt, despite some controversy, was the most influential painter in Vienna. At the center of an extremely lively circle of philosophers, writers and musicians, Klimt founded the movement known as the *Sezession* in 1897, one of the most

interesting of the tendencies that preceded the emergence of the avant-garde. The "Secession" proposed a shift away from the pompous academic style of late nineteenth-century art and toward a luminous and refined painting, of supple and modular elegance, with a considerable emphasis on decoration. A series of journeys through Europe made for the purposes of study placed Klimt at the center of the debate over Art Nouveau. One of the places he visited was Ravenna, where the Viennese painter studied the technique and chromatic effects of mosaic in order to be able to reproduce them in painting. The faces and attitudes of his figures are almost completely surrounded by precious tesserae. Another frequent characteristic of Klimt's pictures is the contrast between the decorative, abstract parts and the great realism of the figures, often highly symbolic in content. After 1910, in parallel with the evolution in Kokoschka and Schiele's style, Klimt turned more decisively in the direction of Expressionism.

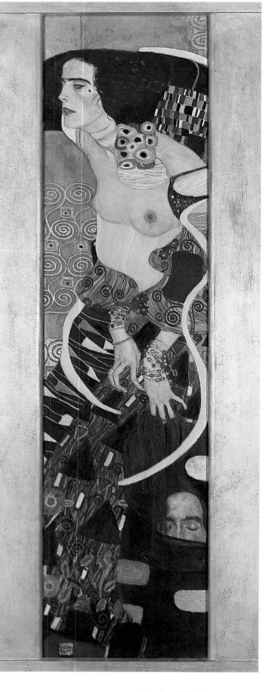

Gustav Klimt
Danaë

1907–08
Oil on canvas,
30¼ × 32¾ in.
(77 × 83 cm.)
Private collection, Vienna

The huddled pose
of the mythical maiden
as she receives the shower
of gold in her womb
is an extraordinary
demonstration of the
painter's skill with form.

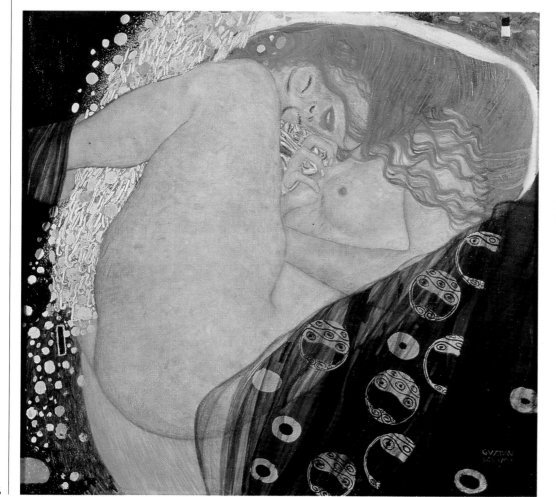

Gustav Klimt
Salome

1909
Oil on canvas,
70 × 18 in. (178 × 46 cm.)
Ca' Pesaro, Venice

This macabre painting epitomizes the fundamental characteristics of the Austrian painter: a precious opulence cloaks the gilded figures with iridescent ornaments, while their forceful personality emerges from the colored patterns. The hands and face are depicted with penetrating psychological realism.

Gustav Klimt
The Kiss

1908
Oil on canvas,
70¾ × 70¾ in.
(180 × 180 cm.)
Österreichische Galerie,
Vienna

One of the painter's greatest masterpieces and, more generally, among the most fascinating pictures of the early twentieth century. Klimt returns to and completes the probing analysis of the relationship between figure and ground that he had commenced with the marvelous frieze in the Palais Stoclet at Brussels. The man and woman are steeped in the atmosphere of a unique moment, carried away by the passion of their first kiss, of the yielding to love. Around the two intensely characterized figures extends an extraordinary ornamental pattern of gold tesserae that is reminiscent of Byzantine mosaics and the sort of two-dimensional ceramic decorations that were used to adorn Art Nouveau architecture. This is yet another interpretation of the theme of the kiss, which we have already seen tackled by Hayez and Munch.

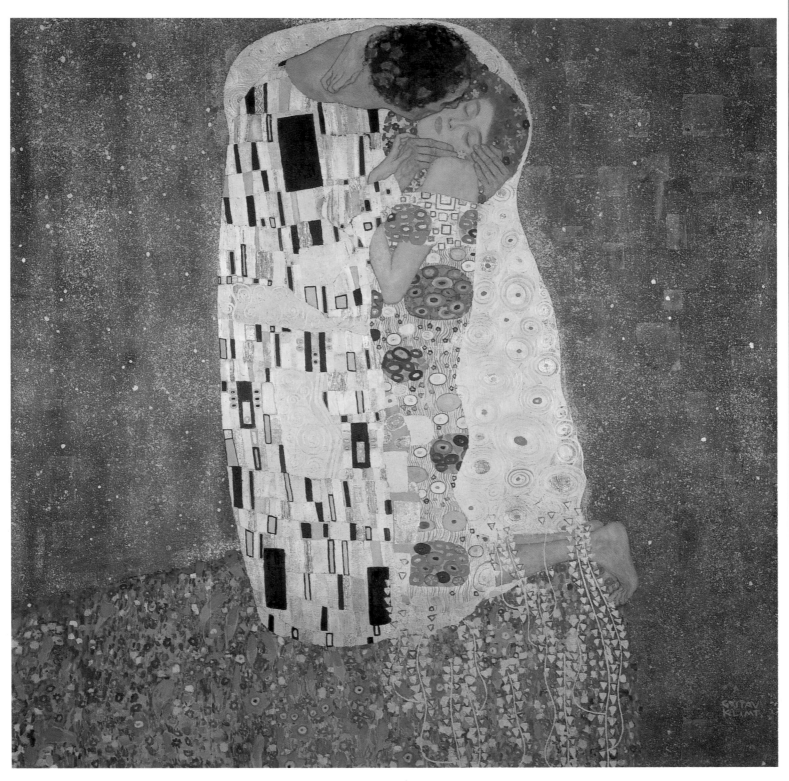

Gustav Klimt
Portrait of Margarethe Stonborough-Wittgenstein

1905
Oil on canvas,
70¾ × 35¾ in.
(180 × 90.5 cm.)
Neue Pinakothek, Munich

Klimt's symbolism and lush decoration are sustained by an impeccable, almost academic quality of execution. It is interesting to compare paintings like this, which can be regarded as formal exercises of undeniable fascination, with other female portraits of the late nineteenth century, from Whistler to Boldini.

Gustav Klimt
Nuda Veritas

1899
Oil on canvas,
99¼ × 22 in.
(252 × 56 cm.)
Theatersammlung, Vienna

The painting belongs to Klimt's Symbolist phase. Two panels on a gold ground bearing a quotation from Schiller (in German) and the title (in Latin) frame the delicate apparition of the girl symbolizing Truth. A classical allegory, with the traditional attributes of the transparent veil, the mirror and the snake threatening the girl. Yet it also contains an element of seduction, expressed through the figure's fixed gaze and tawny head of hair studded with flowers.

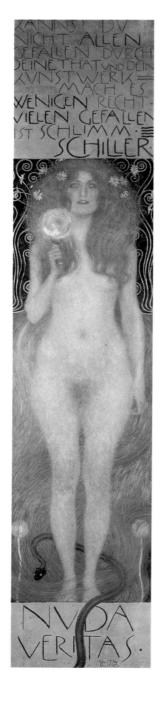

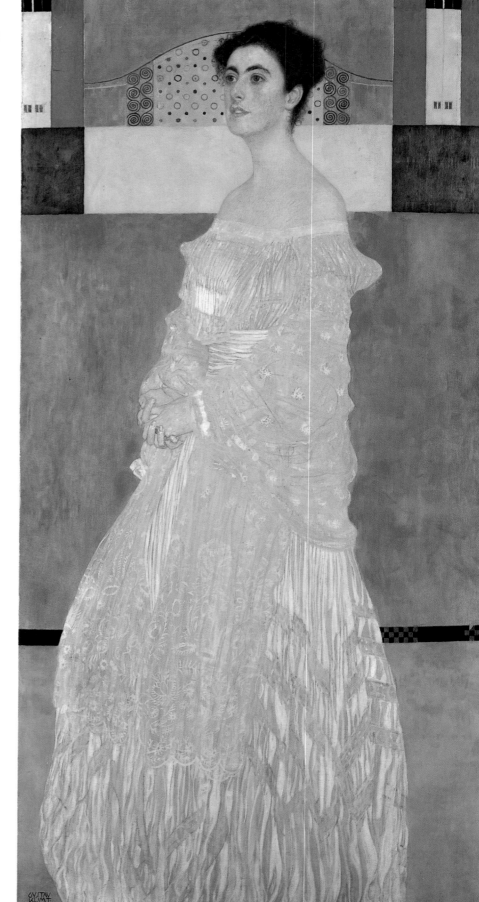

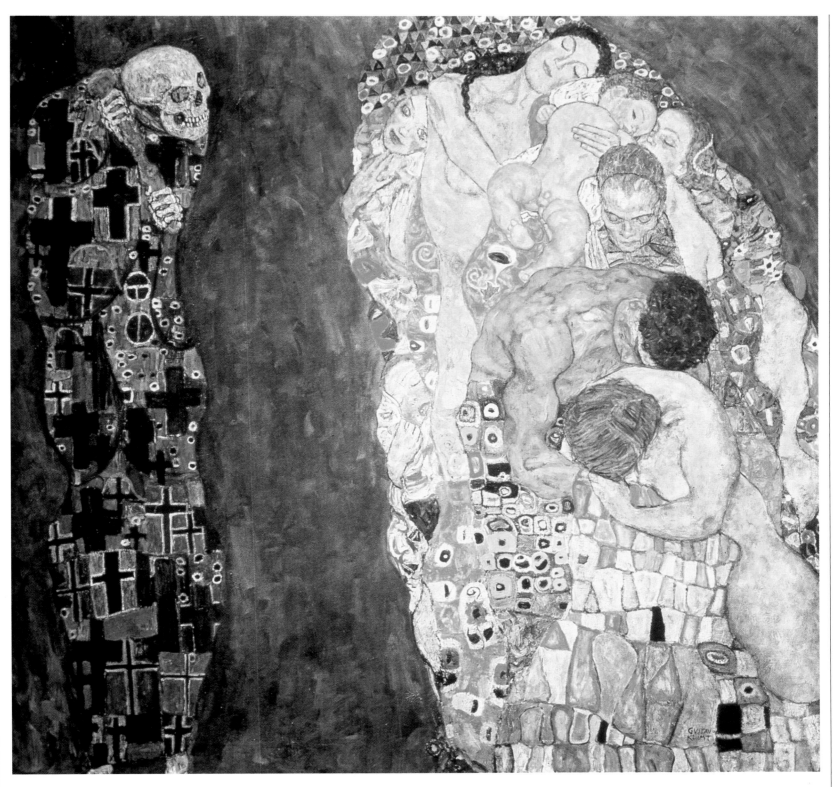

Gustav Klimt
Life and Death

1908–12
Oil on canvas, 70 × 78 in.
(178 × 198 cm.)
Private collection, Vienna

Klimt worked for a long time on this composition, which in fact marks a turning point in his late career. The first version had a gold ground, but this was replaced in 1912 by a dark band between the skeletal figure of death and the unknowing mass of slumbering humanity. As always, the painter foregoes the illusion of depth to present all the figures on the surface of the canvas. Thus the group of sleepers turns into a sort of human pyramid, in which it is also possible to discern Klimt's favorite theme of the succession of generations. In the last years of his life, he tended to renounce the agreeable subjects of earlier days and paint instead allegorical compositions on the theme of fate, in which the gloomy presentiment of death plays an increasingly dominant role.

Gustav Klimt
Portrait of a Lady

1916
Oil on canvas,
26¾ × 21¾ in.
(68 × 55 cm.)
Galleria Ricci Oddi,
Piacenza

This refined portrait, influenced in its style by Schiele, has recently been involved in some exciting events.
A young female scholar has demonstrated that Klimt painted the canvas twice, at a distance of several years. The figure we see now almost completely covers an earlier portrait of a woman, which had been photographed in the artist's studio and subsequently thought to have been lost.
A few days after this discovery, the painting was caught up in another adventure, with its theft and later recovery during transfer to a temporary exhibition.

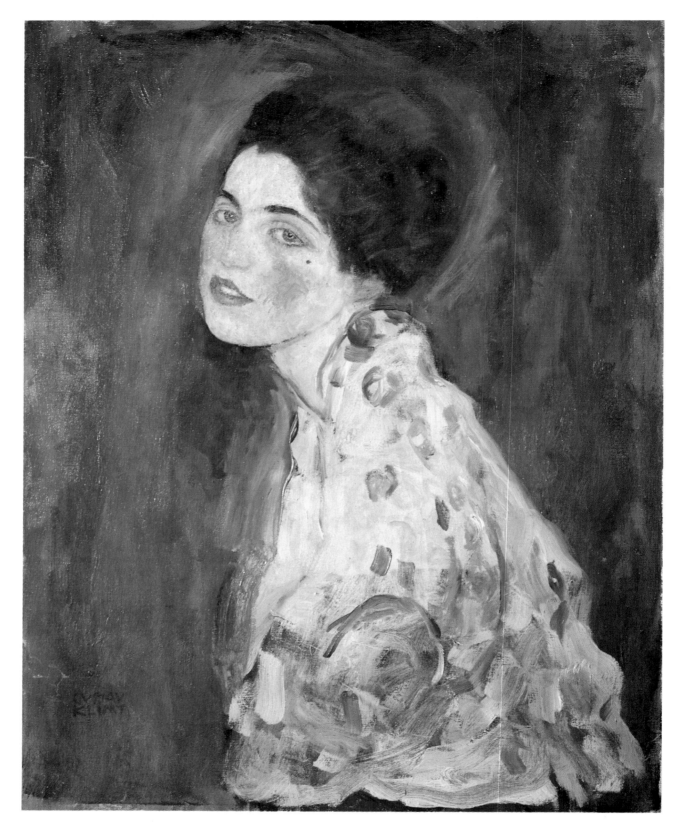

Oskar Kokoschka
Portrait of Gino Schmidt

1914
Oil on canvas,
35½ × 22¾ in.
(90 × 57.5 cm.)
Thyssen-Bornemisza
Collection, Madrid

The picture was painted
during the years of
Kokoschka's greatest
success as a portraitist of
the Viennese upper middle
class. It has an unusual
history: the three Schmidt
brothers, proprietors
of a thriving interior
decoration firm with
branches in Vienna and
Budapest, originally
commissioned the artist
to paint them all together
on a single canvas.
Subsequently, Kokoschka
split the large picture into
three separate portraits.

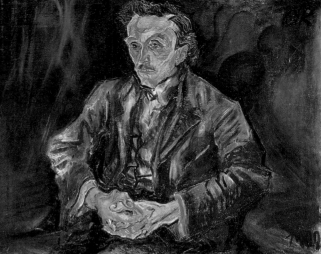

Oskar Kokoschka
Portrait of Adolf Loos

1909
Oil on canvas,
29¼ × 35¾ in.
(74 × 91 cm.)
Nationalgalerie, Berlin

The young Kokoschka and
Loos, one of the boldest
and most severe architects
of the twentieth century,
formed a firm friendship,
based on mutual
admiration.
Kokoschka openly
defended Loos during the
dispute that arose in 1910,
on the occasion of the
inauguration of his
unadorned building
on Michaelerplatz, right
opposite the emperor's
study. Franz Joseph
considered the "house
without eyebrows"
offensive, dragging Loos
into a fierce controversy.
The architect played
an important role in
Kokoschka's entry into
the *Sturm* ("Storm") group
based in Berlin.

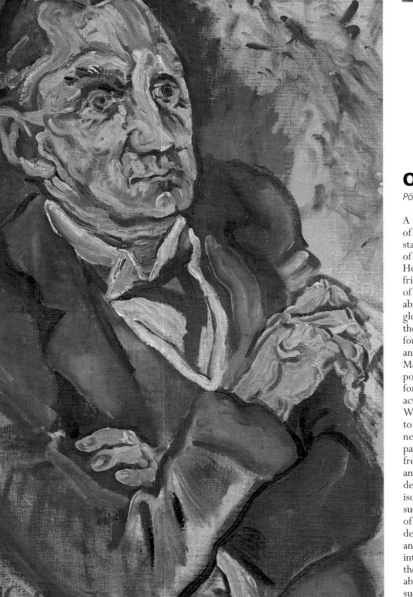

Oskar Kokoschka

Pöchlarn, 1886–Villeneuve, 1980

A leading figure in the most intense period
of Viennese Expressionism, Kokoschka
started out as a pupil and follower
of Klimt in the movement of the Sezession.
However, following the advice of his
friend Adolf Loos and the example
of international currents, Kokoschka
abandoned the ornamental style and
glowing colors of the Sezession in
the first decade of the twentieth century
for a deeper involvement in the artistic
and literary movement of Expressionism.
Major works of drama, penetrating
portraits and paintings of great chromatic
force emerged out of Kokoschka's intense
activity during the years around the First
World War, at the end of which he moved
to Dresden. Although part of a continuous
network of links with other contemporary
painters, maintained in part through his
frequent travels for the purposes of study
and to keep in touch with the latest
developments, Kokoschka represents an
isolated case. Some features of his style,
such as the use of the sinuous brushstrokes
of Austrian Baroque painting, set him
decisively apart from the various groups
and avant-garde movements of
international Expressionism. Over
the course of the twenties Kokoschka
abandoned his more intense themes,
such as psychologically revealing portraits,
for works on a large scale, chiefly views
of cities. In spite of this new tranquillity,
his work was banned by the Nazi regime.
Kokoschka moved first to Prague and
then to London, where he painted large
allegorical cycles.

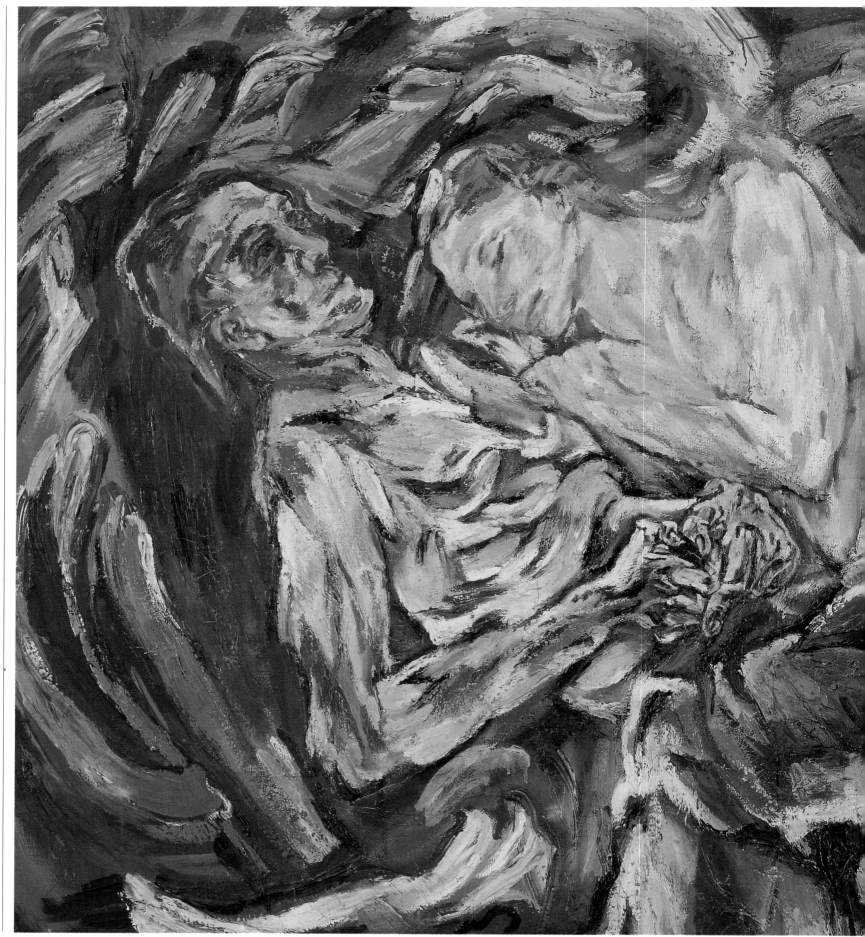

Oskar Kokoschka
Bride of the Wind

1914
Oil on canvas,
71¼ × 86½ in.
(181 × 220 cm.)
Kunstmuseum, Basel

A paean to erotic
abandonment and the
passion of love, the
painting can be compared
with Chagall's different
interpretation of the same
subject. Lover of the
extraordinary Alma,
widow of the composer
Gustav Mahler, Kokoschka
lived through a period of
great intensity for his
private life and for the
world. Alternating spells
in Berlin with a lively
participation in Viennese
cultural circles, he
investigated the Freudian
theme of dream in his
writings and paintings
during these years.
When the war broke out
Kokoschka was enrolled
in a company of dragoons.
Wounded on the Eastern
front, he was sent back
into battle immediately
after his recovery. It was a
brutal experience, which
prompted the artist to take
an interest in biblical
subjects and to introduce
a new aggressiveness into
his painting.

Egon Schiele

Tulln, 1890–Vienna, 1918

Schiele's meteoric life and career has often been seen as a dramatic metaphor of the *finis Austriae*, the end of an era and an empire that had long played a dominant role in history. Initially linked to that of Klimt, Schiele's dramatic and graphic style quickly developed into almost the antithesis of the blazing colors and aesthetic elegance of the founder of the school. Influenced by his friendship with

Kokoschka and his ties with the international Expressionist movements, Schiele turned his attention to the harrowing conflicts of existence: his stupefied and terrified figures are surrounded by empty space, filled with doubts and anxieties. This tension, which led Schiele to look back to the themes, distortions and suggestions of Gothic art, was conveyed chiefly through the harsh and dramatic force of his drawing. In the troubled years of the war Schiele experienced a glimmer of serenity, through the marriage to his beloved Edith Harms.

His young wife became the recurrent, almost obsessive subject of the painter's canvases and watercolors. The violence of the war and his wife's illness reopened the conflict between life and death, which was again to characterize the last works of the painter's short life. Egon and Edith died in 1918, one shortly after the other. They were buried in the same tomb, mourned by the world of culture which, deafened by the roar of the guns, had been unable to hear Schiele's penetrating voice and could now only pay him posthumous tribute.

Egon Schiele
Death of the Maiden

1915
Oil on canvas,
59 × 70¾ in.
(150 × 180 cm.)
Österreichische Galerie,
Vienna

Love and death are interwoven in all of Schiele's work, but in 1915 this contrast took on a new and terrible significance: the painter hurriedly married Edith Harms before being enrolled in the imperial army and setting off for the war.

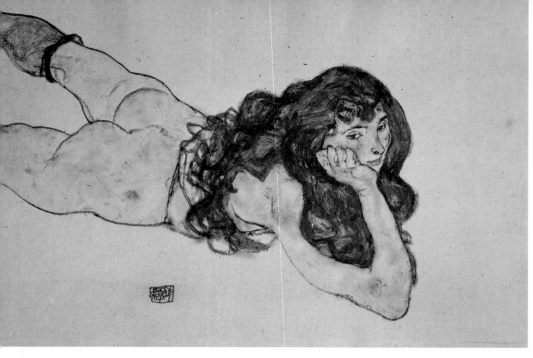

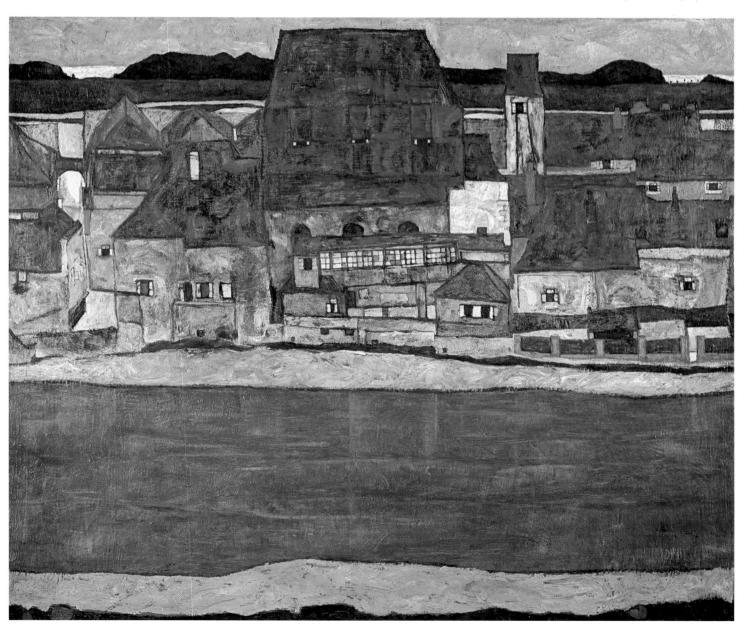

Egon Schiele
Prone Female Nude

1917
Watercolor on paper,
14 × 21¼ in.
(34 × 54 cm.)
Albertina, Vienna

Schiele's eroticism found
expression in unforgettable
female figures of acute
sensuality. The work
belongs to the only
moment of serenity
in the artist's brief career.
In 1917, as the war drew
to its end, Schiele was one
of the promoters of a
major interdisciplinary
movement for renewal
of the arts in Vienna.

Egon Schiele
*Houses on the Current:
The Old Town*

1914
Oil on canvas,
39¼ × 47½ in.
(100 × 120.5 cm.)
Thyssen-Bornemisza
Collection, Madrid

The place represented here
is Wachau, an Austrian
town on the Danube. The
painting, influenced by the
style of Klimt, is composed
of a series of roughly
parallel lines, with the
houses and roofs set on
top of one another without
any sense of depth.

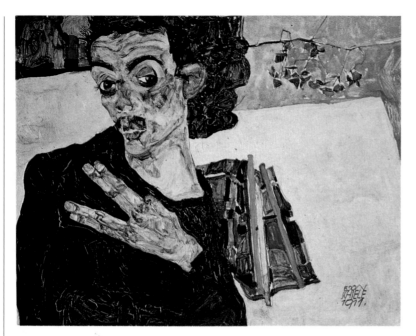

Egon Schiele
Self-Portrait with Fingers Spread

1911
Oil on panel,
10¾ × 13½ in.
(27 × 34 cm.)
Historisches Museum
der Stadt, Vienna

In perennial financial
difficulties and embroiled
in serious problems with
the law and the censors

(he was even jailed for
a month on the charge
of having forced adolescent
models to adopt obscene
poses), Schiele analyzed
himself in a series of biting
portraits, executed in a
wide variety of techniques:
painting, graphics and
sculpture. The artist probed
deeply into the image
of himself and his soul,
assuming unusual positions
with strained gestures
and contorted grimaces.

Egon Schiele
The Old Mill

1916
Oil on canvas,
43¼ × 55 in.
(110 × 140 cm.)
Niederösterreiches
Landesmuseum, Vienna

The force of Schiele's
line also found expression
in landscapes. A formidable
draftsman, Schiele gave a
clear and incisive graphic
foundation to his canvases,
conceding little space to
color. Here even the water
gurgling past the piles of
the mill takes on the gray-
brown tone of the wood.

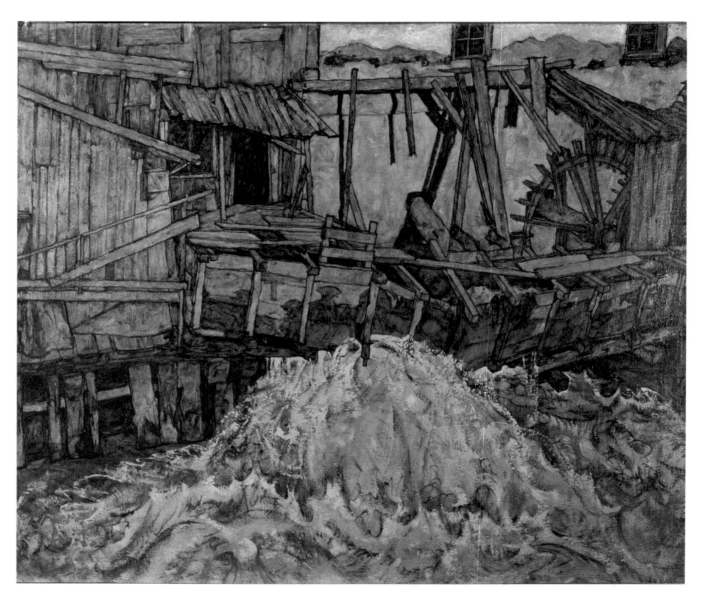

Egon Schiele
Agony

1912
Oil on canvas,
27½ × 31½ in.
(70 × 80 cm.)
Neue Pinakothek, Munich

An image of great power,
it depicts a Franciscan
monk at the bedside of a
dying man. The devastated
face of the figure in its
death throes, whose
hands joined in a last
act of devotion stand out
against the crumpled
blanket, contrasts
dramatically with the
tension that grips the
features of the confessor,
his body hunched up
in the confrontation with
the mystery of death.
Here Schiele's keen
draftsmanship reaches
an apex of expressiveness.

Cubists and Futurists

Pablo Picasso
Portrait of Gertrude Stein
1906
Oil on canvas,
32 × 39¼ in.
(81.2 × 100 cm.)
The Metropolitan Museum
of Art, New York. Bequest
of Gertrude Stein, 1947

It is often said that much of twentieth-century art can be summed up in the figure of Pablo Picasso, thanks to his long life, prodigious talent and exceptional readiness to question his own achievements. Picasso's life and career are studded with masterpieces and sudden shifts in direction. Yet the deepest mark left by Picasso on contemporary painting remains linked to the brief but decisive period of Cubism, the avant-garde movement that represented a figurative point of reference for generations of painters all over the world until after the Second World War, eventually becoming not simply an artistic choice but a political one. To understand the origins of Cubism it is necessary to go back once more to the retrospective of Cézanne's work held in 1907. The Parisian art world was literally revolutionized by the discovery of the painter's masterpieces. Many young painters found just what they were looking for in Cézanne: the possibility of going beyond the schemes of late nineteenth-century painting, shaped in various ways by the market, the tastes of the public, the dead weight of academicism and the legacy of the Impressionists. The example of Cézanne made a particular impression on Picasso and Braque, who were shrewdly supported by the art dealer Daniel-Henri Kahnweiler. Cézanne's decomposition of vision along regular lines and the brutal and powerful expressiveness of primitive art led Picasso to lay the foundations of Cubism. The painting that sums up this very early phase of the avant-garde is the monumental *Demoiselles d'Avignon* (1907), which took the example set by Cézanne's *Bathers* to an extreme. For several years Picasso and Braque worked in close collaboration: they spent the summer together in the countryside, painting rural landscapes, while in the winter they worked in the so-called *Bateau-Lavoir* ("boat-washhouse"), a studio perched on the hill of Montmartre. Picasso and Braque developed Cubism along the lines of a scientific experiment, which entailed the breakdown of objects into geometric lines and shapes, to the point where the solidity of the material was lost and the result, in the last analysis, verged on complete abstraction. As early as 1909 Picasso went so far as to eliminate color, replacing it by a gamut of grays. Two years later, in an extreme sobriety of expression, he started to insert letters, numbers and newspaper cuttings, a technique known as collage. The road taken by Picasso was the same

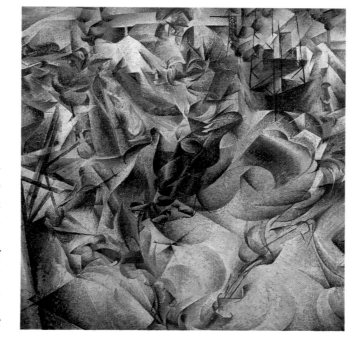

Umberto Boccioni
Elasticity
1912
Oil on canvas,
39¼ × 39¼ in.
(100 × 100 cm.)
Museo d'Arte
Contemporanea, Milan

as Braque's: the two worked together so closely that their pictures were almost indistinguishable, linked by their common research. Cubism was a clean break with the art of the past, a provocative proposal that left the public perplexed. Those who consider Cubism a fraudulent system, a mere formula of simplification, need to be reminded of Picasso's consummate technique, the formal mastery of his Blue and Pink Periods. Cubism was a lyrical choice of great daring, made by Picasso and Braque with full awareness of the consequences. In 1914, as the threat of war grew, the two painters left Paris. They moved to Avignon and commenced the process of "Synthetic Cubism," a phase in which they returned to the use of color and the representation of the object and a prelude to their temporary abandonment of Cubism during the twenties. Picasso himself was to revive Cubism in a monumental and peremptory form during the years of the Spanish Civil War. A painting like *Guernica*, in addition to serving as an explicit manifesto of political and moral commitment, pointed the way to the renewed importance of Cubist decomposition as a guide for the Realism of Socialist and Communist art throughout Europe.

Over the same period as the development of Cubism, another cultural movement of international significance emerged in Italy, perhaps the most important avant-garde movement the country was to produce in the twentieth century. This was Futurism, stimulated by the writings of Filippo Tommaso Marinetti and his efforts to give a new impetus to cultural life in Italy. In 1910 Umberto Boccioni published the *Technical Manifesto of Futurist Painting*, launching the group officially. Futurism, which centered on Milan, rejected the art of the museums and the example of the past, exalting progress, the machine and dynamism instead. Starting out from the technical basis of Divisionism, the Futurists sought to use painting to represent the speed and action of men, horses, trains and automobiles, along with such modern phenomena as the construction of working-class housing projects on the outskirts of the "rising city." They also showed a keen interest in photography and the cinema. Boccioni attained results similar to those of the Cubists as far as the simultaneous view of objects and figures from several different points is concerned. Unlike Picasso and Braque, however, he went on using color, at times in an explosive and luminous manner. As with many other artistic movements that emerged in the early years

of the century, the period of Futurism was brought to a dramatic end by the First World War. This event had a particularly bitter significance for the Futurists: carried away by their own rhetoric, they had urged Italian intervention in the war. The experience of the trenches was a violent shock and Boccioni himself, who had volunteered, was killed in 1916. The year before, Giacomo Balla and Fortunato Depero, two artists of diverse age and experience but linked by their membership of the movement, had drawn up the program for the "Futurist Reconstruction of the Universe," a cheerful utopia which they pursued in very different ways. Giacomo Balla, who had established a reputation for his remarkable ability to section moving images, light and color as if they were a series of stills from a film, would devote himself chiefly to elegant and abstract decorative compositions. Depero, on the other hand, set up a well-equipped workshop of applied arts at Rovereto, out of which emerged not only paintings but also a series of disparate and amusing objects, all bearing the unmistakable mark of the artist's fanciful imagination. The Cubists and Futurists had repeated contacts (especially through the talented Gino Severini, who was long active in Paris), but never collaborated, each claiming the credit for the development of certain formal solutions. However, an original synthesis of Cubism and Futurism, laid on top of a deeply-felt local tradition, was proposed by the Russian avant-garde. Artists in Moscow, stimulated by the city's lively literary and musical circles and kept up to date with what was going on in the West by journeys abroad and the patronage of Russian intellectuals and collectors, formed a group of remarkable coherence and importance. Outstanding among them were the husband-and-wife team of Mikhail Larionov and Natalia Goncharova, founders of the movement known as Rayonism.

Pablo Picasso

Malaga, 1881–Mougins, 1973

A key figure in twentieth-century art, Picasso displayed an impressive willingness to renew his own style, through experiments, avant-garde movements and sensational proposals. The training he received in Spain gave the artist a perfect grasp of techniques of expression. In 1900 he began to spend time in Paris, which was to become his new home. After an initial revision of the themes and style of Impressionism, Picasso entered his "Blue Period" (1901–04), the first of the recurrent phases of reinterpretation of classical art that alternated with periods of the most daring experimentation throughout his career. The subjects and figures of the pathetic human comedy (harlequins, circus performers) also appeared in the subsequent "Pink Period" (1905–06), which touched on peaks of refined, aristocratic disenchantment. Now surrounded by an extensive network of literary and artistic friendships (Gertrude Stein, Matisse), he was profoundly influenced by Cézanne's pictures of *Bathers* and sober landscapes, which he saw in 1907. With the *Demoiselles d'Avignon*, a seminal masterpiece of modern painting, Picasso commenced the rigorous breakdown of images into geometric solids, simplifying shapes and volumes by total abolition of the atmospheric effects of light and shade. The Bateau-Lavoir, the studio in Montmartre which Picasso shared with Braque, became the birthplace of the Cubist movement. In 1909, with the elimination of curved lines and the restriction of color to shades of gray alone, Picasso took Cubism to the level of an extreme, rarefied intellectual purity, on the threshold of abstraction, only to partially return to recognizable objects in the later phase of "Synthetic Cubism." As a result of the First World War, he moved to Avignon. This was the stimulus for a new phase of classicism, in which an almost academic style of drawing was combined with the compact forms of Cubism. In the twenties and thirties Picasso became increasingly fascinated by sculpture. The outbreak of the Spanish Civil War forced Picasso to make radical choices: a militant opponent of Franco, he became director of the Prado Museum and, in 1937, painted *Guernica*. The bloody events of the war left a deep mark on Picasso's painting. Returning to Southern France, he started to devote particular attention to ceramics from 1947 on. By now a legend (partly as a result of his political activity), Picasso led an intense public life. His most profound research in the field of painting concentrated on the reinterpretation of celebrated masterpieces of the past and on his favorite theme of the relationship between the artist and his model.

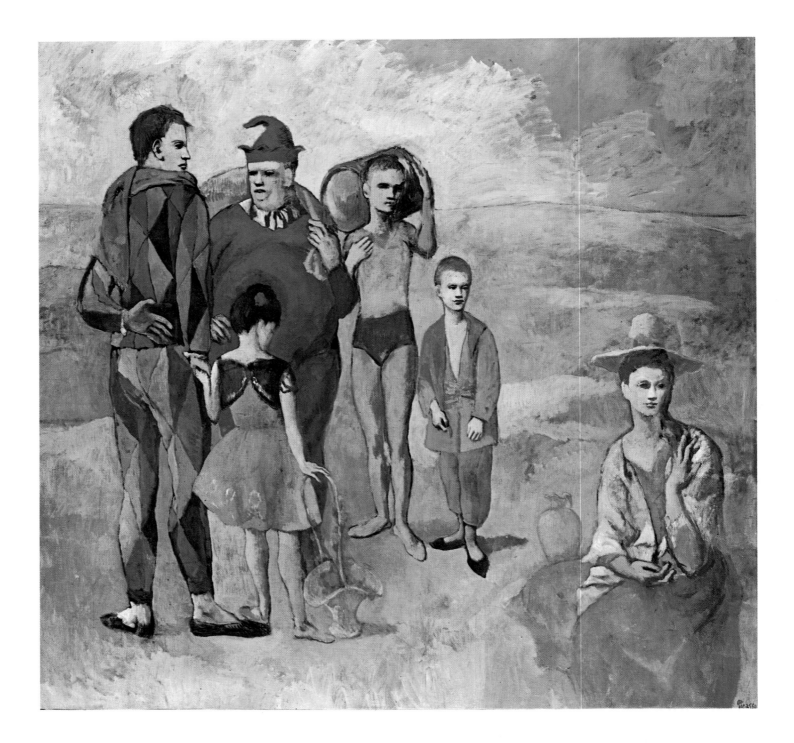

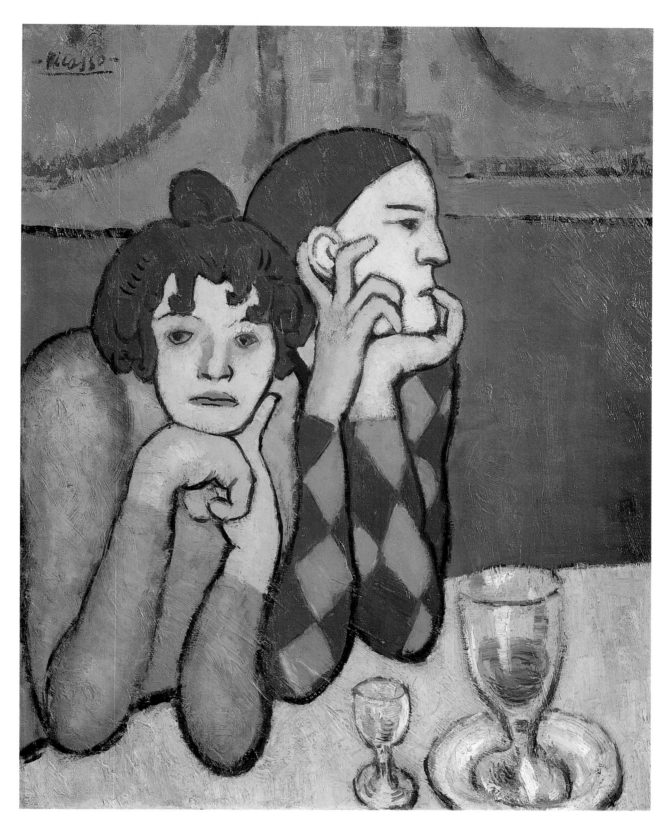

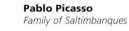

Pablo Picasso
Family of Saltimbanques

1905
Oil on canvas,
87½ × 92¼ in.
(222 × 234 cm.)
National Gallery,
Washington

The academic training
he received in Spain
remained an indispensable
foundation and term
of comparison all through
Picasso's extremely
long career. During
the "Blue Period" he
demonstrated a control
over form that was totally
classical in nature, but
applied to unconventional
images and figures on the
margins of society.

Pablo Picasso
Harlequin and His Friend

1901
Oil on canvas,
28¾ × 23½ in. (73 × 60 cm.)
Pushkin Museum, Moscow

Picasso's "Blue Period"
dates from the first few
years of the twentieth
century. It was one of the
great poetic and artistic
adventures of the emerging
avant-garde and the first
true demonstration of
the painter's quality. After
a thorough and shrewd
reexamination of the
whole course of the
Impressionist movement,
as well as the human
accents of the late Degas
(from whom Picasso took
the atmosphere of the
Absinthe) and the graphic
art of Toulouse-Lautrec,
he devoted a series of
paintings to the world
of acrobats and strolling
players. With their gaudy
but dusty costumes and
expressions of sadness,
Picasso shows us the long
performance of the human
comedy, in which the
masked figures reveal
the reality of their
existence and a profound
dignity.

253

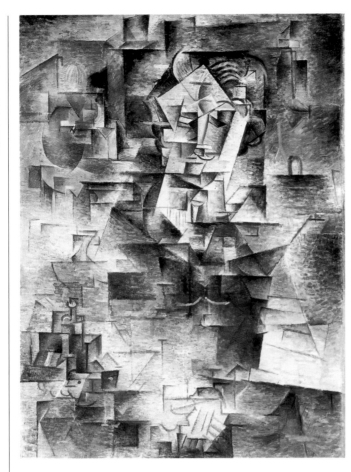

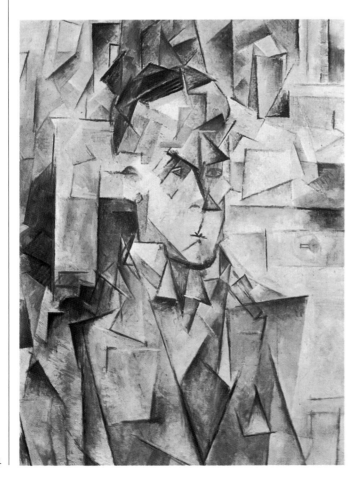

Pablo Picasso
Portrait of Daniel-Henri Kahnweiler

1910
Oil on canvas,
39¼ × 28¼ in. (100 × 72 cm.)
Art Institute, Chicago

The gallery owner Kahnweiler played a fundamental role in the artistic life of the Parisian avant-garde. He was in contact with collectors from all over the world and made a decisive contribution to the international diffusion of the movements of the early twentieth century.

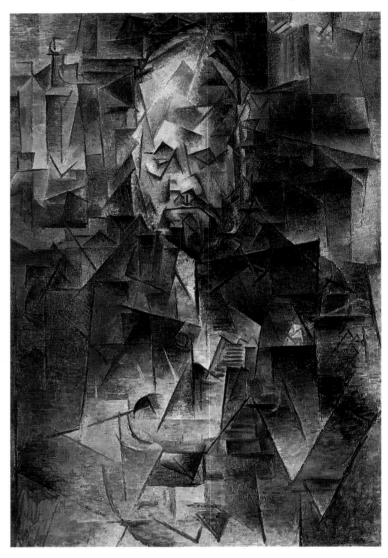

Pablo Picasso
Portrait of Ambroise Vollard

1909–10
Oil on canvas,
25½ × 36¼ in.
(65 × 92 cm.)
Pushkin Museum, Moscow

The face of the art dealer shows the effectiveness of Analytical Cubism.

Pablo Picasso
Portrait of Wilhelm Uhde

1909–10
Oil on canvas,
25½ × 36¼ in.
(65 × 92 cm.)
Private collection

Married briefly to Sonia Delaunay, this highly successful and extremely shrewd art dealer started to buy paintings by Braque and Picasso as early as 1907, in addition to supporting the work of Henri Rousseau, "Le Douanier."

Pablo Picasso
Les Demoiselles d'Avignon

1907
Oil on canvas,
96 × 91¾ in.
(244 × 233 cm.)
Museum of Modern Art, New York

The painting that marks a revolutionary turning point in art was inspired by the deep emotions stirred by Cézanne's posthumous exhibition. Picasso definitively undermined the foundations of "beautiful painting," composing a group of figures from which any hint of realism has been eliminated. Apart from using color, the artist makes no attempt to charm the observer. Cézanne's *Bathers*, sharpened by the reference to African art, become prostitutes waiting for clients. The painting (whose subject recalls Toulouse-Lautrec) is laid out on a smooth surface, with no depth and aggressive force.

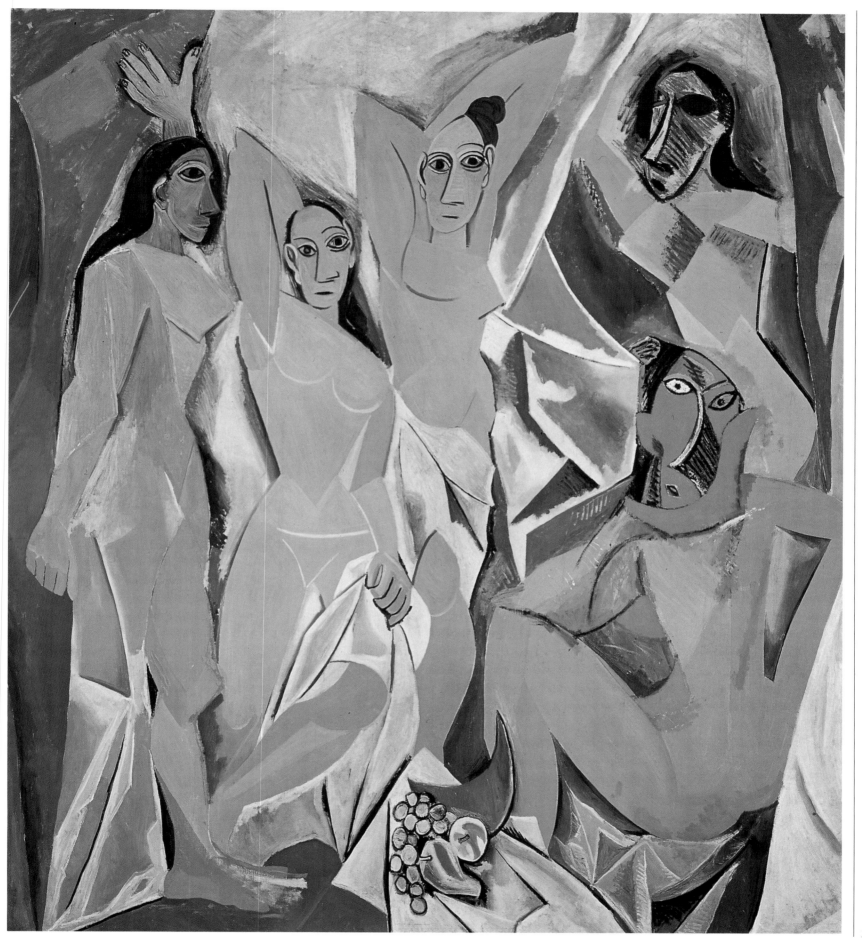

Pablo Picasso
Still Life at the Piano

1911–12
Oil on canvas,
19¾ × 51¼ in.
(50 × 130 cm.)
Berggruen Collection,
Geneva

Musical instruments
appear frequently in
Picasso and Braque's still
lifes during the historic
years of Analytical Cubism.
They were chiefly guitars
or mandolins, repeated
almost obsessively:
the keyboard of a piano
constitutes a surprising
exception. Stimulated
by the subject, Picasso
produced a painting
of elongated shape, like
an ancient predella.
The regular sequence
of the keys is shattered
by the dynamic breakdown
of planes and volumes.

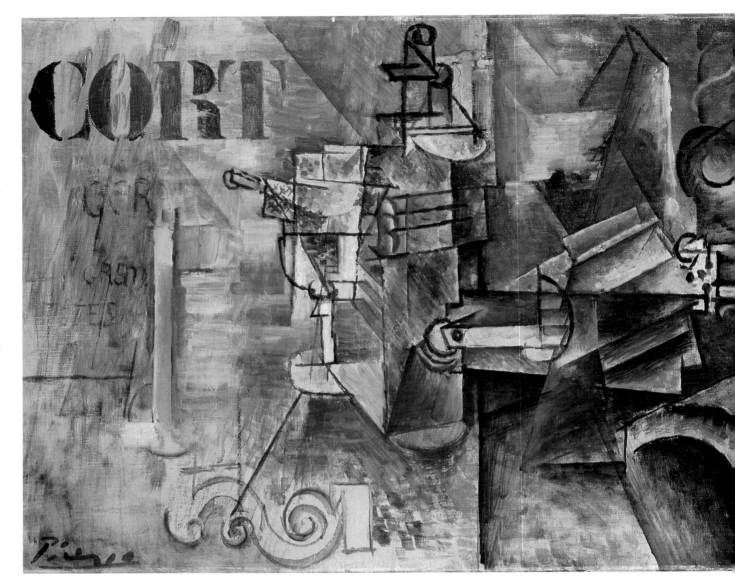

Pablo Picasso
Still Life with Chair Caning

1912
Oil and wax applied
to canvas,
12½ × 11½ in.
(32 × 29 cm.)
Musée Picasso, Paris

Another painting of
unusual shape, it simulates
the seat of a chair on
which certain objects are
placed. Here Picasso brings
some new and important
elements into play, such
as the theme of the
objet trouvé, or "found
object," and the insertion
of letters or words.

Pablo Picasso
Figures on the Beach

1937
Oil, pastel and
charcoal on canvas,
25½ × 36¼ in.
(65 × 92 cm.)
Pushkin Museum, Moscow

Over his long and creative
life Picasso alternated
periods of great Cubist
terseness with phases
in which the forms grew
swollen. This unusual
painting depicts two large
figures, halfway between
mannequins and
automatons, playing with
a toy boat at the edge
of a sea as smooth and
shiny as a sheet
of metal.

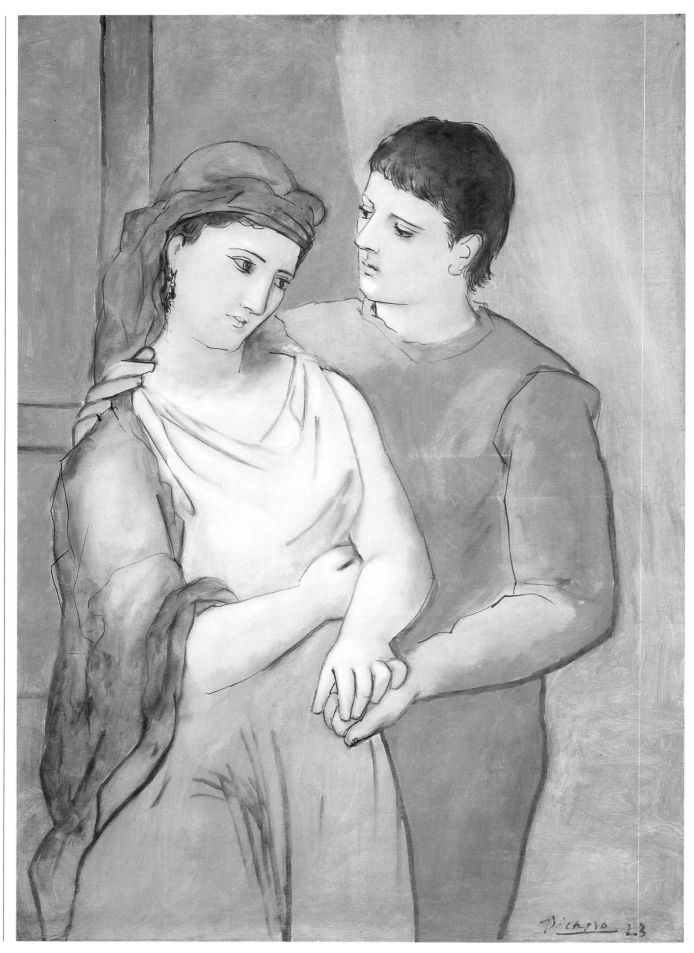

Pablo Picasso
The Lovers

1922–23
Oil on canvas,
51¼ × 38¼ in.
(130 × 97 cm.)
National Gallery,
Washington

After the exhilarating years
of the avant-garde and the
tragic events of the First
World War, art entered
a period of reflection
and there was a return
to traditional themes
and forms. Picasso, who
throughout his long
career as an artist always
demonstrated an ability
to modify his style,
at times radically,
rediscovered the delight
of feelings expressed
in a simple and clearly
recognizable way. The
figures of the two young
people are defined by soft
lines, with no harshness
or experimentation. Their
attitudes and expressions
speak of the game of love,
the interplay between
desire and shyness, the
exchange of glances loaded
with meaning. Despite
limiting himself to outline,
Picasso succeeds in giving
a sense of volume, depth
and gentle movement
to the figures, in a
composition which has
a strong classical flavor.
On the other hand, the
color does not "fill" the
outlines but is laid on with
great freedom, in patches
that do not correspond
to the reality of the natural
world. The colors are all
pale in tone, ranging from
yellow to blue, in order to
convey an additional touch
of suffused sentiment.

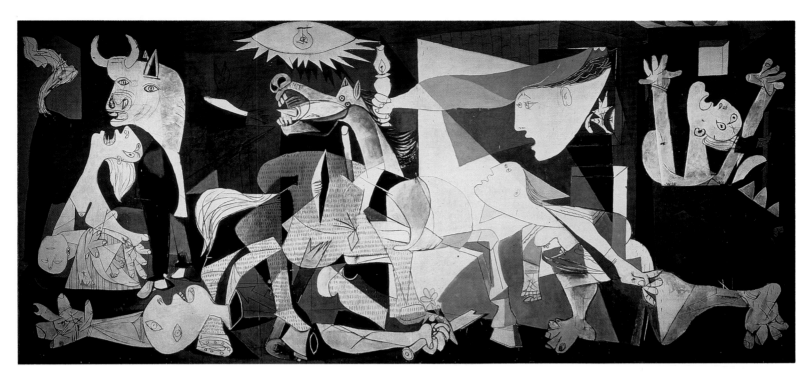

Pablo Picasso
Guernica

1937
Tempera on canvas,
139½ × 308 in.
(354 × 782 cm.)
Reina Sofia/Casón del
Buen Retiro, Madrid

This highly celebrated
picture, perhaps the
best-known work of art
of the twentieth century,
was painted during the
Spanish Civil War, in
which Picasso took the
Republican side. Intended

as the decoration for an
exhibition pavilion
in Paris, the work is based
on a real event that took
place during the war:
the bombing of the town
of Guernica. Drawing
on some elements of
Synthetic Cubism,
but adapted to the new
historical and artistic
situation, Picasso
composed a huge allegory,
crammed with allusions
and symbols. *Guernica*
immediately became
a model for whole
generation.

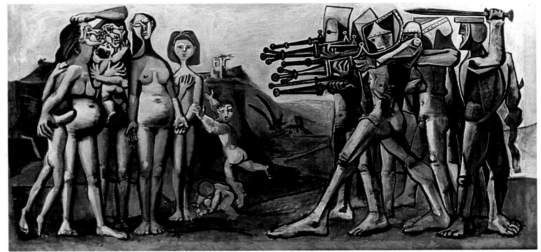

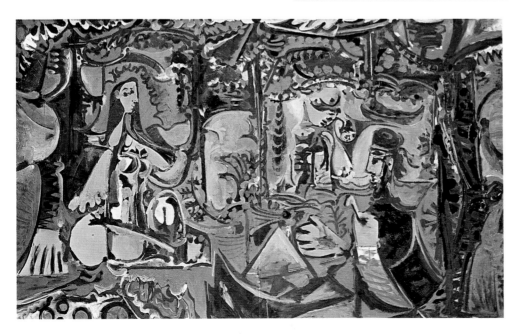

Pablo Picasso
Le Déjeuner sur l'Herbe

1960
Oil on canvas,
51¼ × 76¾ in.
(130 × 195 cm.)
Musée Picasso, Paris

Once again Manet serves
as a point of reference and
comparison: in fact the
painting takes a number
of elements (and not just
the title) from Manet's
masterpiece, now in
the Musée d'Orsay.

Pablo Picasso
Massacre in Korea

1951
Oil on canvas,
43¼ × 82¾ in.
(110 × 210 cm.)
Musée Picasso, Paris

From the fifties onward,
Picasso often tended to
reinterpret and reinvent
important paintings in the
history of art: his series
devoted to Velázquez's
Las Meninas is famous.
As a protest against
the new situation of
international crisis (with
the American intervention
in Korea), Picasso chose
to repeat the scheme
of Manet's *The Execution
of Emperor Maximilian
of Mexico*.

Georges Braque

Argenteuil, 1882–Paris, 1963

A leading figure in avant-garde research between the early part of the century and the Second World War, Georges Braque moved to Paris at the age of eighteen to study Dufy and the late works of the Impressionists. Concentrating on landscape, he soon showed a tendency to handle colors with great freedom, even in an unnatural way, using large expanses of color defined by marked outlines. This was the road taken by the Fauves, with whom Braque came briefly into contact only to establish a close partnership with Picasso, around 1907. Alternating summers in the countryside with work at the legendary Bateau-Lavoir in Montmartre, Braque and Picasso created Cubism through a continual exchange of ideas. The themes of Cubist painting were rapidly fixed: analysis of the human figure (practiced mainly by Picasso and still life. For these compositions, Braque gave up the vivid colors of his early period in favor of a rigorous investigation of forms, volumes and lines. The first phase of "Analytical Cubism" (1908–11), during which the collaboration between Braque and Picasso was so close that their work was almost indistinguishable, was followed by the period of "Synthetic Cubism" (1912–14), in which Braque expressed himself with greater originality, especially through the insertion of numbers, letters and various materials applied onto canvas in the new technique of collage. After the First World War, and the end of his friendship with Picasso, Braque continued his research into the decomposition and recomposition of objects set on a table with a small round top (*guéridon*), attaining effects of total abstraction. Like Picasso, Braque paid homage to the classical tradition in the twenties, painting imposing female figures and trying his hand at sculpture in bronze.

Georges Braque
Houses at L'Estaque

1908
Oil on canvas,
23½ × 28¾ in.
(60 × 73 cm.)
Kunstmuseum, Bern

The unmistakable influence of Cézanne marks a turning point in Braque's painting, leading him to leave the Fauvist group (of which he was a committed and brilliant member) in order to spend his summers with Picasso, engaged in a quest for a sober simplification of color and geometrization of form.

Georges Braque
Violin and Palette

1910
oil on canvas,
36¼ × 16¾ in.
(92 × 42.5 cm.)
Guggenheim Museum,
New York

A historic picture, painted at the height of Analytical Cubism, when Braque and Picasso's work was at its most interchangeable. Braque often included musical instruments and scores in his compositions: these "timeless" objects, whose form has remained unchanged for centuries, had long been favorite subjects for still lifes.

Georges Braque
The Violin - Valse

1913
Oil and charcoal
on canvas,
55 × 39¾ in.
(140 × 100 cm.)
Wallraf-Richartz Museum,
Cologne

Oval pictures (of fairly
elongated form) are a
chapter apart in Braque's
still lifes. Stimulated
by the shape, the painter
constructed towers
of objects piled on top
of one another, insisting
on tones of gray and the
brown of wood. Once
again, these include
musical instruments, while
the title of the composition
(*Valse*, or "waltz"), in
capital letters, constitutes a
strong and direct point of
reference for the observer.

Georges Braque
Large Nude

1907–08
Oil on canvas, 55 × 39¾ in.
(140 × 100 cm.)
Alex Maguy Collection,
Paris

Despite the interlude
of the years of Cubism,
Braque never lost his taste
for the human figure. In
early works like this one,
the influence of Cézanne
is still discernible, with its
simplified lines referring to
the great Provençal artist's
figures of bathing women.
Later on, especially during
the twenties, Braque
would respond to the
general climate of the
"return to order," painting
powerful and massive
female figures.

Umberto Boccioni

Reggio Calabria, 1882–Verona, 1916

Futurism was probably the most important artistic movement to emerge in Italy during the twentieth century, and Boccioni was its founder and most committed and significant exponent. For a brief period (cut short by the First World War, in which Boccioni lost his life following a fall from a horse) the group of painters, writers and musicians led by Boccioni and Marinetti was one of the most active and interesting avant-garde movements in Europe. The phase of his formation, during the first decade of the century, saw Boccioni pass from Balla's studio to Rome and then set off on a series of long journeys (to Venice, Russia and Paris), which allowed the painter to compare the technique of Divisionism with the principal expressions of contemporary art. Settling in Milan in 1907, he was attracted by the social themes of the Lombard painters of the late nineteenth century and watched with curiosity the growth of the new working-class districts on the industrial outskirts. The encounter between Boccioni and Marinetti, a brilliant and eccentric writer, marked the birth of Futurism: a lively and energetic affirmation of the world, a rejection of the past and a love for anything in movement, for action, noise and dynamism. Boccioni wrote the basic manifestoes of Futurist painting, as well as theoretical texts on the motivations and aspirations of the avant-garde. In the same years as Cubism emerged, Boccioni sought to represent things simultaneously from different viewpoints, in his rare but fascinating sculptures as well as in his paintings. His vivid colors, forceful brushwork and themes chosen with an evident symbolic and demonstrative intent are manifestations of a positive approach to creativity, open to influences from technology, sport and progress. The outbreak of the First World War (in which Boccioni took part as a volunteer) marked a turning point in his style, which grew more thoughtful and less frantic. All too soon his death interrupted any possible further development.

Umberto Boccioni
Materia (Matter)

1912
Oil on canvas, 88½ × 59 in.
(225 × 150 cm.)
Mattioli Collection, Milan

This is actually a portrait of the artist's mother. A subject that Boccioni returned to repeatedly, it is here tackled on a monumental scale, in a painting of very great significance. As Boccioni himself wrote in an explanatory text, the artist is seeking a complementarity between the figure and its surroundings. Through an enveloping movement, his mother "enters" the armchair, forming a single piece of "matter" with it.

Umberto Boccioni
Brawl in the Gallery

1910
Oil on canvas,
30 × 25¼ in.
(76 × 64 cm.)
Pinacoteca di Brera, Milan

With an amused and ironic eye, in part still using the technique of Divisionism, Boccioni depicts the small crowd that gathers around two scuffling women. The freedom from the traditional schemes of painting is apparent in the abbreviated forms and blazing colors, which create the effect of a vortex of movement.

Umberto Boccioni
Simultaneous Views

1911, Oil on canvas,
27½ × 29½ in. (70 × 75 cm.)
Von der Heydt Museum,
Wuppertal

This beautiful painting, lit up by vivid tones of color and yet under perfect rhythmic control, epitomizes some of the fundamental characteristics of Futurism: the attention paid to the city, the dynamic breakdown of objects, the linking of architecture and figures. The "simultaneity" of the views consists in the contemporary presence of different objects, figures and backdrops, all set in whirling motion as if in a vortex. The bright colors are an expression of Boccioni's enthusiastic attitude toward progress.

Giacomo Balla

Turin, 1871–Rome, 1958

The oldest but also the most long-lived and consistent of the Futurists began his career as a painter in Rome, where he moved in 1895. He soon came under the sway of Divisionism, painting remarkable pictures inspired by social realism and the industrial suburbs. In 1909 he became a committed member of the new Futurist movement, founded in Milan by the writer Filippo Tommaso Marinetti. Balla's activity, in the brief period of early Futurism, was prolific and enthusiastic. While Boccioni was chiefly interested in the problem of the dynamic breakdown of forms, Balla preferred to investigate light and color, through such studies as *Iridescent Interpenetrations.* The painting that sums up Balla's early Futurist phase is the *Little Girl Running on a Balcony* (1911–12), where the color is split up into individual touches, producing an effective sense of movement. In 1915 he drew up the program of "Futurist Reconstruction of the Universe" with Depero, and after the end of the war his activity extended into a variety of fields, including cinema, interior decoration, design and textiles. Later Balla went into isolation, showing a distinct tendency toward abstract art.

Giacomo Balla
Little Girl Running on a Balcony

1911–12
Oil on canvas,
49¼ × 49¼ in.
(125 × 125 cm.)
Galleria d'Arte Moderna, Milan

Fortunato Depero
My "Plastic Ballets"

1921
Oil on canvas,
74½ × 70¾ in.
(189 × 180 cm.)
Private collection

Fortunato Depero

Fondo in Val di Non, 1892–Rovereto, 1960

The phase of critical reassessment of the prolific activity of this versatile and brilliant artist, the only one to really attempt the Utopian enterprise of the "Futurist Reconstruction of the Universe," has now been brought to a happy conclusion. Joining the Futurist group at a very young age, Depero was still in the middle of his formative stage when the war broke out. He formed a partnership with Balla that yielded some imaginative projects. Depero regarded painting as just one of his many activities, in which commercial art played a significant role. Nevertheless, his paintings sum up the key features of his style, such as the presence of mechanical mannequins, cut-outs painted in glowing colors and complicated machinery operated by automatons. A set designer and director of plays, Depero called his home-cum-studio in Rovereto "the Magician's house." From it emerged a continual flow of creative marvels, such as the large decorative panels described by their author as "mosaics of cloth." He received official recognition for his work, not least an invitation to spend two years in New York (1928–30), where Depero, fascinated by the "Futurist" impetus of skyscrapers, contributed to a number of prestigious magazines. After 1930, however, Depero's activity was restricted to the narrow confines of Fascist autarky.

Here Depero evokes the staging of mechanical ballets and puppet shows. After the early phase of Futurism, he kept alive the cheerful vision of a "Futurist Reconstruction of the Universe."

Mikhail Larionov

Tiraspol, 1881–Fontenay-aux-Roses, 1964

Fellow student and then husband of Natalia Goncharova, Larionov was strongly committed to a shift away from the repetitive painting of the late nineteenth century and a return to the sources of Russian art, brought into line with developments in the international avant-garde. During the first decade of the century Larionov painted in an almost naïve manner, with deliberately simplified forms of a popular and primitive flavor. Through an extensive series of writings, exhibitions and encounters, he contributed to the foundation of Rayonism, a movement that Larionov saw as a springboard for abstract art, unlike his wife Goncharova, who always maintained a figurative approach. An important stimulus for Larionov was the dynamic breakdown of forms carried out by the Futurists, applied to figures in movement. In 1914, Larionov accompanied the ballet company led by the celebrated choreographer Diaghilev to Paris, where he concentrated chiefly on stage design.

Mikhail Larionov
The Brawl

1911
Oil on canvas,
28 × 37 in.
(71.3 × 94 cm.)
Thyssen-Bornemisza
Collection, Madrid

Mikhail Larionov
Venus of Kazapsk

1912
Oil on canvas,
39¼ × 51 in.
(99.5 × 129.5 cm.)
Thyssen-Bornemisza
Collection, Madrid

The painting belongs to the most characteristic phase of Larionov's career, when he was attempting to fuse the great models of the European avant-garde with the Russian tradition.

Mikhail Larionov
Venus

1912
Oil on canvas,
26¾ × 33¾ in.
(68 × 85.5 cm.)
Gmurzynska Gallery,
Cologne

Larionov's next step was
an extreme simplification
of line and color, with a
monumental effect that
derived from the outline
and the self-enclosed
forms, such as the two cats
curled up into spirals.

Mikhail Larionov
Rayonist Landscape

1912
Russian Museum,
St. Petersburg

Rayonism, the movement
founded by Larionov and
his wife Goncharova,
entailed an adoption
of the principles of
dynamism and simultaneity
from the Italian Futurists,
but using less vivid
coloring compensated
by a greater energy of line.

Natalia Goncharova

Ladzymo, 1881–Paris, 1962

She was a highly innovative painter and the founder of Rayonism, a current of painting that represented a brilliant fusion of elements from Orphism, Cubism and Futurism. At the beginning of the century, together with Mikhail Larionov (whom she later married), she proposed a return to traditional forms of expression in Russia, such as icons and popular prints, abandoning the tendencies of nineteenth-century Realism. After a primitivist phase, Goncharova placed herself at the head of a group of young Muscovite artists that set out to combine the roots of the local visual arts with the most advanced expressions of the international avant-garde. After coming into contact with the work of the Blaue Reiter group, she drew up the manifesto of Rayonism in 1913. This was based on an intense dynamism that adapted the forms of reality to produce a highly expressive image in bright and simplified colors. In 1914 Goncharova and Larionov left Russia for Paris, where they continued their research in collaboration with the French avant-garde and achieved renown as costume and scene designers for Diaghilev's Ballets Russes.

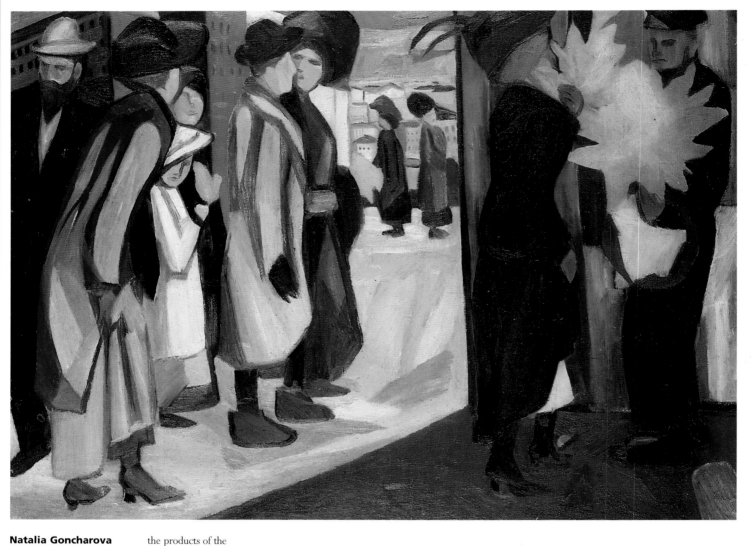

Natalia Goncharova
Springtime in the City

1911
Oil on canvas,
27½ × 35¾ in.
(70 × 91 cm.)
Abram Filippovich
Cudnovsky Collection,
Moscow

The tradition of nineteenth-century Russian Realism represented by Repin and the Wanderers was shattered to permit the emergence of a style fully comparable with the products of the contemporary Expressionist movement, but with a greater subtlety of interpretation. Natalia Goncharova was one of the century's most interesting woman painters, although the evolution of her style ran its course within a fairly short period of time. Here we can note her ability to conjure up atmospheric sensations and subtle hints of exchange between the figures notwithstanding the considerably abbreviated lines and forms.

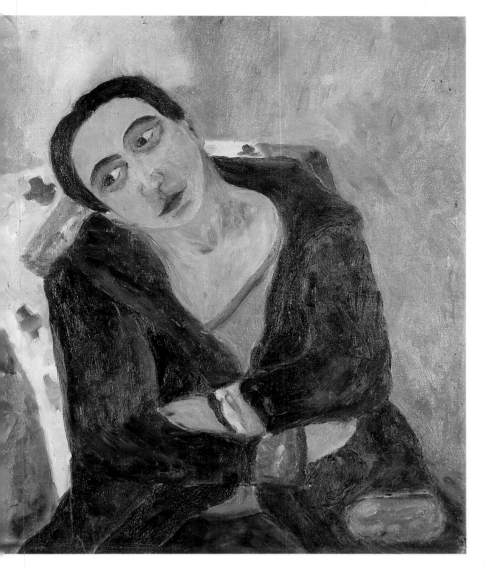

Natalia Goncharova
Woman in Armchair

1904
Oil on canvas,
19 × 19 in. (48 × 48 cm.)
Private collection, Turin

In the painter's early work it is possible to recognize the powerful influence exercised by the arrival in Russia of major works of Impressionist and Postimpressionist art, and in particular a fine group of pictures by Gauguin. Immediately apparent, moreover, is the attempt to achieve a synthesis of expression that demonstrates Goncharova's strong personality.

Natalia Goncharova
Lady with Hat

1913
Oil on canvas,
35½ × 26 in.
(90 × 66 cm.)
Centre Pompidou, Paris

One highly characteristic aspect of Rayonism is the unleashing of dynamic forces, which shoot through the painting like arrows. The features of the sitter are stripped of all elements of recognizability: once again, the Russian avant-garde showed itself to be in constant dialogue with the latest developments in Cubism and Futurism.

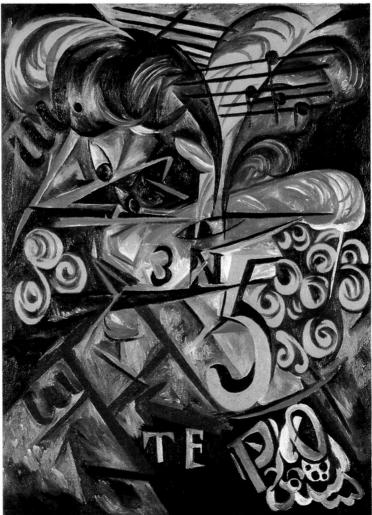

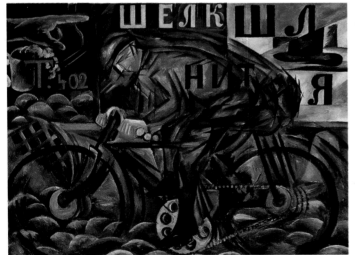

Natalia Goncharova
The Cyclist

1913, Oil on canvas,
31 × 41¼ in.
(79 × 105 cm.)
Russian Museum,
St. Petersburg

This picture can profitably be compared with the products of other avant-garde movements, such as Futurism and Cubism. The heavy bicycle chain is taken from an advertising poster by Toulouse-Lautrec.

The Avant-Garde

Henri Matisse
The Dance (detail)
1910
Oil on canvas, 102¼ × 154 in.
(260 × 391 cm.)
Hermitage, St. Petersburg

Giorgio de Chirico
The Disquieting Muses
1918
Oil on canvas,
38¼ × 26 in.
(97 × 66 cm.)
Private collection, Milan

"Donatello among the wild beasts!" This was what the critic Louis Vauxcelles exclaimed on seeing a sculpture in Renaissance style standing in the midst of works by Matisse, Derain, Vlaminck, Dufy and Rouault at the Salon d'Automne in 1905. And so this group of painters, which had commenced its activity some ten years earlier, acquired its name: the "Wild Beasts" or Fauves.

For the Fauves the picture was not a question of decoration, composition or order, but of pure expression. They saw painting as a way of unleashing the violence of their emotions on the canvas. Just as for the German movement known as Die Brücke, the fundamental point of reference for French Fauvism was the work of van Gogh. In contrast to Symbolism, which was interested in a reality that somehow transcended the everyday, but which could only be glimpsed through the symbol, or imagined in dream, the Fauves were committed to the nature of daily existence, and aspired to have a profound influence on the historical situation. Yet the group was not homogeneous and had no definite program, though it did share a common desire to reject Art Nouveau's hedonistic emphasis on decoration and Symbolism's inconsistency of form and spiritual escapism. The most prominent figure in the movement of the Fauves, which Picasso was to throw into crisis just two years later, when his celebrated painting *Les Demoiselles d'Avignon* (1907) marked the beginning of Cubism and the most revolutionary phase in modern art, was Henri Matisse. His *Joy of Life* (1905–06), of which Picasso's aforementioned picture can be considered the most significant criticism, represents a true compendium of Western painting, in spite of being a highly original work. The most explicit reference is to Stéphane Mallarmé's poem *L'Après-midi d'un faune*, an erotic reverie to which the painting is linked in its overall structure as well as in its images and colors. It is possible to discern the emergence of a new primitivism in the picture, stemming from the experience of the summer that he spent with André Derain at Collioure, in 1905. It was in this fishing village that Matisse and Derain, reacting against Neo-Impressionism, started to paint in the free manner and bright colors that would come to be known as Fauvism.

During the Fauvist period, Matisse's research was close-

Henri Matisse
Still Life with Eggplants
1911
Oil on canvas,
82¾ × 96½ in.
(210 × 245 cm.)
Musée de Peinture
et de Sculpture, Grenoble

ly paralleled by the work of André Derain and Maurice de Vlaminck, who are usually lumped together under the definition of the school of Chatou, the locality on the Seine where they used to go to paint. In fact they had very different temperaments: Derain had a greater feeling for measure, order and harmony and liked to keep the exuberance of the color under check within well-defined architectural forms, whereas Vlaminck used color to transpose his sensations onto canvas with the maximum of force and brutality. It is no accident that, when their Fauvist period had come to an end, Derain composed works that tended toward a classical realism, while Vlaminck went on to a somber and dramatic naturalism, with intensely lyrical accents. A different course was taken by Raoul Dufy, who came under the spell of Matisse

at the Salon des Indépendants in 1904, where the painting *Luxe, Calme, et Volupté* was on show, a picture in which Matisse broke away from Divisionist experimentation and also cut his ties with a certain Japanese style of decoration. Dufy was impressed and dropped his own Post-Impressionist manner, following Matisse in the Fauvist experience but attaining his own most convincing results in an essentially autonomous direction.

An anarchic and desperate pessimism marked the course taken by the painter Georges Rouault, who remained substantially a loner, in spite of a temporary dalliance with the Fauves, through the mediation of Matisse, whom he had met while studying in the studio of Gustave Moreau. In fact he felt indifferent to the distinctive obsession of Fauvism: he was not fond of glaring colors,

André Derain
Blackfriars
1907
Oil on canvas,
30½ × 38½ in.
(77.5 × 97.5 cm.)
Art Gallery, Glasgow

Amedeo Modigliani
Portrait of Paul Guillaume
1916
Oil on canvas,
31¾ × 21¼ in.
(80.5 × 54 cm.)
Museo d'Arte
Contemporanea, Milan

of the exaltation of reds, yellows and blues, which distracted attention from the center of the image. Rouault liked to use a single tone, preferably a dark, deep methylene blue, and a line that curved around to compress the image, giving an intensely dramatic emphasis to his figures of clowns, prostitutes and have-nots in general. The basic element in Rouault's expressionism was the line of Catholic thought (Bloy, Bernanos, Mauriac) that identified with an Augustinian conception derived from Jansenism. In fact many of Rouault's works are inspired by the writings of Léon Bloy, the Catholic intellectual who ventured into the world of sin, sharing the experiences of prostitutes and the poor, consumed by an invincible mystical ardor. Bloy's influence is palpable too in the series of etchings for the books *Guerre* and *Miserere*, made between 1916 and 1927, though the mystical viewpoint does not exclude the presence of a deeply-felt denunciation of social injustice.

A very strong religious current also runs through the unusual artistic career of the Russian Jew Marc Chagall. The religious movement known as Hassidism, widespread among the Jews of Central Europe, which places as much emphasis on mystical and irrational experience as on the observance of religious precepts, played a decisive role in his formation. Hassidic teaching does not draw on Talmudic law alone, but on edifying stories from life as well, in mixture of the sacred and the profane, the real and the miraculous. It is no coincidence that Chagall's earliest work, predating his stay in Paris (1910–14)— *The Musicians* (1907), *The Little Drawing Room* (1908), *The Feast* (1909)—presents a vision of the world in which Hassidism plays a very important part, along with Russian folklore, that stock of fables on which Vladimir J. Propp was working at around the same time. In this phase, however, like all the more advanced Russian artists, Chagall was trying to probe the mysteries of his "Russian soul" through an exploration of French painting, from the Impressionists to the Fauves, though the Dutchman van Gogh was the artist with whom he felt himself most in tune. Arriving in Paris in 1910, he was drawn to the work of the Cubists, though not convinced by their strict analytical rationalism. Rather he shared the approach of the dissident wing of Cubism, whose most prominent exponent was Delaunay. Eventually he arrived at a conception of painting as a transcription of

Marc Chagall
Above the City
1914–18
Oil on canvas,
55½ × 78 in.
(141 × 198 cm.)
Tretyakov Gallery, Moscow

inner psychical reality, a standpoint that would also be adopted by certain German painters, such as Franz Marc and Paul Klee. The themes that constantly recur in his work are drawn from the world of his childhood, spent in the small Belorussian town of Vitebsk. Breaking down figures, houses and landscapes into geometric planes, he creates an arbitrary perspective, an unreal space in which it seems quite plausible to see a woman walking in the air or a red cow. In his patently imaginary world, this helps to construct the dimension of fable, in which the symbology of color plays a decisive role.

The obligatory journey to Paris was also decisive for Amedeo Modigliani from the Italian city of Livorno, though the course of his artistic development cannot in fact be assimilated to any of the avant-garde currents that contended for dominance of the Parisian scene. While in 1906, the year of his arrival in Paris, it was the Fauves who hogged the limelight, Modigliani remained essentially indifferent to their emphasis on color. He did show a great deal of interest in the emerging Cubist movement, but was later, like Chagall, to side with its dissident wing. Drawn to the traditional genres of the portrait and the nude, Modigliani made no attempt to resolve space and objects into a single piece of architecture, but preferred to isolate a fragment of space, rendered meaningful by the presence of a psychological-

ly and physiognomically characterized figure. His early work as a sculptor still had an influence on the mature phase of his career: in fact it was a key factor in the identification of the constructive function of line so important to his painting, especially in the fertile period from 1915 to 1920.

The experience of sculpture played a far from negligible part in the development of Giorgio de Chirico, the painter born in the shadow of the Parthenon who was to become perhaps the most unusual personality in twentieth-century European art. His *Enigma of an Autumn Afternoon*, painted in Florence in 1910, is the pictorial transcription of an architectural space, dominated at the center by a disturbing figure (Dante in Piazza Santa Croce), frozen into an immobility that removes it from the familiar categories of space and time, turning it into a densely enigmatic apparition. It marked the beginning of a totally new approach to art, serving as the manifesto of the Metaphysical School that would be formed in Ferrara around 1916. The singular nature of the course taken by de Chirico cut it off from any linkage with the various avant-garde movements that dominated the European art world in the early twentieth century. If any influences are to be discerned, then we must look for them in the realm of philosophy, literature and music, and in particular the work of Schopenhauer, Nietzsche and Wagner.

Henri Matisse

Le Cateau, 1869–Cimiez, 1954

An important role in Matisse's apprenticeship as a painter was played by his frequenting of the Parisian studio of Gustave Moreau, where he learned that color "had to be thought, dreamed, imagined."

It was by following Moreau's example that Matisse abandoned the traditional principle of imitation in order to make creative use of color. Other significant impetuses in this direction, which would lead Matisse to banish from the canvas any element apart from pure color, came from the painters van Gogh and Gauguin, as well as from his encounter with Japanese woodcuts, Persian ceramics, Moorish textiles and African art. He spent the summer of 1905 working at Collioure, together with André Derain. Returning to Paris, he exhibited his works at the Salon d'Automne in October, thereby launching what would come to be known as the Fauvist movement. This took the form of a Mediterranean response, based on light and color, to contemporary German Expressionism, founded essentially on the graphic line. The decisive moment in Matisse's career came in 1906, when he showed the *Joy of Life* at the Salon des Indépendants. The picture sparked a controversy in which Picasso intervened by painting *Les Demoiselles d'Avignon*, intended as a violent rebuttal of Matisse's work: an angular, harsh, almost monochromatic work, where the *Joy of Life* was curvilinear, exuberant and brightly colored. At the end of the Fauvist experience, Matisse drew closer to Cubism, though he retained a brilliant, highly contrasting, and yet harmonious palette. His journeys to Morocco (1912–13), the United States and Tahiti (1930) were important. In his maturity his activity extended to embrace theatrical decoration, tapestries, ceramics and even sculpture, to which Matisse had in fact devoted himself right from the beginning of his career, under the influence of Rodin. He produced important drawings and illustrations for literary works, such as the poems of Baudelaire and Mallarmé.

Henri Matisse
The Dessert, a Harmony in Red

1908–09
Oil on canvas,
70¾ × 96¾ in.
(180 × 246 cm.)
Hermitage, St. Petersburg

The introduction of the outdoor landscape by means of a picture hanging on the wall of a bourgeois interior expresses the artist's desire to visualize an inner space, in terms of what the artist called "perspective of feeling."

Henri Matisse
The Dance

1912
Oil on canvas,
75 × 45 in.
(190.5 × 114.5 cm.)
Pushkin Museum, Moscow

The panel of *The Dance* can be seen as a lyrical response to Picasso's *Les Demoiselles d'Avignon*. Like Picasso, Matisse reduces and simplifies the outlines of his figures, but unlike that of the Spanish artist, his color remains rich and brilliant. The motif of dancers in a ring, which first appeared in the *Joy of Life*, was the artist's earliest attempt to depict figures in movement, introducing a dynamic element into the picture that seems to animate the surrounding space, whether it is that of an interior or a landscape.

Henri Matisse
The Joy of Life

1905–06
Oil on canvas,
69 × 95 in.
(175 × 241 cm.)
Barnes Foundation, Merion

A variety of sources can be traced in the picture—the subject is drawn from the pastoral tradition, the structure of the composition from Cézanne's *Bathers*, and the decoration from Puvis de Chavannes, while the two women at the center allude to Manet's *Le Déjeuner sur l'Herbe* and the two lovers entwined in the foreground on the right to Titian—giving rise to an effect of extraordinary originality.

Henri Matisse
L'Espagnole: Harmonie en Bleu

1923
Oil on canvas,
18½ × 14 in.
(47 × 35.6 cm.)
The Metropolitan Museum of Art, New York. Robert Lehman Collection, 1975

Abandoning the loose and spontaneous brushwork of the Fauvist period, Matisse has now developed a flat and decorative style, permitting a harmonious continuity between the actual appearance of the model and the artist's mental image.

278

Henri Matisse
The Goldfish

1912
Oil on canvas,
55 × 38½ in.
(140 × 98 cm.)
Pushkin Museum, Moscow

A journey to Morocco inspired Matisse to paint this picture in the spring of 1912. The goldfish—a theme to which he was to return obsessively throughout his career—are enclosed in an artificial environment that contrasts with the surrounding natural one, inviting us to reflect on the profound relationship between the animate and inanimate world.

Henri Matisse
Madame Matisse

1905
Oil on canvas,
16 × 12¾ in.
(40.5 × 32.5 cm.)
Statens Museum for Kunst, Copenhagen

This picture, also known as *Portrait with Green Stripe*, is an example of the unusual way in which Matisse uses color for creative purposes. The strokes of the brush are clear and distinct and have a precise, one might even say sculptural, correspondence with the structure of the image.

André Derain

Chatou, 1880–Garches, 1954

A friend and fellow student of Matisse and Vlaminck, with whom he founded the Fauvist movement, Derain showed a deep interest in reality right from the beginning of his career. In contrast to Matisse's lyricism and Vlaminck's aggressiveness, he was able to establish a masterly balance between a free and highly imaginative use of color and control over form, in a deliberate challenge to the Impressionist tradition. A very interesting example of this is provided by the group of canvases he made of views of the Thames in 1905, an updated version of Monet's celebrated series. From 1908, after the conclusion of the decisive Fauvist period, he came under the influence of Cézanne's work, brought to prominence by the Cubists. But, rather than being stimulated to break down volumes geometrically, Derain found in Cézanne the inspiration for a reinterpretation of the traditional plastic values in landscape painting and scenes of real life, seen in comparison with the products of non-European artistic cultures. As more and more avant-garde movements sprang up with provocative proposals, Derain felt the need to return to the roots of Realism in the work of Caravaggio and Courbet, though mediated by the ancient Roman art which he rediscovered on a visit to Italy. In this sense his work was in line with the "return to order" that characterized the Italian culture of the twenties.

André Derain
Woman in Chemise

1906
Oil on canvas,
39¼ × 32 in. (100 × 81 cm.)
Statens Museum for Kunst,
Copenhagen

Derain juxtaposes warm colors (orange and pink) with cold ones (blue and green) to achieve a perfect balance of tones.

André Derain
Waterloo Bridge

1906
Oil on canvas,
31¾ × 39¾ in.
(80.5 × 101 cm.)
Thyssen-Bornemisza
Collection, Madrid

In Derain's work Fauvist expressionism developed into an intensification of Impressionism. The picture makes use of just a few fundamental tones: reds and yellows, greens and blues.

280

Maurice de Vlaminck

Paris, 1876–Rueil la Gadelière, 1958

Of Flemish origin, Vlaminck took up painting as a result of the strong impression made on him by van Gogh's pictures, seen at an exhibition in Paris in 1901. A friend of Derain and Matisse, he was the most radical exponent of the Fauvist movement. He painted landscapes, still lifes and portraits in a systematically aggressive manner, making arbitrary use of pure colors squeezed directly from the tube onto the canvas. On the breakup of the Fauves in 1907, Vlaminck was inspired to return to the painting of Cézanne by Picasso, with whom he worked in the famous Bateau-Lavoir studio in Montmartre. From the twenties onward his landscapes and still lifes lost the emotional charge of earlier years and showed a more calculated and geometric approach to composition.

Maurice de Vlaminck
The Gardens at Chatou

1904
Oil on canvas
Art Institute, Chicago

Strong colors, combined to form violent contrasts, characterize the picture. Its title is a reminder of his collaboration with Derain, in the so-called school of Chatou, named after Derain's birthplace where the artists used to go to paint.

Maurice de Vlaminck
The Olive Trees

1905
Oil on canvas,
21 × 25½ in.
(53.5 × 65 cm.)
Thyssen-Bornemisza Collection, Madrid

In a manner that is clearly influenced by van Gogh, Vlaminck transfers the violence of his own feelings onto the canvas, using arbitrary colors squeezed directly from the tube.

281

Raoul Dufy

Le Havre, 1877–Forcalquier, 1953

A member of the Fauves, Dufy represented that side of the group most attracted to the beauty of the world and nature. While Vlaminck took the emotional use of violent color to its extreme consequences, Dufy preferred a refined style, working with brief and light brushstrokes in compositions that take on the appearance of precious and original arabesques. Trained at the municipal school of art in Le Havre, he received a grant in 1900 that allowed him to move to Paris and enroll in the studio of Maurice Bonnard. Here he studied Impressionist and Post-Impressionist painting until he joined forces with Matisse in 1905, struck by the painting *Luxe, Calme et Volupté,* shown at the Salon d'Automne the previous year. The Fauve experience at an end, a reexamination of Cézanne brought him to Cubism, as the 1910 painting *Boats in Marseilles Harbor* testifies. But Dufy did not find the strict rationality of the Cubists

congenial and decided to head off in a direction of his own, quite distinct from the currents that dominated the European scene. He developed a flowing, concise and extremely rhythmic style, covering the canvas with broad expanses of color (with a particular emphasis on shades of blue) overlaid with a dense and elegant mesh of tiny motifs, analyzed in every detail. He also produced fine drawings and textile designs that led him to experiment with new techniques of decoration.

Raoul Dufy
The Harbor at Honfleur

1905
Oil on canvas,
23½ × 28¾ in.
(60 × 73 cm.)
A. Roudinesco Collection, Paris

Although the brilliance of the palette is an indication of Dufy's adherence to the Fauvist movement, the calm and natural vision of the whole testifies to the persistence of an Impressionist influence.

Raoul Dufy
The Big Tree at Saint-Maxime

1942
Oil on canvas,
25½ × 31½ in.
(65 × 80 cm.)
Musée des Beaux-Arts, Nice

Against a background of vibrant tones, obtained by the skillful treatment of oil colors so that they assume the fluidity of tempera, the representation takes on an elegant lightness,

a characteristic that he developed after long, personal research. This felicity of expression would later be described by his detractors as facile and superficial.

Raoul Dufy
The Port of Marseilles

1950–52
Oil on canvas,
28¾ × 36½ in.
(73 × 92.5 cm.)
Musée des Beaux-Arts,
Nice

A refined colorist, Dufy
here shows himself to
be an excellent draftsman
as well, capable
of creating arabesques
of extraordinary freshness
and vivacity.

Raoul Dufy
July 14 at Deauville

1933
Oil on canvas,
15 × 36¼ in.
(38 × 92 cm.)
Pushkin Museum, Moscow

The boats moored in the
harbor, a recurrent motif
in Dufy's work, are placed
at the center of a canvas
that demonstrates his
surprising capacity to
reduce a pictorial sensation
to its essentials.

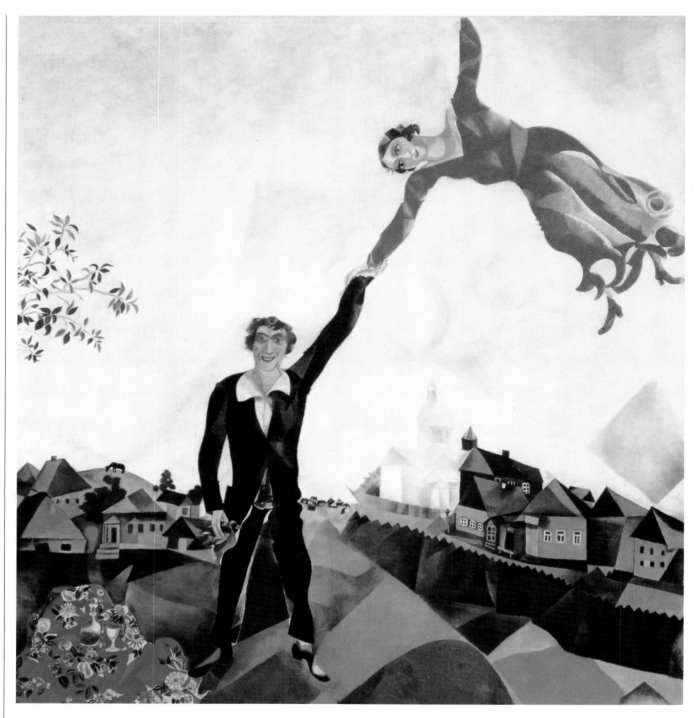

Marc Chagall
The Stroll

1917–18
Oil on canvas,
67 × 64¼ in.
(170 × 163.5 cm.)
Hermitage, St. Petersburg

The geometric forms
and flat areas of brilliant
color are concrete signs
of the influence of various
European avant-garde
movements, from Fauvism
to Orphism and Cubism,
fused in a highly distinctive
synthesis. Against the
backdrop of an urban
landscape, a male figure
with one arm raised above
his head holds on to the
figure of a woman, floating
in the air as if she were a
kite. The figures can be
identified as the artist
himself and Bella, the
woman he had always
loved and whom he had
at last married.

Marc Chagall

Vitebsk, 1887–Saint-Paul-de-Vence, 1985

Chagall's artistic career extends over a very
long span of time, traversing the most
advanced currents on the European scene
and developing, with total originality and
coherence, a body of work that centers
around a few central themes: his family, the
place of his birth, the life of peasants in
the Russian countryside and Jewish rites.
During his first stay in Paris (1910–14) he
frequented Apollinaire's circle, where he
was drawn to Orphism. Returning to
Russia, he gave his enthusiastic support

to the revolution of 1917 and, appointed
commissar of fine arts in his native city,
founded an academy to which he invited
Constructivists and Suprematists. In 1923
he went back to Paris, where he made a
series of engravings for Gogol's *Dead Souls*,
La Fontaine's *Fables* and the Bible.
In the second half of the forties he settled
in Provence, where he devoted himself to
ceramics and sculpture and produced a
number of large and monumental works,
integrated with their architectural
surroundings, such as the stained-glass
windows for Metz Cathedral (1958–68)
and the decoration of the opera houses
in Paris (1962–64) and New York (1965).





Marc Chagall
Rabbi

1910–14
Oil on canvas
Art Institute, Chicago

Figures from Jewish ritual recur obsessively in the world of Chagall's painting. This picture is dominated by the figure of a rabbi holding the Torah, which contains the scrolls of the law. On the right of the painting, against the background of a fabulous landscape, an angel is surrounded by a halo of light while a cow and violin occupy the foreground.

Marc Chagall
Window with View of the Garden

1917
Tempera and oil on paper glued onto paperboard, 18¼ × 24 in. (46.5 × 61 cm.)
Brodsky Museum, St. Petersburg

A window runs the entire length of the picture, separating a bourgeois interior from an external space characterized by luxuriant vegetation.

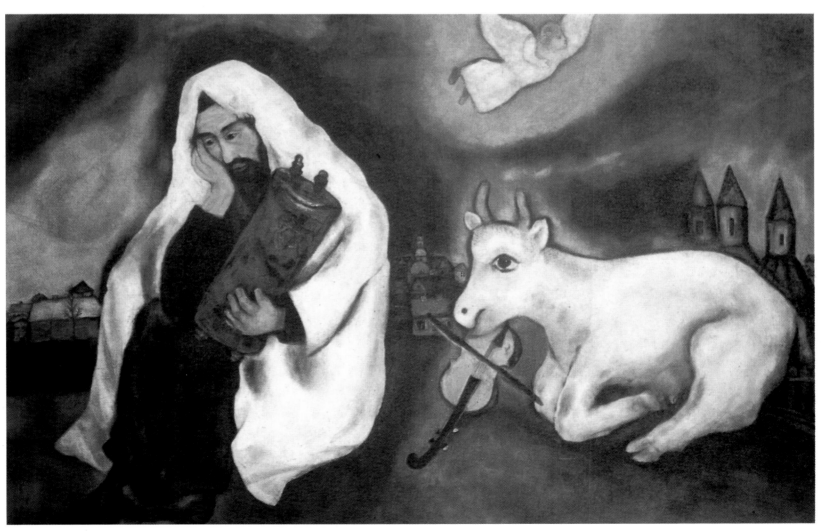

Marc Chagall
Paris at the Window

1913
Oil on canvas,
53½ × 55¾ in.
(135.8 × 141.4 cm.)
Peggy Guggenheim
Collection, Venice

A fairytale image of Paris,
dominated by the Eiffel
Tower, is visible through
the rectangular opening
of a window. In the
foreground, a domestic
interior, with a chair
and a two-faced, seated
figure, whose twofold
gaze emphasizes the
simultaneous presence
of two realities, an
exterior and an interior
one.

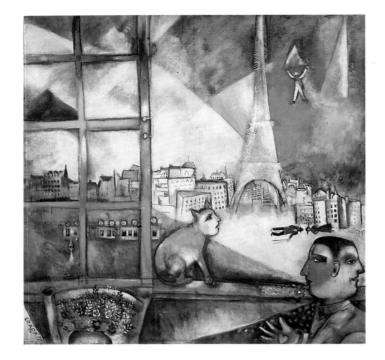

Marc Chagall
The Blue House

1920
Oil on canvas,
26 × 38¼ in.
(66 × 97 cm.)
Musée des Beaux-Arts,
Liege

The imposing bulk of a
blue house, on the right, is
a disquieting presence. On
the left, a brightly-colored
landscape, dominated by
the luminous pile of a
building whose pointed
towers recall fairytale
palaces.

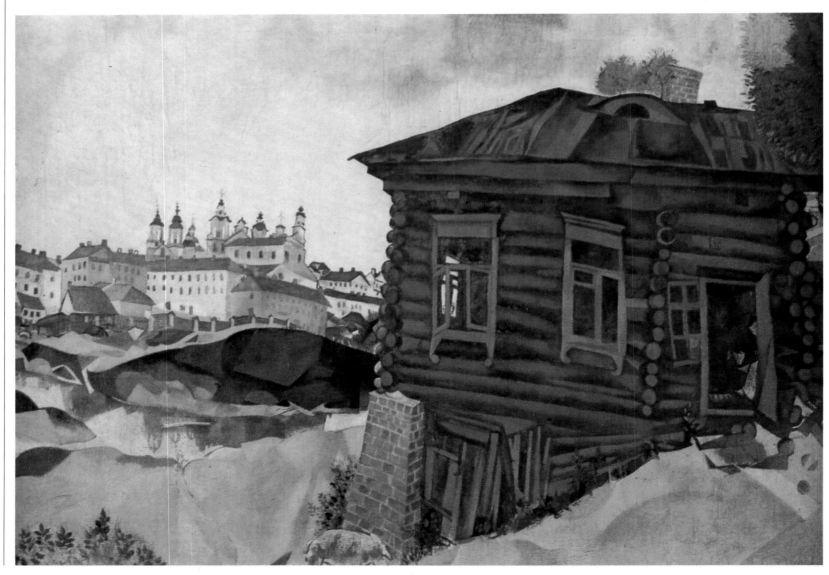

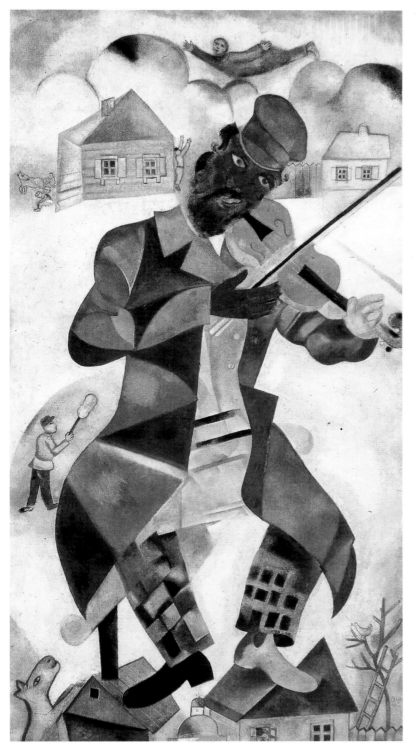

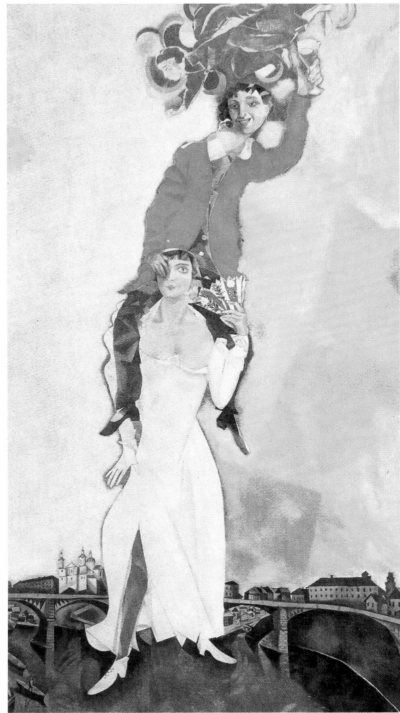

Marc Chagall
Double Portrait with Glass of Wine

1917
Oil on canvas,
91¾ × 53½ in.
(233 × 136 cm.)
Centre Pompidou,
Paris

Another expression of exuberant *joie de vivre*, freely inspired by a portrait of Rembrandt and his wife.

Marc Chagall
The Green Violinist

1923
Oil on canvas,
76¾ × 42½ in.
(195 × 108 cm.)
Guggenheim Museum,
New York

The violinist is an important element of Chagall's imagery, referring both to the figure of the strolling player and to the fate of the wandering Jew, whose only comfort in his continual travels is the company of his musical instrument. The reversal of proportions between the figure of the violin player which occupies the center of the picture and the surrounding landscape and the synthetic treatment of space are marks of an absolute creative freedom and a conception of art as unrestrained play of the imagination.

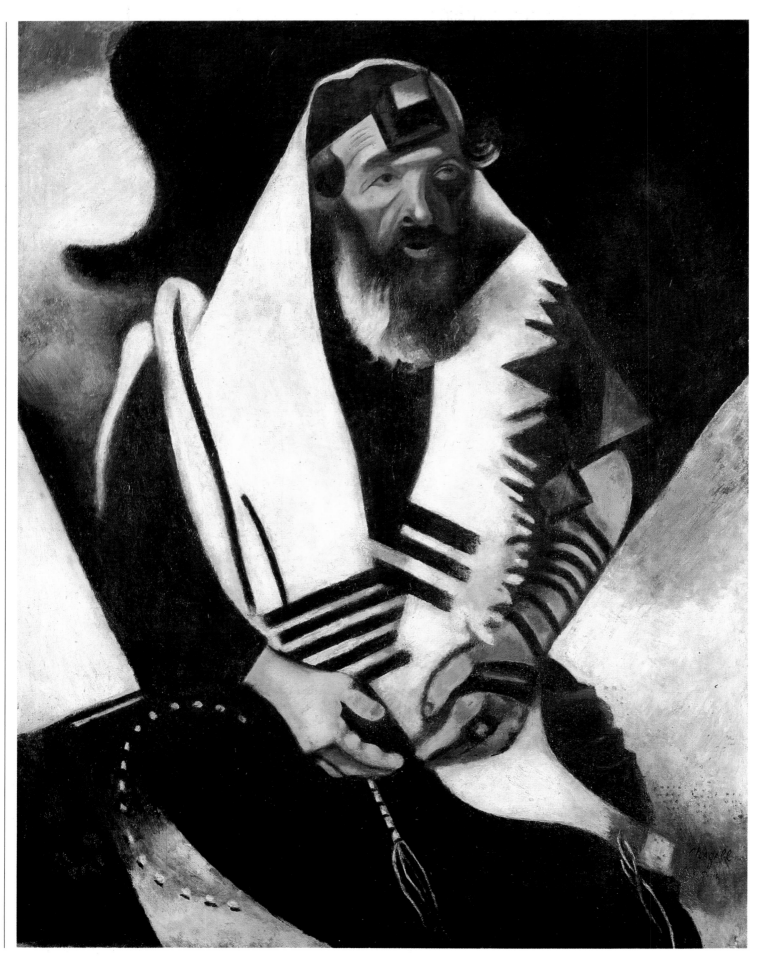

Marc Chagall
Rabbi No. 2

1914
Oil on canvas,
40¼ × 66½ in.
(102 × 169 cm.)
Ca' Pesaro, Venice

A subject dear to the
artist, it recurs frequently
in his pictures, right up
until the last years of
his life. This version,
painted during his first
stay in Paris, clearly shows
the influence of the
decomposition carried
out by the Cubists, who
dominated the French
scene in those years.

Marc Chagall
*Jacob's Dream. Moses
Before the Burning Bush*

1962–68
Stained-glass windows
realized in collaboration
with Charles Marq,
workshop of Jacques
Simon at Reims
Cathedral, Metz

At the end of the fifties
the artist discovered an
ancient technique, that
of painting on glass, which
he tackled after a careful
study of the stained-glass
windows in Chartres
Cathedral. The technique
fascinated him by its ability
to materialize light as
color, producing an intense
luminosity.

Georges Rouault
Paris, 1871–1958

Born in a cellar in Paris during the "bloody week" of massacres when the Commune was suppressed, Rouault's work seems to be imbued with an anarchic pessimism. He received his training from Gustave Moreau, along with Henri Matisse, which led him briefly to adopt the style of the Fauves. His early experience as a restorer of stained-glass windows lies at the origin of some of the peculiar features of his painting, such as the nocturnal luminosity of the backgrounds or the use of black lines in an expressionistic and tonal manner, as a color that compresses and flattens the others, conditioning their chromatic scale. From Moreau he derived the evocative and symbolic use of colors in pictures like *The Mirror* of 1906. His meeting with the Catholic philosopher J. Maritain in 1911 had a decisive influence on him, with the result that Rouault became the greatest painter of sacred art of the twentieth century. After 1930 the artist's dramatic tension attained a greater formal equilibrium, as can be seen in pictures like *The Old King* (1936), *Tiberias* (1947) and *Dusk* (1952).

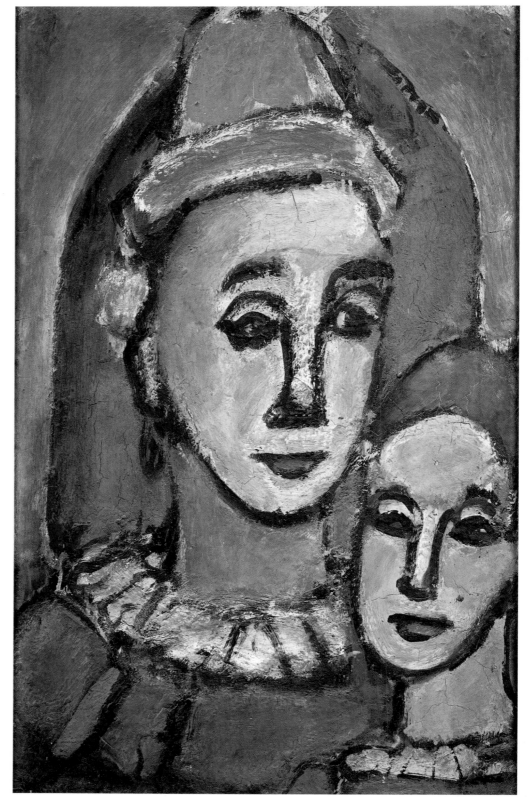

Georges Rouault
Duo

c. 1948
Oil on paper mounted on panel,
25¼ × 16½ in.
(64 × 42 cm.)
Private collection

The emblematic figure of the clown, which appears constantly throughout Rouault's work, represents the modern artist in exile, his rootless and derisory condition. In the years from 1943 to 1948, Rouault extended this identification to all human beings, representing his clowns in groups of two or three.

Georges Rouault
The Accused

1907
Oil on cardboard,
27 × 50¼ in.
(76 × 106 cm.)
Musée de la Ville de Paris,
Paris

Human justice, in the
person of both judges and
defendants, made its first
appearance in Rouault's
work in 1907, when a
magistrate friend took
him along to the court.
Anguished at the sight
of a human being sitting
in judgment over his
fellows, the artist gave
expression to his unease
with figures of an atrocious
ugliness that goes beyond
caricature.

Georges Rouault
Christ and the Fishermen

1937
Oil on canvas,
27 × 50¼ in.
(68.5 × 127.5 cm.)
Musée de la Ville de Paris,
Paris

The picture belongs
to a series of biblical
landscapes, of which
it is the most successful.
Christ's white clothing
stands out in the middle
of the painting, while
around him the scene
of the miraculous catch
unfolds.

Amedeo Modigliani

Livorno, 1884–Paris, 1920

The son of a Tuscan man and a Frenchwoman, Modigliani was trained at academies in Italy (Florence and then Venice). However, he spent the whole of his short career as a painter in Paris, the city that he started to frequent in 1905 and where he moved permanently in 1909. Even in the similarity of sound between his French nickname Modi and the word *maudit*, Modigliani embodies the figure of the "accursed" artist, constantly in search of a satisfactory form of expression that is always out of reach. Living in one of the poorer quarters of Paris, among the crumbling buildings of Montparnasse, and steeped in the fumes of drugs and alcohol, Modigliani turned out to be one of the greatest and most poetic artists of the early twentieth century. His conscious acceptance of a continuity with an age-old artistic tradition of the translation of feelings and emotions into lines and volumes places Modigliani firmly within the history of Italian art. His Italian—or rather Tuscan—training is manifest in the absolute rigor of his drawing and his emphasis on the human figure. Although thoroughly familiar with the Cubists, the artist from Livorno was never particularly attracted to the rationality of their vision. Influenced, if anything, by the synthetic simplicity of African sculpture, the forceful brushwork of Toulouse-Lautrec and the works of Constantin Brancusi, Modigliani for several years limited his output of paintings to concentrate on sculpture. As some well-known stories about his life indicate, Modigliani had a difficult relationship with the medium of sculpture. At the urging of the poet and art dealer Leopold Zborowski, he returned to painting and from 1915 until his death in 1920 at the age of only thirty-six (followed a few days later by the suicide of his despairing wife) produced some three hundred oils, almost all of them portraits. The unmistakable elongation of his figures (Modigliani's necks have become proverbial) enhances the solitary and supple elegance of the images, while the expressions are rendered with a penetrating simplicity. Inclined by nature to hold aloof from avant-garde currents or movements, Modigliani remains a great and isolated figure. His work gave rise to no school, even though it was comparable in its power to what was being produced by the artists of various nations who had decided to converge on Paris in the same years.

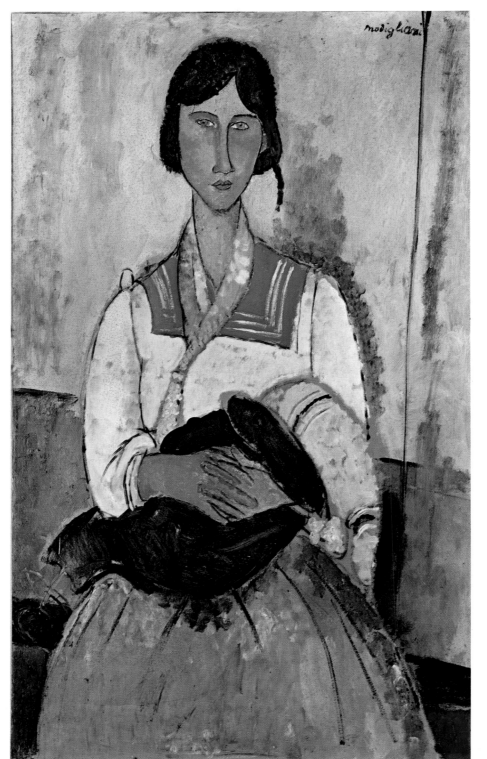

Amedeo Modigliani
Gypsy with Her Child

1918
Oil on canvas,
42¼ × 26½ in.
(116 × 73 cm.)
National Gallery,
Washington

The exceptional control over form, achieved with an impeccable line of classical nobility, never detracts from the inward intensity of expression of Modigliani's figures, conveyed through little gestures, details of dress and subtle but touching hints of personality. Modigliani's portraits are not frozen and insensitive idols, but people with unique and moving stories.

Amedeo Modigliani
Large Nude

1913–14
Oil on canvas,
26½ × 42¼ in.
(73 × 116 cm.)
Museum of Modern Art,
New York

For a long time
Modigliani's pictures
of nude women were
considered simplistically
(and in vulgarly reductive
fashion) "pornographic."
In point of fact, they are
among the few images in
Western art that can truly
be described as "erotic."
Modigliani presents the
outlines of the female
body with the peerless
refinement of a tradition
of drawing rooted
in Tuscan history,
communicating a real
and pulsating sensuality.

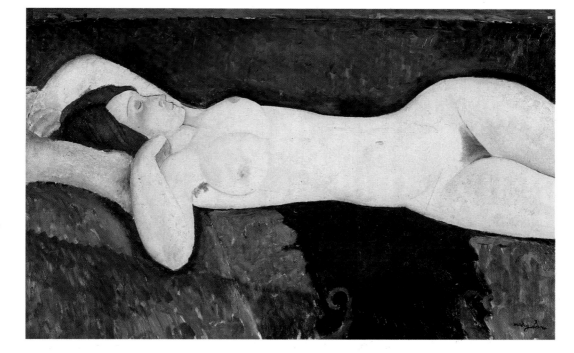

Amedeo Modigliani
Red Nude

1917
Oil on canvas,
21¾ × 33½ in.
(60 × 92 cm.)
Private collection, Milan

One of Modigliani's
most intense nudes,
it was exhibited in 1918
at Berthe Weill's gallery
in Paris, where his friend
Leopold Zborowski had
organized the artist's first
one-man show. Placed
provocatively in the
window facing onto the
street, the painting was
immediately confiscated by
the police, who considered
it indecent.

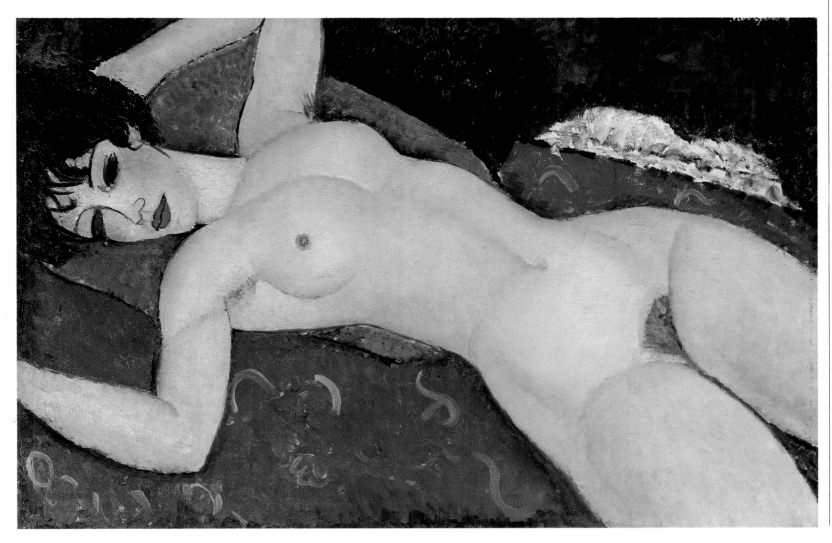

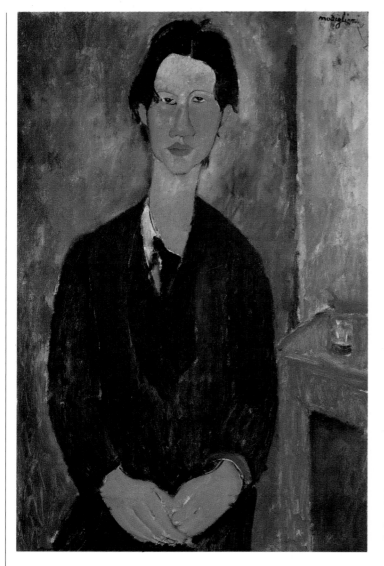

Amedeo Modigliani
Portrait of Soutine Seated

1916
Oil on canvas,
33¼ × 21¾ in.
(91.7 × 59.7 cm.)
National Gallery,
Washington

The Lithuanian Jewish
painter Chaïm Soutine was
one of Modigliani's few
real friends in Paris.
During the second decade
of the century, Modigliani,
Soutine and Chagall spent
a lot of time together,
working side by side in
the *Ruche* (warren) of
Montparnasse for the art
dealer Leopold Zborowski.
Linked by their
experiences and culture,
Modigliani and Soutine
supported one another,
finding in their mutual
solidarity the strength they
needed to remain
unaffected by currents,
influences and fashions.

On the facing page
Amedeo Modigliani
Portrait of Max Jacob

1916
Oil on canvas,
26½ × 21¾ in.
(73 × 60 cm.)
Kunstsammlung
Nordrhein-Westfalen,
Düsseldorf

Max Jacob, poet, friend
of painters and a painter
himself, had his portrait
painted several times by
Modigliani, who conveys
his sitter's intelligence and
sensitivity through the
intensity of his gaze and
composure of his features.

Amedeo Modigliani
Self-Portrait

1919
Oil on canvas,
44¾ × 32 in.
(123 × 88 cm.)
Museu de Arte, São Paulo

This is one of the last
works painted by the
artist, prematurely aged
by his always poor state
of health and by alcohol
and drugs. The poetic
and lyrical sense of
abandonment that
pervades all of Modigliani's
work seems to be summed
up in his sad and gentle
expression, the attitude
of his body and even
the shabby furniture
and clothing, subtle
but unmistakable hints of
the daily difficulties faced
by the "accursed" painter.

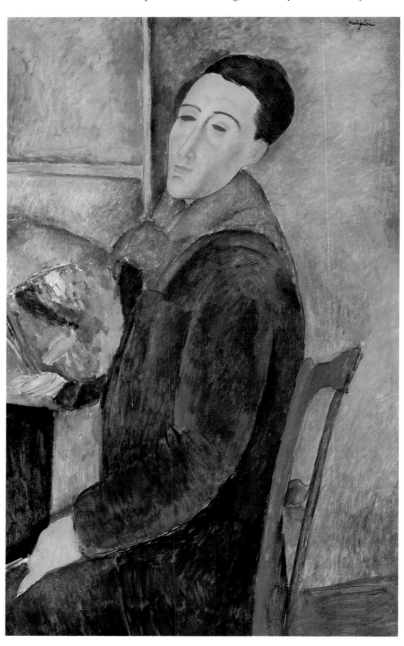

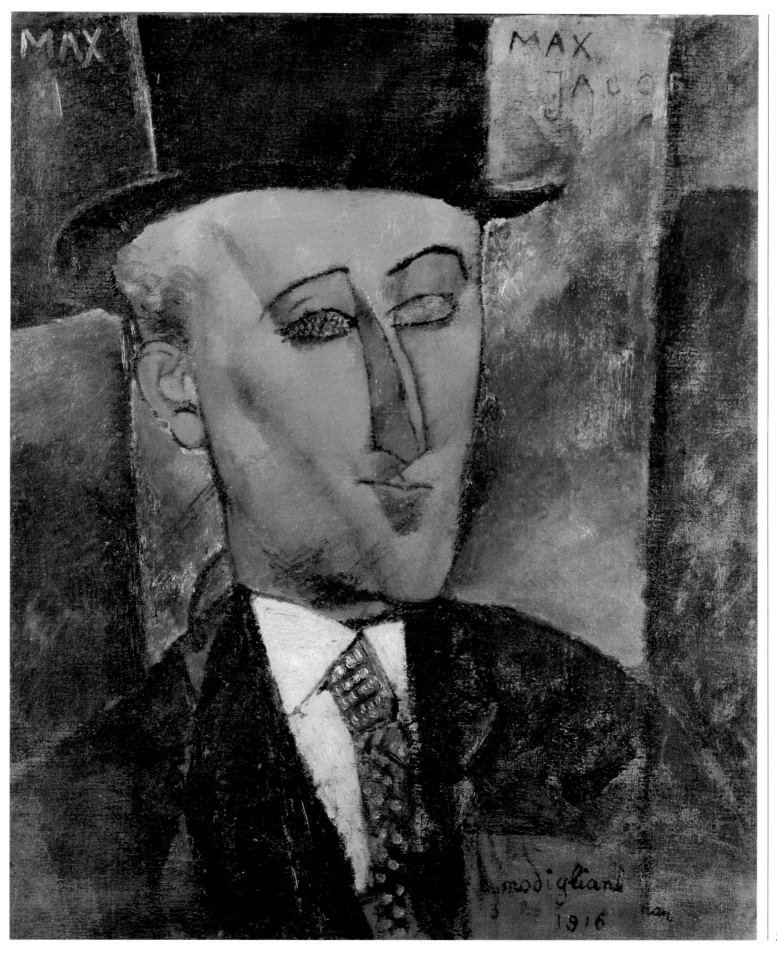

Giorgio de Chirico

Volos (Greece), 1888–Rome, 1978

The son of an Italian engineer employed on the construction of railroads in Greece, de Chirico always regarded the fact that he was born in the land of myths and gods as a sign of destiny. Throughout his life, like his brother Alberto Savinio, he felt that he had a profoundly "classical" identity, and this proved to be the constant essence of his work, despite his various shifts in style and readiness to compare his work with developments elsewhere in the art world. Operating completely outside the sometimes rather provincial schemes of Italian art, de Chirico was in fact far more interested in the tendencies in culture that were emerging elsewhere in Europe. Trained in Munich, he came under the

sway of Nietzsche's philosophy and the late Romantic painting of Böcklin, both strongly imbued with a feeling of nostalgia for the classical world. In 1910 de Chirico went to Paris, where he formed a close friendship with Guillaume Apollinaire and watched developments in Cubism with interest. It was in these years that de Chirico's most characteristic vein of inspiration took shape, the one linked to images of great power, set in disturbing, dreamlike contexts, filled with allusions. A fundamental impetus in this direction came from his celebrated meeting with Carrà and De Pisis at the military hospital of Ferrara in 1916: this marked the "official" birth of Metaphysical painting, one of the most important and original Italian avant-garde movements of the twentieth century. Its typical themes were mannequins, statues, silent and deserted "squares of

Italy," knife-edged shadows, backdrops of empty buildings and objects of everyday use presented completely outside their usual context. In 1918 de Chirico, along with Carrà, helped to found the magazine *Valori Plastici*, which gave the Metaphysical movement a literary underpinning. Dissatisfied with the evolution of Italian painting in the twenties, de Chirico returned to Paris, where he established links with the Surrealists and stepped up his investigation of archeological themes and motifs. This reexamination of the past led, in the thirties, to a "Neo-Baroque" style, in which he painted horses, still lifes and portraits. Over the rest of his long career de Chirico went back several times to themes he had already tackled, and in particular those of the Metaphysical period.

Giorgio de Chirico
The Red Tower

1913
Oil on canvas,
29 × 39½ in.
(73.5 × 100.5 cm.)
Peggy Guggenheim
Collection, Venice

Exhibited at the Salon d'Automne in 1913, the composition has a polycentric structure, marked by the divergent lines of perspective of the porticoes that enclose the square. In the background an equestrian monument and a circular tower are set.

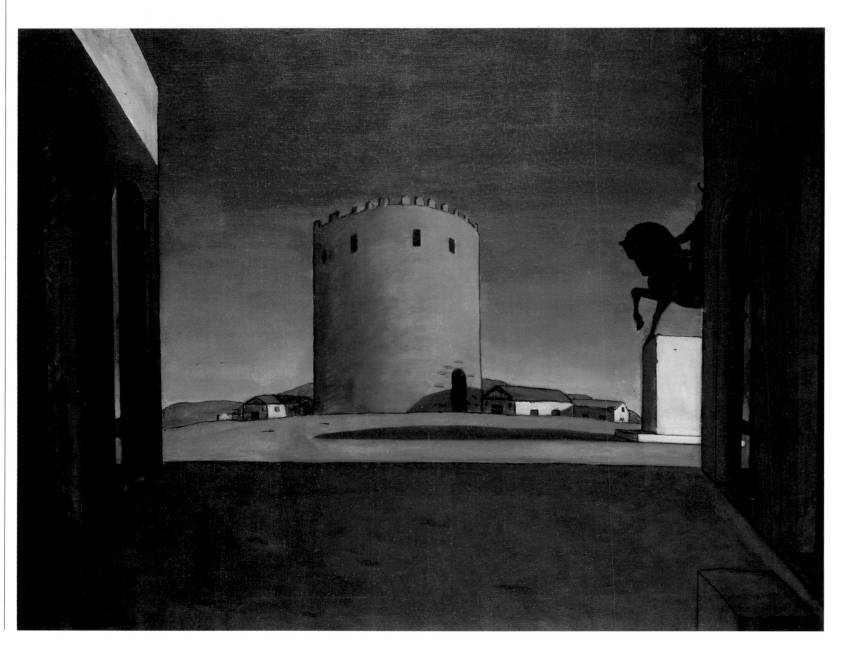

Giorgio de Chirico
The Song of Love

1914
Oil on canvas,
28¾ × 23¼ in.
(73 × 59 cm.)
Museum of Modern Art,
New York

Inspired by the title
of a poem by Guillaume
Apollinaire, de Chirico
conceived an improbable
encounter between the
head of the Apollo
Belvedere, a limp rubber
glove and a ball, while a
locomotive puffs in the
background (a tribute to
the profession of his father,
a railroad engineer).

Giorgio de Chirico
*The Nostalgia
of the Infinite*

1913
Oil on canvas,
53¾ × 25½ in.
(135.5 × 65 cm.)
Museum of Modern Art,
New York

Giorgio de Chirico
The Metaphysical Hour

1911
Oil on canvas,
21½ × 28 in.
(55 × 71 cm.)
Private collection,
Milan

At a time when Italian
art was dominated by
the dynamism of the
Futurists, de Chirico
started to produce his
motionless and
mysterious paintings, in
which the limpid
clarity of the line and
the rhythmic pattern of
the shadows render
the mysterious
suspension of voices,
time and life even more
magical.

297

Giorgio de Chirico
The Spring

1914
Oil on canvas,
13¾ × 10¾ in.
(35 × 27 cm.)
Private collection

A disturbing painting from
the Metaphysical period:
at the center an
emblematic figure,
apparently a doll made
of stone, surrounded by
elements that are recurrent
features of de Chirico's
landscapes, such as a ship,
a tower and a portico.

Giorgio de Chirico
Hector and Andromache

1917
Oil on canvas,
35½ × 23½ in.
(90 × 60 cm.)
Private collection, Milan

The still and silent
presence of the tailor's
mannequin was an
unmistakable characteristic
of de Chirico's work in
the second decade of the
century and of Italian
Metaphysical painting
in general. It should be
remembered that Alberto
Savinio, de Chirico's
brother, had inserted the
strange and disturbing
figure of a mannequin into
his first literary effort,
Les chants de la mi-mort
(*The Songs of Half-Death*),
a work half in poetry and
half in prose written in
French and published in
1914. References to the
world of classical antiquity
and the Homeric heroes
are extremely common
in de Chirico's work and
can be traced back to his
birth in "mythical" Greece.

Expressionists

Wassily Kandinsky
Lyrically (detail)
1911
Oil on canvas, 37 × 51¼ in. (94 × 130 cm.)
Boymans-van Beuningen Museum, Rotterdam

The history of German art is to a large extent characterized by a crude force of expression. Without indulging in charming graces or pointless ornament, the "classical" masters of German painting often used angular lines and harsh colors, sometimes distorting their figures to the point of caricature. This tradition, only partly interrupted by the Romantic and bourgeois styles of the nineteenth century, reemerged with a vengeance in the early years of the twentieth century, displaying a wholly new violence. This was the beginning of the long and important period of Expressionism, a movement that embraced not only the figurative arts but also literature, drama and the cinema. In spite of the diversity of its manifestations, the differences between the schools of painting in various cities and the wide range of artists involved, the Expressionist movement was a powerful articulation of a sense of collective unease, the confusion experienced by an en-

tire nation as it passed through the collapse of the empire, the war of 1914–18, the Weimar Republic and a devastating economic crisis. Throughout the first third of the century, up until the advent of Hitler (1933), Expressionists etched, drew and painted the soul of a Germany that had rushed headlong into the tragedy of the First World War and emerged from it broken, its politics, economy and physical structure undermined, and yet still capable of an acerbic vitality.

Expressionism was born almost contemporaneously in a number of German cities, against the background of the radical transformation that took place in art in the first decade of the century. Once past the generational and psychological threshold of the year 1900, there was a growing demand throughout Europe for the definitive and unlamented abandonment of late nineteenth-century figurative models. While Paris was open to the most disparate contributions from abroad, the cultural centers

Ernst Ludwig Kirchner
*The Alp of Stafel
by Moonlight*
1911
Oil on canvas,
54¼ × 78¾ in.
(138 × 200 cm.)
Museum am Ostwall,
Dortmund

Wassily Kandinsky
Red Wall–Fate
1908
Oil on canvas,
32¾ × 45¾ in.
(83 × 116 cm.)
Kustodiev Picture Gallery,
Astrakhan

of Germany (Dresden, Munich, Berlin) relied largely on the research and experimentalism of local artists. The first organized group emerged in Dresden, around 1905. In forceful opposition to the historical legacy of this "Florence on the Elbe," city of Rococo and porcelain, painters like Kirchner, Schmidt-Rottluff, Heckel and their companions set up Die Brücke, "The Bridge." They organized joint exhibitions and founded a magazine with the same name as a vehicle for their exercises in graphic art and theoretical writings. The dominant characteristic of this first Expressionist avant-garde movement was a heavy and brutal emphasis on line, used to form deliberately terse and crude images that resembled African sculpture. Color, on the other hand, was limited to broad

expanses, in a way that contrasted strongly to what Matisse, Vlaminck and the other Fauves were doing at around the same time. Undoubtedly the most influential of the members of Die Brücke was Ernst Ludwig Kirchner, who produced dry and intense images of Prussian landscape and society, drawing close, in some of his paintings, to the linearity of the Jugendstil, the German version of Art Nouveau.

For a brief period, thanks to his friendship with Schmidt-Rottluff, the self-taught genius Emil Nolde was also drawn into the group. A sort of extravagant and formidable naïf of Expressionism, he soon returned to his isolation on the shores of the Baltic Sea, to continue with his own inimitable investigation of the intoxication of color

Wassily Kandinsky
On White
1920
Oil on canvas,
37½ × 54 in.
(95.5 × 137.2 cm.)
Russian Museum,
St. Petersburg

and line, as if in the grip of an overwhelming visionary rapture.

The group that formed in Munich around 1910 was of quite another intellectual character: Der Blaue Reiter, or "The Blue Rider." In this case too, the name of the movement provided the title for the magazine in which its members published their writings. The pivotal figure was Wassily Kandinsky, unquestionably one of the artists who have had the greatest influence on the development of art in the twentieth century. Kandinsky's unusual background, coming late to painting and out of the Russian tradition, resulted in work of an extraordinarily innovative character. Kandinsky progressively abandoned the tenets of figurative art: from the meticulous illustrations of Russian fables with which he began his career, the

artist moved very rapidly to an ever more synthetic vision of landscapes, objects and people, relinquishing any use of perspective and concentrating on color and shape. The disintegration of the image was the prelude to an inevitable venture into the most daring abstraction. Kandinsky is considered the founder of so-called "Abstract Expressionism." His paintings were not based on geometrical patterns (as those of Mondrian were shortly to be) or on the absolute ascetic rigor of Malevich. On the contrary, Kandinsky unleashed a tempest of color onto the canvas, a graphic frenzy of unleashed dynamism. His painting has the energy of a liberation from age-old fetters. Alongside Kandinsky, the original nucleus of Der Blaue Reiter was made up of Franz Marc and August Macke: painters with a great feeling for color,

they never abandoned figuration and used a less drastic and incisive approach to drawing than their colleagues in Die Brücke. Unfortunately, Marc and Macke met the same tragic fate: they were both killed while fighting on the French front.

The First World War, which marked a watershed for many movements and currents, did not interrupt the development of German Expressionism. If anything, it served to reinforce some of its characteristics. Artistic culture in Germany split into two major tendencies: the rational and regular Constructivism of the Bauhaus in Weimar, represented by Klee, Kandinsky, Feininger and Jawlensky and interested chiefly in abstract art, and the exaggerated realism of the group known as the Neue Sachlichkeit, the "New Objectivity," based in Berlin. Its exponents were Georg Grosz and Otto Dix, artists whose works display both an extraordinary draftsmanship and a caustic and cruel sarcasm. Their painting developed out of the image of the human, material and moral disasters of the war. The great triptych of *The War* painted by Otto Dix is explicitly inspired by the most terrible work of the whole of the North European Renaissance, Mathis Grünewald's polyptych of the *Crucifixion* at Colmar. Perhaps no other painting in the history of art has so vividly conveyed the monstrous horror of a bloodbath. Grosz and Dix lashed out at postwar German society. They showed a tide of wretched invalids, veterans and the maimed pouring into the streets, along with a dizzy crowd of black-market profiteers, dissolute women, industrialists grown fat on war supplies and oily state bureaucrats. In Grosz and Dix the twenties in the Berlin of cabaret and Expressionist cinema found two memorable interpreters, offering a premonition of the direction in which politics was moving. Biting caricatures of Hitler appear very early on in the work of both of them: it is no surprise that their work, along with that of Expressionism as a whole, was condemned as "degenerate art" by the Nazi regime. All the painters who could emigrated from the Germany of the brown shirts, leaving behind them a cultural void that was hard to fill.

Franz Marc
Yellow Cow
1911
Oil on canvas,
55 × 74¾ in.
(140 × 190 cm.)
Guggenheim Museum,
New York

August Macke
The Storm
1911
Oil on canvas,
33 × 44 in.
(84 × 112 cm.)
Saarland Museum,
Saarbrücken

Franz Marc
Large Blue Horses
1911
Oil on canvas,
40½ × 70 in.
(103 × 178 cm.)
Walker Art Center,
Minneapolis

Wassily Kandinsky
Landscape with Church

Wassily Kandinsky

Moscow, 1866–Neuilly-sur-Seine, 1944

Even the life of this great painter of Russian origin, the founder of one of the most significant and enduring currents in contemporary art, Abstract Expressionism, displays some surprising aspects. Kandinsky came to painting very late. Trained in law, he was heading for a university career as a professor of jurisprudence, while studying Russian folk culture almost as a hobby and admiring the paintings of Monet, brought to Moscow by collectors like Shchukin and Morozov. At the age of thirty, he suddenly decided to go to Munich and study painting. At the academy he met his fellow student Paul Klee, with whom he was later to work at the Bauhaus. Kandinsky's early paintings,

though very interesting, can be placed within the late nineteenth-century tradition: landscapes and scenes of life among the Russian people are depicted in a technique reminiscent of Divisionism, while using the attractive colors of Art Nouveau. In 1908 he went to live in the Alpine town of Murnau, where he painted a series of landscapes in which the naturalistic image progressively dissolved into areas of strongly contrasting color. It is possible to discern parallels with the contemporary work of the Fauves, but Kandinsky's evolution was extremely rapid: as early as 1909 he was already venturing into abstraction, covering the canvas in spots and bands of color laid on with great freedom. He accompanied his painting by essays and other writings, which formed the theoretical basis for the birth of the group called Der Blaue Reiter

("The Blue Rider"), founded in Munich in 1911 with Marc and Macke. Returning to Moscow in 1914, Kandinsky took part in the Russian revolution and was given a post as a teacher at the Muscovite art workshops, where he began to carry out Constructivist research. This tendency toward regular and modular forms, very different from the Munich years, was confirmed after his return to Germany (1922) and collaboration with Klee and the Bauhaus at Weimar. Henceforth Kandinsky's pictures were more geometrical in appearance, though he never abandoned his intensely lyrical use of color. After publication of the important *Point and Line to Plane* (1926), he continued to work at the Bauhaus until its closure in 1933. The artist then moved to the suburbs of Paris, where he carried on painting until his death.

1913
Oil on canvas,
30¾ × 39¼ in.
(78 × 100 cm.)
Museum Folkwang, Essen

The great shift to Abstract Expressionism came between 1910 and 1914, the years of the Blaue Reiter group's most intense activity and of Kandinsky's links with the composer Arnold Schönberg. The artist no longer broke down the image in the Cubist manner, along geometric lines, but through the use of color. This canvas still maintains traces of the figurative.

306

Wassily Kandinsky
Couple on a Horse

1906–07
Oil on canvas,
20 × 21¾ in.
(50.5 × 55 cm.)
Lenbachhaus, Munich

The works of his early
period are of great interest
to any attempt to
understand Kandinsky's
complex personality
and unique course of
development. His visual
and poetic memories were
shaped by romantic images
of medieval Russia, but
the technique he adopted
was an updated version
of Divisionism. The whole
was dominated by a
certain taste for literary
illustration, which must
have been well-received
in the artistic circles
of Munich.

Wassily Kandinsky
*The Ludwigskirche
in Munich*

1908
Oil on canvas,
26½ × 37¾ in.
(67.3 × 96 cm.)
Thyssen-Bornemisza
Collection, Madrid

It is interesting to
compare the acute
experimentalism of the
early part of Kandinsky's
career, applied to his group
scenes as well, with the
didactic and descriptive
tradition of bourgeois
realism in late nineteenth-
century Germany, well-
represented by Adolph von
Menzel. It is clear that the
painter of Russian origin
belonged to a completely
new tendency in art, that
was feeling its way toward
striking innovations.

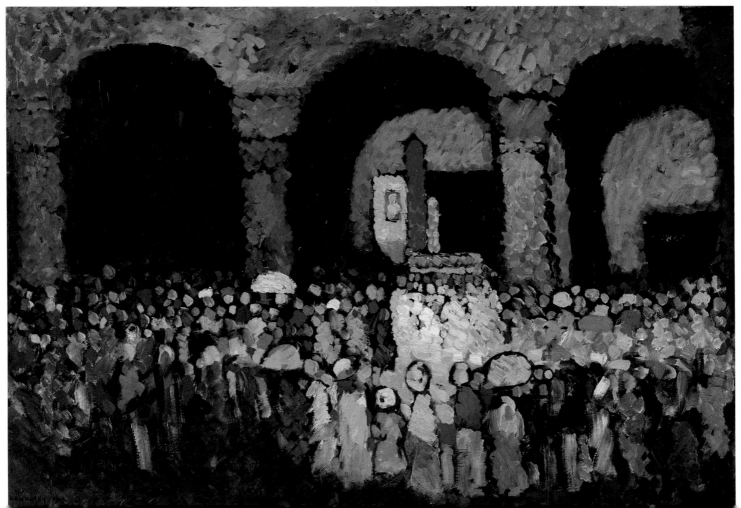

Wassily Kandinsky
The Railroad near Murnau

1909
Oil and pencil (or chalk)
on paperboard,
14¼ × 19¼ in. (36 × 49 cm.)
Lenbachhaus, Munich

The theme of the moving
train has been a stimulating
one for modern painting.
From Turner to Manet and
from Monet to Boccioni, the
image of the railroad, with
its dynamism, steam and
technology, repeatedly drew
the attention of European
artists. For Kandinsky, the
dark silhouette of the
passing train offered the
opportunity to depict a field
of energies, visible not only
in the rushing locomotive
but also in the landscape
itself, overlaid by the shapes
of the telegraph poles.

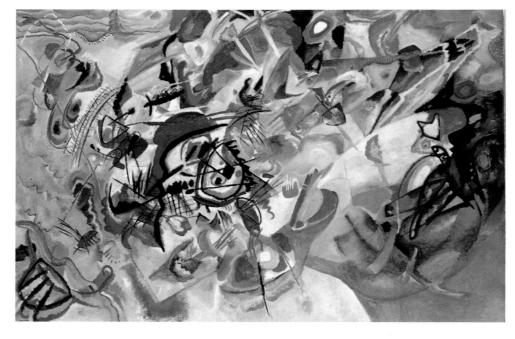

Wassily Kandinsky
Composition VII

1913
Oil on canvas,
118 × 78¾ in.
(300 × 200 cm.)
Tretyakov Gallery, Moscow

This is the largest and most
important painting of
Kandinsky's early abstract
phase. He carried out a
lengthy preparation for the
work through drawings and
watercolors which testify to
the his intense commitment
and progress toward a
definitive structure.
It is also worth remarking
on the choice of title: up
until 1912 Kandinsky called
his abstract pictures
"improvisations," whereas
the term "composition"
reflects a more thorough
meditation on form.

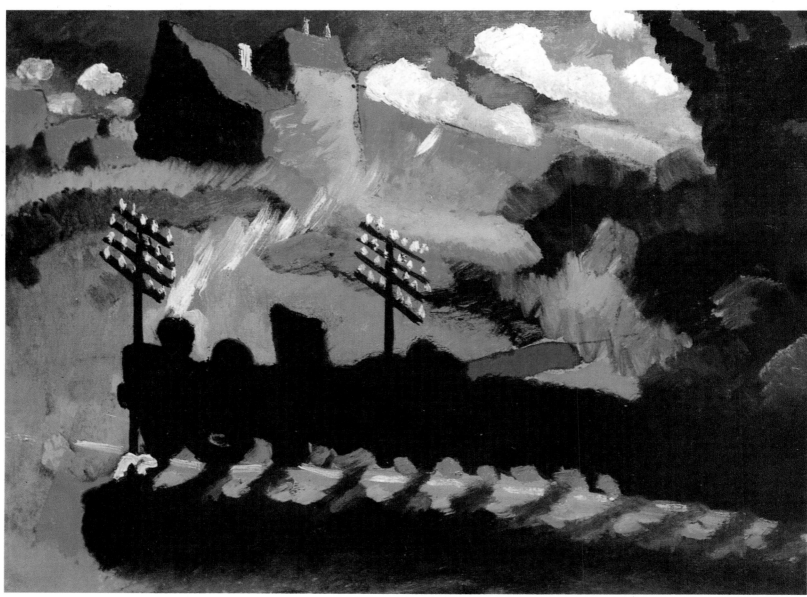

Wassily Kandinsky
Naval Battle–Improvisation 31

1913
Oil on canvas
National Gallery,
Washington

This fascinating painting still maintains a slippery contact with reality. In the lower part it is possible to recognize the stylized masts of old vessels, one of them with its sail torn.

Above
Wassily Kandinsky
Picture with an Archer

1908
Oil on canvas,
57¾ × 69¾ in.
(147 × 177 cm.)
Museum of Modern Art,
New York

To this fundamental painting, one of the "dream landscapes" painted between 1908 and 1910, is perfectly described in Kandinsky's own words: "starting out from the action exercised by the painting on the object, which thereby attains the capacity of self-dissolution, my ability not to notice the object in the picture, to let it escape me, was gradually developing."

Wassily Kandinsky
Composition VI

1913
Oil on canvas,
118 × 76¾ in.
(300 × 195 cm.)
Hermitage, St. Petersburg

This painting, like the contemporary and similar *Composition VII* (see previous page), is based on a rigorous process of research into both color and composition. Kandinsky liked to point out that, in this case, he had started out from an earlier painting on glass, which he redefined in a totally new way without losing the precious color effects.

Wassily Kandinsky
Reminiscences

1924
Oil on canvas,
37½ × 38½ in.
(95 × 98 cm.)
Kunstmuseum, Bern

Bearing the same title as
the artist's autobiography,
this picture underlines
the close relationship
that Kandinsky established
between painting and
literature. It also suggests
taking a look at the artist's
work in the "past." Thus
there is an interesting
connection with
Painting with a Black Arch
(see p. 312), from twelve
years earlier. Here we
again find a vaguely
ogival motif set against
a rich pattern of colors.
Unlike the older painting,
however, with its explosion
of free forms, this one
shows signs of the
evolution in Kandinsky's
painting and culture that
had taken place during
the twenties, when his
contact with the Bauhaus
and Klee pushed him
in the direction of
a new geometric rigor.

Wassily Kandinsky
Improvisation 26

1912
Oil on canvas,
42¼ × 38¼ in.
(107.5 × 97 cm.)
Lenbachhaus, Munich

This splendid painting
should be seen in relation
to the particular stage in
Kandinsky's cultural
development that
commenced after he and
Schönberg met in 1911,
establishing close ties
and a mutual exchange
of influences. The
composer and painter
attained similar results,
one with atonal music
and the other with
abstractionism and a
number of theatrical
works. His use of yellow
in this phase is particularly
interesting.

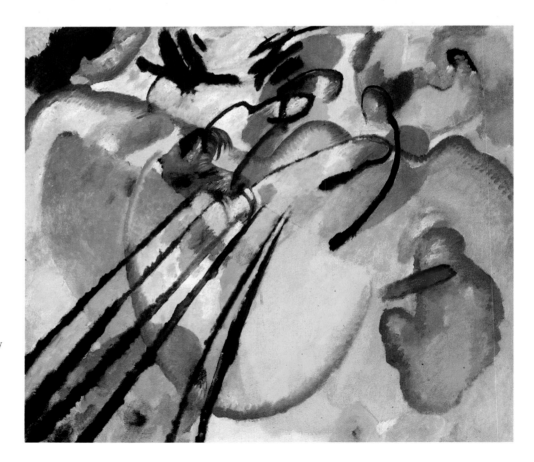

Wassily Kandinsky
Painting with Red Spot

1914
Oil on canvas,
51¼ × 51¼ in.
(130 × 130 cm.)
Centre Pompidou, Paris

In the most vital and intense phase of Abstract Expressionism, Kandinsky frequently interspersed his painting activity with theoretical writings. It is interesting to compare this picture (finished on February 25, 1914) with a number of passages taken from an article he wrote in 1912 on the "Question of Form." Kandinsky argues that form can exist by itself, whereas color has to be placed within limits. Form and color reinforce one another: "The value of a particular color is underlined by a particular form and attenuated by another form. The qualities of 'sharp' colors resonate better in a pointed shape—yellow, for instance, in a triangle—and colors that can be described as deep are reinforced, and their effect intensified, by round shapes. Blue, for example, in a circle."

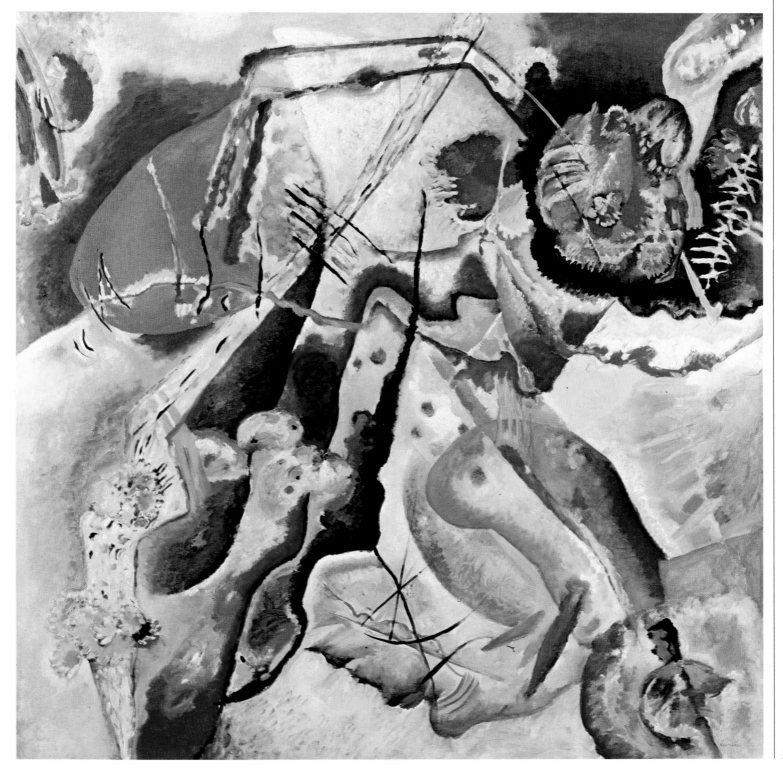

311

Wassily Kandinsky
Improvisation 209

1917
Oil on canvas,
24¾ × 26½ in.
(63 × 67 cm.)
Surikov Museum,
Krasnoyarsk

The picture was painted
during one of the artist's
characteristic phases:
after the development
of Abstract Expressionism,
Kandinsky felt a desire
to go back to the solidity
of the real object. Here
we seem to be able to
make out the profile of
a landscape, and perhaps
a sailing ship, mere hints
of figuration in a context
of color and composition
that is now unmistakable.

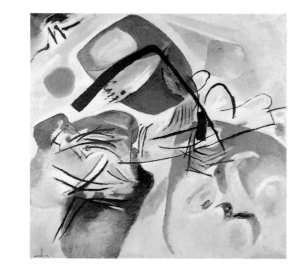

Wassily Kandinsky
Painting with a Black Arch

1912
Oil on canvas,
77¼ × 74 in.
(196 × 188 cm.)
Centre Pompidou, Paris

A justly famous picture,
it clearly marks the
difference between the
apparent "improvisation"
of the paintings and their
actual nature as extremely
carefully thought-out
works, based on a
compositional structure
of great sophistication.
Here the decisive element
is the pointed arch, a
graphic sign that can be
linked with many of the
shapes from Kandinsky's
figurative period (the
roof of a house, the
peak of a mountain,
the pinnacle of a tower,
the fronds of a tree, a sail),
but which has now
become the basic motif
around which a rich and
harmonious range of
colors is organized.

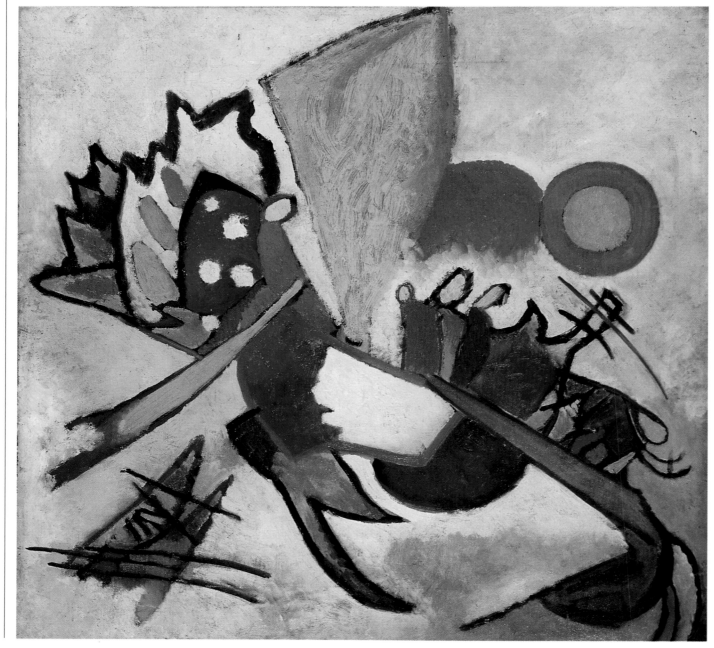

Wassily Kandinsky
Several Circles

1926
Oil on canvas,
55¼ × 55½ in.
(140.3 × 140.7 cm.)
Guggenheim Museum,
New York

In 1926 Kandinsky, in his capacity as professor at the Bauhaus in Dessau, published one of his most important treatises: *Punkt und Linie zu Fläche* (*Point and Line to Plane*). The pamphlet coincided with the moment of greatest geometrization of the artist's paintings, as he sought "the only link between silence and word" in the point. In spite of their extreme formal, theoretical and philosophical rigor, Kandinsky's pictures (like those of his friend Paul Klee) never lost their quality of relaxed and yet fascinating lyricism.

Franz Marc

Munich, 1880–Verdun, 1916

The art and life of Franz Marc are closely bound up with those of his friend August Macke, right up to the tragic fate of both men, killed in battle during the First World War. After studying philosophy and theology at the university in his native city, Marc moved to Paris where he came across the painting of Gauguin and the Nabis, whose love and sense of almost mystical reverence for nature he shared. In 1906 Marc embarked on the most characteristic phase of his painting: a painstaking study of animals. In 1910 he met August Macke, who had a similar taste for bright and transparent color. Along with Kandinsky, the two of them founded Der Blaue Reiter, making a wholly original contribution to the movement. In fact Marc started out from a profound understanding of animal anatomy and then went on to paint them in a non-naturalistic, almost abstract way. The shapes of the animals, always recognizable, become part of a carefully modeled rhythm of lines, forms and colors that freely expresses his feelings about the natural world. This tendency was further accentuated after 1912, through his contacts with Delaunay and Orphism. Enlisted as a soldier in 1914, he assembled an album of war drawings in the trenches, but this work was interrupted by his death in battle, at Verdun.

Franz Marc
Painting with Calves

1913–14
Oil on canvas
Neue Pinakothek, Munich

Although able to convey the movements and attitudes of animals with great effectiveness, displaying a grasp of their anatomy and behavior worthy of a keen zoologist, Marc tended to place all the elements of the painting on the surface, fitting together areas of limpid color as in an old and radiant stained-glass window. The effect is comparable to the tonal gradations used in the Orphism of the Delaunays, with whom Marc was in contact. The use of sweeping curves to link the various parts of the picture can also be associated with the Parisian movement of Orphism.

Franz Marc
Horse on the Seashore

1913
Oil on canvas,
33½ × 44 in.
(85 × 112 cm.)
Museum Folkwang, Essen

Animals were undoubtedly
the subject that appealed
most to Franz Marc. Even
during the painful years of
the war the artist went on
painting pictures of horses,
tigers and other beasts.
This painting cannot help
but recall the name
"Blue Rider," chosen by
Marc and Kandinsky
for the movement they
founded. It is said that
while Kandinsky liked
riders, Marc would have
preferred the name to
refer to the horse alone,
but both agreed on the
choice of blue, their
favorite color.

Franz Marc
The Dream

1912
Oil on canvas,
39½ × 53¼ in.
(100.5 × 135.5 cm.)
Thyssen-Bornemisza
Collection, Madrid

This picture, one
of the most significant
of Franz Marc's entire
career, effectively sums
up the fundamental themes
of his painting. While
adhering to a figurative
approach, Marc simplified
the outlines of humans,
animals and elements of
the landscape, assembling
them to form a jigsaw
puzzle in two dimensions,
with delicate combinations.
The dreamlike quality,
referred to in the title,
is underlined by the
marvelous color, with its
soft shades and surprising
transitions.

August Macke

Meschede, 1887–Perthes-les-Hurlus, 1914

An intense and tragic figure from the early period of German Expressionism, Macke represents the lyrical and joyful side of the movement. Trained in the artistic tradition of late nineteenth-century Germany, Macke changed his style profoundly following a repeated series of visits to Paris. He was particularly attracted by the free and expressive use of color made by Matisse and the Fauves, but also influenced by the transparency of light in Delaunay's work and the lively composition of the Futurists. Out of all these experiences came a painting of great dynamism and imagination, devoid of the harshness of line and violent themes typical of other German artists. In 1911 he joined Kandinsky's Blaue Reiter movement, but the journey he made to Tunisia in 1914 in the company of Paul Klee and the Swiss painter Louis Moilliet had an even greater influence on the limpidity of his color and the simplicity of his landscapes. It was an exotic time, filled with the fascination and light of the Mediterranean, but destined to come to a dramatic end just a few months later. Macke was enlisted on the outbreak of war and killed during one of the first offensives on the Western front.

August Macke
Three on a Stroll

1914
Oil on canvas,
22 × 13 in.
(56 × 33 cm.)
Thyssen-Bornemisza
Collection, Madrid

Macke painted this picture in July 1914: a year that opened with the enthralling journey to Tunisia in the company of Klee and ended tragically with his death in war. It is a touching image of contemplative calm and serenity, in which we can perhaps detect a distant echo of Caspar David Friedrich in the decision to represent the figures from behind, as well as a more recent reference to the Intimism of Vuillard. Sent off to fight like his friend Franz Marc, Macke too sought a moment of liberation from the anguish of the trenches in the themes most congenial to him. Thus, while Marc painted his beloved animals, Macke chose to depict figures communing with one another and with nature.

August Macke
Large Zoological Garden

1912
Oil on canvas, triptych,
51 × 25½; 51 × 39½;
51 × 25½ in.
(129.5 × 65; 129.5 × 100.5;
129.5 × 65 cm.)
Museum van Ostwall,
Dortmund

The presence of animals
is an immediate reminder
of Franz Marc. Yet Macke's
attention is focused on
the human figures, around
which he lays out one
of the most attractive
scenes in the whole of
early twentieth-century
European painting. Note
the sensitive handling of
color, with precious
harmonies of green. The
division into three panels
and the use of clearly
recognizable outlines to
define areas of color are
reminiscent of the
stained-glass windows
in Gothic cathedrals.

August Macke
*Men and Riders
on the Avenue*

1914
Oil on canvas,
22½ × 23½ in.
(57 × 59.5 cm.)
Museum van Ostwall,
Dortmund

Macke's delicate approach
to painting, restrained and
yet filled with light, meant
that the painter never felt
the need for the harshness
and graphic tension typical
of the other Expressionist
currents. In a general
sense, Macke represents
the predominant interest
in color as opposed
to line on the part
of the members of the
"Blue Rider" group.

Ernst Ludwig Kirchner
Street, Berlin

1913
Oil on canvas,
47¾ × 37½ in.
(121 × 95 cm.)
Brücke-Museum, Berlin

In his lively urban scenes, which look as if they might have been sketched on the spot in the streets of Berlin, it is possible to discern the painter's delight in creating successions of rhythmic lines, almost in the manner of Art Nouveau. One of the leaders of the group Die Brücke, Kirchner used accentuated contours and forceful lines. There is a striking difference between these elegant streets, through which the smartly-dressed and highly-strung representatives of a "gilded youth" pass with a rather bored air, their faces bearing the simpering expressions of mannequins, and the sidewalks crowded with human relicts and ambiguous figures painted by Grosz and Dix after the war.

Ernst Ludwig Kirchner

Aschaffenburg, 1880–Davos, 1938

Founder of the Die Brücke group, Kirchner is perhaps the most typical and consistent exponent of the German group of Expressionists. Kirchner started painting almost by chance. As a student of architecture in Dresden, he was able to study the artists of the German Renaissance (Cranach, Dürer) in the city's museums, along with a few pictures by Munch and van Gogh. The common denominator of all these works was their distortion of reality and intensity of line, simplified and dramatic in its effect. In 1905, Kirchner and some of his fellow students set up Die Brücke, an artistic movement which published writings and engravings in a magazine of the same name. Kirchner was the driving force: he painted landscapes and portraits in brilliant colors, characterized by their energetic distortions of expression. In 1911 he went to live in Berlin, where his attention was caught by street scenes, urban landscapes and the people who made up the city's variegated social panorama, emaciated figures represented with blunt and spiky outlines. During the war Kirchner moved to Switzerland, where he concentrated on Alpine and forest scenes, further accentuating the dissonance of color and line.

Ernst Ludwig Kirchner
Fränzi with a Carved Chair

1910
Oil on canvas,
28 × 19½ in.
(71 × 49.5 cm.)
Thyssen-Bornemisza
Collection, Madrid

Like her sister Marcella,
Franziska was a young
model in Dresden who
often posed for the
painters in Kirchner's
group. In the early years

of the Expressionists'
activities, Fränzi saw
her face appear distorted
and colored in unnatural
ways in their paintings
and drawings. Here
the girl is even menaced
by the back of the chair
she is sitting on, which
has been transformed
from a humble and
innocuous piece of
furniture in the artist's
studio (present in other
pictures as well) into an
anthropomorphic idol.

Ernst Ludwig Kirchner
Woman with Naked Torso

1911
Oil on canvas
Wallraf-Richartz Museum,
Cologne

A painting that clearly
shows the direction in
which Kirchner's research
was going, it demonstrates
on the one hand that he
was perfectly aware of
developments in other
currents of international
Expressionism, such as
Fauvism. On the other, it is

a work of great originality,
displaying an incisive
graphic force. Kirchner
has rendered the drawing
sharp and precise: the
female figure looks almost
as if it has been "cut out"
against the background
without any concession to
softness and grace. Yet this
woman with a strange hat
has a peculiar fascination.
The sideways glance, the
full breasts, the shawl with
its delicate flower pattern
and the shaven armpits
are sensual allusions of
gripping intensity.

Ernst Ludwig Kirchner
Self-Portrait as Soldier

1915
Oil on canvas,
27¼ × 24 in.
(69 × 61 cm.)
Allen Memorial Art
Museum, Oberlin (Ohio)

This is a symbolic image
of the artist during the
war. Kirchner, in a
soldier's uniform, feels
as if he has been maimed,
with his right hand cut off,
owing to the impossibility
of painting. His face
screwed up in a tense
grimace, with a cigarette
dangling from his lips,
is an expression of the
brutalization of people
and the loss of human
relationships in an
existence that has been
rendered almost bestial.

Ernst Ludwig Kirchner
The Red Bell Tower of Halle

1915
Oil on canvas,
47¼ × 35½ in.
(120 × 90 cm.)
Museum Folkwang, Essen

The method adopted
by Kirchner is clearly
apparent in his landscapes.
He starts out from a real
view, in this case that
of a historic landmark,
and depicts it in hard and
angular lines, without any
concession to perspective.
The totally unnatural
colors accentuate
the violent effect
of the distortion.

Karl Schmidt-Rottluff

Rottluf, 1884–Berlin, 1976

An important and versatile exponent of Expressionism, he was one of the youngest of the original members of the Die Brücke group. After training as an architect (which left him with a preference for robust and well-defined volumes), he founded the movement together with Kirchner and Heckel (Dresden, 1905). Schmidt-Rottluff's paintings are distinguished by their synthetic forms, with blocks of color that are reminiscent of van Gogh and related to the style of Nolde. In 1911 the painter (who also produced prints and sculptures) moved to Berlin and his art, consisting chiefly of landscapes and portraits, became even more brutal, almost naïf. On the outbreak of the First World War he was enlisted. His experience of fighting imparted a new, religious quality to his work and, over the following years, he painted almost mystical images of rural life. Schmidt-Rottluff too was placed on the Nazi list of "degenerate artists."

Karl Schmidt-Rottluff
Fall Landscape in Oldenburg

1907
Oil on canvas,
29½ × 38¼ in.
(75 × 97 cm.)
Thyssen-Bornemisza
Collection, Madrid

The picture belongs to a highly characteristic phase in the artist's development and throws light on his fundamental influences.

Moving with Heckel to Dangast, a village on the North Sea coast, Schmidt-Rottluff painted numerous landscapes between 1907 and 1911, experimenting with the expressive qualities of free brushwork and the mixture of colors and producing results that recall the work of van Gogh.
Later on, he would partly abandon this approach to dedicate greater attention to the outlines of forms.

Karl Schmidt-Rottluff
Double Portrait of S. and L.

c. 1925
Oil on canvas,
29½ × 38¼ in.
(65.3 × 73 cm.)
Museum am Ostwall,
Dortmund

Large faces with stylized
and distorted features
often appear in the
paintings of Schmidt-
Rottluff and the other
members of Die Brücke.
In this extreme but
effective synthesis of
lineaments it is possible
to recognize the influence
of "primitive" African
and Polynesian sculpture,
which affected the whole
of European art in the first
decade of the century.
Of all the artists in the
movement, Schmidt-
Rottluff was the most
interested in the effect
of pictorial mass. It would
be inaccurate to speak of
"volume" as his style was
based almost entirely on
the use of line and surface.

Karl Schmidt-Rottluff
The Village of Dangast

1909
Watercolor,
20¾ × 25¾ in.
(52.5 × 65.5 cm.)
Thyssen-Bornemisza
Collection, Madrid

Another painting of great
expressive freedom and
fluid line, but this time
with a luminosity unusual
for Schmidt-Rottluff.
There is an interesting
parallel with what was
being done around the
same time by artists like
Vlaminck and Derain,
also influenced by the
work of van Gogh. The
picture dates from the
time spent in Dangast, a
key phase in the artist's
career. Here he seeks
to convey the effect
of a rhythmic and
undulating movement
of color through curved
lines, avoiding angles
and straight lines.

323

Emil Nolde

Nolde, 1867–Seebüll, 1956

The most unusual and free exponent of German Expressionism was actually called Emil Hansen: a perhaps too obviously Scandinavian surname that he replaced by the name of his hometown. Nolde was an extraordinary self-taught artist, who operated outside schools and academies. His life was a romantic one. He worked as a woodcarver supplementing his salary by selling postcards illustrated with droll "anthropomorphic" images of the Swiss mountains. On the proceeds he was able to spend time studying first in Munich and then in Paris (1899), eventually

settling on painting as a career. From the outset, Nolde's pictures displayed the characteristics that were to distinguish his style throughout his life: simplified forms, imposing silhouettes, violent colors and a magical and mystical feeling for nature. In 1906 he worked for a while with Schmidt-Rottluff, but though he was persuaded to tackle the Expressionist themes of Die Brücke and later on those of other German avant-garde movements as well, Nolde maintained his independence. He gradually began accentuating the mystical, dramatic and highly autobiographical character of his painting, a tendency that was reinforced by a serious illness in 1909. A long journey to the Far East in 1914 resulted

in a further change in the painter's style, with exotic elements (such as Japanese masks) being used to suggest a dynamic deformation of the human figure, with its features and attitudes exaggerated almost to the point of caricature. In the twenties Nolde became a well-known figure and received public recognition. But in 1927 he chose to retire to his small house at Seebüll, almost on the border with Denmark, painting forceful and brightly-colored pictures of its enchanting garden. In spite of his secluded life, Nolde too was persecuted and denigrated by the Nazis and for a long time was practically forgotten, only to be rediscovered in the fifties.

Emil Nolde
*Flowering Garden.
Two Women*

1908
Oil on canvas,
23½ × 27½ in. (60 × 70 cm.)
Erbengemeinschaft Lange,
Krefeld

Nolde had a great passion for flowers: all the houses he lived in were surrounded by luxuriant gardens, which he tended himself. The explosion of colors when they were in bloom resulted in pictures of stirring beauty.

Emil Nolde
Dance Around the Golden Calf

1910
Oil on canvas,
34¾ × 41¼ in.
(88 × 105 cm.)
Staatsgalerie Moderner
Kunst, Munich

Very few artists in the
twentieth century have been
as drawn to aspects of
religion as Nolde, who took
them to the point of frenzy,
excess and superstition. In
this painting the wildness
of the heretics' dance
around the idol is expressed
through the violence of the
colors and the brutality
of the summary shapes
and gestures.

Emil Nolde
Moonlit Night

1914
Oil on canvas,
27¼ × 35 in. (69 × 89 cm.)
Private collection, Vaduz

In Nolde's painting periods
filled with a wild and
dramatic, almost unseemly
vitality alternate with
precious moments of peace,
spent in silent contemplation
of nature. The enchantment
of a starry night, under
northern skies, is depicted by
the artist with a calm lyricism,
a surrender to the mystical
forces of the universe. Nolde
never renounced the use
of thick layers of paint,
spread on the canvas with
broad brushstrokes.

Emil Nolde
Autumnal Sea

c. 1910
Oil on canvas,
15½ × 25½ in.
(39.5 × 65 cm.)
Museum am Ostwall,
Dortmund

Nolde liked to paint
standing at the window
of his isolated studio.
"From here I can see
nothing but sky and sea,"
he wrote. His seascapes,
with their windswept and
cloudy skies, are always
extremely personal works,
in which the dull tones
of the color contrast with
the impetuous brushwork.
The horizons are lost
or blurred in the union
of the two elements
(air and water), resulting
in compositions that
are almost abstract.

Emil Nolde
Young Horses

1916
Oil on canvas,
28¾ × 39¼ in.
(73 × 100 cm.)
Museum am Ostwall,
Dortmund

Compared with the
delicate "blue horses"
of Franz Marc, these
restless foals are bursting
with the simplified and
even visionary energy
of Nolde's painting.

Emil Nolde
Masks and Dahlias

1919
Oil on canvas,
35 × 29 in.
(89 × 73.5 cm.)
Nolde-Stiftung, Seebüll

The four masks, acquired
by the artist on his visits
to Bali and Japan, can
still be seen in the Nolde
collection at Seebüll.

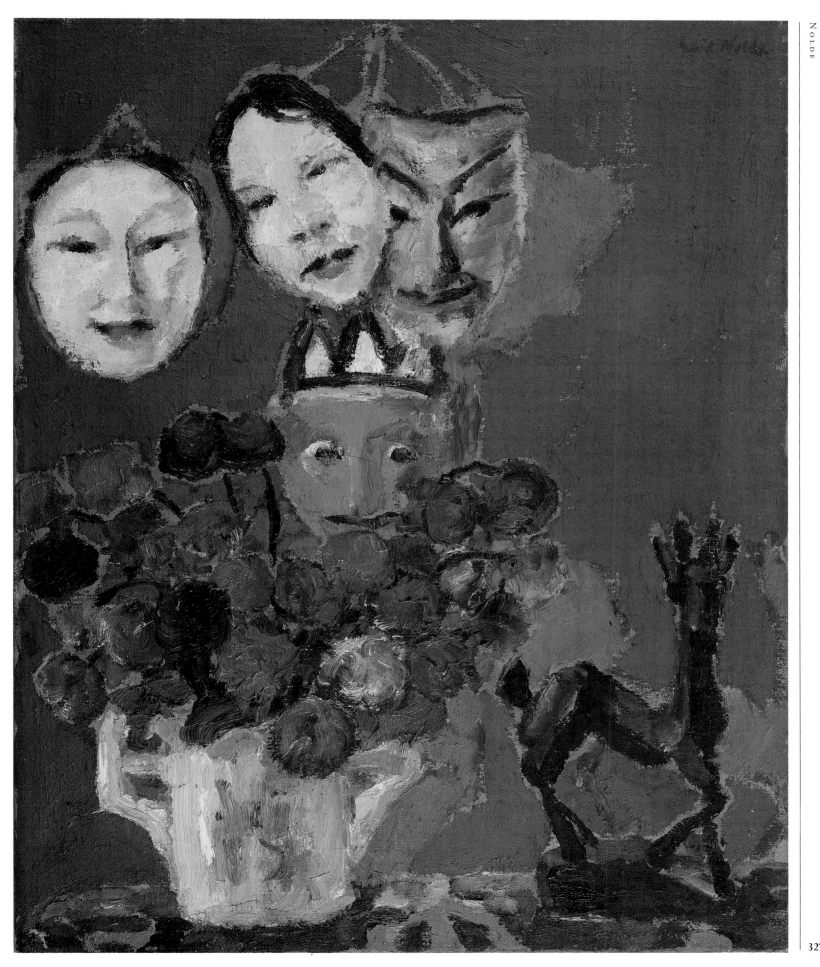

Abstraction

Paul Klee
Wald Bau (detail)
1919
Mixed media on canvas,
10¾ × 10 in.
(27.5 × 25.5 cm.)
Museo d'Arte Contemporanea, Milan

The early decades of the twentieth century were one of the richest and most fertile periods in the entire history of art, with very few parallels. Perhaps only around the year 1500 was there such a lively debate, with an exceptional international effort to come up with new solutions, supported by theoretical writings. There are other important affinities between these two moments in the history of Western culture, including the abrupt and traumatic conclusion of many lines of research by the end of the second decade of the century, with the Reformation at the beginning of the sixteenth century and the First World War in our own era. Among the historic avant-garde movements of the early twentieth century, often glaring in their contrast to previous styles, one innovation stands out above all: the birth of abstract art around 1910.

A number of possible precedents for nonfigurative art have been sought, for instance in the aniconic character of Islamic and Jewish art (where the representation of people and, in strictly orthodox circles, even living creatures is forbidden), in Oriental calligraphy or in a few isolated periods in the history of art. In particular, stress has been placed on the effect on European figurative culture of African idols and statues, with their simplified outlines and expressive force. Yet none of these

comparisons adequately explains such a radical development. It may be worth considering the fact that several of the founding fathers of abstractionism (such as Kandinsky and Malevich) were Russian: i.e. they belonged to the cultural world of Byzantine art, where divine figures and sacred scenes are based on iconographic rules that have not changed over time, remaining intellectual, aristocratic and essentially divorced from reality. The development of abstractionism in the twentieth century has followed a contradictory course. After the inevitable initial perplexities, nonfigurative painting proved increasingly popular. Opposed by regimes of the Right and Left for its "individualism" and lack of any immediately recognizable "message," abstract art spread well beyond the confines of the nonrepresentational after the Second World War, to the point where it was considered the only "modern art." Any painting in which objects were recognizable was dismissed as passé or, at the most, a mere formal exercise. Only in very recent times has there been a redressing of the balance between figuration and abstractionism, two currents that can and perhaps therefore should coexist, complementing one another in their respective approaches.

Historical abstractionism did not start out as an organized movement, and so it is very difficult to assign the credit for its invention, given its rapid spread in many countries. If anything, it was a natural consequence of a number of tendencies at the very beginning of the century: the rejection of late Romantic and Post-Impressionist illustration, the value given to the sign, expressive deformation, the analysis of color and the release from constraints on the way to handle paint led many artists to the verge of abstraction. Only a few painters, however, decided to make the historic leap and move permanently into the world of abstract art. For others, it was no more than a short-lived experiment.

Right from the start it was possible to distinguish three main currents in abstract art, very different from one another: a style concerned exclusively with surface, divided up by regular geometric lines (Malevich and Mondrian); a sophisticated investigation of light and the chromatic scale (the Delaunays, Klee, Feininger); a total freedom of expression, intensely dramatic in its effect (Kandinsky). Of course there were exchanges and contacts, as in the case of Kandinsky working alongside Klee

Paul Klee
Rotating House
1921
Gouache on painted muslin glued onto paper,
14¾ × 20½ in.
(37.7 × 52.2 cm.)
Thyssen-Bornemisza Collection, Madrid

at the Bauhaus, but the three tendencies were to remain distinct even in the subsequent history of abstract art. The Russian Kazimir Malevich was one of the first artists to accompany the choice of abstraction with theoretical writings. Starting out from the compact and solid Cubism of Léger, Malevich, in common with his fellow countryman Larionov, sought a rigorous and clear image. He found it by going beyond the representation of objects and painting the "supremacy of the feeling" that they arouse. Thus Malevich gave the name Suprematism to the movement he founded, which operated alongside the Rayonism of Larionov and Goncharova during the most intense period of the Russian avant-garde, on the eve of the October Revolution of 1917.

For reasons and by means different from Malevich's, the Dutchman Piet Mondrian also wanted to cast off the shackles of figuration. Some of his early work, such as the pictures in which sand dunes on the deserted beaches of the Netherlands were reduced to mere bands of color, offers a clear foretaste of what was to come during the years of the First World War. In his enforced solitude, Mondrian "saw" the landscape pared down to a pattern of lines, laid out over a single surface. Very soon he transferred this pure and linear structure onto his canvases: the picture was divided into geometric shapes by a grid of straight lines. Mondrian "constructed" the painting like an architectural plan. Together with van Doesburg, he founded the movement De Stijl, "The Style," but soon chose to go his own way in this research, which culminated in the last works he painted in New York.

The direction taken by Robert and Sonia Delaunay, founders of the movement in Paris to which Apollinaire gave the name Orphism, was less sober and ascetic. Indeed, the results displayed a modular and lyrical grace. Drawing on scientific research into the diffusion of light, the Delaunays traced concentric circles and spirals of gradated and harmonized colors. The Delaunays' activity extended beyond the realm of painting and into the theater, book illustration and fashion design.

After the First World War abstract art represented a radical alternative to the brutal denunciation of Expressionism. In Germany the two tendencies were clearly distinguished: on the one hand, the lashing and bitter satire of Dix and Grosz; on the other, the exceptional cultural experimentation of the Bauhaus, or "House of

Building," founded at Weimar by Walter Gropius in 1919 and transferred to Dessau in 1925. The Bauhaus was primarily a school of applied arts, whose basic aim was to investigate the role of function without ornament, to bring clarity and simplicity into design, with a feeling for rhythm, light and material. A technical approach to art, a strict discipline that led to a total abandonment of the emphasis laid on decoration in Art Nouveau and made the concepts of "functional" and "beautiful" synonymous, clearing the way for industrial design. During the twenties, some of the most important exponents of abstract art worked at the Bauhaus, invited there by Paul Klee. Klee, along with Kandinsky, Jawlensky and Feininger, created the movement known as the Blue Four, an extraordinary but unfortunately short-lived attempt to pool their efforts in the research into expression.

Kazimir Malevich
Suprematist Composition
1915
Oil on canvas,
27½ x 19 in.
(70 × 48 cm.)
Regional Museum of Art,
Tula

Piet Mondrian

Amersfoort, 1872–New York, 1944

The son of a strict Calvinist teacher (his name should actually be written Mondriaan), Piet was introduced to art by his uncle Frits, who painted agreeable landscapes in the Impressionist tradition. Mondrian's early activity, carried out chiefly in Amsterdam, comprised still lifes, landscapes and academic studies in the late nineteenth-century mold. To earn a living, the young Mondrian made copies of old paintings in the Rijksmuseum and illustrations for books and treatises. Around 1901, deeply shocked by the

spectacle of the bullfights he saw in Spain, Mondrian underwent a sort of spiritual crisis which induced him to go and live by himself in the countryside, seeking a supreme order, a pure and concise set of rules. His landscapes were gradually stripped of their nineteenth-century Naturalism. Between 1907 and 1908 he came into contact with the Fauves and Munch through van Dongen, but his first experiments with a new style, exhibited at Amsterdam in 1909, met with violent criticism. Mondrian then moved to Paris, where he made a passionate study of Cubist decomposition, concentrating on the essentiality of the straight line. He painted his first canvases entitled simply

Composition. In 1914 he went back to the Netherlands and the outbreak of the First World War made it impossible for him to return to Paris for four years. In his enforced isolation, Mondrian moved away from Cubism: the paintings of these years consisted of a sequence of mathematical signs ("plus" and "minus") laid out on the surface of the canvas, with no depth. In 1917 Mondrian founded the movement De Stijl with the artist van Doesburg and in the same year painted his first pictures made up of blue, yellow and red rectangles on a white ground, wholly divorced from any reference to reality. From 1920 onward Mondrian's work became one of the poles of the international debate over

Constructivism and the painter moved closer to the themes of the Bauhaus. After his lozenge-shaped pictures of the twenties, Mondrian began to insert more and more prominent elements, such as vertical double black lines. The Second World War induced him to leave Paris for London and then New York. Here, inspired by the soaring skyscrapers and the rhythms of jazz, Mondrian abandoned the continuous black line, replacing it by a series of small colored squares and rectangles. Mondrian died of pneumonia in 1944, just as the Allies were beginning to win the war, and it was to this prospect that he dedicated his last, unfinished masterpiece, *Victory Boogie Woogie*.

On the facing page
Piet Mondrian
Composition A

1919
Oil on canvas,
36 × 36¼ in.
(91.5 × 92 cm.)
Galleria Nazionale d'Arte
Moderna, Rome

The painting, of particular
intensity and richness,
dates from the period
of collaboration between
Mondrian and Theo van
Doesburg. The two Dutch
artists founded the
magazine *De Stijl*,
"The Style," laying the
theoretical foundations
for geometric and
constructivist
abstractionism.

Piet Mondrian
The Silvery Tree

1911
Oil on canvas,
30¾ × 41¼ in.
(78 × 105 cm.)
Haags Gemeentemuseum,
The Hague

During the years leading
up to the First World War
it is possible to follow
precisely the mental and
creative process that led
Mondrian to abandon
representation of the
natural world in favor of
abstraction. Progress along
this path was marked by a
few, often repeated
themes, such as trees,
which were gradually
reduced to a lattice
of lines.

Piet Mondrian
*Composition in Gray
and Blue*

1912
Oil on canvas,
38½ × 25½ in.
(98 × 65 cm.)
Thyssen-Bornemisza
Collection, Madrid

This painting takes the
figurative right to its limit.
The natural element
(a tree) has now virtually
disappeared, pared down
to a few outlines. But
Mondrian has not taken
the decisive step into
abstraction yet.

Piet Mondrian
Pier and Ocean
(Composition No. 10)

1915
Oil on canvas,
30¾ × 41¾ in.
(78 × 106 cm.)
Rijksmuseum Kröller-
Müller, Otterlo

The crucial moment came
for Mondrian during the
years of the war. Unable to
leave the Netherlands and
almost completely cut off
from contact with his
French or German

colleagues, Mondrian
explored the theme of
mathematical symbols. This
was like a vision, described
by the painter as a creative
illumination that came to
him while looking at the
sea, which suddenly
appeared and was summed
up in a sequence of "+"
and "−" signs. These
symbols, laid out on a
canvas of almost uniform
whiteness, form a
mysterious pattern,
confined to the two-
dimensional surface
of the picture.

Piet Mondrian
Composition

1922
Oil on canvas
Museum of Modern Art,
New York

Piet Mondrian
Painting I

1921
Oil on canvas,
38¾ × 23¾ in.
(98.6 × 60.5 cm.)
Private collection, Basel

For over twenty years
Mondrian was to explore
the patterns of his abstract
painting. His contacts with
movements abroad
(including the Bauhaus) did
not modify his style, based
on an absolute and pure
mathematical rigor. Broad
straight black lines run
across the white canvas:
the rectangles they create
are filled with primary
colors (blue, yellow, red),
painted with no gradation
of tone to form smooth
and compact surfaces.

Piet Mondrian
Composition I

1931
Oil on canvas
19¾ × 19¾ in.
(50 × 50 cm.)
Thyssen-Bornemisza
Collection, Madrid

Piet Mondrian
Broadway Boogie Woogie

1942–43
Oil on canvas,
50 × 50 in.
(127 × 127 cm.)
Museum of Modern Art,
New York

Only at the end of his
career did Mondrian
introduce a substantial
change into his painting.
Stimulated by the vitality
of New York, where he had
taken refuge during the
Second World War, the
Dutch artist substituted a
succession of small colored
squares and rectangles for
his previous straight black
lines. This imparted a
driving and joyful rhythm
to his pictures.

Kazimir Malevich

Kiev, 1878–St. Petersburg, 1935

Founder of the Suprematist movement, Malevich was one of the principal points of reference for the emerging international tendency of abstractionism. In his case, the quest for an "absolute," nonfigurative form of expression entailed the use of purely pictorial means, only later going on to develop the relationship with Constructivism that many Western artists were finding in the same years through their links with the Bauhaus. In fact, critics have persuasively suggested that the legacy of Byzantine and Orthodox art played a considerable role in the birth of abstractionism in Russia. After a training in Moscow along Neo-Impressionist lines, Malevich came into contact with Larionov around 1907, and this opened him up to influences from abroad, ranging from the Fauves to Léger and from the Cubists to Italian Futurism. A surprising capacity for the assimilation and reworking of these ideas renders the pictures he painted between 1910 and 1914 particularly fascinating, presenting as they do a catalogue of his highly personal themes and solutions. In 1915, vigorously asserting the "supremacy" of abstractionism in the arts, Malevich painted the symbolic *Black Square on a White Ground* (Russian Museum, St. Petersburg). This was followed, after a period of return to color, by the still more rarefied *White on White* (1918, Museum of Modern Art, New York). After the Russian Revolution, Malevich became aware of the political significance of his art, drawing a parallel between the social and economic innovations of Communism and the new painting, free of academic rules and attentive to the development of modern technologies. So, from 1920 on, Malevich devoted more and more of his energy to teaching, taking on increasingly responsible posts until he was appointed director of the Institute for the Study of Artistic Culture in St. Petersburg. Though he now painted few pictures, Malevich was already one of the most important names in contemporary art: his works proved particularly popular in Germany and the Netherlands. However, on the rise to power of Stalin, Malevich's lofty ideas about the order of things were dismissed as a mystical and idle utopia. The official art of the Soviet regime went back to a nondescript and popular realism and Malevich (after serving time in prison for subversive activity in 1930) was forced to repudiate abstraction and call for a return to figurative painting. For at least two decades after his death, one of the greatest exponents of abstract art was forgotten, and his rediscovery was one of the most sensational critical developments of the sixties.

Kazimir Malevich
Suprematism–Abstract Composition

1915
Oil on canvas,
31½ × 31½ in.
(80 × 80 cm.)
Museum of Figurative Arts, Ekaterinberg

The painting takes its name from the movement founded by Malevich, one of the most interesting currents in avant-garde Russian art. Believing in the "supremacy" of pure form and geometry, Malevich composed arcane abstract scenes, in which flat and smooth elements are arranged on the surface of the picture.

Kazimir Malevich
Untitled

c. 1919
Tempera on paper,
12½ × 8½ in.
(31.7 × 21.8 cm.)
Thyssen-Bornemisza
Collection,
Madrid

In Malevich's compositions with intersecting rectangles on neutral grounds it is possible to discern echoes of crosses and other Orthodox religious symbols. If true, this hypothesis would underline the importance of the role played by Byzantine painting, with its symbolic character and timeless rules, in the emergence of abstractionism.

Kazimir Malevich
Landscape with Five Houses

1928–32
Oil on canvas,
32½ × 24½ in. (83 × 62 cm.)
Russian Museum,
St. Petersburg

This painting marks, with perhaps a slight touch of sadness, what may have been an unwilling return toward recognizable subjects following the shift toward realism in the official art of Soviet Russia. Nevertheless, Malevich manages to avoid illustration of a social theme, staying loyal to the "supremacy" of the surface.

Kazimir Malevich
Running Man

1933–34
Oil on canvas,
31 × 25½ in.
(79 × 65 cm.)
Centre Pompidou, Paris

Robert Delaunay
Paris, 1885–Montpellier, 1941

Robert Delaunay and his wife Sonia are considered the founders of Orphism, the artistic movement born in 1912 under the patronage of the poet Guillaume Apollinaire: references to the Cubist breakdown of the object in space were mixed with an investigation of rhythm in color, of an almost musical harmony that favored soft and circular forms. Initially influenced by the Symbolist currents and an admirer of Cézanne, Delaunay showed a very early interest in the theater, working in the studio of a set designer. The various views of Paris (including the one of the Eiffel Tower) he painted around 1910 reveal his taste for color, combined with a division of the image into geometric planes. It is interesting to note his contacts with the Blaue Reiter group in this period: thus Delaunay provided a unique link between the Parisian avant-garde and the research under way in Munich. The example of Seurat's experiments and a scientific interest in optics and the refraction of light led Delaunay to develop the characteristic circular patterns, almost whirlpools of color, that mark the historic phase of Orphism. For some years Robert alternated periods of return to the figurative with an ever clearer trend toward abstraction, which finally won out from 1930 onward.

Robert Delaunay
The Eiffel Tower

1910
Oil on canvas,
78¾ × 53¾ in
(200 × 136.5 cm.)
Peggy Guggenheim
Collection, Venice

The great iron tower is the totem of Delaunay's figurative painting. The unmistakable shape of the tower is made to rotate, bend and collide with other elements. Far from being a faithful representation, a souvenir of Paris, Delaunay's Eiffel Tower is an endless modular structure, used for experiments in composition.

Robert Delaunay
The Cardiff Team

1912–13
Stedelijk van Abbe
Museum, Eindhoven

Robert Delaunay
First Simultaneous Disk

1912
Oil on canvas,
diam. 52¾ in. (134 cm.)
Burton Tremaine
Collection, Meriden
(Conn.)

Orphism, the movement founded by Delaunay and his wife Sonia, entailed careful analysis of color transitions, drawing on techniques for the scientific investigation of the refraction and composition of light.

Sonia Delaunay-Terk

Gradizhsk (Ukraine), 1885–Paris, 1979

Trained in Russia, Sonia Terk moved to Paris, where she met and married Robert Delaunay, collaborating with him on the research into color and poetics known as Orphism. In particular, Sonia developed the theme of "simultaneous painting," a free expression of color, often arranged in concentric circles of gradated tones. Sonia carried out her first experiments in the field of book illustration and collage. A separate mention should be made of her costume designs for Diaghilev's Ballets Russes, as well as her clothing designs, which were to have a considerable influence on the Parisian fashion of the twenties and thirties. Around 1914 Sonia played an active part in the artistic and scientific experiments conducted by her husband into the refraction of light. Later on, Sonia showed a distinct preference for abstract painting, with compositions entitled "rhythm-color," and for the production of cartoons for tapestries.

Sonia Delaunay-Terk
Illustration for Blaise Cendrars's *La Prose du Transsibérien et de la petite Jehanne de France*

1913
Oil and tempera on paper,
76¼ × 7¼ in.
(193.5 × 18.5 cm.)
Centre Pompidou, Paris

A fine example of a "simultaneous book," an original blend of words and color devised by the painter.

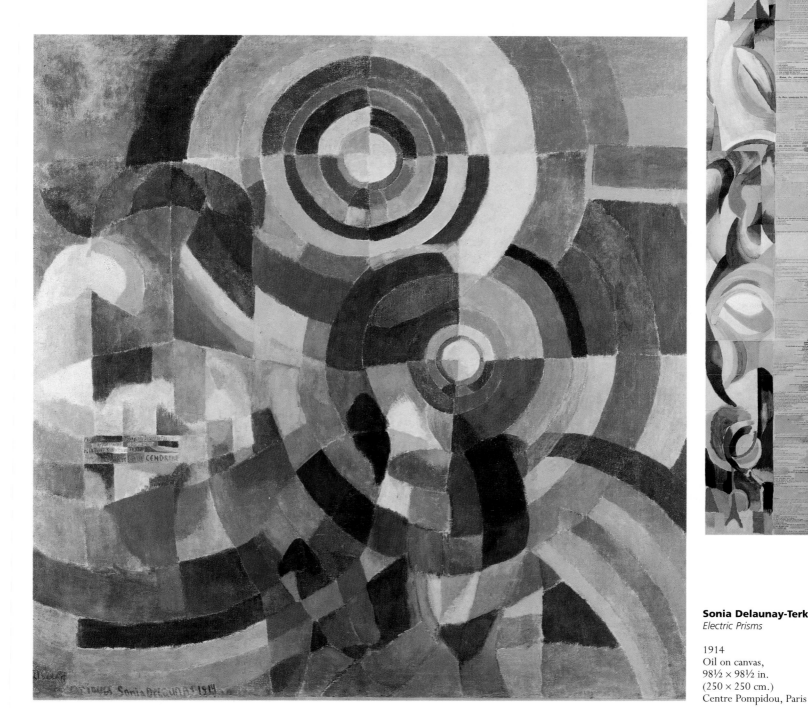

Sonia Delaunay-Terk
Electric Prisms

1914
Oil on canvas,
98½ × 98½ in.
(250 × 250 cm.)
Centre Pompidou, Paris

Paul Klee
Light and Other

1931
Watercolor and varnish
on canvas,
37½ × 38¼ in.
(95 × 97 cm.)
Private collection

A perfect example of
Klee's painstaking analysis
of every element
of the composition.
The Swiss-German painter
follows a hidden plan,
determining the position
of lines, points and areas
of light and color. At first
glance, it looks like an
exercise in mathematics,
but on close examination
we discover all the charm,
poetry and intimate beauty
of the world laid bare
by Klee.

Paul Klee

Münchenbuchsee, 1879–Muralto, 1940

An extremely precocious talent, he was
encouraged to paint by his musician
parents. He trained first in Bern and then
in Munich, during the Jugendstil period.
Throughout the first decade of the century
the young Klee traveled, wrote, drew and
studied artists of the past and present,
gaining a truly thorough understanding of
developments in painting. He was most
impressed by Cézanne, but displayed an
extraordinary eclecticism, in graphic art as
well as painting. In contact with Kandinsky,
he exhibited in Berlin with the artists of
the Blaue Reiter in 1912. In particular, he
formed a close friendship with August
Macke, with whom he made a memorable
journey to Tunisia in 1914. At the end
of this immersion in the light of the
Mediterranean, Klee declared "color
and I are one and the same thing: I am
a painter." This marked the beginning
of an important phase in which the artist
commenced his patient, solitary and poetic
investigation of gradations of light and
color. Appointed a teacher at the Bauhaus
in Weimar in 1920, Klee managed to pull
off the far from easy trick of remaining
true to a strictly constructivist and
scientific approach while preserving
a strong element of lyricism in images that
never completely lost touch with the real
world. In 1924 he founded the group of
the "Blue Four" with Kandinsky, Feininger
and Jawlensky. Klee saw his paintings
of the twenties, almost all on a small scale,
as miniature idylls, in which the color was
laid on in a regular, geometric and abstract
way, while the graphic signs, barely hinted
at, evoke objects, animals and elements
of reality. Over the years he produced not
only paintings, drawings and engravings
but also theoretical writings, and gave
fundamental lectures on color at the new
seat of the Bauhaus in Dessau. Condemned
as a degenerate artist by the Nazis, Klee
gave up his teaching post and returned to
Bern. In the last years of his life, plagued
by grave illness, Klee painted bitter
pictures, laden with gloomy omens and
characterized by dark and heavy lines.

Paul Klee
Saint-Germain near Tunis

1914
Watercolor,
8½ × 12½ in.
(21.8 × 31.5 cm.)
Centre Pompidou, Paris

This splendid watercolor
provides a record
of the emotions
experienced by Klee in
1914, on a visit to Tunisia
made in the company of
August Macke. For Klee,
the journey to North
Africa was an opportunity
to discover the light
of the south, which he
immediately captured in
paintings of great delicacy.

Paul Klee
*Colored Construction with
Black Graphic Elements*

1919
Gouache,
6½ × 8¾ in.
(16.4 × 22 cm.)
Berggruen Collection,
Geneva

Immediately after the war,
Klee started to conduct
his own research into
the organization and
rationalization of the
image. Here we are still
in a fairly chaotic phase,
in which the artist is
inserting various elements,
including letters and
irregular shapes, to test
their impact on the
organization of the
painting.

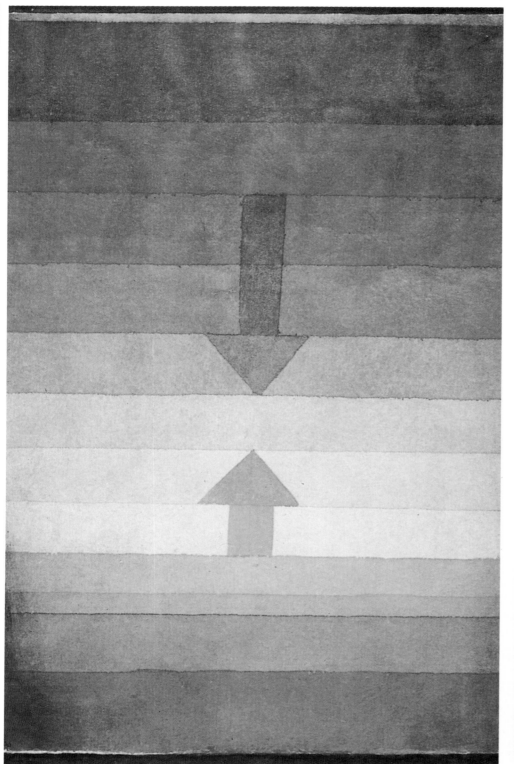

Paul Klee
Evening Separation

1922
Watercolor on paper,
13¼ × 9¼ in.
(33.5 × 23.5 cm.)
Felix Klee Collection,
Bern

Deservedly famous, this
work is highly symbolic of

the approach taken by
Klee. The two arrows that
are inserted into the
extremely regular pattern
of superimposed bands of
color are able to
communicate a feeling and
to convey, magically, an
impression of the fading
light of evening. His
researches into gradations
of color, carried out in

parallel with the evolution
of contemporary music,
have had an enduring
influence on the art of the
twentieth century, serving
as a model for painters and
graphic artists.

Paul Klee
The Spirit on the Stalk

1930
Mixed media on paper
Centre Pompidou,
Paris

During the thirties
Klee suffered both
persecution by the Nazis
and a serious illness.
In his painting, strange

figures—little sprites
and other disquieting
creatures—began to
appear alongside his
customary rhythmic
investigations of light
and color. Thus his work
became a sort of private
journal, reflecting the
artist's changing moods.
As in this case, Klee
sometimes made use
of childish forms.

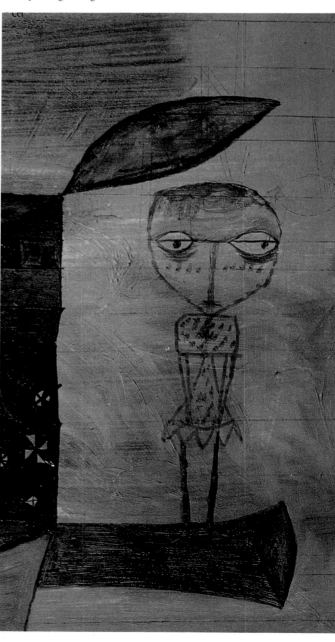

Fernand Léger
Argentan, 1881–Gif-sur-Yvette, 1955

In order to understand the development of Léger's style it is important to know that he started his career as a technical draftsman in an architect's studio. A fondness for the exact definition of objects, for geometric solids and for line was to remain a constant feature of his work. Entering the pulsating artistic world of Paris in the first decade of the century, Léger quickly identified the works of Cézanne and the early Cubists as the principal road he wished to follow, though he was also influenced by the simple and essential style of Rousseau le Douanier. Around 1910 he carried out experiments in the decomposition of the image into geometric planes along with Picasso, Braque and Delaunay, but he found Analytical Cubism too cerebral and detached from reality. Perhaps partly under the influence of the Futurists, Léger sought and found inspiration in modern industrial civilization, to which he devoted a number of interesting writings. Combining horizontal and vertical elements, sharply-defined volumes and dense colors laid on in tightly-controlled areas, Léger created rigorous compositions that are sometimes reminiscent of sections through machinery, in which cones, cylinders and parallelepipeds fit together with ingenious precision. These themes (machines, workshops, factories) are characteristic of the largely abstract pictures Léger painted after the First World War. In the twenties, especially after receiving commissions for large-scale murals, Léger returned to the human figure, celebrating artisans, laborers and builders in paintings based on the three primary colors (blue, yellow and red) and defining the personages with broad and precise lines.

Fernand Léger
Composition

1918
Oil on canvas,
57½ × 45 in.
(146 × 114 cm.)
Pushkin Museum, Moscow

Léger's art represents a highly personal development of Cubism and early Constructivism. After the First World War, Léger began to place more emphasis on contemporary themes: the city, the workplace, the factory and mechanical progress provided the inspiration for compositions made up of lines, colors and regular volumes that conveyed a feeling of modern life, riding a knife edge between the figurative and (as in this case) abstraction.

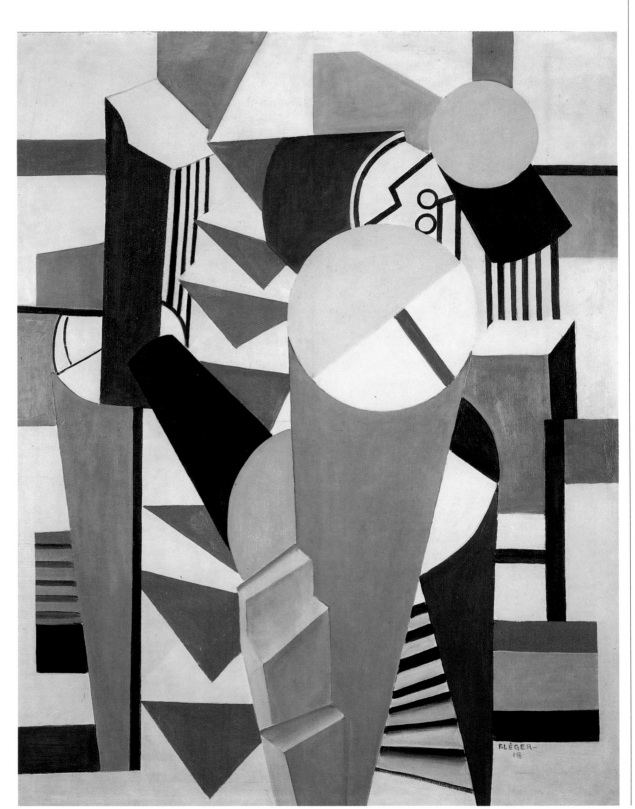

Fernand Léger
Still Life with Candlestick

1922
Oil on canvas,
45¾ × 31½ in.
(116 × 80 cm.)
Musée de la Ville de Paris,
Paris

Léger often reworked the compositions of his Cubist friends, proposing completely new versions of them. Here he carefully selects elements typical of Braque's still lifes (the round table with various objects, the newspaper).

In contrast to the dynamic decomposition of Cubism, however, he presents them in a calmly reflective manner. Each detail is defined within precise outlines, occupies a three-dimensional space and has a recognizable shape,

and yet the carefully-chosen colors and a kind of detached approach on the part of the artist lends an unnatural appearance to the composition as a whole.

Fernand Léger
Man and Woman

1921
Watercolor,
14¼ × 10½ in.
(36.5 × 26.5 cm.)
Thyssen-Bornemisza
Collection, Madrid

Alongside still lifes and compositions of objects and machinery, a significant part of Léger's

production was devoted to the human figure. This work was painted in the initial phase of his career, when the painter was exploring the major avant-garde currents of the day. Later on, he adopted a monumental style, with features in common with socialist realism, in which the human figures became much more recognizable and characterized.

Fernand Léger
Still Life with Fruit Bowl

1923
Oil on canvas,
45¾ × 33½ in.
(116 × 85 cm.)
Musée d'Art Moderne,
Villeneuve d'Ascq

In this painting we see a
conflict between figuration
and abstraction. The clearly
recognizable fruit bowl
seems to be "under siege"
by pure geometric shapes
that drastically reduce the
space devoted to the
representation of the table,
the fruit bowl itself and
even the open window
in the background. This
continual alternation,
even within the same
picture, is perhaps the
most interesting
characteristic
of Léger's work.

Dada and Surrealists

Joan Miró
Catalan Landscape (*The Hunter*) (detail)
1923–24
Oil on canvas,
25½ × 39½ in.
(64.8 × 100.3) cm.
Museum of Modern Art, New York

The Dada movement (1916–23) can be interpreted as an extreme psychological and moral reaction to the war raging in Europe, itself seen as the logical consequence of the scientific and technological progress on which bourgeois culture was founded. Within the sphere of avant-garde art, Dada put itself forward as a total rejection of all values and models, including those handed down by the movements of the second decade of the century. The fact

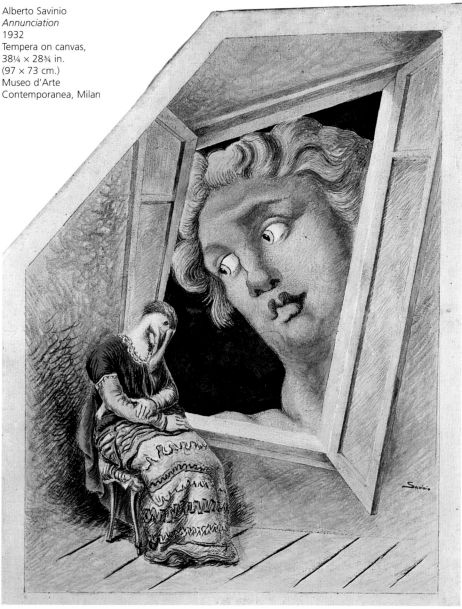

Alberto Savinio
Annunciation
1932
Tempera on canvas,
38¼ × 28¾ in.
(97 × 73 cm.)
Museo d'Arte
Contemporanea, Milan

is that, while there had been a radical transformation in the historical conception of art at that time, the result had turned out to be no more than a shift from the representation of stasis to the representation of movement, as in Duchamp's *Nude Descending a Staircase* (1912) or Boccioni's *States of Mind* (1911). With the Cubists and Futurists art continued to be a production of objects, leaving its social basis unaltered, i.e. there was no change in the equation on which bourgeois society was founded: object = merchandise = wealth = authority = power. Thus Duchamp, with his *Large Glass* (1915–23), which is not a painting or even an object but a contrivance made up of images on a transparent support, and Picabia, with his mechanistic pictures, tried to shift the attention from the object to the mental process, in an ironic comment on the Cubist analogy between the functioning of the work of art and that of the machine. In short, what determined aesthetic value was no longer a technical procedure but a purely mental act. When Duchamp signed his urinal-fountain with the name R. Mutt and sent it to an exhibition in New York in 1917, he was simply pointing out that the object has no artistic value in itself but assumes it through the act of putting it on show. Hence aesthetic activity represents a mode of conduct free from constraints, similar to that of a game, in accordance with Schiller's idea of art as play and play as freedom. But if play is freedom and freedom is the supreme value, it follows that art, as a game, is an extremely serious activity. Duchamp and Picabia, together with Man Ray and the photographer Alfred Stieglitz, founded the magazine *291* (1915–16), which anticipated many of the themes of the Dada movement that they were to join following their move to Paris. However, Dada was born two years earlier, in Zurich, when the Rumanian poet Tristan Tzara, the writer Hugo Ball and the sculptor and painter Jean Arp formed the literary and artistic circle Cabaret Voltaire. Unlike other "isms," the name *dada*, found by chance in a dictionary, was not meant to signify anything. Symptomatic of their rejection of all existing values, it appeared for the first time in the issue of the circle's magazine, *Cabaret Voltaire*, published on June 15, 1916. The group's activities were deliberately disorganized and disconcerting: Dada proclaimed itself anti-art, anti-literature and anti-poetry, setting itself the task of throwing a wrench into the works, of turning society's own mechanisms

against it or demonstrating the meaninglessness of the things to which it assigned value. In fact it did not hesitate to use the materials and techniques of industrial production, but in a way that broke all the rules.

Conflicts soon emerged within the group in Zurich, inducing Ball to break away, while Tzara entered into correspondence with Picabia, who had just returned to Paris from the United States, where he had been working alongside Duchamp. On Picabia's urging, Tzara published the "Dada Manifesto 1918" in the third issue of the magazine *Dada*. The manifesto immediately caught the attention of the Parisian literary circles most open to the avant-garde. In 1920 Tzara moved to Paris, where the first Dada exhibition in that city was organized in his honor. *Littérature*, the magazine founded by André Breton in 1919 along with Soupault and Eluard, became the official mouthpiece of Parisian Dadaism. One of their more sensational actions was the "Trial of Maurice Barrès" (1921), charged with having placed his talent at the service of the bourgeoisie: Tzara played the role of witness and Breton that of judge. In 1922 Breton and Tzara found themselves on opposing sides: Breton became the sole editor of *Littérature*, in which he published the anti-Dadaist tract "Lâchez tout," accusing the movement of a purely destructive attitude. It is evident that Breton wanted to change the movement's direction, and it was in the December 1922 issue that the first definition of the term surrealism appeared. At the same time he recognized that Dadaist modes of thought and action were simplified versions of the mental process that would lie at the heart of the Surrealist adventure. The final break came in July 1923, on the occasion of the performance of a play by Tzara, *Le coeur à gaz*, when Breton intervened to protest and was manhandled. In fact Breton had already prepared the ground for the launch of a new movement. The first manifesto of Surrealism came out in 1924. Although this is considered to mark the birth of the movement, the manifesto was far from a programmatic declaration of principles.

Even though there was no actual fusion of the two movements, Dada was in reality transformed into Surrealism, whose program was founded on the Freudian discovery of the unconscious. If the unconscious operated by means of images, then art was the most suitable means of bringing its repressed contents to the surface. Drawing on the

Marcel Duchamp
The Large Glass, or The Bride Stripped Bare by Her Bachelors, Even
1915–23
Oil on glass,
105 × 67 in.
(267 × 170 cm.)
Philadelphia Museum of Art, Philadelphia

Joan Miró
Figure and Bird in Front of the Moon
1944
Oil on canvas,
9¼ × 13¼ in.
(23.5 × 33.5 cm.)
Perls Galleries, New York

technique of the inner monologue adopted in Joyce's *Ulysses*, the Surrealists developed an automatic procedure that allowed images welling up from the unconscious to flow freely and to be recorded without the artist's intervention. This technique led to the construction of a new model of reality: surreality, a term that Breton borrowed from Guillaume Apollinaire, the tutelary genius of the Parisian avant-garde of the early twentieth century.

Just as in psychoanalytic therapy, the experience of dreaming took on enormous significance in art. In his manifesto, Breton stressed how right Freud had been to concentrate his efforts on the dream and expressed amazement that so little importance had been attached to mental activity during sleep. Breton held that it was possible to arrive at an absolute reality in which the images of the waking and sleeping states would coexist. Given this line of research, it was natural that Breton should have seen the early writings of Alberto Savinio, of which de Chirico's Metaphysical experiments represent a sort of visual translation, as clear anticipations of Sur-

Max Ernst
Solitary and Conjugal Trees
1940
Oil on canvas,
32 × 39½ in.
(81.5 × 100.5 cm.)
Thyssen-Bornemisza
Collection, Madrid

realist poetics. In Savinio's *Chants de la mi-mort*, a musical drama performed on the premises of Apollinaire's magazine *Les Soirées de Paris* in 1914, conscious and dreaming states were interwoven, with explicit references to the psychoanalytical theories that were widely discussed in Apollinaire's circle. Savinio declined Breton's invitation to become involved in Surrealism, but the whole of his literary and musical activity was pointed in a direction that Breton could not fail to recognize as the dominant one of his own movement. Breton had a similar attitude toward Savinio's brother Giorgio de Chirico, whom he hailed as the great initiator of Surrealist painting.

In 1928 Breton published his essay-manifesto *Le Surréalisme et la Peinture*. In it, describing his idea of Surrealist painting, he pointed to the work of contemporary artists like Arp, Masson, Ernst, Tanguy and Miró, while discussing de Chirico's pictures of 1909–19 at great length. But the painter with whom Breton felt most in tune was Max Ernst. Unlike Delvaux, Magritte and Dalí, who used a traditional technique of painting to express the surreal dimension of the unconscious, Ernst mixed up styles and languages in a continual metamorphosis. However, Ernst did not agree with Breton's desire to give the movement a clearly revolutionary political coloring. From de Chirico, the only artist whose influence he acknowledged, he learned that silence and immobility could not be used to fight against a noisy and restless world, but that they could embarrass it. And yet it was also true that the historical conditions in which he was operating, between the wars, were no longer the ones that had justified the mute Metaphysics of de Chirico. In the *Second Manifesto of Surrealism*, published in 1930, Breton clearly presented the movement's political position, entailing a marriage of dialectical materialism with psychoanalysis. At the same time *La Révolution Surréaliste*, the magazine of which Breton had assumed the editorship from the fourth issue of July 1925 onward, was renamed *Le Surréalisme au service de la Révolution* and formally joined the Third International. Yet the Surrealists, while adhering to Marxism, remained critical of the dogmatic and sectarian positions taken by the French Communist party, which they had joined in 1925, though this was not made public until 1927.

During this period, in which artistic activity was combined with intense political involvement, Surrealism spread beyond the confines of France. Groups of intellectuals who shared Breton's theoretical ideas were formed in Belgium, Switzerland, Great Britain and Japan.

The last issue of *Le Surréalisme au service de la Révolution* was published in May 1933, but for some time Surrealist painters like Duchamp, Man Ray, Delvaux, Ernst, Miró and Magritte had been contributing to a luxury art magazine called *Minotaure*, taking it in turns to illustrate the cover.

In 1938 the assassination of Trotsky, with whom Breton had drawn up the manifesto for "a revolutionary and independent art," brought the politically engaged period of Surrealism to a close. The outbreak of the Second World War and the flight of many artists from Europe marked the end of the Surrealist movement's role as a driving force.

René Magritte
The Empire of Light
1954
Oil on canvas,
57½ × 45 in.
(146 × 114 cm.)
Ertegun Collection,
New York

Marcel Duchamp
Blainville, 1887–Neuilly, 1968

An irreverent and provocative artist, he broke with the traditional conception of art and above all the concept of the work of art itself, in an attempt to demonstrate the artist's absolute freedom within society. After an early Fauvist phase, Duchamp moved on to Cubist decomposition, taking its principles to an extreme. In 1912 he took part in the exhibition of the Section d'Or, which comprised works by the dissident Cubists who belonged to Apollinaire's circle. The following year saw him break away from the Cubists and head in a direction unconstrained by the techniques of painting itself: the "work of art" was transformed into an object of everyday use, detached from reality and elevated to the status of an art form. Out of this came the first "ready-mades": a bicycle wheel fixed to a stool, a bottle rack and, more embarrassingly, a ceramic urinal turned upside down and signed with the apparent pseudonym R. Mutt, which concealed the key to the work's interpretation. In 1915 Duchamp moved to New York where, together with Francis Picabia and Man Ray, he created the American Dada movement, publishing the sole issue of the magazine *New York Dada* in 1921. In addition to his ready-mades, the artist produced a large work on glass, *The Bride Stripped Bare by Her Bachelors, Even*, which he left incomplete and seemingly incomprehensible in 1923, when he gave up art for the game of chess. After a long pause he resumed an intense activity, producing ironic and paradoxical objects such as the *Boîte-en-valise*, a suitcase containing miniature copies of his most significant works that served as a sort of portable museum and emblematic testimony to his artistic career. In the fifties and sixties he shuttled back and forth between Paris and the United States. In 1966 he completed his *Etant donnés*, the last great piece on which he had worked for twenty years: a female nude against the backdrop of a landscape and viewed through a keyhole. The installation was set up in a room at the Philadelphia Museum of Art and inaugurated after his death. It marks a return to the themes of virginity and maternity, no longer set in a space dominated by forms alluding to modern technology, but in a sort of theater of nature, offering an optimistic vision of the world.

Marcel Duchamp
Nude Descending a Staircase

1912
Oil on canvas,
58¼ × 35 in.
(148 × 89 cm.)
Philadelphia Museum
of Art, Philadelphia

The work, excluded from the exhibition of Cubists at the Salon des Indépendants because it was thought too critical, was included in the Armory Show in New York, the first international exhibition of modern art, where it caused a scandal and established Duchamp as one of the most innovative artists of the day. Here the artist transcends the divisions between the avant-garde currents, adding Futurist movement and speed to Cubist decomposition.

Francis Picabia

Paris, 1879–1953

A French painter of Cuban origin, he took up Dadaism after trying out the Fauvist and Cubist styles. In 1915 he left Paris for New York, where he had already spent six months in 1913, showing his celebrated picture *Udnie* at the Armory Show of modern art and establishing links with exponents of the avant-garde, including the photographer Alfred Stieglitz. His first one-man show of abstract watercolors was held at the gallery owned by Stieglitz. He also met Marcel Duchamp and Man Ray in New York and the three of them formed the nucleus of American Dada. Sharing with Duchamp a deep aversion to the myth of technological modernity, he produced his cycle of large "machinist" pictures. Returning to Europe in 1918, the artist came into contact with Tristan Tzara, injecting new blood into the Dadaism of first Zurich and then Paris. These were the decisive years in which the Dada experience came to an end and its exponents were absorbed into the emerging Surrealist movement. Picabia joined the movement in 1924, the same year as Breton published the Surrealist manifesto, and displayed an extraordinary freedom of imagination in his series of "monsters" and "transparencies." After the Second World War, influenced by the poetics of nonrepresentational art, he devoted himself for a while to abstract painting and then went back to Surrealism.

Francis Picabia
Music Is Like Painting

1917
Oil on canvas,
47¼ × 26½ in.
(120 × 67 cm.)
Private collection

The break with traditional figurative language is evident in this painting, whose title is emblematic of the interest in music shared by all the artists associated with the magazine *391*, which commenced publication at Barcelona in 1917.

Francis Picabia
Dances at the Fountain

1913, Oil on canvas,
18¾ × 18¾ in.
(47.5 × 47.5 cm.)

Philadelphia Museum of Art, Philadelphia

Painted during the artist's phase of Orphic Cubism. Excluded from the Cubist exhibition at the Salon des Indépendants, it was included in the Armory Show held in New York in 1913.

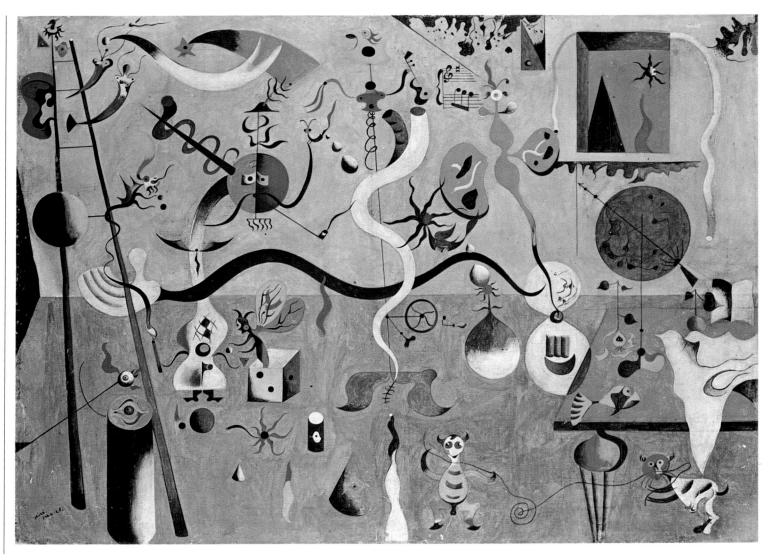

Joan Miró
Harlequin's Carnival

1924—25
Oil on canvas,
26 × 36½ in.
(66 × 93 cm.)
Albright-Knox Gallery,
Buffalo

Joan Miró

Barcelona, 1893–Palma, Majorca, 1983

Miró's love for Catalonia, the land of his birth, was a prime source of inspiration in his work. This tie is particularly evident in the early phase of his career, strongly influenced by recent developments in European art, from Cézanne to the Fauves, Expressionists, Cubists and Futurists. Moving to Paris in 1919, he frequented Dadaist circles and events, meeting Picasso and Tzara. In 1921 he made friends with André Masson and came into contact with the Surrealist writers Artaud, Eluard, Aragon and Péret. He ceased making any further attempt at representation in his painting and developed a lyrical abstraction based on carefully considered graphic signs, sometimes disturbing and at others joyful, which expressed the impulses of his memory and unconscious. It was in this period that he painted works like

Harlequin's Carnival (1924—25), in which his highly personal interpretation of Surrealism, characterized by a fabulous vision of the world, is evident. In 1928 the masterpieces of Dutch seventeenth-century painting, seen on a visit to the Netherlands, inspired the series of *Dutch Interiors*, in which forms defined by contrasting colors or the same black line used to enclose images and geometric shapes and, at the same time, reconstruct them, stand out against a flat background. After the outbreak of the Spanish Civil War in 1936 and his enforced exile, his work grew darker and less monumental. This was the period in which he produced his *papiers collés*, with insertions of material, and the gouaches of the series *Constellations* (1940–41). The latter, all of the same format, represent an extension of the process of deconstruction to which the artist subjected the system of signs that he had himself created. In fact the figures became even more dilated and

buoyant and the line was reduced to a thread. This happened at a time when he was in close contact with Paul Klee, though where Klee was sinking and exploring the depths, Miró was rising to the surface. In 1954 the Venice Biennale awarded him its international prize for graphic art, one of Miró's many fields of interest. Two years later he went to live in the house-cum-studio designed for him at Palma on Majorca by the architect José Luis Sert. He developed closer ties with the United States, where he received the Guggenheim Prize in 1959. In 1966 major retrospectives were dedicated to him in Japan (Tokyo and Kyoto) and the influence of Zen and the tradition of calligraphy induced him to eliminate any residue of narrative or aesthetic elements from his pictures, in a quest for essentiality. When he died in Palma tributes were paid to him all over the world.

The artist fills the transfigured space of his studio with natural and symbolic elements, in a fertile blend of the figurative and the abstract. Motifs drawn from the repertory of fantasy and dream, with obvious echoes of Bosch, are reduced to graphic signs and float to the surface of the painting.
Two serpentine forms, one white and the other black, intersect in the middle of the picture. They are set on top of the figure of Harlequin, holding a guitar from which emerge the notes that set off the festival of Carnival.

Joan Miró
Motherhood

1924
Oil on canvas,
35¾ × 29¼ in.
(91 × 74 cm.)
Private collection,
London

Two lines cross on a
neutral field. At their ends
are set a few graphic signs
that symbolize the idea of
motherhood: a woman's
head, womb and breasts,
to which a female child
and a male one are
attached like insects.

Joan Miró
Dutch Interior II

1928
Oil on canvas,
36¼ × 28¾ in.
(92 × 73 cm.)
Peggy Guggenheim
Collection, Venice

This is one of the three
interiors he painted after a
visit to the Netherlands in
1928, where the artist was
greatly impressed by
Dutch seventeenth-century
painting, especially the
intimate and bourgeois
pictures of Vermeer.

Joan Miró
*Figure Throwing a Stone
at a Bird*

1926
Oil on canvas,
28¾ × 36¼ in.
(73 × 92 cm.)
Museum of Modern Art,
New York

A typical example of a
picture-poem, a type of
composition halfway
between painting and
literature. By using
painting in a verbal sense
and writing in a figurative
one, Miró practiced an
automatism that was both
visual and verbal.

355

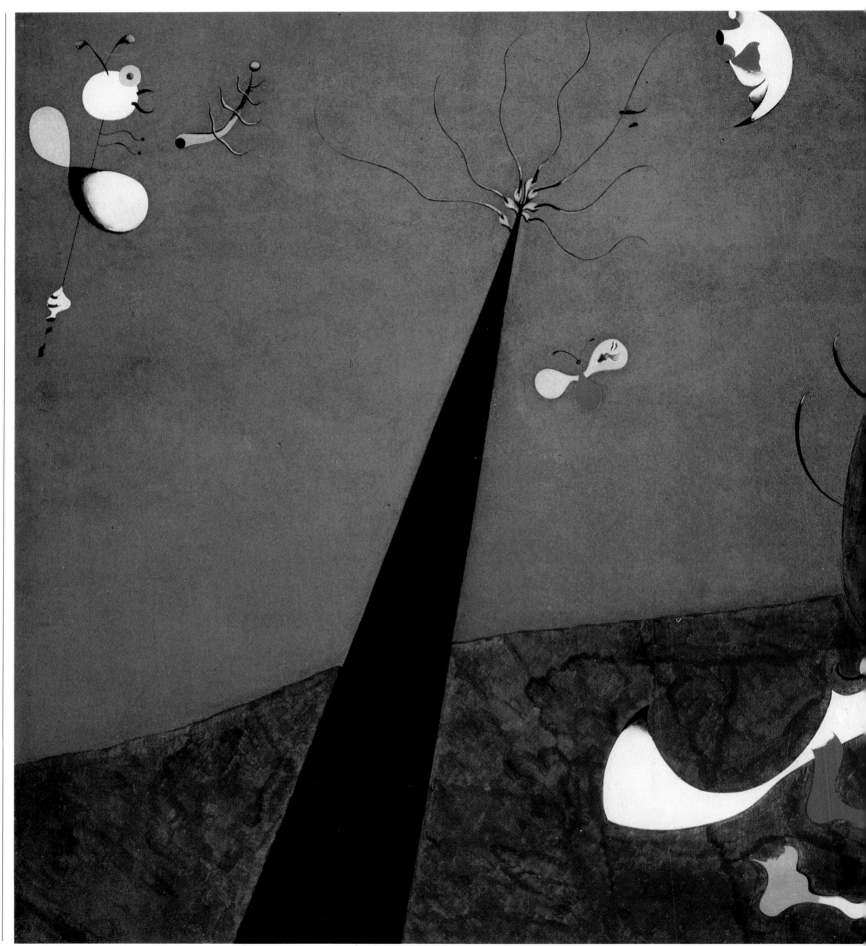

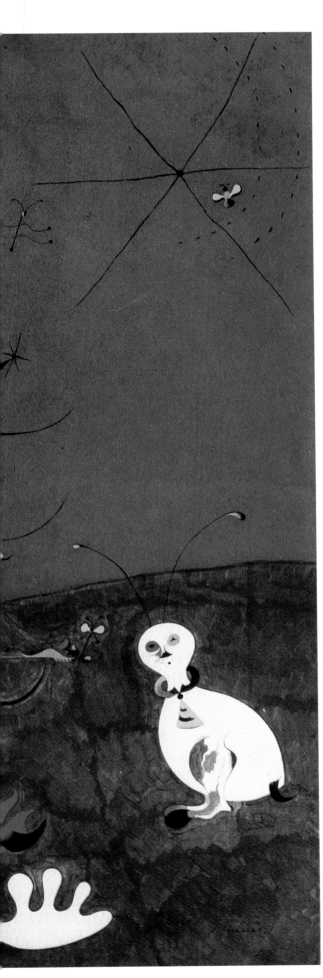

Joan Miró
Dialogue of Insects

1924–25
Oil on canvas,
29¼ × 36½ in. (74 × 93 cm.)
Berggruen Collection,
Geneva

Painted in his studio on Rue Blomet in Paris during the winter of 1924–25, at around the same time as the celebrated *Harlequin's Carnival*, this picture testifies to the radical change in Miró's style. Thanks to André Masson, who introduced him to the work of Paul Klee and the Surrealists, Miró gradually moved away from figurative painting to adopt a language of pictographic symbols. The deep blue ground reinforces the dreamlike atmosphere conjured up by the bright colors of the insects.

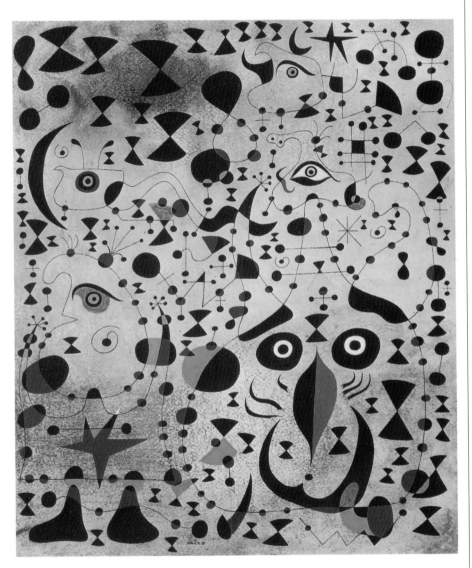

Joan Miró
*The Beautiful Bird
Revealing the Unknown
to a Pair of Lovers*

1941
Gouache and oil wash on paper, 18 × 15 in. (45.7 × 38 cm.)
Museum of Modern Art, New York

During the Second World War he painted the *Constellations*, a series of gouaches which inspired Breton to produce similar works in the form of poems.

Alberto Savinio

Athens, 1891–Rome, 1952

Alberto Savinio started out as a musician and poet and only began to paint in the mid-twenties. Born in Athens to a railroad engineer and a Genoese noblewoman, he spent his childhood steeped in classical myth, which left a deep mark on his artistic imagery. A decisive influence on his formation came from the years he spent in Munich, from 1906 to 1908, when his brother Giorgio de Chirico introduced him to the work of Max Klinger, characterized by a strong link between painting and music. In 1914 he was in Paris, where he launched "Sincerism," a current of music that Apollinaire interpreted as a

transposition of de Chirico's painting into musical terms.

In the essay "Le drame et la musique," published in Apollinaire's magazine *Les Soirées de Paris* in April 1914, he declared that the aim of the artist was to extract the metaphysical element from things, to bring out the unknown part, the mysterious side of reality. Savinio's entry into the world of painting was marked by a one-man show at the Galerie Bernheim-Jeune in Paris in 1927, presented by Jean Cocteau. His pictorial work was in line with that of the Surrealists, though the artist declined any involvement with the movement led by Breton, insisting on the uniqueness of his approach.

Alberto Savinio
Gomorrah

1929
Oil on canvas transferred onto panel,
23¼ × 28¾ in.
(59 × 73 cm.)
Private collection

Drawing on images from the Bible, Savinio represents the dark mass of a square city, surrounded by walls and towers, under assault from lightning bolts hurled by avenging angels. The event is viewed through the

frame of a window, to underline the separation between the artist and observer, both on this side of the window, and the scene depicted. In the upper right-hand corner of the picture the black shape of a drape is blown by the storm gathering over the city, a signal of imminent disaster. In the middle we see, in a tangle of brilliantly colored forms, the host of avenging angels.

Alberto Savinio
The Faithful Bride

1930–31
Oil on canvas,
31½ × 25½ in.
(80 × 65 cm.)
Galleria dello Scudo,
Verona

In the setting of a typically
Savinian room, the figure
of a woman with the head
of an ostrich, an ironic
image of the mother
that he loved and hated,
is seated at a window
offering a spectacular view
of the world outside.

Max Ernst
Untitled - Dada

c. 1922
Oil on canvas,
17 × 12½ in.
(43.2 × 31.5 cm.)
Thyssen-Bornemisza
Collection, Madrid

The painting deliberately
sets out to create a sense
of bewilderment. The
random combination
of objects in everyday use
and totally invented forms
produces an ironic and
arbitrary composition.

Max Ernst

Brühl, 1891–Paris, 1976

The anti-systematic philosophy of
Nietzsche and Freudian psychoanalysis
played a decisive role in the development
of this German painter and sculptor, who
followed his own line of research without
ever becoming fully involved in any of the
avant-garde movements with which he
came into contact. Only to Giorgio
de Chirico did Ernst profess the devotion

due to a master, whose teachings were
beyond question. He shared de Chirico's
conviction that the marriage between
artistic creativity and industrial
production, the objective of the Weimar
school, was totally impracticable: art
was the only medium that ensured
freedom and made it possible to strip
away the grotesque mask of power.
In 1921 Ernst took part in the exhibition
organized by Breton in Paris, moving to
the city the following year and establishing
links with the Dada group and then

Surrealism, but following a course that
could not be assimilated with their
approach.
He invented new techniques, such
as *frottage*, based on the child's game
of taking an impression of the texture
of a material by rubbing, and produced
works of a visionary character, but always
extremely lucid. After a period in the
United States (1939–53), he returned
to France, where he continued to work
intensely, producing graphic art
and totem-like sculptures as well.

Max Ernst
Zoomorphic Couple

1933
Oil on canvas,
35 × 27½ in.
(89 × 70 cm.)
Peggy Guggenheim
Collection, Venice

The painting appears to be
the automatic transposition
of a nightmare, along the
lines of Surrealist poetics.
In any case, Ernst's early
exposure to the ideas of
psychoanalysis explains his
interest in the nocturnal
activity of the ego, even
before his contact with
Surrealism.

361

Salvador Dalí

Figueras, 1904–1989

An egocentric artist—he liked to describe himself as "El unico"—who passed through the most significant avant-garde movements of the early part of the century, from Futurism to Metaphysical Art, Cubism and Surrealism, which he took up in 1929. In a vulgar and indecorous fashion Dalí applied his own peculiar interpretation of Surrealism to daily life as well, cultivating what he himself described as a "paranoiac-critical" state. According to psychiatric tests, the paranoiac critical is an individual who, blinded by a feeling of omnipotence, interprets the world in terms of a delirious vision but is able to rationalize the delirium. In 1934, repudiated by Breton, he left the Surrealist group in Paris and in 1939 moved to the United States, where he spent the war years, publishing his autobiography *The Secret Life of Salvador Dalí* in 1942. After the war he kept up his prolific output, trying his hand at illustration and graphic art as well. His hallucinatory and deserted landscapes, filled with symbolic elements, and the series of limp and melting watches, intended to symbolize the transience of time, gave way to a more academic style, which he used to revise and correct the same themes as he had tackled in his early work.

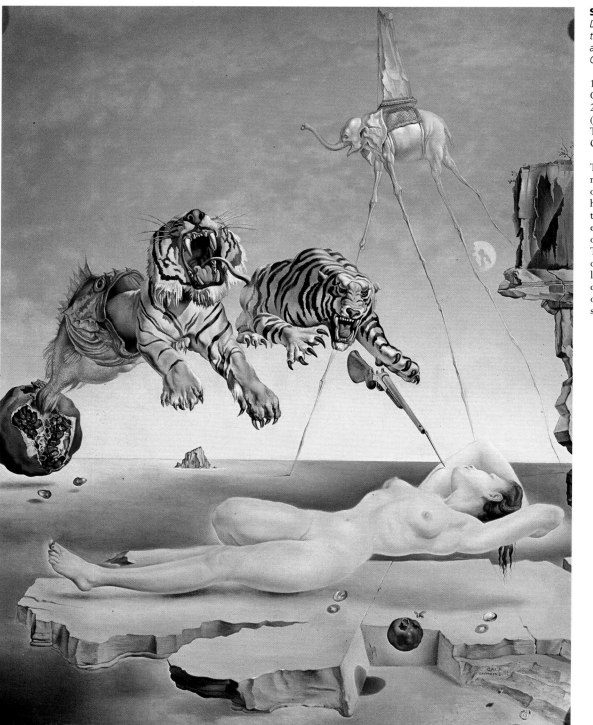

Salvador Dalí
Dream Caused by the Flight of a Bee around a Pomegranate One Second before Waking

1944
Oil on canvas,
20 × 16¼ in.
(51 × 41 cm.)
Thyssen-Bornemisza Collection, Madrid

The "paranoiac-critical" method was a sort of self-induced hallucination that allowed the artist to create behind every image another one ready to take its place. Thus reality can suggest other realities, just as legitimate. Everything depends on the faculty of interpretation of the subject.

Salvador Dalí
Gradiva Rediscovers the Ruins of Anthropomorphes

1931
Oil on canvas,
25½ × 21¼ in.
(65 × 54 cm.)
Thyssen-Bornemisza
Collection, Madrid

His works, painted
in a slick style, are rich
in emblematic and often
provoking images and
unusual combinations
of forms that produce
a bewildering effect.

Salvador Dalí
The Persistence of Memory

1931
Oil on canvas,
9½ × 13 in. (24 × 33 cm.)
Museum of Modern Art,
New York

Dalí joined the Surrealist
movement at the end of
the twenties and his lively
creative methodology
helped to throw new light
on the group's research.
In a deserted landscape
and at an indefinite
time, the only signs
of life in the past are
melted watches, symbols
of the fleeting nature
of time.

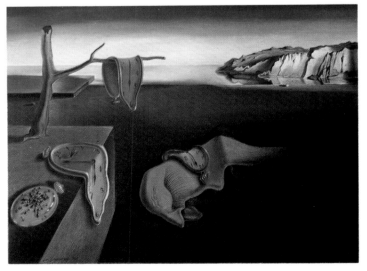

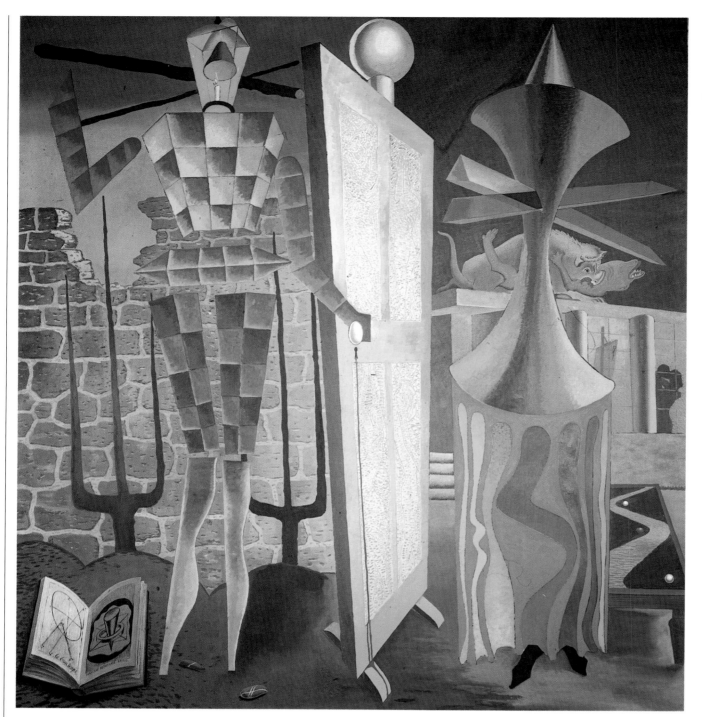

Man Ray
Good Weather

1939
Oil on canvas
Private collection

The painting, which remained in the possession of his wife Juliet until her death, was sold at Sotheby's in London in 1994. In the foreground we see two mysterious and threatening figures: an androgynous mannequin, whose head is a lantern lit by a candle, is opening a door with a trickle of blood running from its keyhole. On each side of the mannequin, two gigantic forks are outlined against the backdrop of a breached wall, under a limpid sky. On the other side of the door, itself anthropomorphic in appearance, the second mannequin stands in front of a building. Through its glass walls we can see an easel and a man and woman embracing, while two wild beasts are locked in combat on the roof. With this work, painted on the eve of the Second World War, Man Ray took his leave of Paris and returned to the United States.

Man Ray

Philadelphia, 1890–Paris, 1976

An American painter, photographer and filmmaker, he was convinced of the absolute preeminence of the image and its significance over the technique used to produce it, assigning complete equality to all means of expression. He met Picabia and Duchamp in New York in 1915 and together they founded the American Dada movement. When he moved to Paris in 1921, Duchamp introduced him to the Dadaists there, who involved him in their activities. While Duchamp with his ready-mades turned any chosen object into a work of art, Man Ray intervened to modify the object, taking away its natural function. Famous are his *Le Cadeau* (*The Gift*, 1921), a flatiron with a row of tacks fixed onto its bottom, and *Object to be Destroyed* (1923), a metronome with a photograph of the eye of the woman he loved and hated attached to its pendulum. His irreverent research led him to try out new techniques in the realm of photography. Working directly on the film, without a camera, Man Ray produced abstract images in black and white. He called these pictures, made by placing objects directly on light-sensitive paper and exposing them, "rayographs."
In 1922 he published a collection of twelve rayographs, entitled *Les Champs Délicieux* and with an introduction by Tzara. He brought a similar freedom of imagination to the language of film: irrationality, automatism, absence of plot, psychological and dream sequences devoid of apparent logic. In 1926 he made the short film *Anemic Cinema* in collaboration with Marcel Duchamp.
In the thirties he went back to the construction of enigmatic objects, often repeating them several times as he considered the act of making them more important than the idea itself. From 1940 to 1951 he lived in the United States and then returned to Paris, where he remained until his death.

Paul Delvaux

Antheit, 1897–1994

A Belgian painter, he did not discover Surrealism until 1934, when he saw Magritte's work at the exhibition "Minotaure," held at the Palais des Beaux-Arts in Brussels, and fell under its spell. So he decided to destroy the works of his Expressionist period, just as he had destroyed his Post-Impressionist ones after coming into contact with the painting of Ensor. Though he adopted Surrealism wholeheartedly, he was still able to develop a personal and consistent style. In his pictures Delvaux expressed the dreamlike dimension of reality, creating disturbing and visionary compositions. They combine the Metaphysical space of de Chirico with Magritte's process of enigmatic estrangement. Classical architecture and bourgeois interiors are peopled with disquieting female figures, often naked and possessing an arcane sensuality and unattainable beauty. In spite of his solitary disposition, Delvaux showed his work at the movement's main exhibitions and staged his first retrospective in Brussels in 1944.

Paul Delvaux
Woman in the Mirror

1936
Oil on canvas,
28 × 36½ in.
(71 × 92.5 cm.)
Thyssen-Bornemisza
Collection, Madrid

A picture pervaded by a dreamlike and mysterious sensuality, whose cold and tenuous colors render the female figure recondite and inscrutable.

Paul Delvaux
The Staircase
(*Nude on the Stairs*)

1946
Oil on panel,
48 × 59¾ in.
(122 × 152 cm.)
Museum voor Schone Kunsten, Ghent

A complex setting, serving as a reminder of the fact that Delvaux studied architecture while training in Brussels, is dominated by two enigmatic female nudes, figures from a dreamworld clearly derived from de Chirico.

René Magritte
Lessines, 1898–Brussels, 1967

After working in the Cubist and Futurist styles, Magritte's attention was caught, in 1922, by a reproduction of de Chirico's mysterious *Song of Love* (1910). It seemed to him a new vision in which the observer "rediscovers his isolation and perceives the silence of the world."

In the spring of 1927 Magritte moved to Paris, where he met Breton and joined the Surrealists, though continuing to go his own way. There is no space in his pictures for figures that transcend everyday reality: they are crowded with banal objects, rendered bizarre by their gigantic proportions or distortions of their appearance. The result is an absurd and disquieting image of reality, as full of snares as a nightmare. In 1930 Magritte returned

to Brussels, where he frequented a select circle of Surrealist friends and wrote the manifesto *L'action immédiate* in 1934, documenting his ties with Breton and his plan to bring Surrealism into the field of political struggle. After a short stay at Carcassonne, where he painted *Le Mal du Pays* (*Homesickness*, 1940), he spent the rest of his life in Brussels, briefly adopting the style of Renoir before returning to his more usual manner.

René Magritte
The Key of the Fields

1936
Oil on canvas,
31½ × 23½ in.
(80 × 60 cm.)
Thyssen-Bornemisza
Collection, Madrid

If the window opening onto nature is a clear metaphor for the human condition, the shards of broken glass, representing the elimination of the barrier between container and content, interior and exterior, humanity and reality, are a metaphor for painting, which was Magritte's instrument of choice for deepening his understanding of the world.

René Magritte
Homesickness

1940
Oil on canvas,
39¼ × 31½ in.
(100 × 80 cm.)
Private collection

Immobility and silence impart a sense of loss to the image as a whole, which is cut in half by a balustrade, separating two irreconcilable realities. On the right-hand side, a man-angel leans against the balustrade, gazing at the city that is faintly visible in the distance. A street lamp stands in the background, on the left. In the foreground, in the middle of the picture, the figure of the lion harks back to the iconography of Venetian painting in the fifteenth century.

René Magritte
Manet's Balcony

1950
Oil on canvas,
32 × 23½ in.
(81 × 60 cm.)
Museum voor Schone
Kunsten, Ghent

The picture is a citation
of Manet's famous painting
The Balcony. The setting
is reproduced exactly:
the open Persian blinds,
the railing, the potted
flower and the chair. But
the scene has been emptied
of all signs of life. The little
dog in the foreground
has gone, while the four
human figures have been
replaced by coffins, in
an absurd and disturbing
reminder of the presence
of death in daily life.

René Magritte
Arnheim's Domain

1962
Oil on canvas,
32 × 23½ in.
(81 × 60 cm.)
Museum voor Schone
Kunsten, Ghent

A thin crescent moon
illuminates an immense,
snow-covered mountain
which assumes the form
of an eagle with its wings
spread. The foreground
is taken up by a wall on
which sets a nest with
three eggs. The title
is a reference to Rudolf
Arnheim's *Art and Visual
Perception* (1954), a book
on the figure-ground
relationship and the way
the mind completes images
in painting.

Between the Wars

Otto Dix
The Match Seller (detail)
1920
Oil on canvas and collage,
56¾ × 65¼ in. (144 × 166 cm.)
Staatsgalerie, Stuttgart

Georg Grosz
The Engineer Heartfield
1920
Watercolor, pasted
postcard, and halftone
on paper,
16½ × 12 in.
(41.9 × 30.5 cm.)
Museum of Modern Art,
New York

The complexity and variety of the international-
al movements and the artists who operated in
the years separating the two world wars can
only be presented in an extremely summary
fashion, by pointing out some of the most significant fig-
ures and main trends in painting over this period. In the
first place it is indispensable to record the development
of the American artistic schools. Painting in the United
States, which had been heavily influenced by European
art throughout the nineteenth century, now showed signs
of complete independence. No longer in awe of London
or Paris, American painters covered the widest possible
range of expression, from photographic realism to the
most extreme abstraction.

To sum up the vitality of American painting we have
chosen two emblematic figures. Edward Hopper was a
painter with a refined, lucidly realistic technique, per-
fectly in keeping with the novels of F. Scott Fitzgerald
and the developments in cinematography. In a country
coping with the Great Depression that followed the
Wall Street crash of 1929, Hopper's figures eked out a
solitary existence, in soulless cities that had grown too
fast. Their neon signs and bar lights threw no light on the
problems of indifference and lack of communication. In
spite of their concrete clarity, Hopper's paintings are ac-
tually metaphysical compositions, in which reality is
immobilized, frozen. Jackson Pollock, on the contrary,
expressed himself through action, to such an extent that
he chose to describe his work as "Action Painting." Pol-
lock's large canvases are abstract compositions in which
there is practically never any link with the figurative:
they are magnificent monuments to the "act" of painting,
in which the initial influence of the Italian Futurists and
Miró has been swept away by the impetus of expression.
The epitome of nonfigurative painters, Pollock imbued
his works with a throbbing vitality, so that they took on
the appearance of living, pulsating forms, the exact op-
posite of Hopper's motionless scenes.

Remaining on that side of the Atlantic, the artistic awak-
ening of the Latin American nations deserves a separate
mention. The long struggle for independence, the reeval-
uation of the ancient pre-Columbian civilizations, and
the fresh and innovative vitality of peoples and artists
making their first appearance on the artistic scene
stimulated the birth of the Mexican school. Siqueiros,

Orozco and Rivera (along with his wife, the ill-stared painter Frida Kahlo) created a movement that attained worldwide prominence. Their most characteristic works are enormous murals, painted on the walls of public and commemorative buildings and drawing their themes from politics, Communism and the history of the Aztecs. It was a style in tune with popular and social realism but one that avoided the traps of rhetoric, as well as a movement that involved some weighty figures: Diego Rivera was the outstanding talent among them.

The Europe of the twenties and thirties perhaps did not have the hunger for renewal and boldness of expression that it had displayed in the first fifteen years of the century, before the bloodbath and collective trauma of the war. In previous chapters we have followed the evolution of various antithetical currents, such as Surrealism and the Bauhaus. The defeat and collapse of the Habsburg empire brought an abrupt change in the role of Vienna, which went from a great and brilliant capital of culture and politics to a prematurely aged city, fated to become a mere province of Hitler's haughty Third Reich. For its part Paris maintained its role as a point of reference and meeting place for artists from all over the world, but many painters decided to move elsewhere, to the countryside or the Côte d'Azur, thereby impoverishing the city's cultural life. In general, Europe seemed to dither over radical choices. "Return to order" or avant-garde? Figuration or abstraction? Line or color? The indecision shown by artists was a reflection of political developments, with the rise and consolidation of fiercely autarkic regimes.

In the iron grip of Stalin, Mussolini, Hitler and Franco, European artists saw not only their opportunities for meeting and exchange of ideas limited, but even their freedom of expression. The sinister glow of bonfires in the streets, where (in Berlin as well as in Moscow) great masterpieces of contemporary painting were burned as "degenerate art," throws a somber light on the culture of the thirties.

The world edged toward a new tragedy and the Spanish Civil War was its dress rehearsal. In *Guernica*, Picasso captured its anguish and drama. We can find an echo of Goya's paintings and drawings *The Disasters of War* in this picture, in an ideal connection spanning the centuries as well as the pages of this book. From Goya

to Picasso, "modern" painting made a journey filled with exciting discoveries, surprises and upheavals, but at bottom always using traditional means: palette, brushes, paints, canvases. With the Second World War the situation changed radically. The very concept of "painting" in the classical sense was undermined, the means of expression fused and enriched. The language of the arts became a common tongue, with continual exchanges that broke down the historical barriers between different forms of communication. The old capitals of the figurative arts (Rome, Paris, Vienna) gradually lost their role to new centers of production and confrontation between experiences from all over the world. The world we now live in, dynamic and interactive, multiracial and uninhibited, but one which still feels the need, every now and then, to wander through the rooms of the museums and discover, in the paintings of the past, the mirror of its soul.

Max Beckmann
The Night
1918–19
Oil on canvas,
52¼ × 62¼ in.
(133 × 158 cm.)
Kunstsammlung Nordrhein-Westfalen, Düsseldorf

David Alfaro Siqueiros
Portrait of the Bourgeoisie
(detail)
1939
Fresco, 1076 sq. ft.
(100 sq. m.)
Union of Electricians,
Mexico City

Max Beckmann

Leipzig, 1884–New York, 1950

An independent and intense personality, Beckmann's life and career are exemplary of the condition of the artist in the troubled decades between the two wars. After an initial training at the Weimar Academy, Beckmann spent time in Paris and Geneva. In 1904, following the success of a one-man show, he moved to Berlin. Over this period his style changed several times, passing from late Impressionism to Realism. Like Dix, however, Beckmann discovered the roots of German Expressionism during the First World War, finding in them an effective means of expressing his dismay at the agony it caused, at the physical, moral and social devastation. The tragic cruelty of a painting like *The Night* (1918–19) made Beckmann one of the greatest interpreters of the terrible conditions in defeated Germany. Yet in Beckmann's work, unlike that of Dix and Grosz, it is possible to detect the influence of other, contemporary European movements, such as Cubism and, in the twenties, the call for a "return to order." Alternating his activity as principal of the school of fine arts in Frankfurt with journeys to Paris, Beckmann gradually transformed his graphic style of Expressionism into scenes and figures with simplified, monumental volumes, which also showed a renewed taste for color. In 1937 he was forced to leave Germany following persecution by the Nazis and spent the war years in Amsterdam, painting pictures on a large scale. In 1947 he moved to the United States, where he taught at Washington University in St. Louis, Missouri, before settling in New York.

Max Beckmann
Self-Portrait in Tuxedo

1927
Oil on canvas,
55½ × 37¾ in.
(141 × 96 cm.)
Fogg Art Museum,
Cambridge, Mass.

The stern features of the face, the volume sharply defined in black and white and the graphic emphasis on outline place Beckmann within the current of German Expressionism. The choice of dress, however, shows that Beckmann was also a refined and ironic interpreter of Berlin society.

Max Beckmann
Quappi in Pink

1932–34
Oil on canvas,
41¼ × 28¾ in.
(105 × 73 cm.)
Thyssen-Bornemisza
Collection, Madrid

In this portrait of his wife
Mathilde (known as
"Quappi"), whom he had
met at the time they were
both studying at the

Frankfurt Academy,
Beckmann offers further
proof of the range of his
figurative culture. The
painting seems to be linked
not so much to German
Expressionism as to
developments in France,
and Matisse's work in
particular. On the other
hand, the spare and
forceful handling of certain
details, such as the hands,
the incisive and simplified
graphic treatment of the

bodice and background
and the slight deformation
of the features (the
excessively large eyes, the
slender hands with their
extremely long fingers,
the unnatural length
of the neck) are all
elements that recall the
painter's German origins.

Max Beckmann
Aerial Acrobats

1928
Oil on canvas,
83¾ × 39 in. (213 × 99 cm.)
Von der Heydt Museum,
Wuppertal

A display by two acrobats,
suspended from the basket

of a hot-air balloon, gave
Beckmann the opportunity
to paint a cheerful picture,
with its colors and waving
flags. But the figures' antics
are also a symbol of the
precarious state of affairs
in a period when Germany
was seeking a new social,
artistic and cultural
equilibrium.

Otto Dix

Untermhaus, 1891–Singen, 1969

The son of a railroad worker, Dix studied at the art schools of Dresden and Düsseldorf (1910–14). His early works appear to lie completely outside the avant-garde currents of German Expressionism and to be influenced, if anything, by Impressionism. The call to arms in the First World War brought about an abrupt change in his style and his life. When he emerged from the horrors of the war, Dix seems to have been shocked by the physical and moral wounds that had been opened in the body of German society. Thus he developed a means of expression in which he took a drastic and biting realism to the point of absurdity. A typical example is the *Match Seller*, in which a disabled soldier, his legs reduced to stumps, squats on the sidewalk as people pass by with indifference. The paintings of social protest were combined with a prolific output of portraits, characterized by their incisive and penetrating line. Dix went on to explore the roots of Expressionism in the tradition of German painting and, together with George Grosz, founded the movement called Neue Sachlichkeit ("New Objectivity") in 1924. Dix's preferred themes were social satire and the denunciation of violence, offering an interesting parallel with the films of Fritz Lang and the hard-hitting cabaret of Berlin. The polemical violence of his paintings did not prevent Dix from pursuing an academic career. In 1927 he was appointed a professor at the Dresden Academy and in 1929 invited to the exhibition of contemporary art in Paris. In 1931 he was elected to the Prussian Academy. The advent of Nazism, in 1933, coincided with his grotesque picture, the *Seven Deadly Sins*, which included a vicious caricature of Hitler. Dix's work was declared "degenerate art" and about 250 of his canvases were burned in public. In 1939 the painter, accused of involvement in a plot to kill the Führer, was arrested and imprisoned in Dresden. Though soon released, he was conscripted into the Home Guard in 1945 and captured by the French. After the war he went back to live on Lake Constance, where he continued to work for many years, choosing themes from the Bible and adopting a much gentler style than that of the Berlin period.

Otto Dix
Triptych of the War
(central panel and predella)

1929–32
Mixed media on canvas, central panel
80¼ × 80¼ in.
(204 × 204 cm.)
Gemäldegalerie Neue Meister, Dresden

Barbed wire entanglements, a devastated landscape and macabre human remains are all that is left after the blind fury of battle.

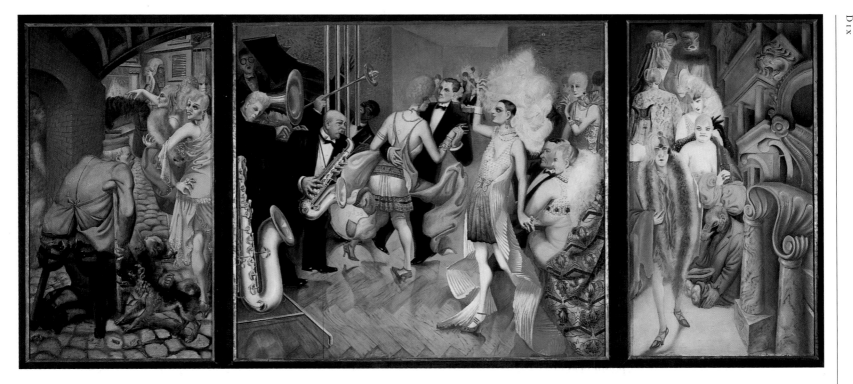

Otto Dix
Homage to Beauty

1922
Oil on canvas,
55 × 48 in.
(140 × 122 cm.)
Von der Heydt Museum,
Wuppertal

This painting precedes
the artist's large triptychs
and is indicative of the
transition to a phase
of analytical, implacable
realism. Unlike Grosz,
who always tended to use
a heavy hand, exaggerating
gestures and expressions,
Dix's development
comprised a period of
lucid and apparently
"objective" representation
of reality, as called for by
the program of the Neue
Sachlichkeit movement.
Yet the result was still a
powerful and pungent
interpretation, perfectly
in keeping with the cinema
of Fritz Lang and the
drama of Erwin Piscator.

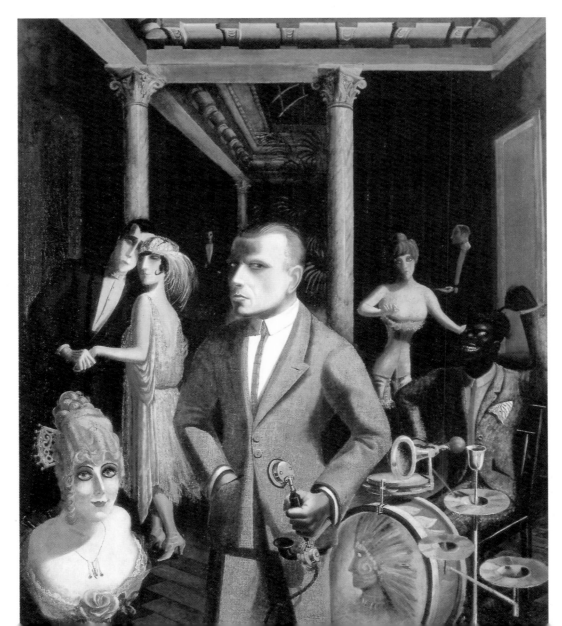

Otto Dix
Triptych of the City

1927–28
Mixed media on panel,
71¼ × 158¼ in.
(181 × 402 cm.)
Staatsgalerie Neue Meister,
Stuttgart

At once a parallel and a
contrast to the *Triptych
of War*, this masterpiece has
to be considered one of the
most striking and effective
testimonies to the climate
of Germany in the heyday
of Berlin cabaret. In the
middle, a dance band in
evening dress is playing to
a jazz beat, while elegant
couples dance in an unreal
atmosphere, the women's
heavy makeup and
fashionable attire unable to
conceal their underlying
tension. In the side panels,
two very different scenes:
on the left, a disabled ex-
serviceman hobbles on
crutches over treacherous
cobbles; on the right, a
disturbing image of
prostitutes waiting for
customers, in a shocking
mix of sensual allusions
and coarse brutality.

Otto Dix
The Seven Deadly Sins

1933
Oil on canvas,
70½ × 43 in.
(179 × 109 cm)
Staatliche Kunsthalle,
Karlsruhe

This large picture, which
escaped the systematic
destruction of "degenerate
art," clearly harks back
to the allegories and
techniques of late Gothic
painting, but applies them
to developments in
contemporary society.
The theme is that of the
seven gravest sins, depicted
in a hyperrealistic manner,
as if it were a scene from
a Grand Guignol or
Carnival. In the very year
that Hitler rose to power,
Dix included a caricature
of the dictator, in the guise
of a dazed and sinister
little boy riding on the
back of Envy. At the center
of the scene, a figure
wearing a skeleton
costume is threatening all
with the scythe of Death.

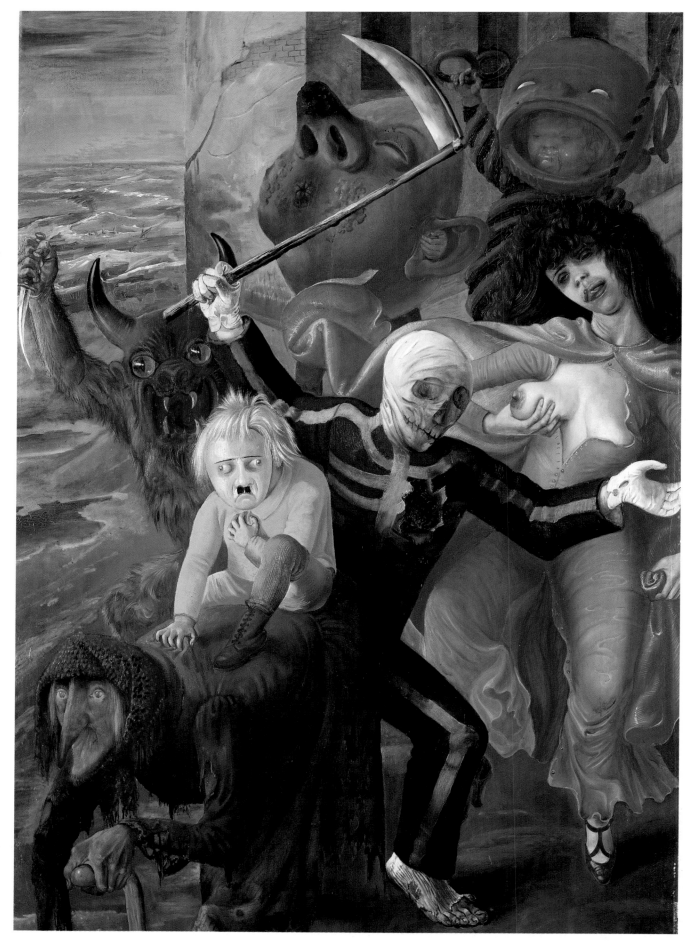

Georg Grosz
Gray Day

1921
Oil on canvas
45¼ × 31½ in.
(115 × 80 cm.)
Nationalgalerie, Berlin

A desolate image of
postwar Germany, the
painting represents a
morning on the outskirts
of Berlin. In the
foreground we see the
protagonist, a state official
in charge of pensions for
disabled soldiers. Dressed
with scrupulous care
(a decoration is pinned
to the lapel of his jacket)
and with a pince-nez over
his squinting eyes, the
bureaucrat is the very
image of an evasive and
pedantic type of assistance,
which the man keeps
locked up in the briefcase
he is carrying under his
arm. Symbolically, a wall
of bricks and indifference
separates the functionary
from the veteran who is
supposed to be receiving
his help. A black marketeer
is the hidden but real
puppet master of this
squalid scene.

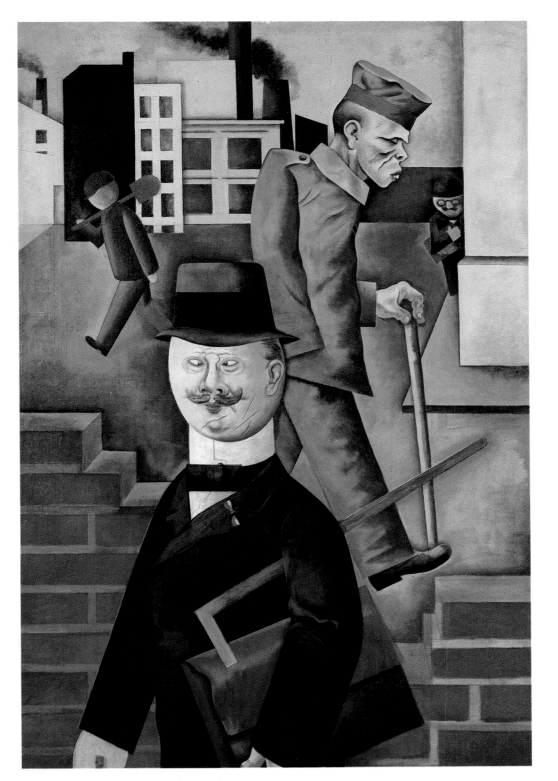

On the following page

Georg Grosz
*Picture Dedicated
to Oskar Panizza*

1917–18
Oil on canvas,
55 × 43¼ in.
(140 × 110 cm.)
Staatsgalerie, Stuttgart

The picture was painted
in the early part of Grosz's
career, when he was still
under the influence of
international tendencies:
his line is already
unmistakable, while the
dynamism of the
composition, with its tilted
perspective and teeming
horror vacui, can be linked
with Futurism.

Georg Grosz

Berlin, 1893–1959

A painter and draftsman of pungent and
dramatic power, Grosz was the most
typical exponent of German art after the
country's defeat in the First World War.
Right from his debut (an album of
drawings representing obscene, scandalous,
erotic and immoral subjects), Grosz

showed himself to be totally uninhibited
by bourgeois tastes and the demands
of the art market. Even his stylistic
technique, based on an abbreviated and
almost childish line in both his graphic
work and his painting, avoided any
concession to either academicism or the
avant-garde. From 1918 onward Grosz's
favorite subjects were scenes denouncing
physical and moral degradation: disabled
soldiers, profiteers, the shady characters

who peopled the turbid political and social
world of the Weimar Republic. He was
truly prophetic in his caustic depiction
of figures that seem to anticipate Nazism,
with their outbursts of militarism, thirst
for profit, desire for revenge and myths of
heroism that were unable to conceal the
squalid backdrop of abjection and greed for
power. During the twenties Grosz and Dix
founded the Neue Sachlichkeit group and
played an enthusiastic part in the seething

theatrical world of Berlin. In 1933
the Nazis banned Grosz's paintings and
drawings and he at once decided to
emigrate to the United States. There,
while toning down the most openly
political aspects of his art, Grosz continued
to use his biting line and bittersweet
brushwork to point out the discrepancy
between morality and vice, looking on
with growing anguish as the world
stumbled toward a new war.

Georg Grosz
The Pillar of Society

1926
Oil on canvas,
80¾ × 43 in.
(205 × 109 cm.)
Nationalgalerie, Berlin

Viewed in the light of what
was to happen in the
thirties, the pictures Grosz
painted in Berlin have a
prophetic quality. With a
despairing, sarcastic vein of
humor, the artist produced
horrifying images of the
"pillars of society" on
which Nazism would be
founded: industrialists

smarting from the war
and nursing a desire for
revenge. One, his glass
of beer just emptied, has
the memory of the
Teutonic cavalry galloping
through his mind and is
already wearing a swastika
on his tie. Another, an
indefatigable reader of the
papers, is quite unaware
that his head is stuck inside
a chamber pot. A third,
grossly fat figure is
adorned with the motto
"socialism is work."
In the background,
comrades in arms are
a mere mask for the evil
face of militarism.

Georg Grosz
Untitled

1920
Oil on canvas,
32 × 24 in.
(81 × 61 cm.)
Kunstsammlung
Nordrhein-Westfalen,
Düsseldorf

Around 1920 Grosz
went through a clearly
recognizable stylistic
phase: his pictures
insistently represented
scenes and settings from

the industrial suburbs,
in sharp and rigid lines.
These frozen and deserted
views were peopled
with mannequins, static,
faceless and sometimes
mutilated figures. It is
interesting to note the
parallel with the works of
the Metaphysical painters
(Carrà, Sironi, de Chirico)
in Italy, a country that,
despite emerging
victorious from the war,
found itself in similar
economic and social
conditions to Germany.

David Alfaro Siqueiros
Self-Portrait
or *The Great Colonel*

1945
Synthetic lacquer
on masonite,
36 × 47¾ in.
(91.5 × 121.6 cm.)
Museo Nacional de Arte,
Mexico City

In the midst of the
Mexican revolution, the
painter presents himself
as the demiurge of
reconstruction.

David Alfaro Siqueiros

Cihuahua, 1898–Cuernavaca, 1974

Along with Rivera and Orozco, Siqueiros made up the trio of great Mexican mural painters who set out to revive the grandeur and function of the cycles of frescoes of the past, usually with a strong element of political and social criticism. Trained at the San Carlos Academy of Fine Arts, Mexico City, Siqueiros gave his enthusiastic support to the Mexican revolution, joining Carranza's army. Sent to Paris as a military attaché in 1919, he was able to bring his style up to date. He also met his fellow countryman Diego Rivera and returned to Mexico with him in 1922 to launch a movement of monumental and heroic painting. The redemption of the Mexican people, along the lines of Marxist-Leninist ideology, was illustrated through a revival of Mayan and Aztec art. During the thirties the painter underwent a series of strong personal and artistic experiences in Spain and the United States. Siqueiros's epic realism, often rendered dramatic by the gulf between social aspirations and everyday life, maintained its lofty declamatory tone even after the Second World War, not only in his large-scale murals but also in paintings on canvas. This resulted in a definitive break with Rivera, who in Siqueiros's eyes was guilty of having at least partly abandoned ideology for a "non-committed" stylistic research.

Diego Alfaro Siqueiros
Portrait of the Bourgeoisie

1939
Fresco, 1076 sq. ft.
(100 sq. m.)
Union of Electricians,
Mexico City

This is probably Siqueiros's best-known work, carried out in a space that was far from easy to handle. The fulcrum of the composition is a sort of secular altar, overflowing with money, guarded by grim figures wearing gas masks. The dull gray of these masters of finance and war contrasts with the gigantic and overwhelming vitality of the representatives of the people's revolution.

Diego Rivera
History of Mexico

1930–32
Fresco, 3899¼ sq. ft.
(362.38 sq. m.)
Palacio Nacional, Mexico City

This vast cycle of frescoes, tackled with a great freedom of expression and a powerful sense of popular realism, marks the high point of the public commissions received by Rivera.

Diego Rivera
Guanajauto, 1886–Mexico City, 1957

The most cultivated and influential Mexican painter of the twentieth century, Rivera brought lengthy experience and study, assimilated in a highly personal way, to his "popular" activity. In his youth and early maturity, he alternated journeys to Europe with stays in Mexico, continuing to mix up-to-date stylistic references (Gris and Picasso, but also the great art of the Baroque era and Italian fresco painters from Giotto to Michelangelo) with elements of local, pre-Columbian culture and representational art. Between 1922 and 1929 he and Siqueiros began to decorate Mexican public buildings with huge cycles of frescoes, inspired by Marxist ideology. The result was a great popular saga, which did not fail to stir fierce controversy. In some cases the overtly ideological content of Rivera's paintings has led to their destruction in Mexico and in the United States, where the artist worked during the thirties. After the war he softened his polemical tone, but continued to produce narrative works on a vast scale that depicted the history and traditions of Mexico.

Diego Rivera
Woman of Oaxaca

1949
Oil on canvas,
61¾ × 47¼ in.
(157 × 120 cm.)
Private collection,
Mexico City

This refined painting,
evidently intended for
hanging in a bourgeois
drawing room, may appear
to contradict the populist
ideals of socialism and
patriotism evinced in
his frescoes. Yet it is an
eloquent demonstration
of Rivera's great versatility
and capacity to modify his
style drastically to suit the
need and occasion.

On the facing page
Diego Rivera
*The Children
of My Old Friend*

1930
Oil on canvas,
17 × 13½ in.
(43 × 34 cm.)
Collection of the Banco
Nacional de México,
Mexico City

The picture belongs
to a characteristic phase
in Rivera's painting, when
his commitment to the
interests of the Mexican
people began to give way
to an investigation of color
and the dilation of forms.

Lyonel Feininger

New York, 1871–1956

Feininger was an artist of great originality and independence of mind. Influenced by the main currents of German Expressionism and yet inclined to develop a poetics all of his own, he managed to create a unique blend of German and American culture, the two sources of his inspiration. Born to a family of musicians of German origin, he went back to Germany to study music. But he decided to become a painter instead, studying first in Hamburg and then in Berlin. Between 1890 and 1910 he earned his living drawing caricatures and cartoons for German and French magazines. Several stays in Paris brought him into contact with the avant-garde. In particular, he formed a close friendship with Robert Delaunay. The process of development of his style was slow, but deep. In 1913 Feininger was invited to take part in the historic exhibition staged by Kandinsky and Marc's Blaue Reiter group. This gave him an opportunity to demonstrate the independence of his style, confirmed by his first one-man show (Berlin, 1917) and by a flourishing activity as a graphic artist. Stimulated by his contacts with Cubism and Futurism, Feininger started to break down the image into three-dimensional planes, geometric shapes and regular parallelepipeds. The most interesting characteristic of this approach (applied not only to human figures but also and above all to architectural scenes) was the artist's great sensitivity to light, which permeated all his pictures and produced effects close to abstraction. At the end of the First World War, Feininger was called by Walter Gropius to work at the Bauhaus, where he chiefly taught engraving. In 1926 he formed the group known as Die Blaue Vier, "The Blue Four," with Kandinsky, Klee and Jawlensky. But the political situation was growing hostile: in 1933 Feininger's works were placed on the list of "degenerate art." A few years later, in 1937, Feininger was forced to leave Germany and return to the United States, where he spent the final part of his career observing and representing the skyscrapers of Manhattan.

Lyonel Feininger
The White Man

1907
Oil on canvas,
26¾ × 21 in.
(68 × 53.3 cm.)
Thyssen-Bornemisza
Collection,
Madrid

The lean figure loping through the city late in the evening is an apt allegory of Feininger's subtle and refined role in the art of the early twentieth century. Apart from the period spent at the Bauhaus, Feininger cannot be pinned down or associated with a particular avant-garde, following a course of his own that led him to build a bridge between Germany and the United States. The density of the paint in his prewar pictures was later to give way to sophisticated light effects and transparent tones.

Lyonel Feininger
Road at Night

1929
Oil on canvas,
14¼ × 22 in. (36 × 56 cm.)
Gemäldegalerie Neue
Meister, Dresden

The regular modules,
typical of Constructivist
architecture, take
on varying appearances
as the light changes.

Lyonel Feininger
Illuminated Row of Houses II

1932
Oil on canvas,
26¾ × 21 in. (68 × 53.3 cm.)
Kunstmuseum, Basel

In his urban views, with
their fine balance of realism
and abstraction, Feininger
shows his main point of
contact with Klee and the
Bauhaus, evident in the
regular sequence of straight
lines and the subtle
variations of light and color.

Edward Hopper
Nyack, 1882–New York, 1967

The principal exponent of twentieth-century American Realism, Hopper seems to have continually anticipated the themes, scenes and figures that are now familiar to us from the movies. The disillusionment and solitude, the spaces, lights and silence of a provincial America often imbue his canvases with a highly suggestive atmosphere. Trained at the New York School of Art, Hopper went to Europe three times between 1906 and 1910 to deepen his artistic culture. Yet he did not fall under the spell of any of the flourishing avant-garde movements during his visits to the Old World. Indeed, it was a long time before Hopper began to paint seriously. For years he devoted himself almost exclusively to commercial art and etchings, and it was not until 1924 that he staged an exhibition of watercolors, followed by another of oil paintings in 1927. His success was immediate, to the point where Hopper became the most characteristic and influential interpreter of the American image. His early pictures, almost all of them landscapes, already convey a sense of great melancholy, with their distant horizons and forms that are at once sharply-defined and elusive. This feeling is still more explicit in the scenes set in the city, where his figures, depicted with limpid objectivity, live lonely and isolated lives. It is clear that Hopper's apparently "photographic" realism is actually constructed with great skill: the empty spaces separating one figure from another, the geometrically schematic settings and the carefully studied lighting are all means to an intensely lyrical sense of participation, comparable to that of the Italian Metaphysical painters.

Edward Hopper
My Roof

1928
Watercolor on cardboard,
13¾ × 19¾ in.
(35 × 50 cm.)
Thyssen-Bornemisza
Collection, Madrid

Hopper's studio was at number 3, Washington Square in New York, in the heart of Greenwich Village, the district of Manhattan that was to become the haunt of artists and intellectuals.

Edward Hopper
Hotel Room

1931
Oil on canvas,
60 × 65¼ in.
(152.4 × 165.7 cm.)
Thyssen-Bornemisza
Collection, Madrid

Here we can recognize some of the influences of European art (the silence and immobility of Metaphysical painting, German Realism) on which Hopper built his own interpretation of the world.

Edward Hopper
Rocky Cove, Maine

1927
Watercolor on cardboard,
15½ × 19½ in.
(39.2 × 49.5 cm.)
Thyssen-Bornemisza
Collection, Madrid

Even in his landscapes
Hopper expressed the
feeling of solitude and
distance that pervades all
his painting. The majority
of them are uninhabited
and stark views, whose
exact geographical location
is unclear.

Edward Hopper
Motel in the West

1957
Oil on canvas,
30¼ × 50 in.
(76.8 × 127.3 cm.)
Yale University Art
Gallery, New Haven

The most typical and
powerful of Hopper's
themes are the ones linked
to the daily existence of
anonymous people. The
painter was particularly
drawn by hotel rooms,
where faces, lives and
sentiments changed every
day. There is an evident
contrast between the
furnishings, "decent" but
totally impersonal, and the
woman who brings them
temporarily to life. Hopper
depicts a situation of
unease and impersonality,
confronting the "nameless"
setting with the unopened
suitcases to which the tags
identifying their owner are
attached.

389

Jackson Pollock

*Cody (Wyoming), 1912–East Hampton,
New York, 1956*

An artist who exercised a decisive influence on the fate of easel painting after the Second World War, Pollock is an excellent point at which to close this volume, given his pivotal position in the history of art. In his revolutionary approach to painting it is possible to discern ideas and characteristics drawn from other twentieth-century artists, but there can be no doubt that the dynamism of his Action Painting and the apparently random nature of his technique of dripping paint onto the canvas represent radical breaks with tradition. Pollock, in short, marks the beginning of "contemporary painting," whose further developments lie outside the scope of this book. There are some romantic aspects to the artist's life, such as his youth spent in contact with Navaho Indians (whose ritual drawings in sand made a deep impression on him), or his encounter with the great collector Peggy Guggenheim, who established a relationship with Pollock that was worthy of the bond between patron and artist in the Renaissance. Arriving in New York in 1929, the year of the Wall Street crash, Pollock combined a keen interest in American art (and the Mexican muralists in particular) with studies of European painting. He was especially attracted by Miró's freedom of expression and at once began to investigate the possibilities of abstraction. At the end of the thirties, when he had built up a fully conscious and up-to-date figurative culture, Pollock returned to the theme of primitive, arcane and archaic art, investigating the symbolic meaning attached to every gesture and sign. Following this line of research, he developed the technique of "drip and splash" shortly after the end of the Second World War. This innovative approach entailed pouring and dripping enamel paint onto canvases laid on the ground, often of very large size. In this sense, Pollock can be considered the founder of "nonrepresentational" art, the dominant international current in painting during the fifties.

Jackson Pollock
Enchanted Forest

1947
Oil on canvas,
87 × 45 in.
(221 × 114 cm.)
Peggy Guggenheim
Collection, Venice

The paintings by Pollock on show at the Palazzo Venier dei Leoni in Venice were commissioned directly by Peggy Guggenheim and constitute a group of fundamental importance to an understanding of the American artist's stylistic development.

Below

Jackson Pollock
Eyes in the Heat

1946
Oil on canvas,
54 × 43¼ in.
(137 × 110 cm.)
Peggy Guggenheim
Collection, Venice

The "eyes" are the circular
patterns that dot the
composition, heated by
the expressive agitation of
the image. They constitute
a living presence within
the picture that holds a
dialogue with the observer.

Jackson Pollock
Mural

1943
Mixed media on wall,
95¾ × 237½ in.
(243.2 × 603.2 cm.)
The University of Iowa
Museum of Art, Iowa City

The monumental
characteristics of Pollock's
painting make it ideal for
the decoration of large
architectural spaces.

Jackson Pollock
Blue Poles

1952
Oil on canvas,
58 × 82 in.
(147.3 × 208.6 cm.)
Formerly Heller
Collection, New York

The "poles" constitute
the series of slanting
elements that divide up
the surface of the canvas,
creating a powerful rhythm
in spite of the apparent
improvisation of the lines.

Above

Jackson Pollock
Number 11

1950
Oil and aluminum
paint on panel,
22¼ × 22¼ in.
(56.5 × 56.5 cm.)
Thyssen-Bornemisza
Collection, Madrid

Another of Pollock's
innovations was the use of
industrial paints, clearing
the way for Pop Art.

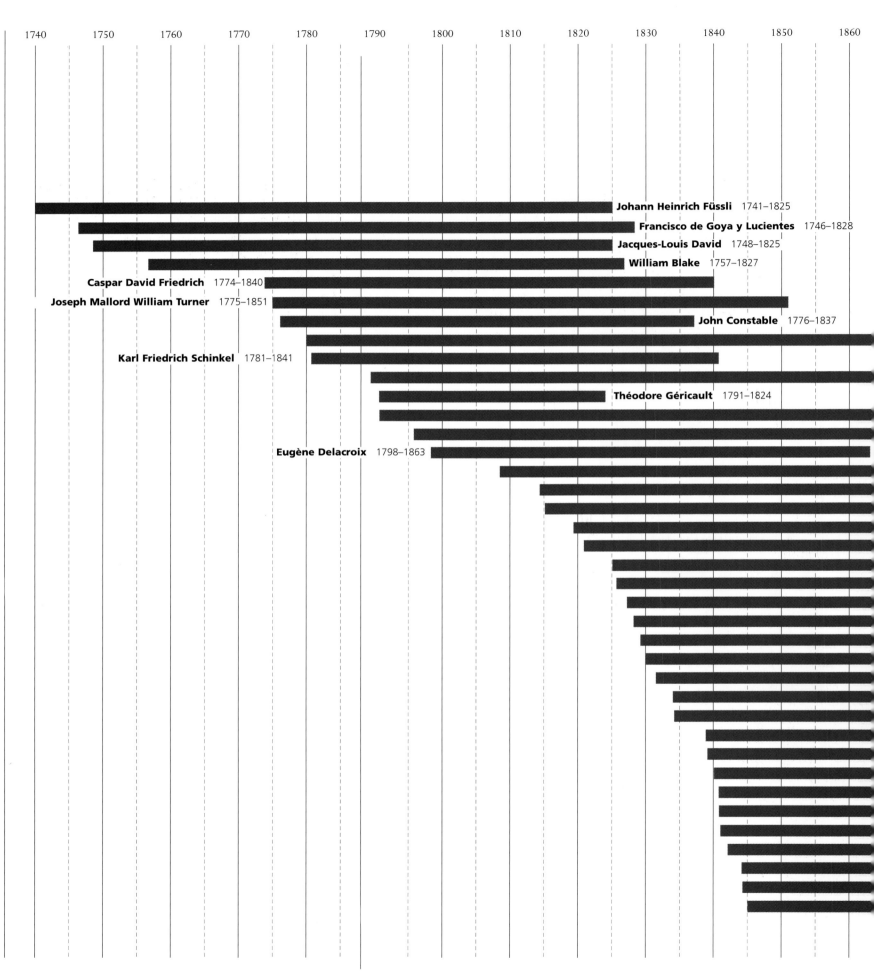

1740 1750 1760 1770 1780 1790 1800 1810 1820 1830 1840 1850 1860

Johann Heinrich Füssli 1741–1825

Francisco de Goya y Lucientes 1746–1828

Jacques-Louis David 1748–1825

William Blake 1757–1827

Caspar David Friedrich 1774–1840

Joseph Mallord William Turner 1775–1851

John Constable 1776–1837

Karl Friedrich Schinkel 1781–1841

Théodore Géricault 1791–1824

Eugène Delacroix 1798–1863

| 1870 | 1880 | 1890 | 1900 | 1910 | 1920 | 1930 | 1940 | 1950 | 1960 | 1970 | 1980 | 1990 |

Jean-Auguste-Dominique Ingres 1780–1867

Johann Friedrich Overbeck 1789–1869

Francesco Hayez 1791–1882

Jean-Baptiste-Camille Corot 1796–1875

Honoré Daumier 1808–1879

Jean-François Millet 1814–1875

Adolf von Menzel 1815–1905

Gustave Courbet 1819–1877

Ford Madox Brown 1821–1893

Giovanni Fattori 1825–1908

Gustave Moreau 1826–1898

Arnold Böcklin 1827–1901

Dante Gabriel Rossetti 1828–1882

John Everett Millais 1829–1896

Camille Pissarro 1830–1903

Edouard Manet 1832–1883

James Abbott McNeill Whistler 1834–1903

Edgar Degas 1834–1917

Alfred Sisley 1839–1899

Paul Cézanne 1839–1906

Claude Monet 1840–1926

Berthe Morisot 1841–1895

Federico Zandomeneghi 1841–1917

Pierre-Auguste Renoir 1841–1919

Giovanni Boldini 1842–1931

Henri Rousseau 1844–1910

Ilya Repin 1844–1930

Mary Cassatt 1844–1926

393

1740 1750 1760 1770 1780 1790 1800 1810 1820 1830 1840 1850 1860

Pab▶

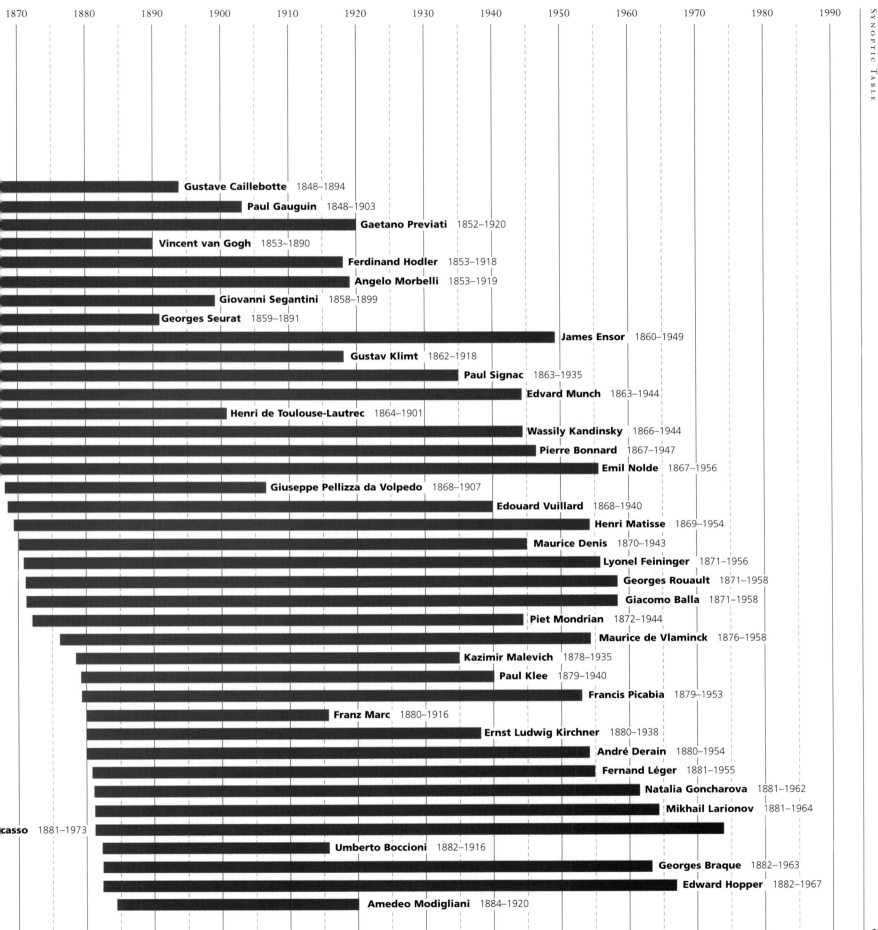

1870 1880 1890 1900 1910 1920 1930 1940 1950 1960 1970 1980 1990

Gustave Caillebotte 1848–1894
Paul Gauguin 1848–1903
Gaetano Previati 1852–1920
Vincent van Gogh 1853–1890
Ferdinand Hodler 1853–1918
Angelo Morbelli 1853–1919
Giovanni Segantini 1858–1899
Georges Seurat 1859–1891
James Ensor 1860–1949
Gustav Klimt 1862–1918
Paul Signac 1863–1935
Edvard Munch 1863–1944
Henri de Toulouse-Lautrec 1864–1901
Wassily Kandinsky 1866–1944
Pierre Bonnard 1867–1947
Emil Nolde 1867–1956
Giuseppe Pellizza da Volpedo 1868–1907
Edouard Vuillard 1868–1940
Henri Matisse 1869–1954
Maurice Denis 1870–1943
Lyonel Feininger 1871–1956
Georges Rouault 1871–1958
Giacomo Balla 1871–1958
Piet Mondrian 1872–1944
Maurice de Vlaminck 1876–1958
Kazimir Malevich 1878–1935
Paul Klee 1879–1940
Francis Picabia 1879–1953
Franz Marc 1880–1916
Ernst Ludwig Kirchner 1880–1938
André Derain 1880–1954
Fernand Léger 1881–1955
Natalia Goncharova 1881–1962
Mikhail Larionov 1881–1964
casso 1881–1973
Umberto Boccioni 1882–1916
Georges Braque 1882–1963
Edward Hopper 1882–1967
Amedeo Modigliani 1884–1920

395

1740	1750	1760	1770	1780	1790	1800	1810	1820	1830	1840	1850	1860

Karl Sch

Sonia

O

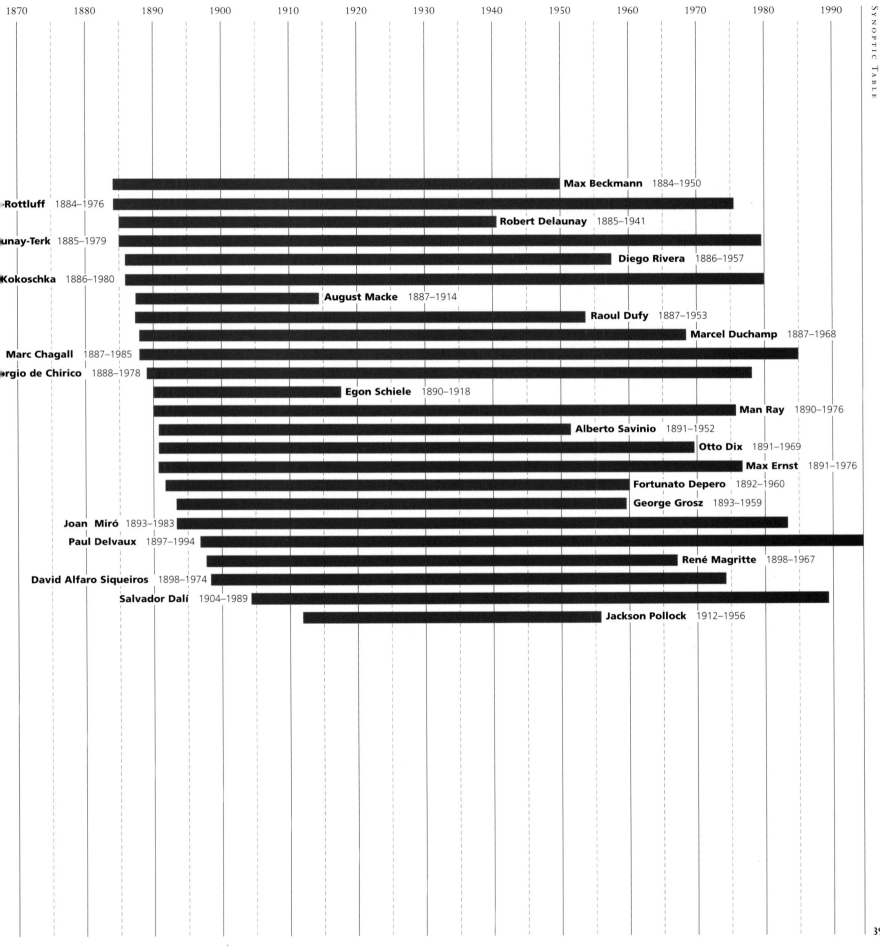

1870 1880 1890 1900 1910 1920 1930 1940 1950 1960 1970 1980 1990

Max Beckmann 1884–1950

Rottluff 1884–1976

Robert Delaunay 1885–1941

unay-Terk 1885–1979

Diego Rivera 1886–1957

Kokoschka 1886–1980

August Macke 1887–1914

Raoul Dufy 1887–1953

Marcel Duchamp 1887–1968

Marc Chagall 1887–1985

rgio de Chirico 1888–1978

Egon Schiele 1890–1918

Man Ray 1890–1976

Alberto Savinio 1891–1952

Otto Dix 1891–1969

Max Ernst 1891–1976

Fortunato Depero 1892–1960

George Grosz 1893–1959

Joan Miró 1893–1983

Paul Delvaux 1897–1994

René Magritte 1898–1967

David Alfaro Siqueiros 1898–1974

Salvador Dalí 1904–1989

Jackson Pollock 1912–1956

397

Index of Artists

Photograph Credits

Electa Archives, Milan
Mondadori Archives, Milan

We also wish to thank all of the museums
and institutions who have so kindly
provided photographs from their archives.

Any person claiming to hold the copyright
for unidentified photograph sources should
contact the publisher.

This volume was printed in Italy in September 1998
at Arnoldo Mondadori Editore, Verona